Thorburn's Naturalist's Sketchbook

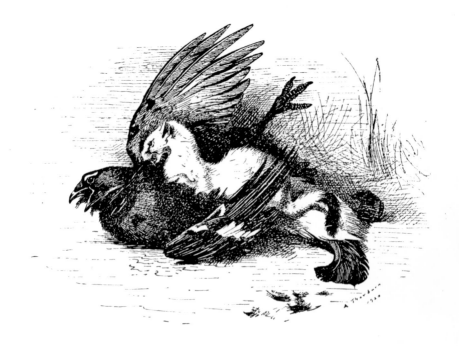

With an Introduction by

Robert Dougall

Michael Joseph Limited
London

Thorburn's Naturalist's Sketchbook

Published in Great Britain by
Michael Joseph Limited
52 Bedford Square
London WC1

Illustrations and text by Archibald Thorburn,
first published 1919 in *A Naturalist's Sketchbook*
This edition © Rainbird Reference Books Limited 1977,
and reproduced by permission of The Tryon Gallery.

The line drawings listed below are reproduced from
Thorburn's *British Mammals*, London, 1920–1, as follows:
page 1 Stoat, from Volume 1, page 76
 2 Mountain Hare, from Volume 2, page 33
 3 Roe Deer, from Volume 2, page 49
 6 Black Rat, from Volume 2, page 14
 9 Badger, from Volume 1, title page
 134 Wild Cattle, from Volume 2, page 54

The quotation on page 6 is from the obituary of
Thorburn that appeared in the *Ibis,* January 1936, 13th series,
vol. VI: 205–7, and is reproduced by kind permission of
the British Ornithologists' Union.

First published 1977
ISBN 0 7181 1567 8

This book was designed and produced by
Rainbird Reference Books Limited
36 Park Street, London W1Y 4DE
House Editor: Perry Morley
Designers: Pauline Harrison and Chris Sorrell

Text filmset and printed by Jolly & Barber Ltd, Rugby
Bound by Dorstal Press Ltd, Harlow

Contents

Editorial Note

In this new edition, we have reproduced from the 1919 edition almost all of Thorburn's sketches and the text in its entirety except for a few references to illustrations which have not been included here. Since the illustrations have been slightly rearranged to suit the small format, we have amended the text where necessary to take account of their new positions. We have added eleven plates from *British Birds* and four from *British Mammals*, and a few engravings from the latter; notes identifying these appear in square brackets or on page 4.

A word of caution: we felt that it was more appropriate to accompany the illustrations by the artist's original notes than to attempt to update information about the species shown and we must emphasize that the text is not up-to-date. Recent information on the distribution of these species in the British Isles as well as more plates by Thorburn may be found in *Thorburn's Birds*, edited with an introduction and text by James Fisher, revised by John Parslow (London, 1976) and *Thorburn's Mammals*, with an introduction by David Attenborough and notes by Iain Bishop (London, 1974).

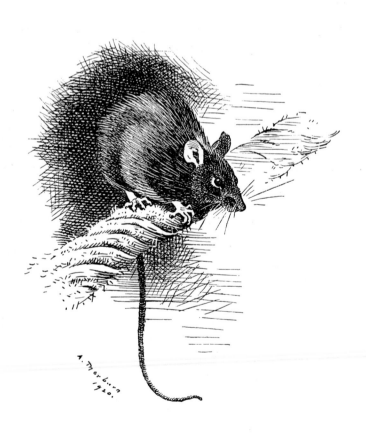

Golden Eagle

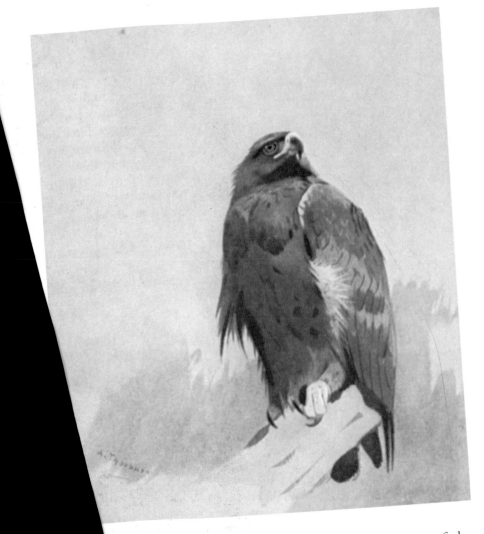

...e bird is still fairly plentiful in the wilder parts of the
...Highlands, where, owing to the protection afforded by
...forests, it is not even rare as a breeding species.
...rie is usually placed on a ledge in some rocky cliff and
...ly in trees. A typical nest I had the opportunity of
...several occasions lately contained one white downy
...consisted of a large mass of dead heather and sticks
...e upper part of a sloping ledge covered with turf,

Introduction
by Robert Dougall

It seems to me a cause for no small rejoicing that Archibald Thorburn's *A Naturalist's Sketchbook*, now a rare collector's piece, is being revived in this edition for a new generation to enjoy. It first appeared when the artist was at the height of his powers in 1919. He was then aged 59 and living at Hascombe, near Godalming in Surrey, where he resided until his death on 9 October 1935.

A few months later his great friend and fellow artist, George Lodge, called him a great ornithological artist, who 'at once demonstrated . . . his infinite superiority to all contemporaries in the same line of work. . . . He had a wonderful gift for placing his bird subjects in harmonious surroundings. . . . Whether he was painting a large picture of a whole covey or flock of birds or merely a scientific depiction of a single bird for a book illustration, his method and execution were equally admirable. . . . He appeared to visualize a subject so well before beginning to paint it that his work was very rapid, and wonderfully fluent and direct.' Lodge then spoke of another of his characteristics that shines through everything he did: 'Thorburn was a man of most lovable qualities, very modest about his own work, but never reticent about his methods of producing it, and always ready to impart his knowledge to others in the most generous way.'

In a sense, his work bridged the differing techniques of the nineteenth and twentieth centuries and in both he was supreme. It is strange to think that much of his meticulous observation of birds and mammals may have come from a disciplined study of the anatomy of Greek statues. That was in his boyhood days of the 1860s and '70s in Scotland, when he was greatly influenced by his father, Robert Thorburn, R.S.A., A.R.A., who was portrait miniaturist to Queen Victoria.

Then, after his education at Dalkeith and in Edinburgh, he came to London to study at art school in St John's Wood. As a young man of 20 he first exhibited at the Royal Academy and the painting selected owed much to his Scottish background – 'On the Moor'.

In a few years he won recognition as a leading illustrator and soon attracted the attention of one of the foremost ornithologists of the day, Lord Lilford, who was working on a major treatise, *Coloured Figures of the Birds of the British Islands* (1885–98). The original artist chosen, J. G. Keulemans, fell ill, and Thorburn was commissioned to complete the work. He learned much and benefited greatly from his association with Lord Lilford, who was the most exacting of men.

While still engaged on this project, he met Constance Mudie, whom he married in 1896. They continued to live in London and he was by this time greatly in demand as an illustrator of scientific and sporting books. He was also an enthusiastic supporter of the then newly formed Royal Society for the Protection of Birds and in 1899 started a long tradition when he painted its first Christmas card. It was a study of roseate terns, with a verse by the Poet Laureate, Alfred Austin. In all Thorburn did 19 Christmas cards and the last was of a goldcrest: it was also the last thing he painted before his death, after a long and painful illness. The originals were all given to the Society and sold in aid of funds: prices ranged from 10 to 30 guineas.

There is no doubt that Thorburn's paintings did much to stimulate a growing interest in birds and their place in nature; in recognition of his services to bird protection he was elected a vice-president of the Society in 1927.

A Naturalist's Sketchbook was one of five books he wrote and illustrated himself between 1915 and 1926. It is a special example of his art and Sir Hugh Gladstone, the Scottish historian and

ornithologist, said of it: 'Some of these sketches – done, as they must have been, in but a few minutes – are, perhaps, the most intimate and fascinating examples of his skill.'

This new edition has 49 colour and over 90 monochrome illustrations, most of which are reproduced from the original book. Thorburn had gathered them from various sketchbooks and portfolios and they span about 30 years of his life. Some of the sketches were preliminary drawings for two of his other books, *British Birds* and *British Mammals*, and so a few colour plates from these works have also been included for interest and comparison.

I should like to stress that the text is the identical and rather generalized one Thorburn wrote over half a century ago. Thus, the essential character of his original publication has been faithfully retained. It is also interesting to note some of the changes that have taken place in the distribution of birds since his day – particularly the gains. Noteworthy among them is the osprey, whose disappearance 'banished and exterminated by the egg collector' the kindly genius so lamented. How delighted he would have been to know that since 1950, when one pair bred successfully at the now famous Loch Garten eyrie on Speyside, this splendid fishhawk has spread out elsewhere in the Highlands and the population has built up to 14 pairs. A happy thought too that over 1500 acres of the ancient Caledonian pine forest and moorland, centred on Loch Garten, have now been acquired by the RSPB as a nature reserve for all time. Incidentally, it is heartening, too, to know that the Society has flourished exceedingly and now numbers a quarter of a million members.

In Thorburn's day the black and white wader, the avocet, the Society's emblem, was known only as 'a rare straggler'. It constitutes another conservation triumph that since these elegant birds tentatively returned to breed in Suffolk after World War II, successful colonies have now been established at Minsmere and on Havergate Island. Thorburn would also have rejoiced to know that the snowy owl has bred successfully in most years since 1967 on the tiny Shetland Isle of Fetlar to become Britain's rarest breeding bird.

Yet another enterprise which he would be sure to approve is the attempt being made by the Hon. Aylmer Tryon to re-establish the great bustard in its former haunts on Salisbury Plain. In his capacity as a leading wildlife art connoisseur and director of a famous London gallery, Aylmer Tryon is also one of those best qualified to give a final assessment of Thorburn's place in the world of natural history illustration. In his opinion: 'No other artist has achieved so well the softness of fur or feather, nor captured the wonderful colouring of the sheen of a drake mallard's head or of a cock pheasant in snow. His pencil sketches from life, too, so essential for success, have a delicacy of touch unsurpassed by others. Archibald Thorburn was, in my view, the best of all illustrators of British wildlife.'

These are words with which most people will heartily concur.

Author's Preface

The series of water colour and pencil sketches reproduced in this volume ha
various sketch books and portfolios, representing part of the congenial th
labour of some thirty years, and were drawn mostly direct from life in
Islands, while a few pictures, showing the birds in their natural surround

Looking at things with the eye of the ordinary lover of nature, one ca
with brush and pencil the wonderful beauty of the living creatures arou
of the true spirit and sense of movement may sometimes be sugges
elaborate and finished pictures. The chief essential is to acquire the f
down the many subtle differences in pose and little tricks of hab
knowledge can only be obtained by patient watching.

To quote the words of the late J. Wolf, the most original obser
known, 'We see distinctly only what we know thoroughly.'

A short description of the different subjects has been added
various species in the Plates.

Hascombe,
Godalming, *July* 1919

This fi
Scottish
the deer

The e
occasiona
visiting o
eaglet and
placed on t

ferns, and woodrush, the latter plant being invariably used as a lining to the nest.

As I believe is usually the case, the nest had a northerly aspect to shield the eaglet from the heat of the mid-day sun and on looking upwards one could see it was well protected from the weather by overhanging rocks, while below the precipice fell sheer into the waters of a loch.

The sketch opposite represents the Golden Eagle in repose, with loosened plumage revealing the grey downy feathering on the flank of the bird, the sketch below the attitude when feeding, both sketched from life.

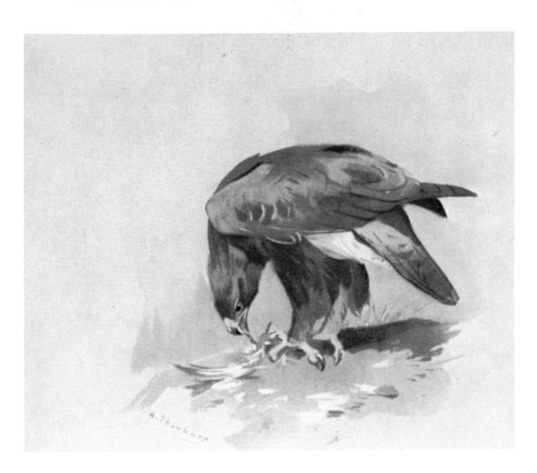

Golden Eagle

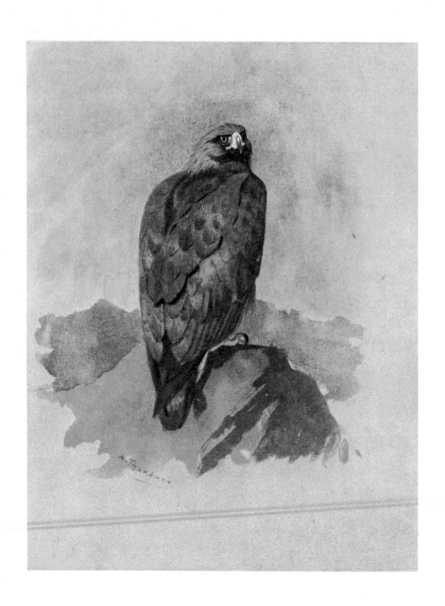

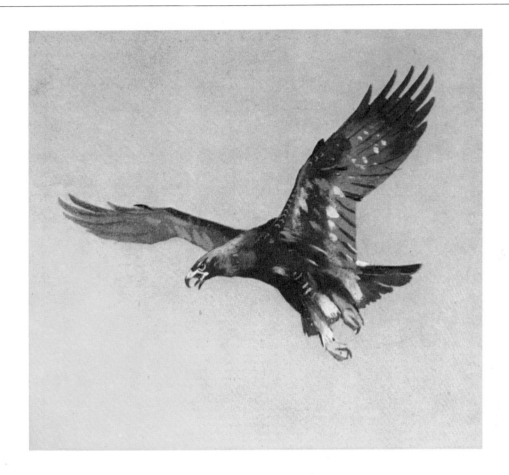

The figure above shows the Golden Eagle in flight about to clutch and carry off his prey, when he always uses his talons for the purpose.

In spite of his considerable weight, the bird rises with great ease and buoyancy, often soaring in wide circles and appearing to float in the air without effort. As shown in the sketch, the pinion feathers of the wing are separated during flight.

The sketch opposite gives the back view of a Golden Eagle when at rest.

Golden Eagle

The sketches of the Golden Eagle's talons taken direct from nature show how the claws interlock when the bird seizes his victim, making it next to impossible for any unfortunate hare or other quarry to effect its escape when once securely grasped.

The lower part of the tarsus and foot serve as an easy means of distinguishing this species at any time from the White-tailed or Sea Eagle, figured on page 16, the latter having the lower half of the tarsus unfeathered and the toes plated with large scales, whereas in

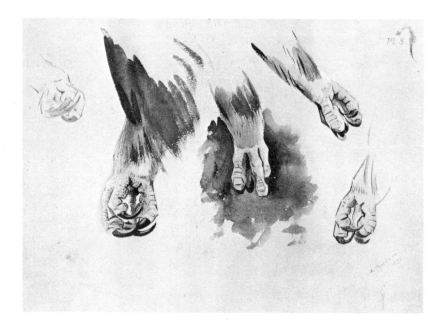

the Golden Eagle the legs are clothed with feathers as far as the base of the toes, which are covered with a network of small plates with three or four broad scales next the claws.

In adult plumage the two species may be easily known, the Sea Eagle having a white tail, while that of the other is dull grey, barred with a darker tone.

[The Golden Eagle shown opposite is reproduced from Plate 32 of Thorburn's *British Birds*, London, 1915–18.]

Introduction
by Robert Dougall

It seems to me a cause for no small rejoicing that Archibald Thorburn's *A Naturalist's Sketchbook*, now a rare collector's piece, is being revived in this edition for a new generation to enjoy. It first appeared when the artist was at the height of his powers in 1919. He was then aged 59 and living at Hascombe, near Godalming in Surrey, where he resided until his death on 9 October 1935.

A few months later his great friend and fellow artist, George Lodge, called him a great ornithological artist, who 'at once demonstrated . . . his infinite superiority to all contemporaries in the same line of work. . . . He had a wonderful gift for placing his bird subjects in harmonious surroundings. . . . Whether he was painting a large picture of a whole covey or flock of birds or merely a scientific depiction of a single bird for a book illustration, his method and execution were equally admirable. . . . He appeared to visualize a subject so well before beginning to paint it that his work was very rapid, and wonderfully fluent and direct.' Lodge then spoke of another of his characteristics that shines through everything he did: 'Thorburn was a man of most lovable qualities, very modest about his own work, but never reticent about his methods of producing it, and always ready to impart his knowledge to others in the most generous way.'

In a sense, his work bridged the differing techniques of the nineteenth and twentieth centuries and in both he was supreme. It is strange to think that much of his meticulous observation of birds and mammals may have come from a disciplined study of the anatomy of Greek statues. That was in his boyhood days of the 1860s and '70s in Scotland, when he was greatly influenced by his father, Robert Thorburn, R.S.A., A.R.A., who was portrait miniaturist to Queen Victoria.

Then, after his education at Dalkeith and in Edinburgh, he came to London to study at art school in St John's Wood. As a young man of 20 he first exhibited at the Royal Academy and the painting selected owed much to his Scottish background – 'On the Moor'.

In a few years he won recognition as a leading illustrator and soon attracted the attention of one of the foremost ornithologists of the day, Lord Lilford, who was working on a major treatise, *Coloured Figures of the Birds of the British Islands* (1885–98). The original artist chosen, J. G. Keulemans, fell ill, and Thorburn was commissioned to complete the work. He learned much and benefited greatly from his association with Lord Lilford, who was the most exacting of men.

While still engaged on this project, he met Constance Mudie, whom he married in 1896. They continued to live in London and he was by this time greatly in demand as an illustrator of scientific and sporting books. He was also an enthusiastic supporter of the then newly formed Royal Society for the Protection of Birds and in 1899 started a long tradition when he painted its first Christmas card. It was a study of roseate terns, with a verse by the Poet Laureate, Alfred Austin. In all Thorburn did 19 Christmas cards and the last was of a goldcrest: it was also the last thing he painted before his death, after a long and painful illness. The originals were all given to the Society and sold in aid of funds: prices ranged from 10 to 30 guineas.

There is no doubt that Thorburn's paintings did much to stimulate a growing interest in birds and their place in nature; in recognition of his services to bird protection he was elected a vice-president of the Society in 1927.

A Naturalist's Sketchbook was one of five books he wrote and illustrated himself between 1915 and 1926. It is a special example of his art and Sir Hugh Gladstone, the Scottish historian and

ornithologist, said of it: 'Some of these sketches – done, as they must have been, in but a few minutes – are, perhaps, the most intimate and fascinating examples of his skill.'

This new edition has 49 colour and over 90 monochrome illustrations, most of which are reproduced from the original book. Thorburn had gathered them from various sketchbooks and portfolios and they span about 30 years of his life. Some of the sketches were preliminary drawings for two of his other books, *British Birds* and *British Mammals*, and so a few colour plates from these works have also been included for interest and comparison.

I should like to stress that the text is the identical and rather generalized one Thorburn wrote over half a century ago. Thus, the essential character of his original publication has been faithfully retained. It is also interesting to note some of the changes that have taken place in the distribution of birds since his day – particularly the gains. Noteworthy among them is the osprey, whose disappearance 'banished and exterminated by the egg collector' the kindly genius so lamented. How delighted he would have been to know that since 1950, when one pair bred successfully at the now famous Loch Garten eyrie on Speyside, this splendid fishhawk has spread out elsewhere in the Highlands and the population has built up to 14 pairs. A happy thought too that over 1500 acres of the ancient Caledonian pine forest and moorland, centred on Loch Garten, have now been acquired by the RSPB as a nature reserve for all time. Incidentally, it is heartening, too, to know that the Society has flourished exceedingly and now numbers a quarter of a million members.

In Thorburn's day the black and white wader, the avocet, the Society's emblem, was known only as 'a rare straggler'. It constitutes another conservation triumph that since these elegant birds tentatively returned to breed in Suffolk after World War II, successful colonies have now been established at Minsmere and on Havergate Island. Thorburn would also have rejoiced to know that the snowy owl has bred successfully in most years since 1967 on the tiny Shetland Isle of Fetlar to become Britain's rarest breeding bird.

Yet another enterprise which he would be sure to approve is the attempt being made by the Hon. Aylmer Tryon to re-establish the great bustard in its former haunts on Salisbury Plain. In his capacity as a leading wildlife art connoisseur and director of a famous London gallery, Aylmer Tryon is also one of those best qualified to give a final assessment of Thorburn's place in the world of natural history illustration. In his opinion: 'No other artist has achieved so well the softness of fur or feather, nor captured the wonderful colouring of the sheen of a drake mallard's head or of a cock pheasant in snow. His pencil sketches from life, too, so essential for success, have a delicacy of touch unsurpassed by others. Archibald Thorburn was, in my view, the best of all illustrators of British wildlife.'

These are words with which most people will heartily concur.

Author's Preface

The series of water colour and pencil sketches reproduced in this volume have been gathered from various sketch books and portfolios, representing part of the congenial though by no means easy labour of some thirty years, and were drawn mostly direct from life in many parts of the British Islands, while a few pictures, showing the birds in their natural surroundings, have been added.

Looking at things with the eye of the ordinary lover of nature, one can only attempt to represent with brush and pencil the wonderful beauty of the living creatures around us, though perhaps more of the true spirit and sense of movement may sometimes be suggested in sketches than in more elaborate and finished pictures. The chief essential is to acquire the faculty of observing and noting down the many subtle differences in pose and little tricks of habit in different species, and this knowledge can only be obtained by patient watching.

To quote the words of the late J. Wolf, the most original observer of wild animal life I have ever known, 'We see distinctly only what we know thoroughly.'

A short description of the different subjects has been added as an aid to the identification of the various species in the Plates.

AT

Hascombe,
Godalming, *July* 1919

Golden Eagle

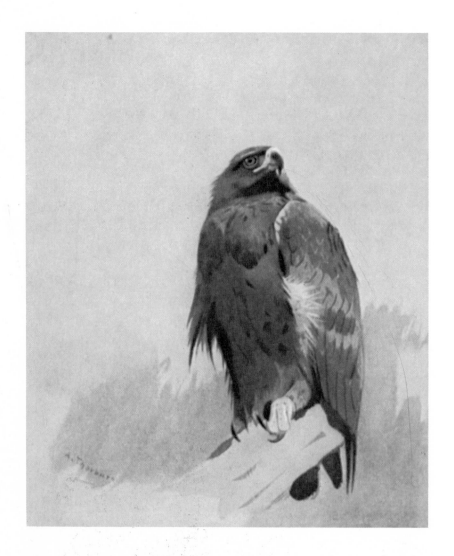

This fine bird is still fairly plentiful in the wilder parts of the Scottish Highlands, where, owing to the protection afforded by the deer forests, it is not even rare as a breeding species.

The eyrie is usually placed on a ledge in some rocky cliff and occasionally in trees. A typical nest I had the opportunity of visiting on several occasions lately contained one white downy eaglet and consisted of a large mass of dead heather and sticks placed on the upper part of a sloping ledge covered with turf,

Pl. 32

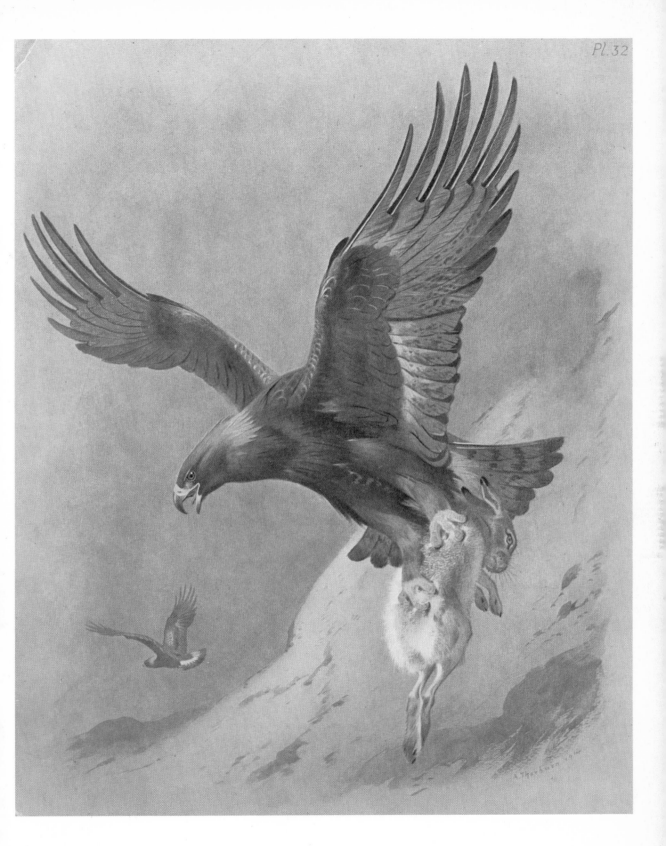

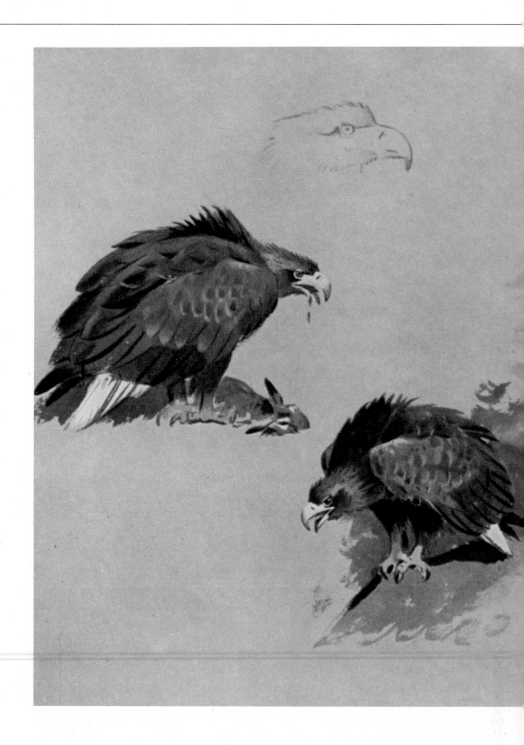

White-Tailed or Sea Eagle

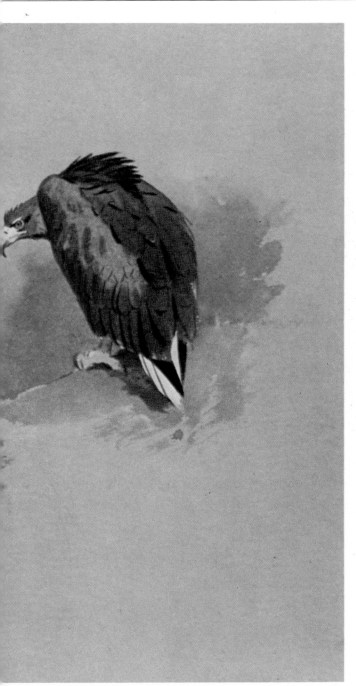

This bird may now be considered extinct as a breeding species in the British Islands, except possibly in the Outer Hebrides, though it was at one time apparently more numerous than the Golden Eagle.

Usually placing its eyrie in precipitous cliffs on the sea coast it was outlawed by the shepherd and crofter and finally extirpated by the ruthlessness of the egg collector.

Immature migratory individuals from the northern continent of Europe may still be looked for along our coasts during autumn and winter, being easily distinguished from the adults by their dark tails and generally darker brown plumage.

In character this species has more of the vulture than the Golden Eagle, but though partial to dead fish and carrion found on the shore, it also frequently destroyed lambs as well as rabbits on the sheep farms and warrens.

Common Buzzard and Osprey

The Buzzard is not uncommon in many parts of Scotland, in the Lake District of England as well as in Wales, while in Ireland it has disappeared except as a spring and autumn visitant.

Owing to the neglect of game preserving during the late war, it appears to have become more numerous in the last few years, and on account of its sluggish habits and fondness for rabbits, moles, fieldmice and other small rodents, it does little harm to winged game, and spends much of its time sitting on some stony hillside or soaring with a style of flight not unlike that of the Golden Eagle.

In Scotland the nest is generally placed in a steep cliff, though in wooded districts it is built in trees.

The two sketches above show the Buzzard in repose.

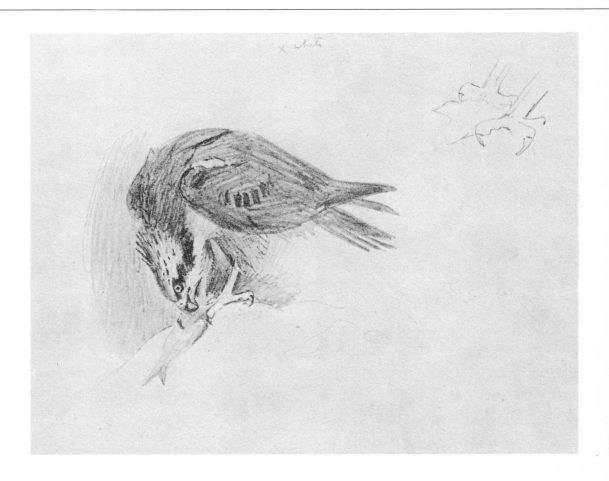

The figure above gives the attitude of the Osprey when feeding, sketched from life in the Zoological Gardens of London.

At one time to be found breeding on various Highland lochs, this bird has now been banished and exterminated by the egg collector. The ancient nesting places, usually a conical rock, ruined building, or weathered pine on an island, are still there, and although situated among most beautiful surroundings have lost much of their charm by the Osprey's disappearance.

The food, consisting entirely of fish, is obtained by a sudden plunge from above, the slippery prey being firmly held by the long curved claws and roughened toes which distinguish this species.

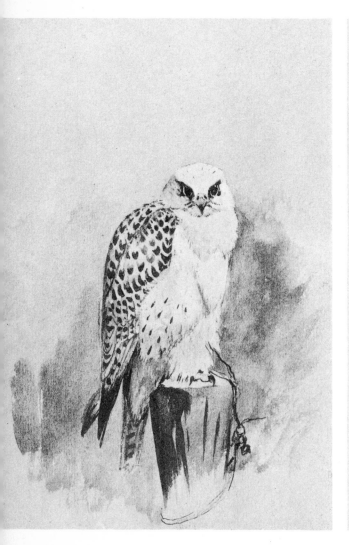 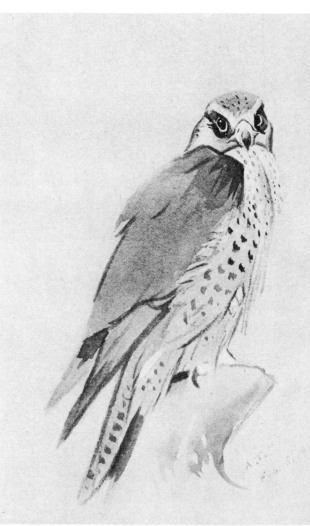

Iceland Falcon and Greenland Falcon

On the opposite page are shown sketches from life of the two typical northern Falcons, that on the left-hand side a native of northern Greenland, and the other a darker bird inhabiting Iceland as well as southern Greenland.

The ground-colour of the first-mentioned species is pure white at all stages, whereas in the Icelander it is grey or brown.

These birds, as well as a still darker species now known as the Gyr Falcon (the three in former days were apparently classed as one under this name), were much sought after in the days of falconry and were prized on account of their great docility and powerful flight.

The Greenlander in the Plate was an extremely tame and gentle bird and when sitting for her portrait would allow one to turn the block on which she rested without showing any fear or changing her position.

All these northern Falcons have a certain noble and distinguished bearing, too subtle to give expression to in a picture, and kill their prey in a truly sporting manner by a lightning stoop from above. They feed chiefly on ducks and ptarmigan.

Iceland Falcon and Greenland Falcon

The two pencil sketches reproduced on this page were taken from life in the Gardens of the Zoological Society of Scotland, Edinburgh.

The Iceland Falcon appears to visit the British Islands less frequently than its near relation the Greenland Falcon, which, living

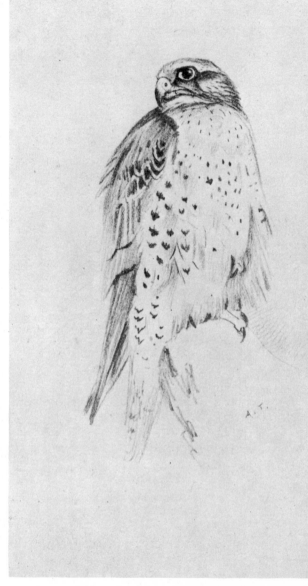

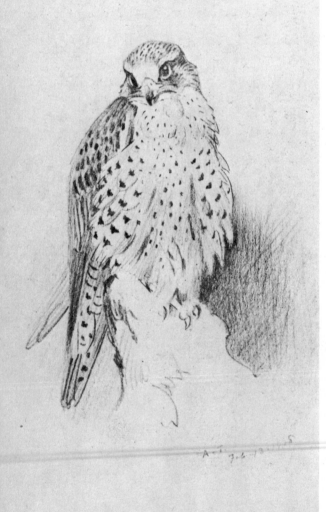

in a more severe climate, is often compelled to wander southwards in winter.
[The female Greenland Gyrfalcon (left) and the male Iceland Gyrfalcon (right) shown opposite are reproduced from Plate 36 of Thorburn's *British Birds,* London, 1915–18.]

Pl. 36.

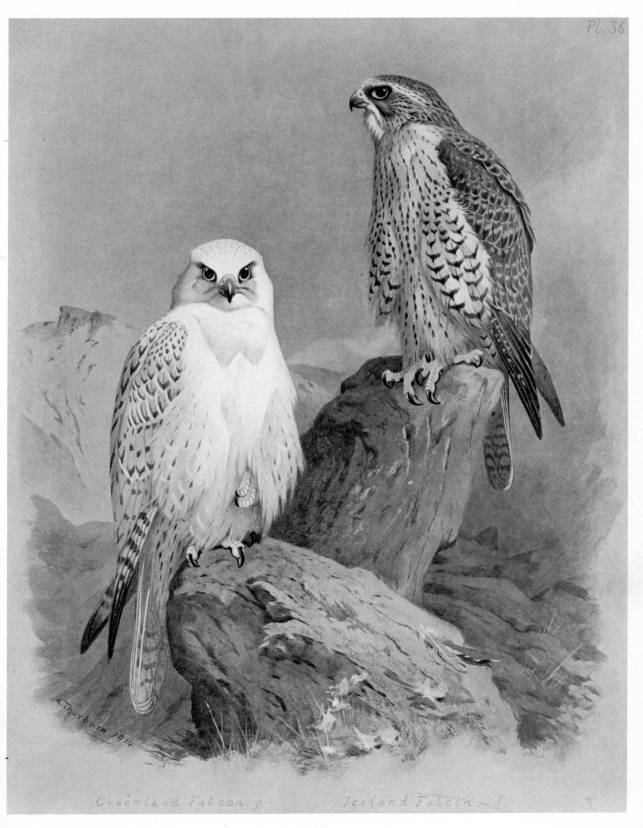

Greenland Falcon. ♀ Iceland Falcon. ♂

Peregrine Falcon

The Peregrine, the best known of our British Falcons, is found breeding in suitable places from the Shetlands to the Scilly Islands and is also plentiful in Ireland.

The nest, consisting of a hollow scraped out on an earthy ledge of rock, is often tenanted by successive pairs of birds for many generations, and if one of the pair be destroyed its place is soon filled by another bird.

The female is considerably larger than the male as in other members of the family and in hawking language was always styled the 'Falcon,' the male, reckoned as about one-third less, being known as the 'Tercel' or 'Tiercel'. The Peregrine is a bird of high courage and intelligence, and is easily tamed for purposes of falconry, the best for training being the immature birds which are caught on passage, i.e. when they follow the flocks of migrating wildfowl which leave northern Europe in autumn for warmer climates.

The two sketches show the birds at rest after feeding, with loosened feathers and standing on one leg as is their usual habit.

Pl. 8

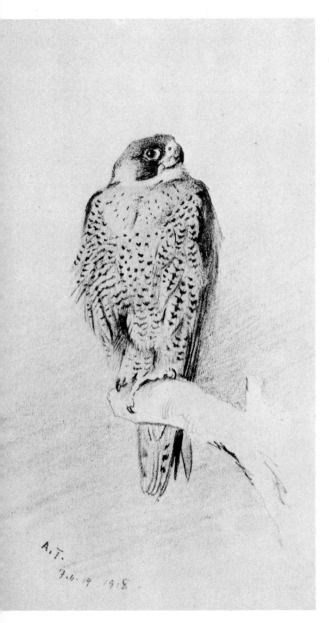
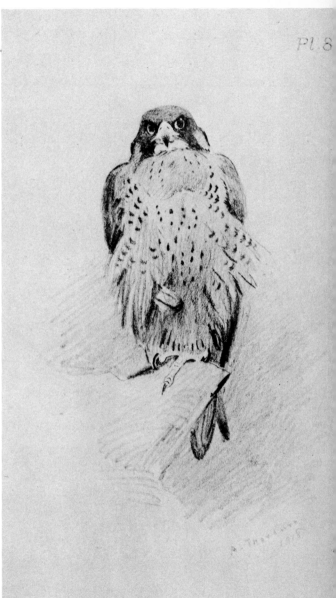

Iceland Falcon and Peregrine Falcon

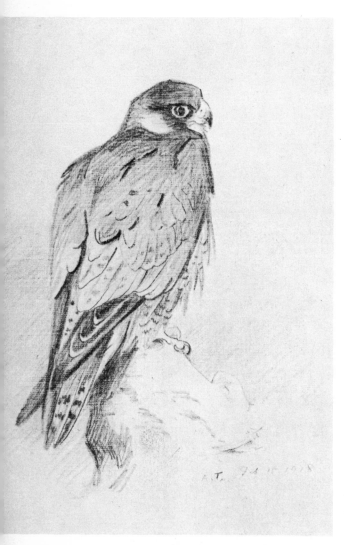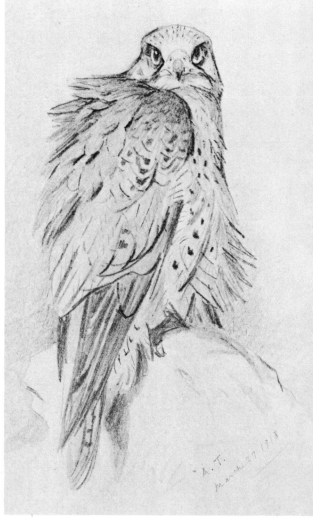

Opposite are studies of the Peregrine at rest, from watercolour sketches.

The right-hand sketch above gives the attitude of the Iceland Falcon in repose with ruffled plumage, taken on a stormy day in March. The left-hand study shows a back view of the Peregrine and gives roughly the proportionate size of the two species.

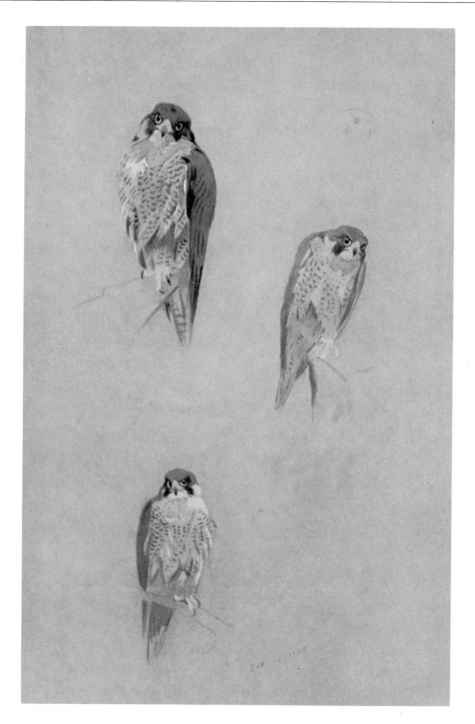

Merlin

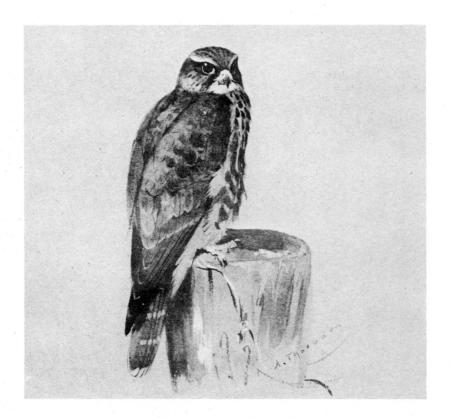

The Merlin is the smallest of the resident British Falcons and is still not uncommon in moorland districts, where it nests on the ground among rocks and heather.

When trained it is chiefly used by falconers for flying at larks, while in a wild condition it feeds on pipits, larks, thrushes, and other small birds, though it will master a quarry as large as the Golden Plover. In the adult male the upper parts and wing coverts are mostly a beautiful slatey grey in colour, while in the female they are in general brown. The sketch above was taken from a young bird in its first plumage, showing the jesses and block used for trained hawks.

[The Merlin (bottom left) and other falcons shown opposite are reproduced from Plate 38 of Thorburn's *British Birds,* London, 1915–18.]

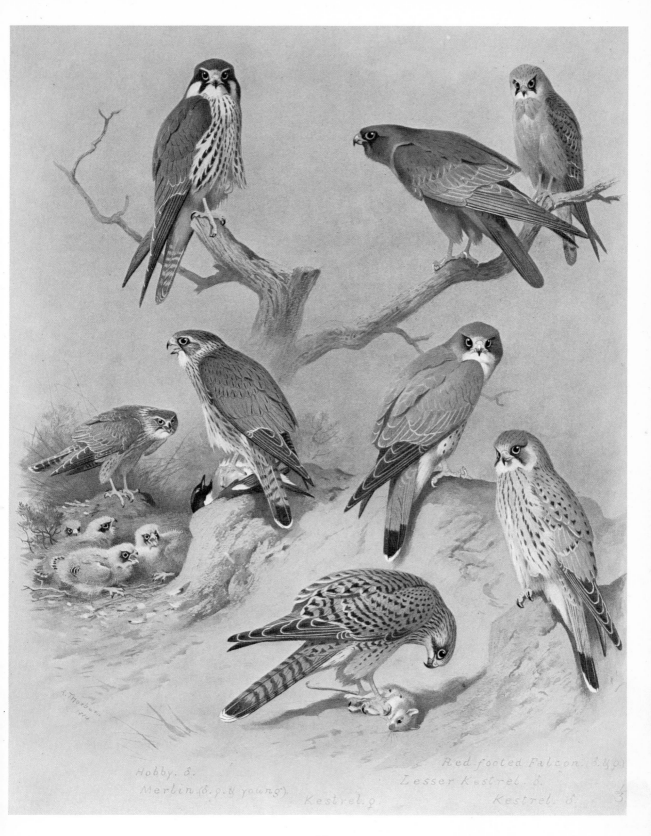

Hobby. ♂.

Merlin (♂, ♀ & young).

Kestrel. ♀

Red-footed Falcon. ♂ & ♀

Lesser Kestrel. ♂

Kestrel. ♂

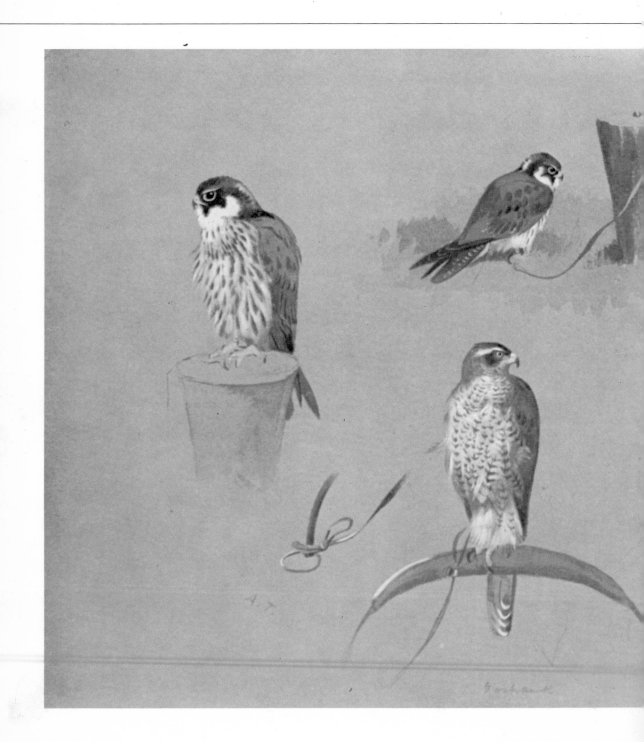

Goshawk and Hobby

The Goshawk sketched on a bow-perch at the bottom of the opposite page is an entirely different type of hawk from those described in the preceding pages, and in build and character may be considered a giant Sparrow Hawk. Fierce and rapacious and of great strength, it preys on hares, rabbits, squirrels, and other mammals, as well as on game birds and water fowl.

It is by nature a forest-loving species, and when trained is used chiefly for hares and rabbits.

The Goshawk is now rarely met with and never appears to have been common in a wild condition in the British Islands, though in former days it was resident and nested in the great pine forests of Rothiemurchus and Glenmore in Inverness-shire.

Accompanying the Goshawk are three studies from life of trained Hobbies.

The Hobby is a migratory Falcon annually visiting England, but rare in Scotland and Ireland. It likes a wooded district where large oaks are common and nests high up in the trees, usually occupying the former home of a crow or some other bird.

In form it is remarkable for the great length of its wings, which reach, when folded, beyond the tail.

Besides attacking small birds, it preys on dragon-flies, cock-chafers and other insects, while its great powers of flight enable it to master the Swallow, the Martin, and even the Swift.

It was formerly used in hawking, but is delicate in constitution and does not usually live long in confinement.

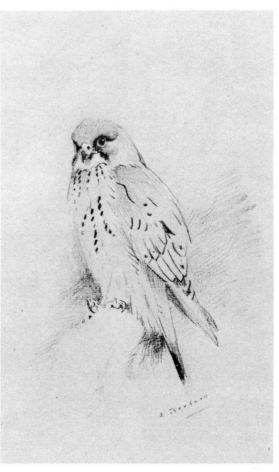

Kestrel and Hen Harrier

On the right of the opposite page is given a sketch of the Kestrel, the small Falcon, familiar to us under the name of Wind-hover, from its habit of hanging, while facing the wind, at some distance above the ground as if suspended by a thread, while searching for the mice and other rodents which constitute its food.

The Hen Harrier, represented on the left, is a sketch from life of the male bird in immature plumage. Now very rare, this species was once plentiful in the British Islands and acquired its name from the ravages it committed in the poultry yard. The flight is easy and buoyant, and when questing for food it quarters the ground in the most thorough manner, so that little escapes its notice. All the individuals of this species I have seen in captivity seemed of a dour and sullen disposition, and quite untameable.

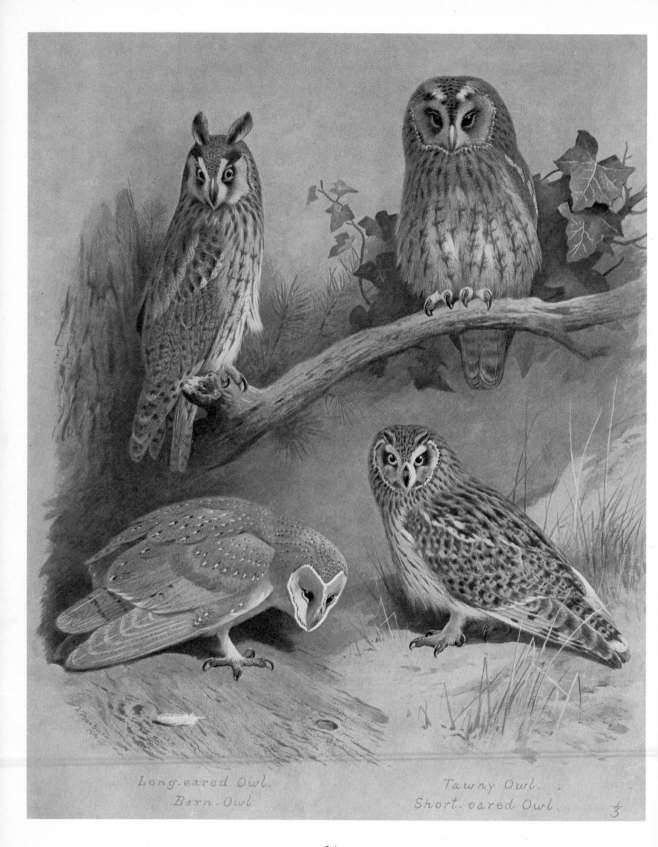

Long-eared Owl.
Tawny Owl.
Barn-Owl
Short-eared Owl.

Tawny Owl

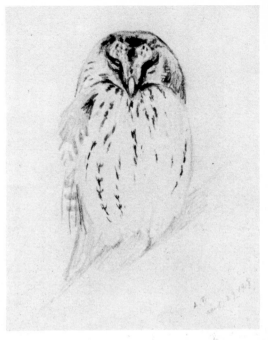

The two studies on this page show the
Tawny Owl, also called the Brown or
Wood Owl. On the mainland of Great
Britain it appears to be more common than
any of its family, though not known in
Ireland except where artificially introduced.

In habits it is more nocturnal than any
other British species, and its loud hooting
notes may often be heard after dark.

The sketches show the bird with closed
eyes as it usually appears during the daylight
hours.

[The Tawny Owl (top right) and other
owls shown opposite are reproduced from
Plate 26 of Thorburn's *British Birds,*
London, 1915–18.]

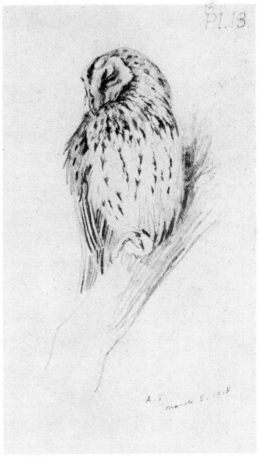

Barn Owl

The coloured sketches opposite were taken from a young Barn Owl before leaving the nest, which consisted of a mere collection of castings in a dove-cot in which a box had been placed for the purpose of inducing the birds to breed. The young remain in the nest until apparently fully grown and feathered, when there is little difference between them and their parents. The old birds were most regular in their habits, every evening at sundown regularly quartering their beats in search of mice and voles, as could be proved by an examination of the castings or pellets of fur and bones which the owl, like other birds of prey, disgorges.

Before leaving the young alone for the day, the parents would furnish a supply of mice which were placed beside the owlets. The feathers on the face of this species form a characteristic heart-shaped disk, as shown in the sketches.

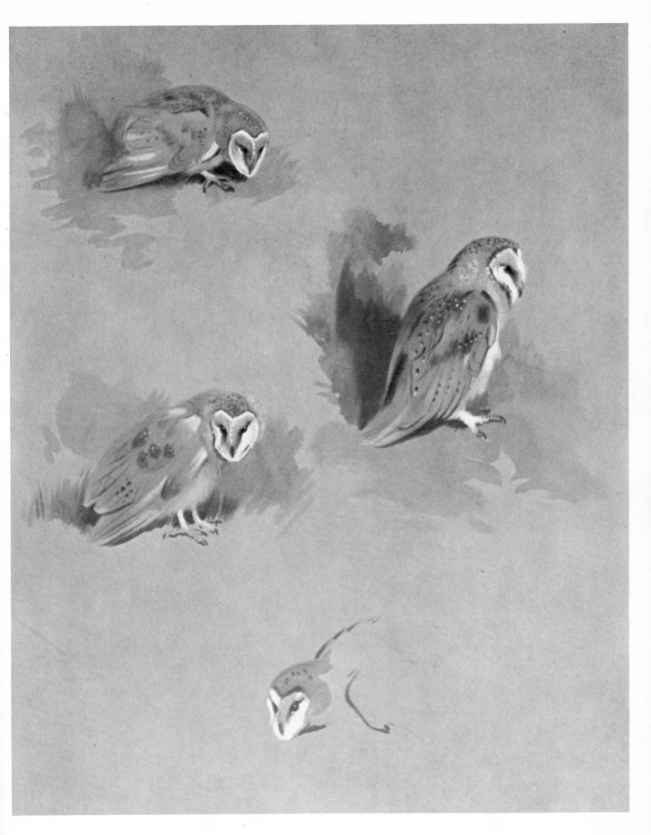

Pl. 28

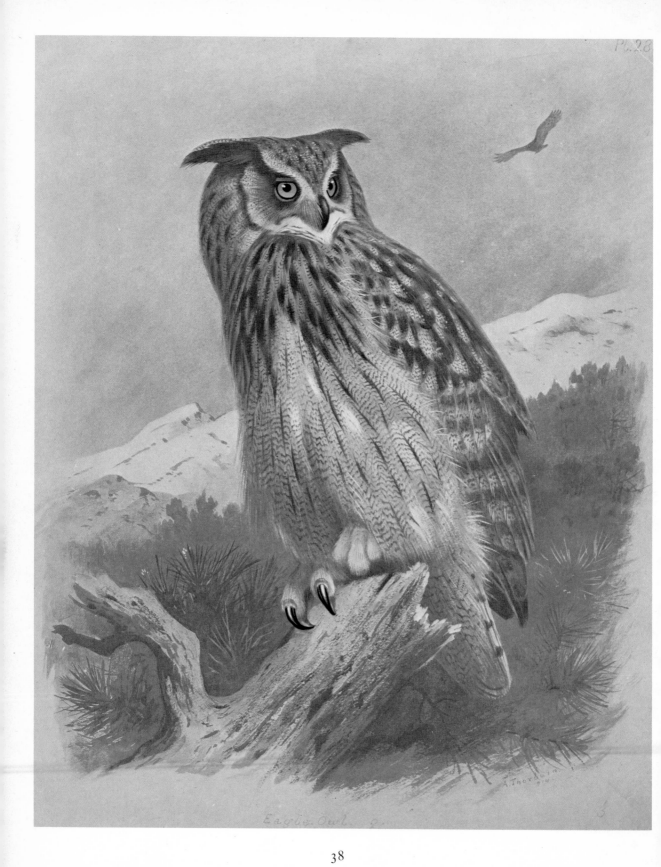

Eagle. Owl ♀

Eagle Owl

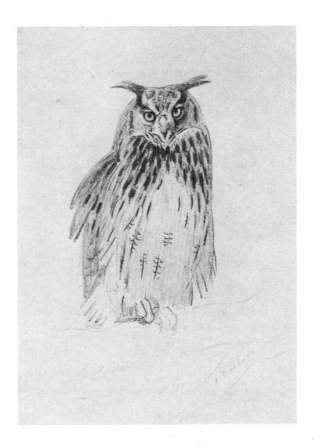

The pencil sketch above of the Eagle Owl
was drawn from life in the Zoological
Gardens of London. Inhabiting the
mountainous and wooded parts of the
Continent of Europe, this fine bird only
occasionally straggles to our shores. Owing
to its size and great strength it can kill birds
as large as the Capercaillie, as well as hares,
rabbits and even fawns. Its cry is a loud
sonorous 'Uhu'.
[The Eagle Owl shown opposite is
reproduced from Plate 28 of Thorburn's
British Birds, London, 1915–18.]

Snowy Owl

The Snowy Owl is an Arctic species and a winter visitor to the northern islands and mainland of Scotland, and occasionally to England.

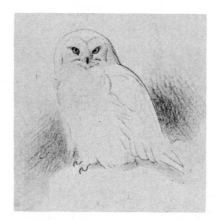

A good deal of variation occurs in the plumage, some specimens being pure white with only a few dark dots and markings, while others, especially the females, are strongly marked with bars. Its food consists of the Lemming and Arctic Hare, beside Ptarmigan, Willow Grouse and other birds. The yellow eyes and rounded head of this owl give it a curious wild-cat expression.

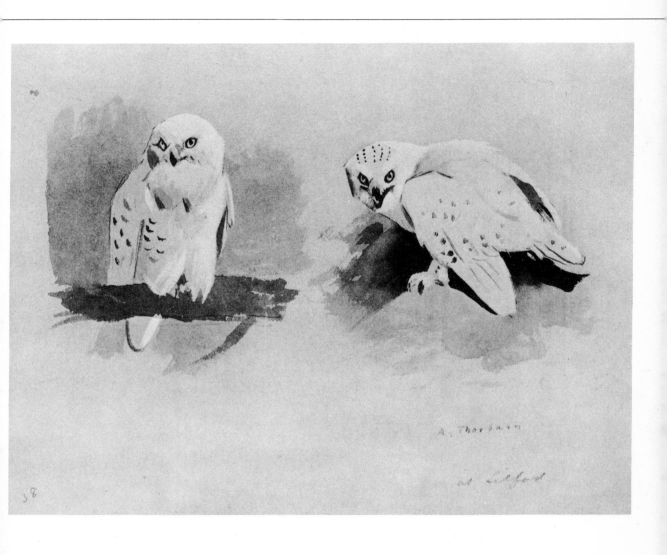

Raven

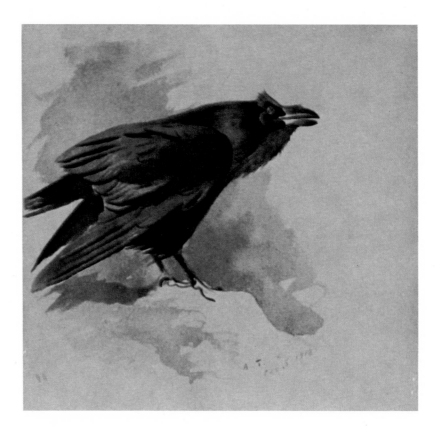

Above is given a coloured study of the Raven, taken from life during the courting season in spring when the bird displays his glossy plumage at its best, and has a characteristic habit at this time of raising the crest as shown in the sketch.

The brain of the Raven is said to be more highly developed than that of any other bird, while his bold and masterful spirit has enabled him to hold his own in spite of every man's hand being against him.

Good care is taken by the birds in selecting a safe situation for the nest, which is constructed of sticks with a lining of wool or hair. One I have in my memory was placed on a steep cliff above the Atlantic, quite inaccessible from below, and only to be got at from above by the use of a rope.

Kingfisher

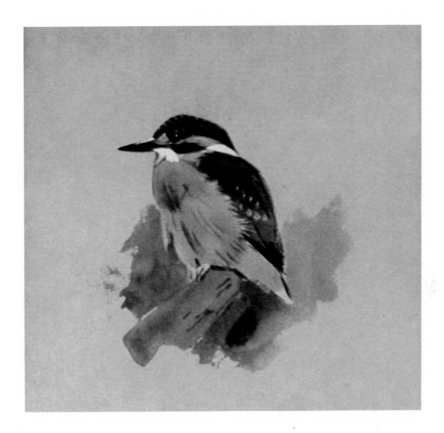

The water-colour sketch of the Kingfisher shown above was taken from a living specimen in the Zoological Gardens of London. This well-known bird is distributed over the greater part of the British Islands, though not so common as it might be were it not for the persecution it receives at the hands of bird-stuffers and others, and also by the owners of fisheries.

Seen perched on a dead bough or post on the lookout for minnows in the stream below, or darting like a meteor along its course, this little fisherman adds much to the charm of his surroundings.

Raven

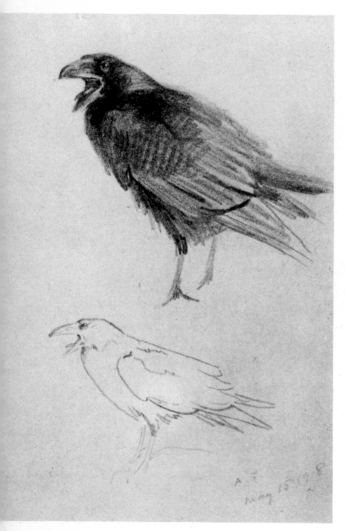 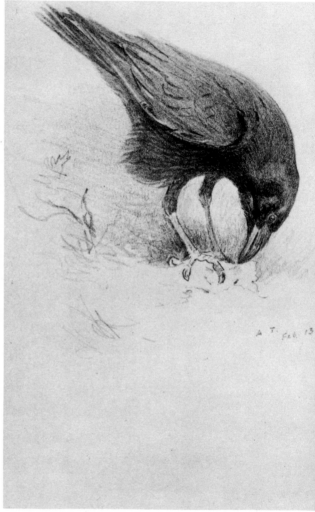

On these two pages are given various life studies of the Raven showing the action of the bird feeding, or when, with open bill, he utters his loud harsh croak.

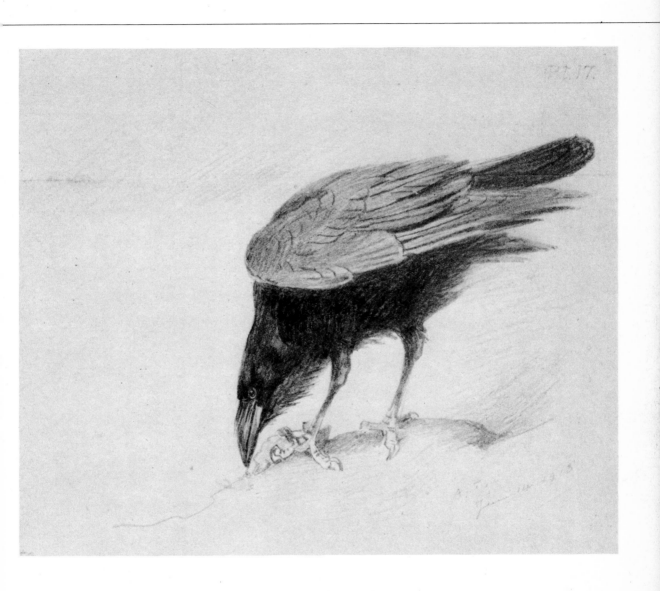

Hooded Crow, Raven and Jackdaw

The Hooded or Grey Crow is given in the top left sketch, and shows the attitude of the bird when uttering its cry.

A winter visitor to the eastern counties of England, this species is a common resident in the Highlands of Scotland. About Aberfeldy, on the Tay, and also in the area watered by the Clyde, where it meets its near relation, the Carrion Crow, the two species often interbreed.

Below left is given a study of the Raven showing the pose of the bird when suspicious, though keen to get in touch with some carrion.

The Jackdaw figured in the centre is a common and familiar British bird, inhabiting the country as well as the outskirts of towns.

It is easily distinguished from the other Crows by its small size, the ashen grey on the nape and sides of the neck, and pearly white eyes.

The sketch was taken from life by the aid of a field-glass in the neighbourhood of Edinburgh, where a colony of birds were nesting in the cavities of some old beech trees.

[The Magpie, Raven and Jackdaw shown opposite are reproduced from Plate 20 of Thorburn's *British Birds,* London, 1915–18.]

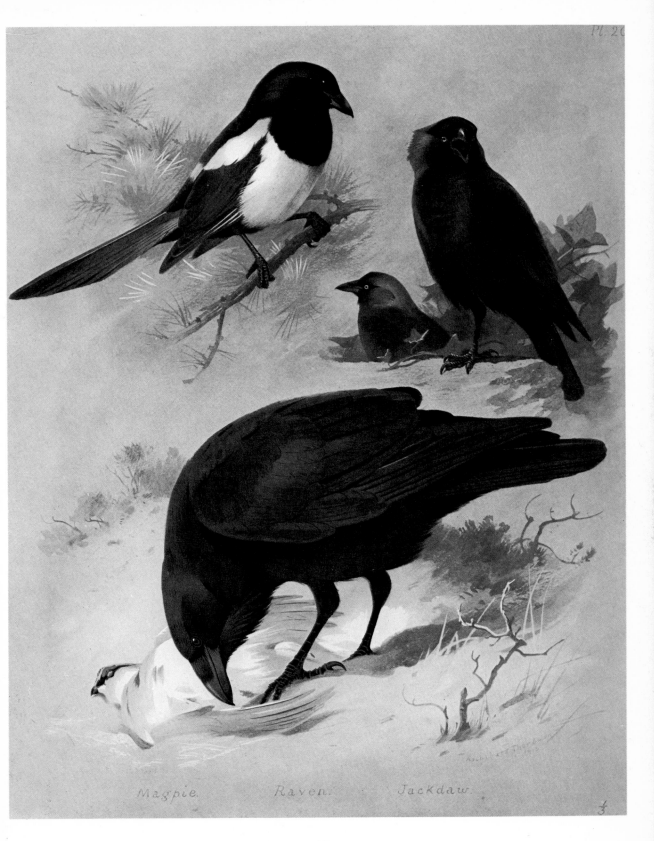

Magpie. Raven. Jackdaw.

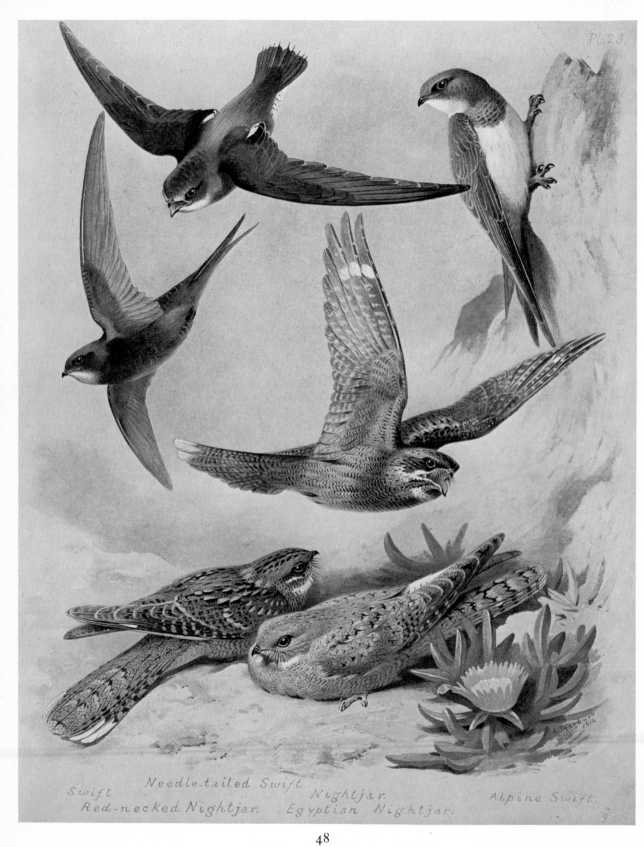

Pl.23.

Needle-tailed Swift.

Swift. Nightjar. Alpine Swift.
Red-necked Nightjar. Egyptian Nightjar.

Nightjar

Below are shown sketches of the Nightjar or Goatsucker, taken in Surrey by means of a field-glass. The bird, on being flushed, soon alighted on the branch of an oak, sitting, as they always do when at rest, with the body placed lengthways along the bough. It has been stated that the head is held level with or lower than the tail, but on this occasion it certainly was not so.

The female may easily be distinguished from the male as the bird takes wing, by the absence of the conspicuous white spots on the first three feathers of the wing and the two outermost tail feathers, which are peculiar to the male.

[The Nightjars and Swifts shown opposite are reproduced from Plate 23 of Thorburn's *British Birds,* London, 1915–18.]

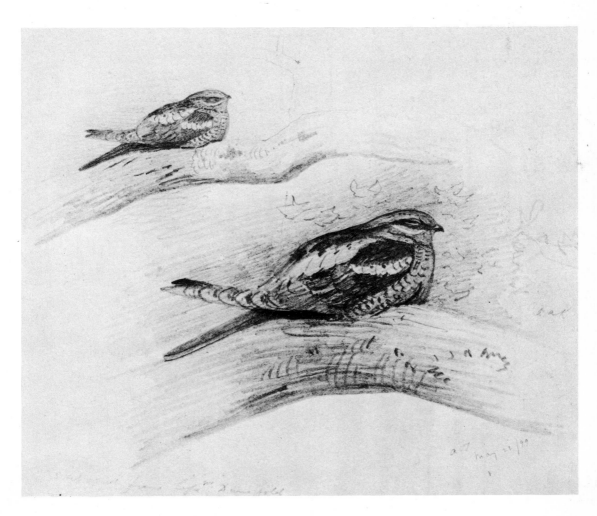

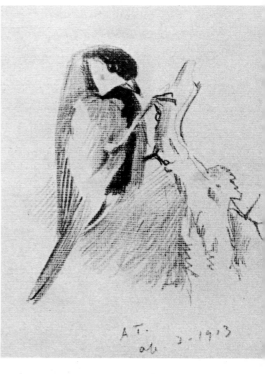

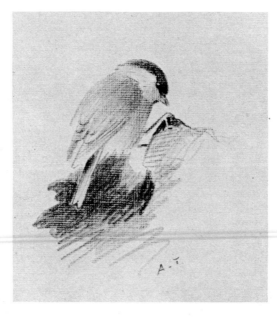

Blue Titmouse, Coal Titmouse, Great Titmouse, Marsh Titmouse and Bearded Titmouse

These two pages show four species of British Titmice, all more or less common, and also the much rarer so-called 'Bearded Titmouse', which does not by rights belong to this family. Below, on the left, are given sketches of the Blue Titmouse. This is the familiar little blue-capped bird of our gardens and shrubberies.

On the right of the Blue Tit is the Coal Titmouse, always distinguishable by the white spot on the nape, as well as by the irregular broken line of the black cap where it meets the white on the cheeks and sides of the neck.

On the opposite page, at the top right, is shown a sketch of the Great Titmouse, or Ox Eye, easily known by his large size, by the black on the throat extending downwards to the tail, and also by his clear metallic notes in early spring which compose the song of his species.

Below him, the Marsh Titmouse is represented. This species is not at all uncommon in some parts of England, but local in its distribution. The crown of the head is deep black, and the colour in general more sober than in the other species depicted.

These sketches were all taken from wild birds attracted by a feeding table near a window.

The Bearded Titmice on the top left of the opposite page were taken from life in the Zoological Gardens of London, where they appeared quite happy and at home in a large out-door aviary. This species, though rare, is still to be found among the fens of Norfolk, and also in Devonshire.

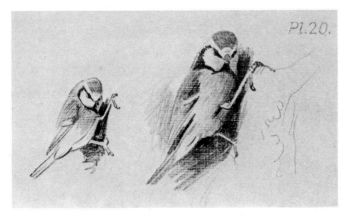 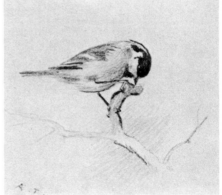

It is a bird of the reed beds, nesting in the dense aquatic vegetation in summer and roving among the dead stems in winter, while supporting itself on the seeds of the plants which form its chief food supply.

The long black mustachial feathers on the cheeks have given the bird its name.

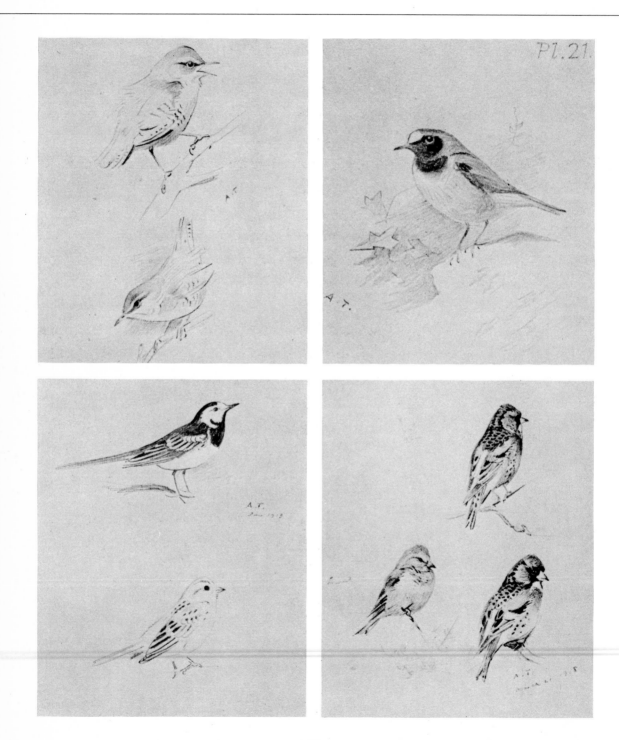

Brambling, Linnet, Redstart, Wren, Pied Wagtail and Yellow Hammer

In the lower right-hand corner of the opposite page are shown studies of the Brambling, and one of the Linnet.

The Brambling, a winter visitor to Great Britain, leaves us in spring for its breeding quarters in northern Europe. It is a handsome species, with finely-contrasted plumage of glossy black, white, and chestnut.

The Linnet may commonly be found about uncultivated land, where it nests among furze or other low bushes. The crimson forehead and breast of the adult male have given it also the name of Rose Linnet.

The upper right-hand sketch gives the Redstart, one of the most beautiful of our summer visitants. It is local in distribution, though not uncommon in favoured districts. The drawing was made from a bird haunting a roadside in Perthshire, where a pair were apparently nesting in an old stone wall.

In the upper left-hand side of the opposite page are two studies of the Wren. This bird does not always erect the tail, as usually shown in pictures of the species, but frequently lowers it as indicated in one of the sketches.

Immediately below the Wren, at the bottom on the left-hand side, are given sketches of the Pied Wagtail and Yellow Hammer, two of our familiar wild birds. The former is commonly to be seen in meadows and pastures, and in the breeding season is fond of the neighbourhood of buildings, where it often nests among climbing ivy or in recesses of stone walls.

The Yellow Hammer, or Yellow Bunting, is common everywhere, and hardly needs description. Its well-known song is continued till late in the summer, after the notes of most of the other songsters have ceased.

Hawfinch, Linnet, Redwing, Mistlethrush and Blackbird

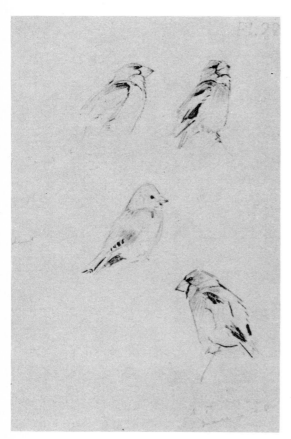 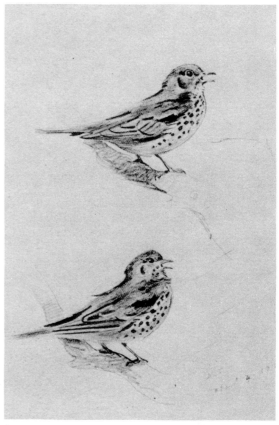

Above, on the left are shown sketches of the Hawfinch and Linnet. The Hawfinch is locally distributed in Great Britain, and often overlooked owing to its shy and retiring habits, though its fondness for green peas and cherries frequently attracts it to our gardens if situated near its haunts. The kernels only of cherries, haws, and other fruits are eaten.

On the left of page 55 are some sketches of the Redwing, a regular winter migrant, which comes to our shores about the same time as the Fieldfare. Slightly smaller than the common

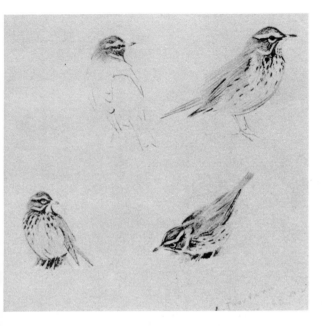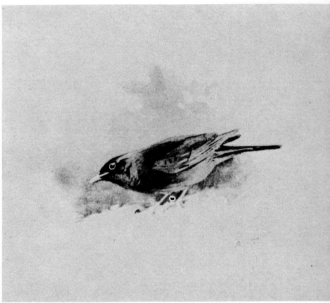

Song Thrush, to which it is closely related, it is easily distinguished by the rich chestnut colour of the flanks and under wing coverts, and also by the distinct yellowish eye-stripe.

Its summer home is in Norway, and other parts of northern Europe. Redwings are delicate creatures, and among the first to suffer hardship during prolonged frost and snow.

Next to the figures of the Hawfinch and Linnet, are given two sketches of the Mistle Thrush, also known as the Storm Cock from its custom of pouring forth its wild and desultory notes during the gales of early spring. Perched on a bough, and facing the wind and sleet, the bird from which the sketches were taken seemed quite at home, and rather to enjoy the blast than otherwise. This bird is our largest native British Thrush.

A sketch of the Blackbird is shown on the right, above.

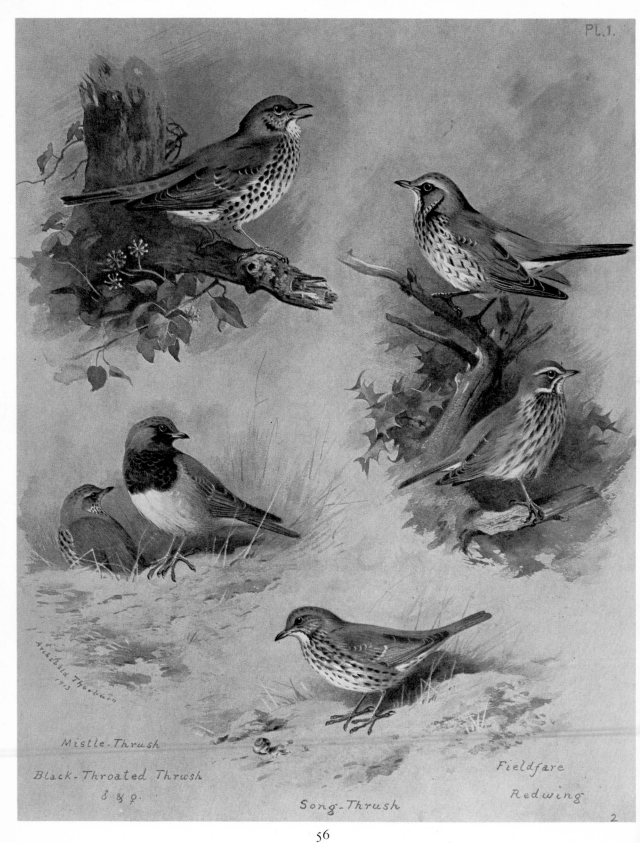

Mistle-Thrush

Black-Throated Thrush
♂ & ♀.

Song-Thrush

Fieldfare

Redwing

2

Redwing

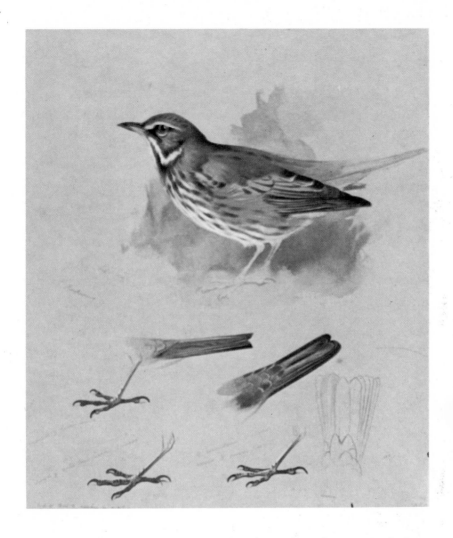

On this page are shown some sketches taken from a Redwing, previously described.
[The Thrushes shown opposite are reproduced from Plate 1 of Thorburn's *British Birds,* London, 1915–18.]

Fieldfare

On the opposite page is the Fieldfare, a winter visitor to the British Islands, usually arriving in October and leaving us in spring for its breeding quarters in northern Europe.

The slatey grey head and rump as shown in the sketch serve to distinguish it from our other thrushes. The Fieldfare breeds in colonies, the nests being often placed in birch trees near the ground.

It has never been known to nest in the British Islands, though often recorded as doing so by people who confuse this species with the Mistle Thrush.

Goldfinch and Greenfinch

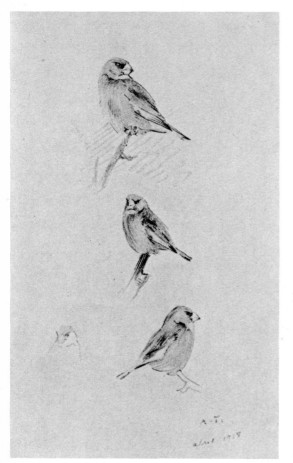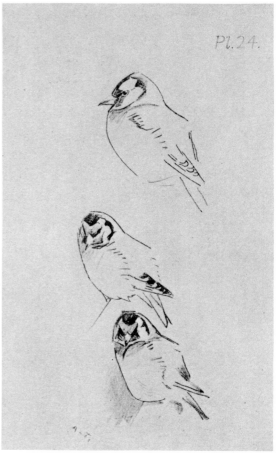

On the right, above, and also on the opposite page are given various pencil studies from life of the Goldfinch, perhaps the most beautiful and interesting of all our British Finches. The soft delicacy of its tawny colouring, touched up with crimson, black, and gold, make a charming picture as the little bird perched on some downy thistlehead extracts the seeds which form its favourite food.

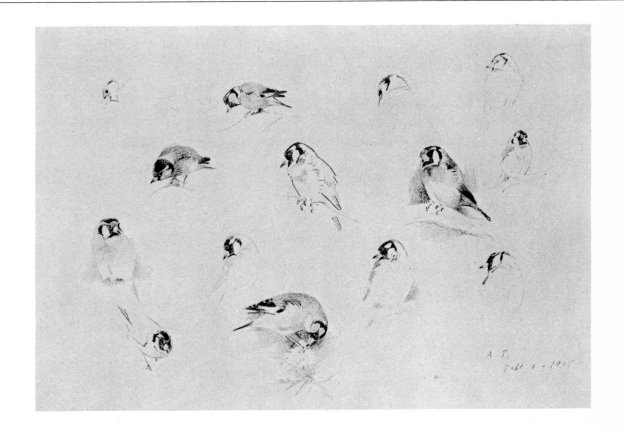

It is to be regretted that it is now not nearly so numerous as in former days though by no means scarce in some parts of the country.

On the left of page 60 are sketches of the Greenfinch, a common British species, which show the birds as they rest when sunning themselves on a tree top.

The yellow and green of the plumage and thick flesh-coloured bill serve to distinguish it.

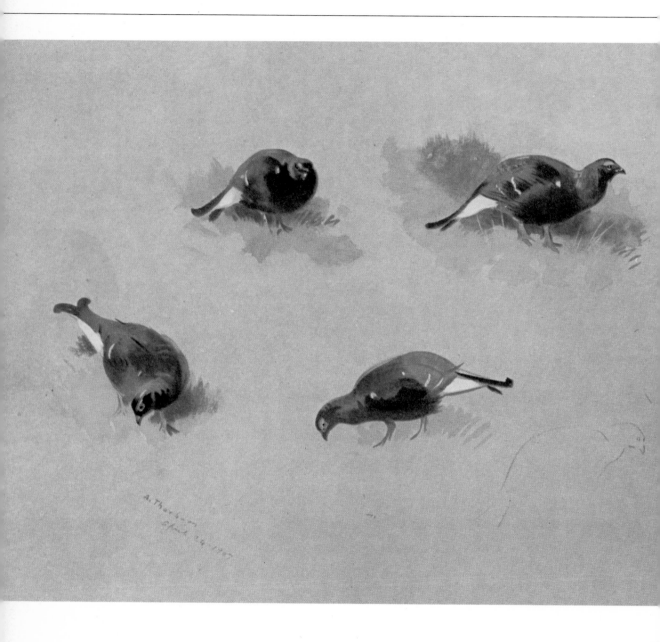

Blackcock

The four coloured studies of Blackcock given here were sketched direct from nature by means of a field-glass by the side of the river Helmsdale, in Sutherland.

During the courting season in early spring, I have not found these birds difficult to approach if ordinary care be taken. Soon after dawn the old cocks meet at some chosen spot, often a grassy opening in a birch wood, where a kind of tournament is held, and various contests take place for the possession of the females.

On the following two pages may be seen some of the striking attitudes assumed by the Blackcock during this display as he proceeds along the ground with drooping wings and outspread lyre-shaped tail, producing at the same time a succession of whirring or crooning notes which, though soft in tone, may be heard at a considerable distance on a still morning.

Blackcock

These sketches of the Blackcock courting were drawn from life near the Helmsdale, Sutherland.

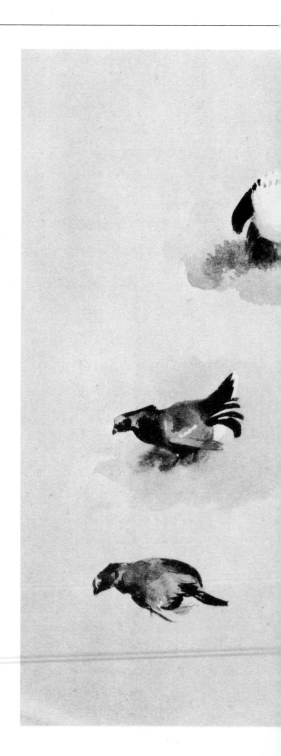

Pl. 26.

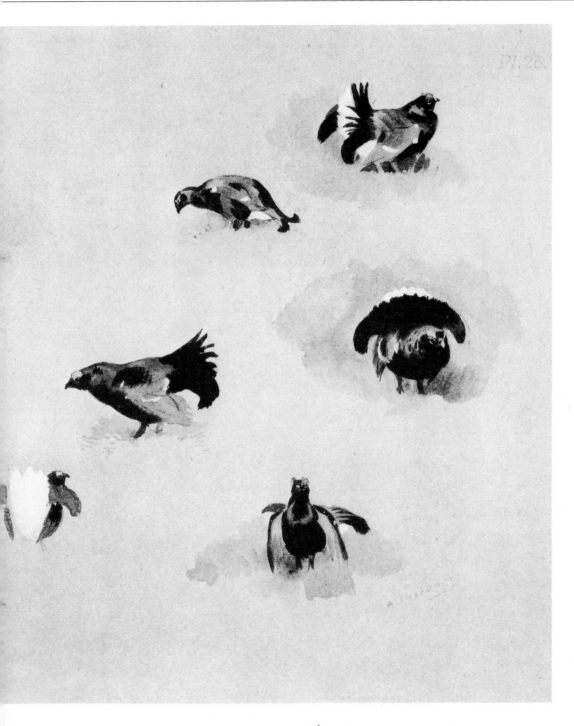

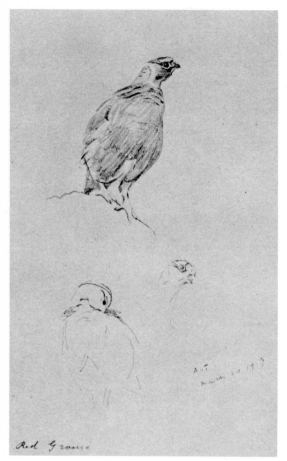

Red Grouse

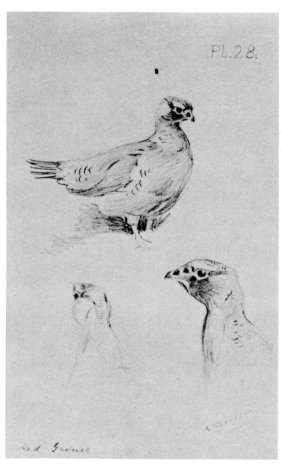

Pl.28.

Red Grouse

Red Grouse

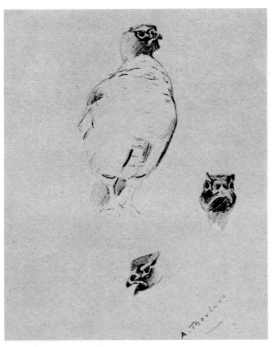

Here are various rough sketches from life of the Red Grouse in spring, taken from one of the birds in the Gardens of the Zoological Society of Scotland. Some of these show the attitude of the bird when uttering its well-known call. It may be noted that the comb over the eye in this species differs from that of the Blackcock in colour, being more of a scarlet than the other.

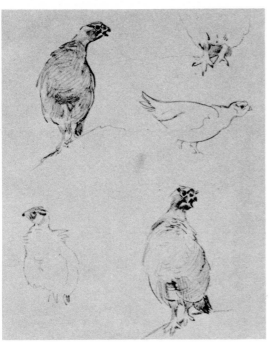

Red Grouse

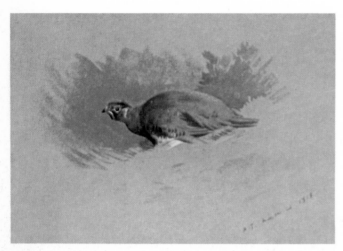

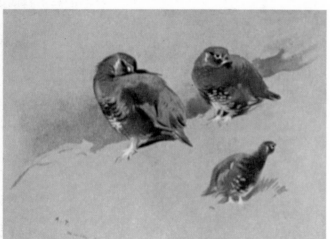

On this page are shown sketches in colour of a Red Grouse which lived for some time in the Gardens of the Zoological Society of Scotland in Edinburgh.

This bird soon became quite fearless and absurdly tame, and in the breeding season would challenge and attempt to attack anyone approaching its enclosure.

The picture on the page opposite represents a pair of this species among their natural surroundings of rock and heather.

The Red Grouse is peculiar to the British Islands, where it is abundant on hill and moorland, its nearest relation, the Willow Grouse, which turns white in winter, representing our bird in Scandinavia.

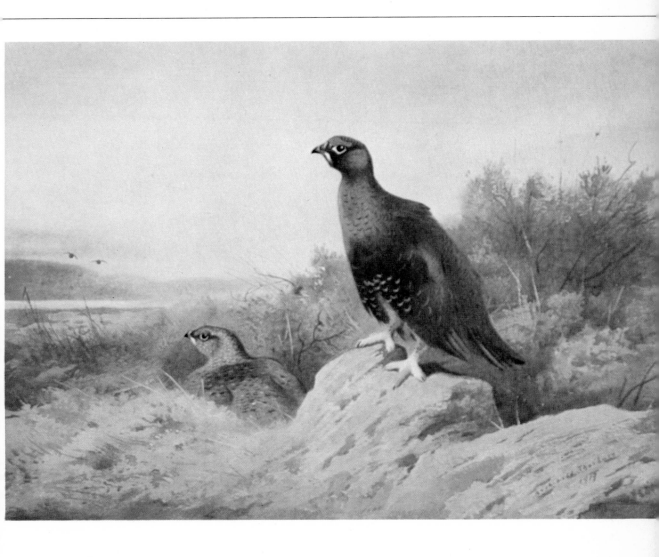

Ptarmigan

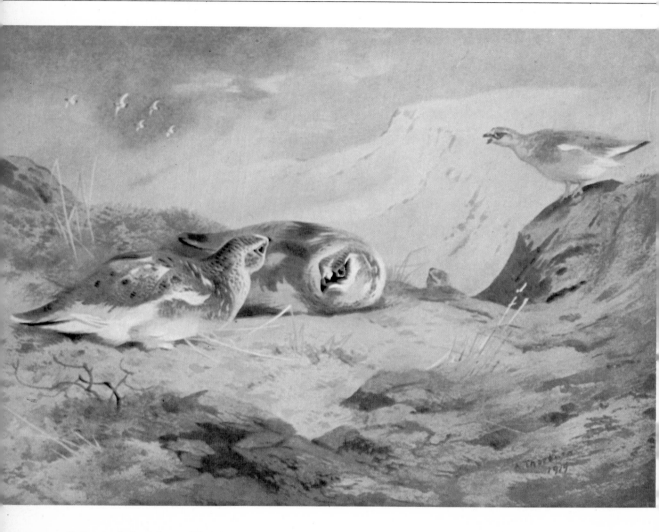

Coloured sketches of the Ptarmigan in autumn plumage are given on these two pages. The studies above were obtained by the help of a field-glass as the birds made their way down a stony slope high up among the haunts of these birds in one of the Scottish deer forests, during the month of October.

If once located, often a difficult matter to accomplish, unless the birds move or utter their grating call, they are easy to approach when the weather conditions are settled, and apart from the interest of their wild and picturesque surroundings, the birds have a certain charm

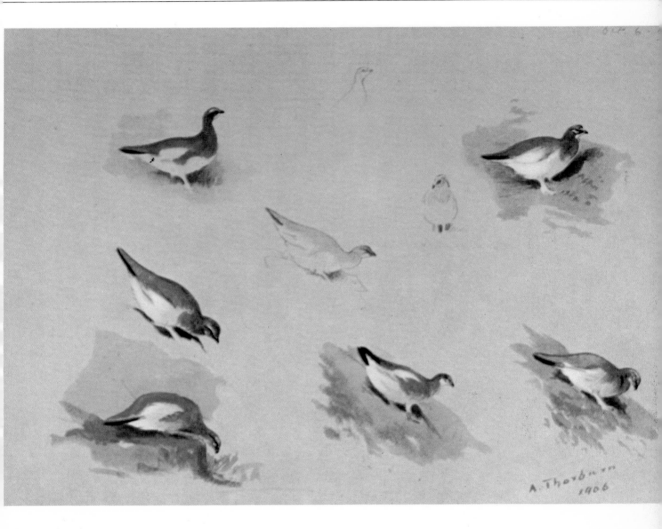

of their own which appeals to all lovers of nature. The landscape sketch on pages 126–7 shows the hill near where the birds were feeding, and indicates the rough and stony character of their territory.

The coloured picture opposite gives the plumage of the Ptarmigan a little later on in November, when the mottled grey of their feathers is beginning to change to the snowy white of winter.

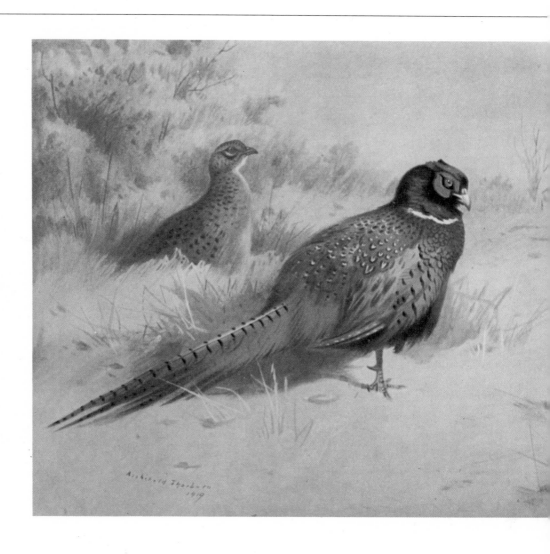

Common Pheasant

The picture opposite represents Pheasants in winter.

There are practically no pure-bred birds left in our coverts to-day, the original dark-breasted Pheasant, showing no white on the neck, and introduced before the Norman Conquest, having mingled, first with the Ring-necked Pheasant from southern China, imported about the end of the eighteenth century, and later with various other races since introduced. A complete and excellent account of the various species may be found in Millais' *Natural History of British Game Birds*.

Mongolian Pheasant
and Common Pheasant

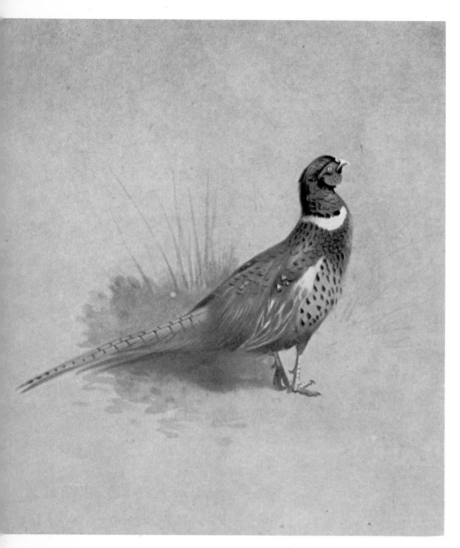

The figure above is the Mongolian Pheasant, one of the most beautiful of the family, and only introduced in recent years to our woods and coverts. It may easily be distinguished from the Common Pheasant by the broad white collar and whitish wing coverts.

On the right are given various studies of Pheasants taken from some birds in an aviary.

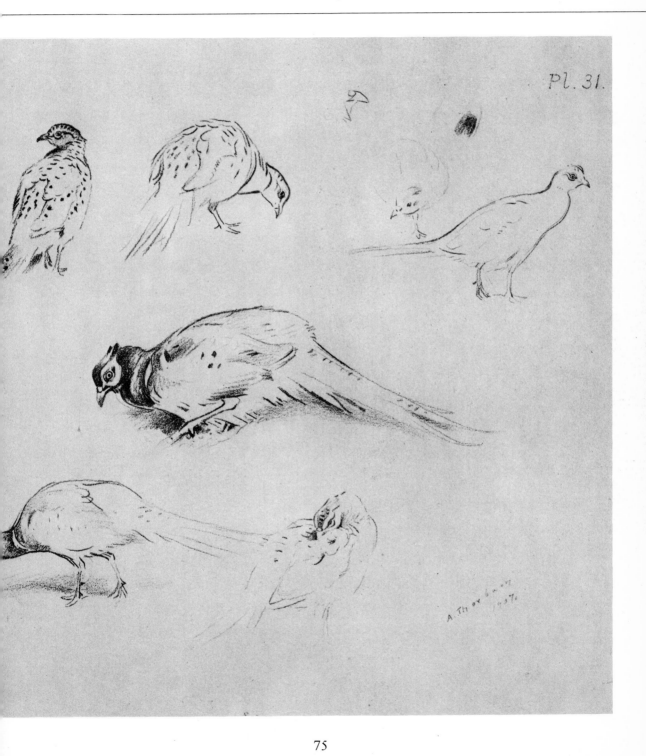

Pl. 31.

Common Partridge and Quail

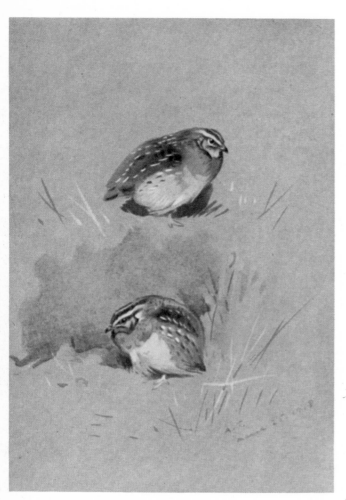

The two figures on the left show the Quail, our smallest game bird and a summer visitant to the British Islands.

It is now much less plentiful than in former times, which may be attributed to the higher cultivation of land, and also no doubt to the netting of thousands of birds on migration in southern Europe. The sketch on the opposite page is from a water-colour study of a hen Partridge, and shows the difference in marking on the upper plumage which distinguishes the sexes.

Apart from the chestnut horseshoe on the breast of the male, which is either absent or only partly developed in the female, the latter has the scapular feathers and wing coverts barred with buff-coloured markings, whereas these are lacking in the male.

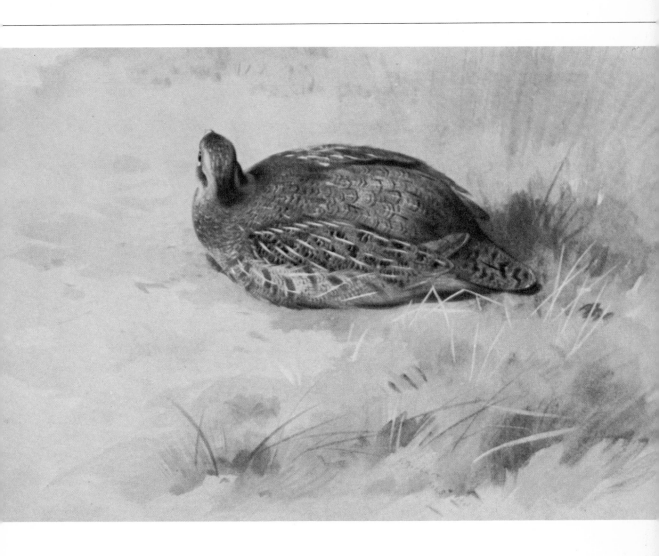

Common Partridge
and Common Pheasant

These two pages give some coloured studies from life of a cock Partridge basking, when with loosened feathers he shakes out the dust used for cleansing the plumage.

A female of this species I kept for some time in an aviary laid fertile eggs, which were afterwards hatched by a Bantam fowl. I believe this seldom happens when Partridges live in confinement, and are not allowed to select their own mates.

Some outline sketches of the Common Pheasant are also shown in the upper left-hand corner.

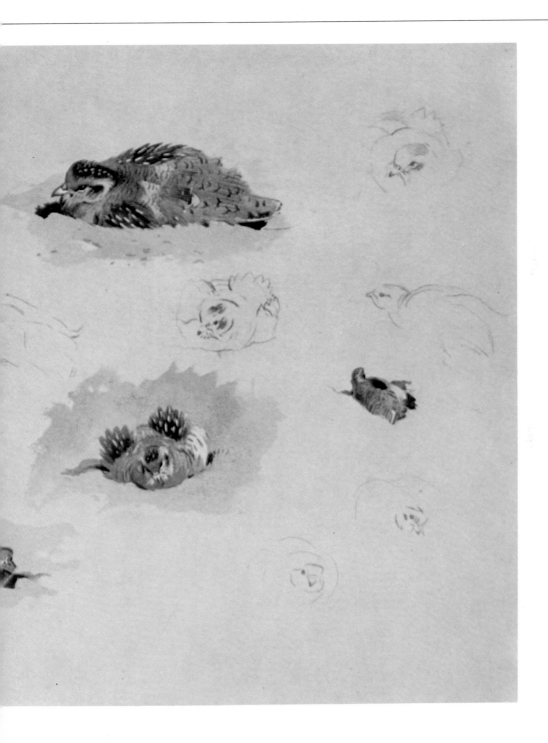

Common Partridge and Quail

Above is given a study from life of a Partridge, and opposite are four of the Quail.

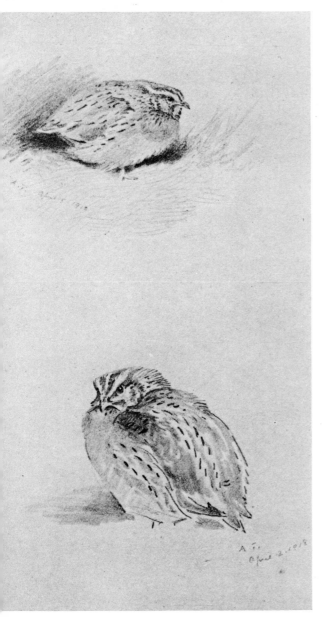
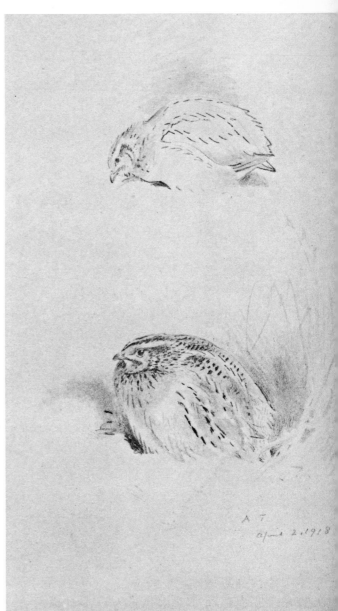

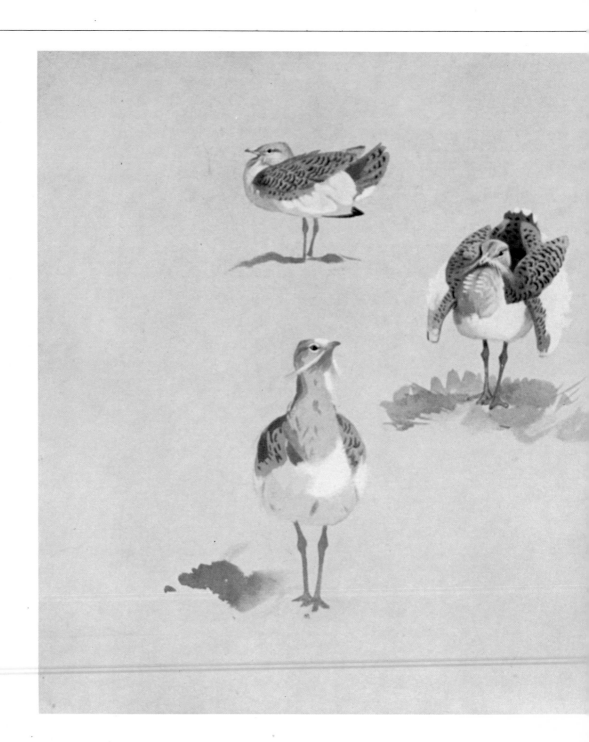

Great Bustard

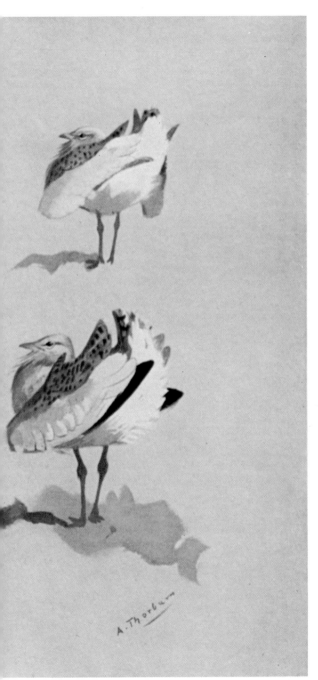

This splendid species, now extinct as a resident British bird, lingered in gradually diminishing numbers till 1838, when the last survivor was killed in Norfolk.

The coloured sketches shown were taken from a bird in confinement, and give some of the extraordinary attitudes assumed by the male during the period of courtship.

It is still found in some numbers in suitable places on the Continent of Europe, while attempts made to re-establish it in its old haunts in England have met with no success, for when once an indigenous species like the Great Bustard has been thoroughly exterminated, it is extremely difficult to restore it.

Cormorant, Shag and White Stork

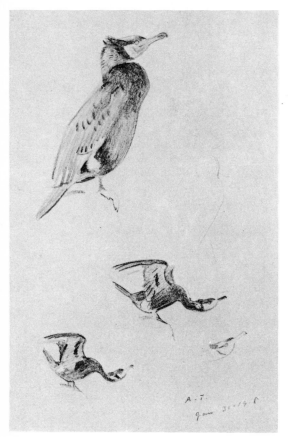

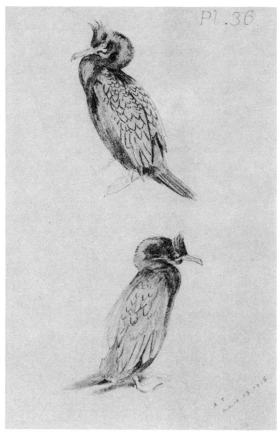

The Cormorant, shown in the sketches on the left-hand side of both these pages, is a common bird along the rocky parts of our shores, and on the north-east coast of England and eastern side of Scotland appears to be more plentiful than its near relation the Shag, or Green Cormorant, though the latter species prevails in many parts of the west.

The sketches show the adult Cormorant in nuptial plumage, when the crest and white thread-like feathers on the head and neck are fully developed.

These decorations, as well as the white thigh patch, are lost later on in the summer.

A colony of breeding birds is always interesting, as they can then be more easily approached than on other occasions.

I have had the opportunity of visiting one of these colonies, on an island off the west coast of Sutherland in the month of May, which contained many nests placed on ledges at various levels on a steep sea cliff, some occupied by sitting birds, others guarded by their owners

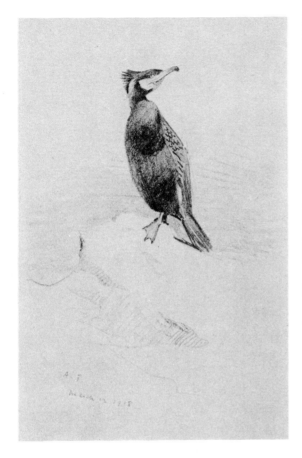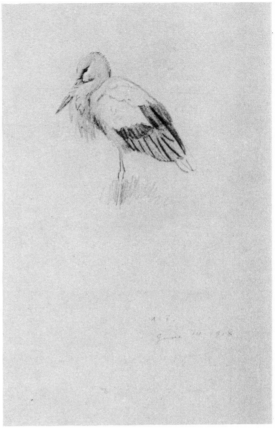

standing by, as at this time no eggs are safe from the attacks of marauding Gulls or Hooded Crows.

The Shag, Green or Crested Cormorant, figured on the right of page 84, is a smaller, slimmer, and more elegantly-formed bird than the Common Cormorant, and in early spring assumes a curved tuft-shaped crest as shown in the sketches of this species.

The White Stork, shown above, right, is a scarce wanderer to our shores, though breeding regularly in many parts of Continental Europe.

It has never been known to breed in Great Britain in recent times, but Dr Eagle Clarke has drawn attention to an old record (*Scottish Naturalist,* 1919, p. 25) of this species having nested on the top of the Church of St Giles, Edinburgh, in the year 1416.

The white plumage of the Stork has usually a dingy soiled appearance; this, I am told, even occurs in wild specimens.

Gannet and Heron

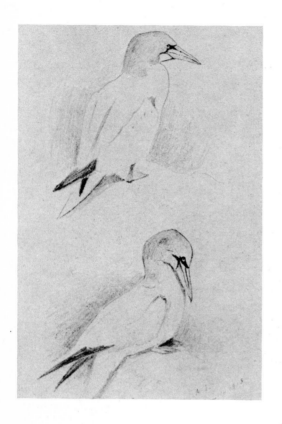 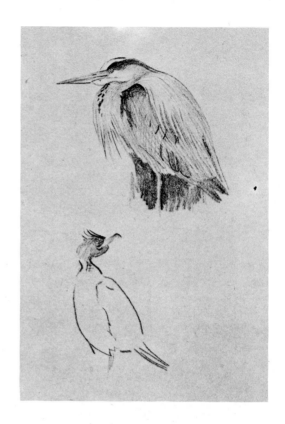

On the left-hand side of this page are given two sketches of the Gannet, or Solan Goose.

This species breeds in colonies on various rocky islands in British waters, two of the best known being those on the Bass on the eastern, and Ailsa Craig on the western side of Scotland. There are also breeding stations on the St Kilda group of islands, Sulisgeir, Outer Hebrides, Suliskerry, west of the Orkneys, Grassholm, off the Welsh coast, the Skelligs and Bull Rock, Ireland, the latter station being the most southerly in Europe. The Gannet, formerly bred on Lundy Island, its only English breeding place, but is now extinct there.

The sketch of the Common Heron given on the right-hand side of this page shows the attitude of the bird when standing motionless by the edge of a pool, ready for any prey that may come within reach of its long and pointed bill. According to the late Lord Lilford, the Heron does not transfix fishes by the bill, but seizes them between the points of the mandibles.

[The Herons shown opposite are reproduced from Plate 40 of Thorburn's *British Birds,* London, 1915–18.]

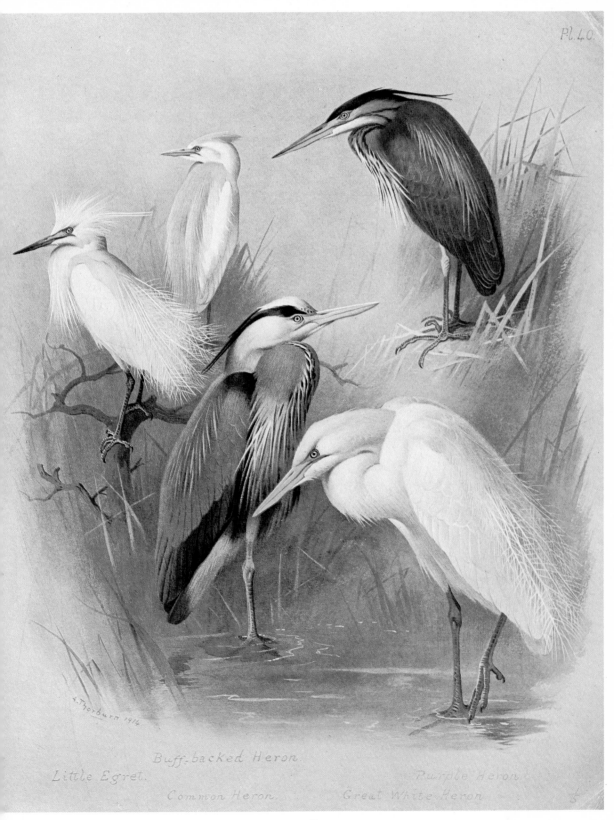

Little Egret.

Buff-backed Heron.

Common Heron.

Great White Heron.

Purple Heron.

A. Thorburn. 1914

Pl. 40.

Bittern

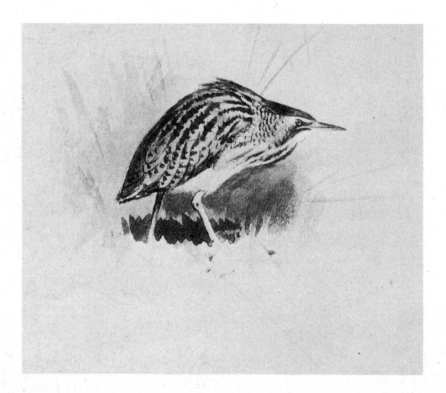

A study of the Bittern is given above. Before the draining of the fens and bogland became common in the British Islands, this bird was numerous in such parts of the country, where in the breeding season its deep booming notes were constantly heard at night.

At one time the Bittern ceased to exist as a breeding species in England, but thanks to the protection it has received, it is now re-established in some of its old haunts in Norfolk, where it appears to be yearly increasing in numbers, and its strange love-song may now again be heard in the marshes.

The sketch shows the curiously marked and spotted plumage, which serves to hide the bird among the dead reeds and sedges in which it seeks concealment by day.

[The Bitterns and other members of the Heron family shown opposite are reproduced from Plate 41 of Thorburn's *British Birds*, London, 1915–18.]

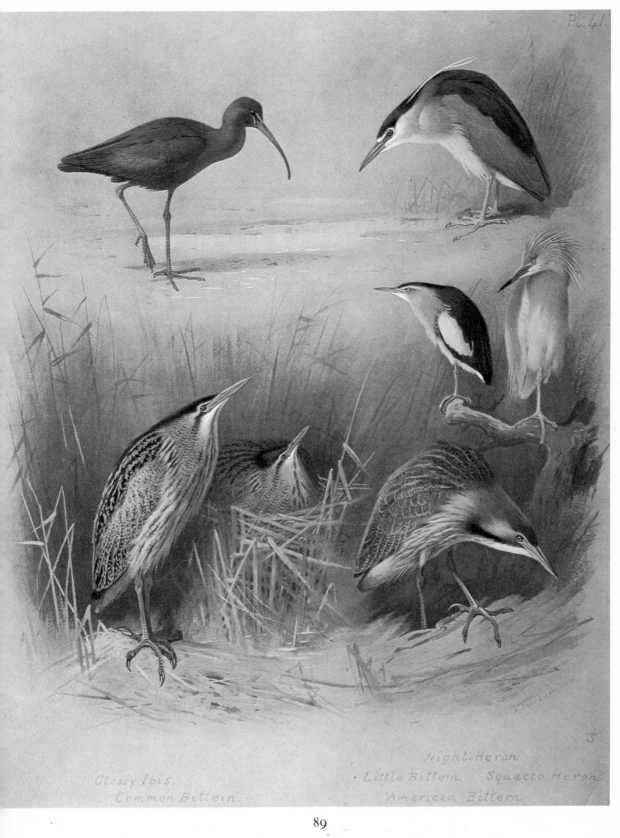

Pl. 41.

Glossy Ibis.
Common Bittern.

Night-Heron.
Little Bittern. Squacco Heron.
American Bittern.

89

Golden Plover, Grey Plover and Curlew

On these two pages are given various sketches from life of the Golden and Grey Plover, and also of the Curlew, distinguished by its long curved bill.

The Golden Plover is a resident, nesting on moorlands mostly in the northern parts of the British Islands and flocking to the low ground and mud-flats in winter, while the Grey Plover is best known as a bird of passage, never breeding in this country. Apart from the

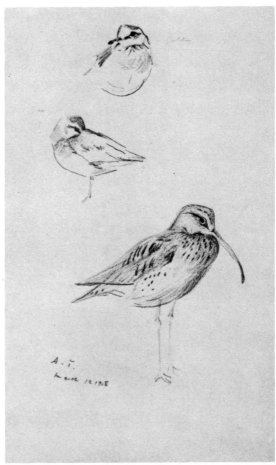

larger size and silvery colour of the latter, the bird differs from the Golden Plover in possessing a small hind toe which is absent in the other, while under the wing the axillary feathers are black instead of white.

The Curlew is a well-known bird on many of the moorland districts in the British Islands in summer and moves down to the coast in winter.

Woodcock

The lower sketches on the opposite page give details of the Woodcock's plumage, also the bill and feet of the bird. On the wing feathers may be seen the intricate pattern of brown, black and buff, which imitate so closely the fronds of dead bracken and other foliage in the leafy coverts where the bird loves to conceal itself when resting, though often betrayed by its large dark eye.

Above is a sketch of the Woodcock in winter when this species suffers much during prolonged spells of frost and snow, as their food supply, consisting chiefly of worms, is then cut off.

A remarkable fact in the history of the Woodcock is the habit the bird has of carrying her young, which has long been known, but I think never so clearly described as in an account of this performance by Mr George Brooksbank in the *Scottish Naturalist* for 1919, pp. 95, 96, from which I have taken the following extract: 'On 14th June, 1918, I flushed a Woodcock from some bracken in an open space among the rhododendrons growing near the top of an exposed rocky hill. She began to fly straight away from me up wind, but on meeting the full force of the blast as she rose, she turned and came back close past me, and I was able to see that she was carrying a small young one. Her flight was laboured and unusual, and her tail was much depressed, so that her position in the air recalled that of a wasp when carrying a fly. The wind was strong and she quickly dipped over the rock or cliff a little way behind me. On going back and cautiously looking over the edge I saw her standing on a sort of ledge not far off and rather below me, but facing my way – up wind – and I could also see the young one crouched at her feet between her legs. As soon as she caught sight of me, she bent her neck and pushed the young one securely into position with her bill, raising her wings as she did so, and flew off out of sight down among the trees below. . .

'The young bird was carried close to the old one's body and well concealed by the lowered tail. In fact, from behind it would not have been possible to see it at all, and it was only when the old bird flew past me, or was facing towards me, that I could tell that a young one was being carried.'

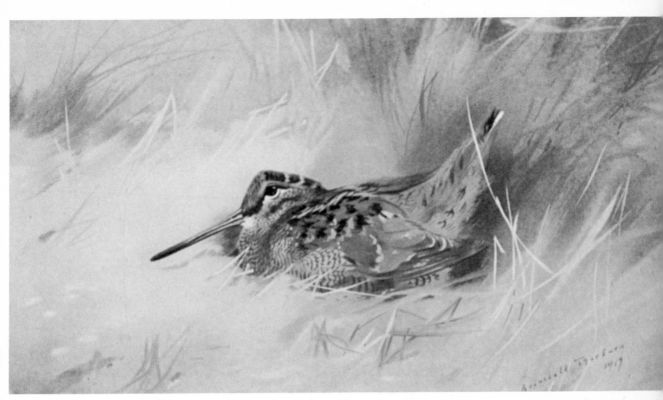

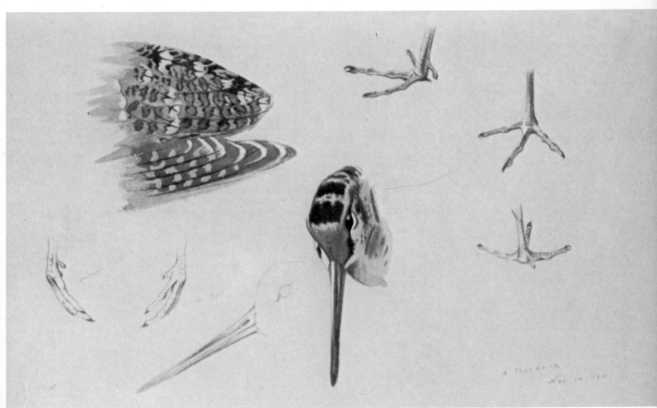

Brent Goose and Bean Goose

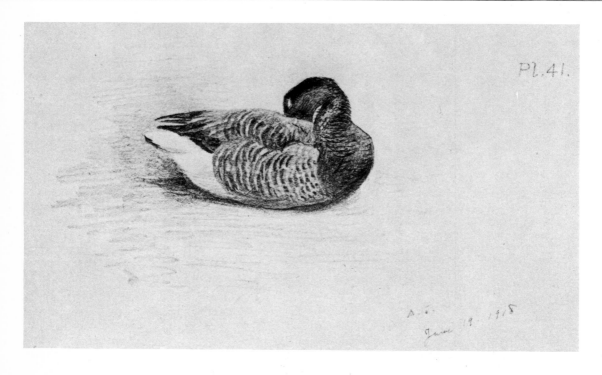

A sketch of the Brent is given above. This small dark Goose is a winter visitor from the Arctic regions, and chiefly frequents the Shetlands, Orkneys, and eastern shores of Great Britain as well as the Irish coast. The birds often congregate in immense flocks, which are much sought after by punt gunners.

The Brent keeps to the sea and never comes inland unless by accident.

On page 95 the Bean Goose is figured. This species visits us in autumn from its breeding grounds in northern Europe, and may be distinguished from the Greylag and White-fronted Geese by the black nail at the point of the bill.

These three species, and also the Pink-footed Goose are known to shore shooters as 'Grey Geese', and are larger than the Brent and Bernacle, which are the so-called 'Black Geese'.

I have noticed that these two groups have each a characteristic method of feeding, the Grey Geese nibbling the grass in a slow deliberate manner, whereas the Brent and Bernacle snip the blades with a much quicker movement of the head and neck, more like the action of a common fowl when eating.

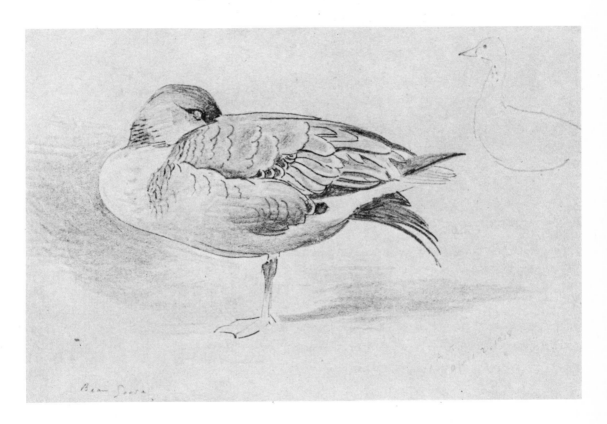

Bean Goose

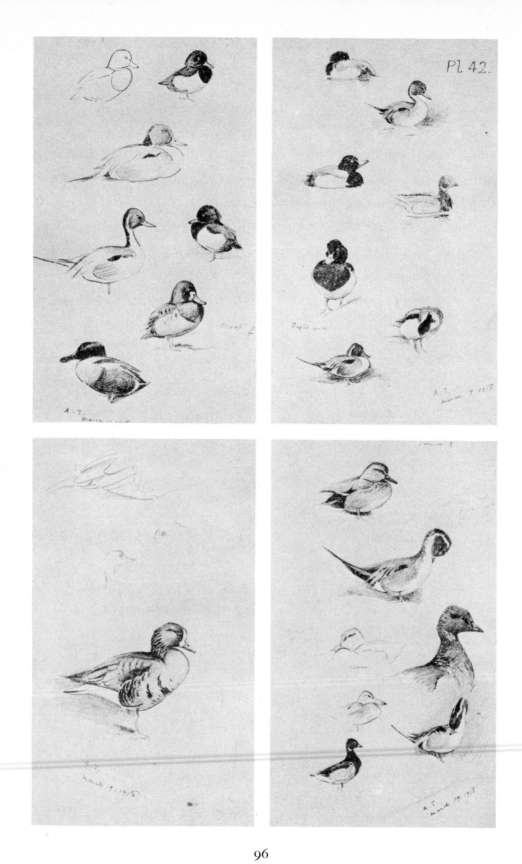

Pl. 42.

White-Fronted Goose, Brent Goose, Sheld-Duck, Gadwall, Shoveler, Pintail, Tufted Duck and Scaup

In the lower left-hand corner in this Plate are sketches from life of the White-fronted Goose. This species is a winter visitor to the British Islands, more abundant on the western and southern coasts than on the eastern side of Great Britain, except in the neighbourhood of the Moray Firth, the Shetlands and Orkneys. It is easily recognised by the white frontal patch bordered by black, and the prominent black bars on the lower part of the breast.

Opposite the White-fronted Goose on the right-hand side of the Plate, is a sketch showing the head and shoulders of the Brent Goose, also figured on page 94. This shows the distinctive character of the head and neck in this small Goose, which also applies to the Bernacle, viz., the shortness of bill and absence of the strongly-marked ridges in the plumage of the neck. Along with the Bernacle are sketches of the Gadwall, Shoveler, and Pintail.

The Gadwall is dull in colouring compared with the other British fresh-water ducks, though the plumage is marked by beautiful pencillings of black and grey, and it may always be distinguished by the pure white wing spot or speculum.

In habits it is quiet and unobtrusive, and closely resembles the Mallard, though more partial to the seclusion of quiet fresh-water pools than the other. The Pintail, figured next the Gadwall in the act of preening its breast feathers, is easily known by its long-pointed tail feathers, which have given the bird its name.

This graceful species is a resident and also a regular winter visitor to Great Britain, being more common on the mud flats and shores than on inland waters. It has lately increased as a breeding species, and now nests on Loch Leven as well as in other parts of Scotland.

In the upper right-hand corner of this Plate are given sketches of the Scaup, Pintail, Brent Goose, Tufted Duck and Sheld-Duck.

In the upper-left hand corner are the Tufted Duck, Pintail, Scaup, and Shoveler. The Tufted Duck is resident as well as a winter visitor to the British Islands, and has much increased of later years as a breeding species. Like the Scaup, it obtains its food by diving, the other ducks shown on this Plate being all of the surface-feeding kind.

If one compares living specimens of these two species it will be noticed that the shape of the mass of flank feathers differs, those in the Tufted Duck usually forming a concave outline, while in the Scaup this is convex. This point is indicated in the sketches, which were taken from life in the Gardens of the Zoological Society of Scotland.

Bean Goose, Bernacle Goose, Common Sheld-Duck, Garganey, Pintail, Tufted Duck and Eider Duck

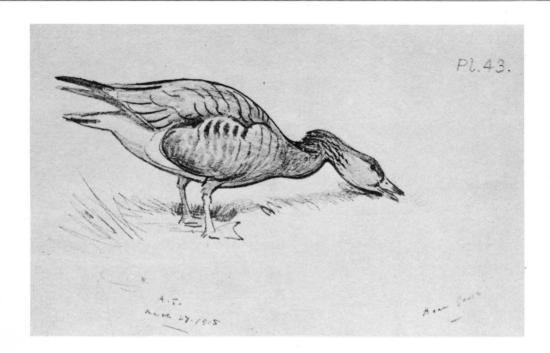

Above is a sketch of the Bean Goose feeding, showing the characteristic angle in the neck when the bird is nibbling the grass blades on which it chiefly subsists.

On the left-hand side of the opposite page in the centre of the sheet of studies, is given a sketch of the Bernacle Goose feeding and of the Tufted Duck swimming, and above one of the Pintail.

Below these are outline sketches of the Eider Duck.

In the right-hand set of studies is one of the Garganey at the top and three of Sheld-Ducks below, also the head of a Brambling. The Garganey is best known as a spring visitor to England, and is chiefly found in Norfolk, where it breeds during the summer months. In colour it is beautifully marked with various shades of brown and bluish-grey. During the breeding season the male utters a curious rattling note.

The Common Sheld-Duck is plentiful on many parts of the coast where there are stretches of sand and bents which suit its habits.

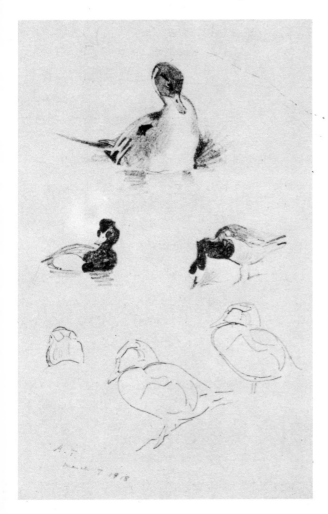

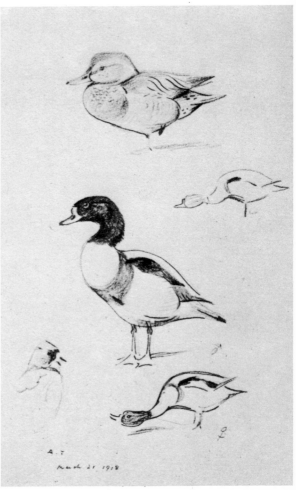

This is a very handsome species, with crimson bill and strongly contrasting plumage of black, white, and rich chestnut.

It nests in burrows, sometimes using the disused home of a rabbit, at others excavating a tunnel for itself.

The lower sketch of the female Sheld-Duck shows a characteristic pose of the bird in spring.

Wigeon, Scaup and Eider Duck

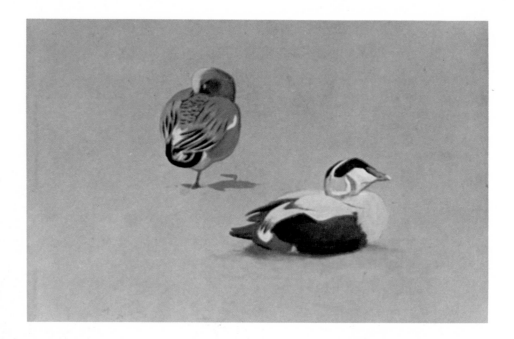

The sketch on this page shows a male Wigeon when asleep, with bill tucked into the scapular feathers. The Wigeon is best known as a winter visitor to the British Islands, though some birds nest in the wilder parts of Scotland, and a few have been recorded breeding in the north of England and in Wales.

Included in the same sketch is a study of the Eider Duck at rest on shore, and the same bird is given opposite on the water.

When the females, whose nests provide the well-known eider-down of commerce, are sitting, the males may be seen at sea in the neighbourhood, when their curious crooning notes, which carry such a long distance across the water, may frequently be heard.

They are clumsy, ungainly birds on land, though graceful enough and quite at home in the water, and are splendid divers, going down to a great depth, even thirty feet or more, after the mussels on which they feed.

They breed as far south as the Farne Islands in England, along the east coast of Scotland, and are also very plentiful on the islands off the west coast of Sutherland, where I have had many opportunities of watching them.

The Scaup, shown in the middle portion of the sketch below, is another handsome diving duck, the drakes, with their dark glossy green heads and mantle of grey, and the ducks, easily distinguished by their brown plumage and large patch of white next the bill.

Like the Eider, they go down deep for the food, and may be seen in large numbers off the mussel-beds during winter.

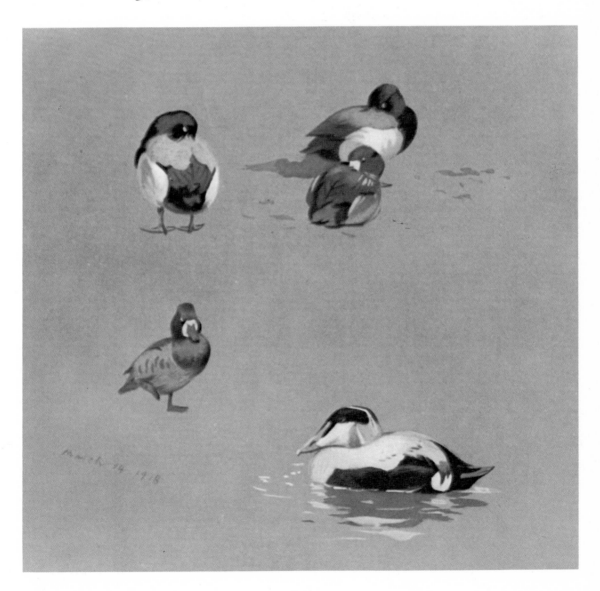

Mallard, Teal and Pintail

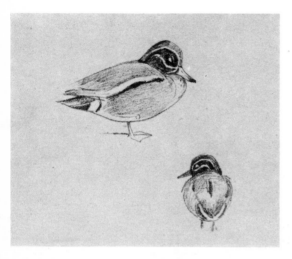 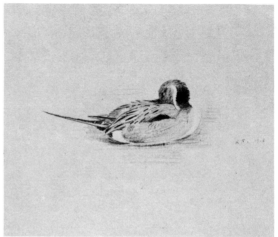

Two studies of the Teal from life are given above, on the left.

This is a common British species, and nests regularly in many parts of our islands.

Next to the Teal, on the right, is a sketch of the Pintail, and opposite are others of the Mallard, or Wild Duck, the origin of our domestic Duck, and the most common and best known of this family.

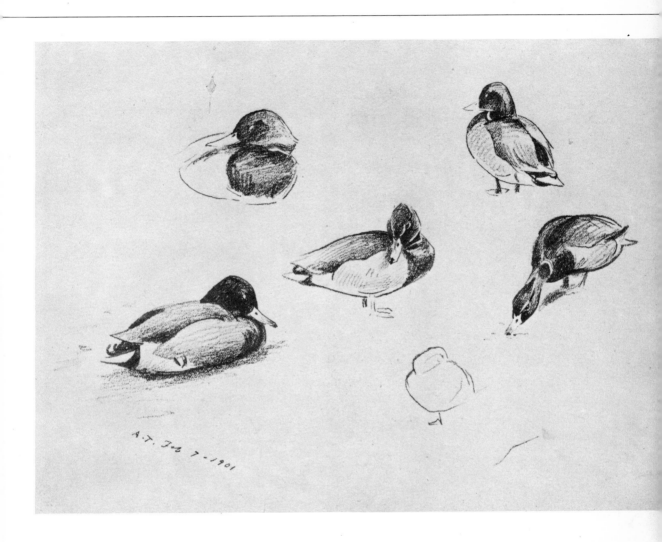

Gadwall, Shoveler, Teal, Garganey, Wigeon, Scaup, Tufted Duck and Eider Duck

On the right-hand side of this page are sketches of the Wigeon (female) and Shoveler (male and female), the latter species being easily known by the large spoon-shaped bill, and also by the deep chestnut on the lower part of breast, and

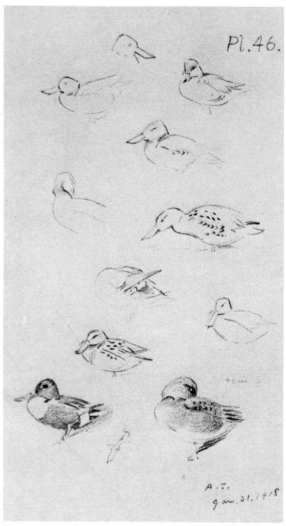

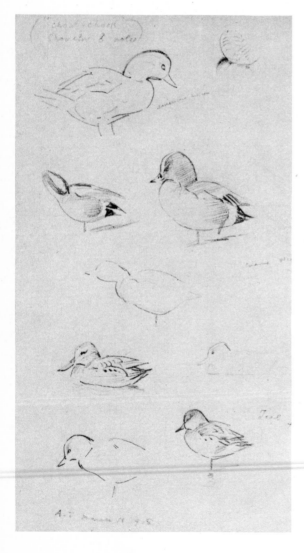

the glossy green head which mark the male bird.

The Shoveler has greatly increased in numbers in Great Britain during the last forty years, and frequents fresh water lakes in preference to the sea.

On the left-hand side of page 104
will be found sketches of the Wigeon,
the American Wigeon, Shoveler,
and Teal.

Below are two sketches of the
Garganey feeding, showing the action of the

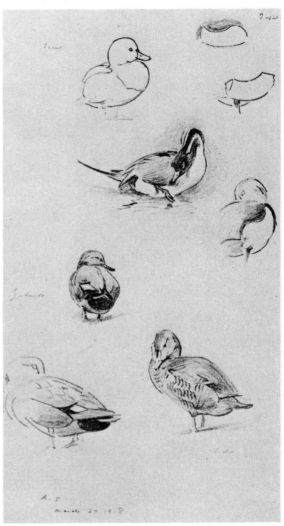

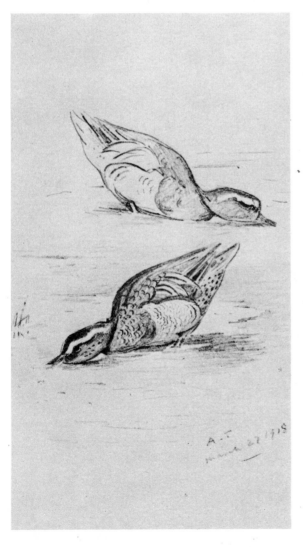

birds when paddling after insects in muddy
water.

Above are sketches of Scaup, Tufted
Duck, Pintail, Gadwall, and Eider Duck.

Great Black-Backed Gull, Turnstone, Ringed Plover and Smew

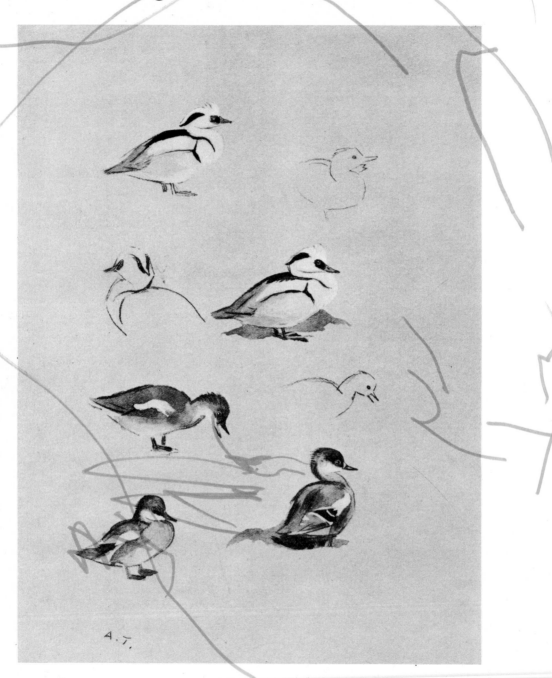

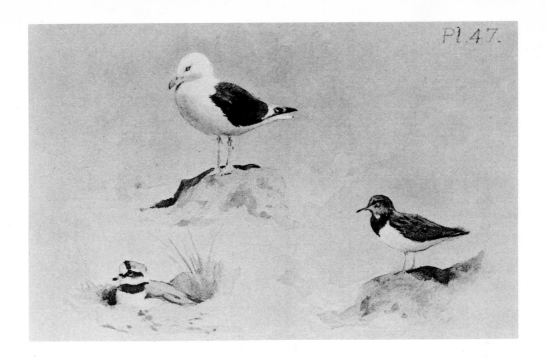

The sketch of the Great Black-backed Gull on this page, was taken by the help of a field-glass on one of the Scilly Islands where this fine bird is plentiful.

It may always be readily distinguished from the Lesser Black-backed Gull by its much larger size, darker mantle, and flesh-coloured legs, the latter species having the legs of a bright yellow tint.

The Great Black-backed is the largest resident British Gull, and usually selects for its breeding place an isolated rocky 'stack', where the two or three olive-brown, darkly blotched eggs are laid in a nest placed in some hollow among the turf or earth.

Below the Gull on the right is a study of the Turnstone, and on the left one of the Ringed Plover, both sketched on the Scilly Islands.

The studies of the Smew (male and female) shown opposite were taken from living specimens in the Gardens of the Zoological Society of London.

This beautiful little diving duck only visits us in winter, when it is not uncommon on the eastern coasts of Great Britain, though the full plumaged males, like the one figured in the Plate, are not often met with.

The peculiar shape of the black bars on the breast and flanks can only be seen to advantage in the living bird.

The food, consisting chiefly of small fishes, is obtained by diving, the prey when captured being securely held by means of the saw-like teeth with which the bill is furnished.

Tern

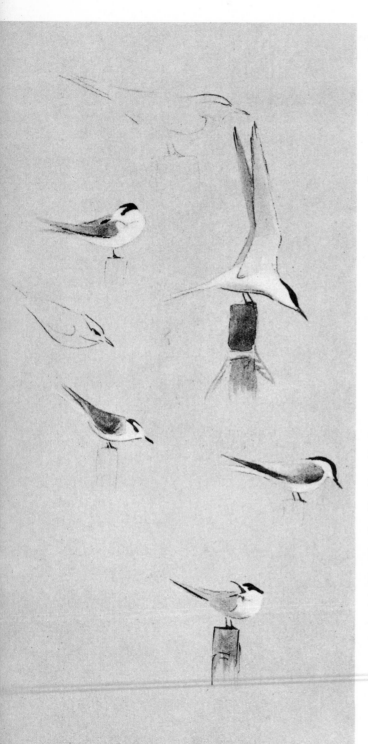

The slight sketches of Terns on this page were made on the shores of the Moray Firth in August, by means of a field-glass.

At this time of the year, when the young have left the nest, large flocks frequent the shore before starting on their southward journey to spend the winter in warmer seas. The most numerous are the Common and Arctic Terns, but the two species are not easily distinguished except when handled, the last mentioned having the bill of a uniform deep red, without the dark tip of the other bird's, the tarsus is shorter, the wings extend farther beyond the tail, while the under parts of the body are greyer in colour than in the Common Tern.

Whether flying, basking on the beach, or poising their slender bodies with uplifted wings on the top of a stake, they are the most graceful of birds and can be recognised from any gull when on the wing by a curious bounding action in their flight. [The Terns shown opposite are reproduced from Plate 71 of Thorburn's *British Birds*, London, 1915–18.]

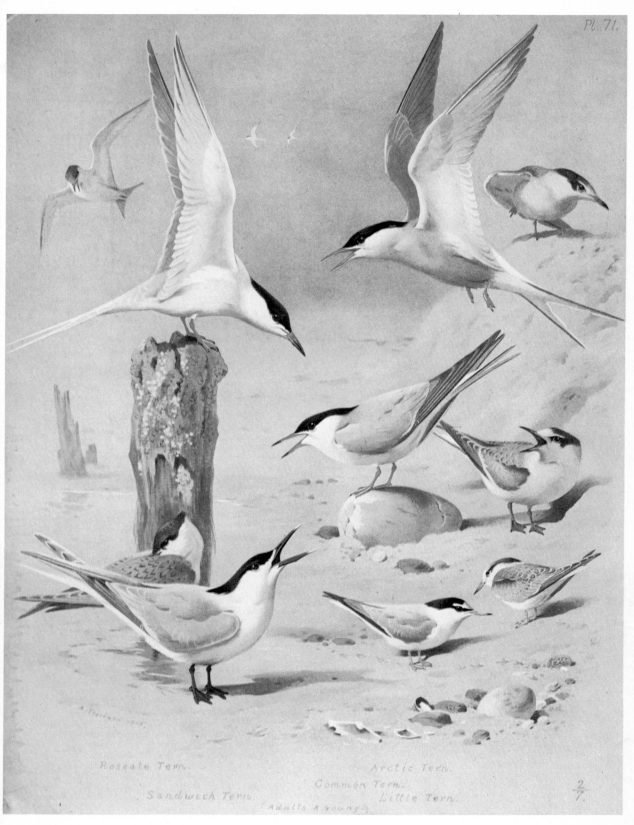

Pl. 71.

Roseate Tern.

Arctic Tern.

Common Tern.

Sandwich Tern.

Little Tern.

(Adults & young)

2/7.

109

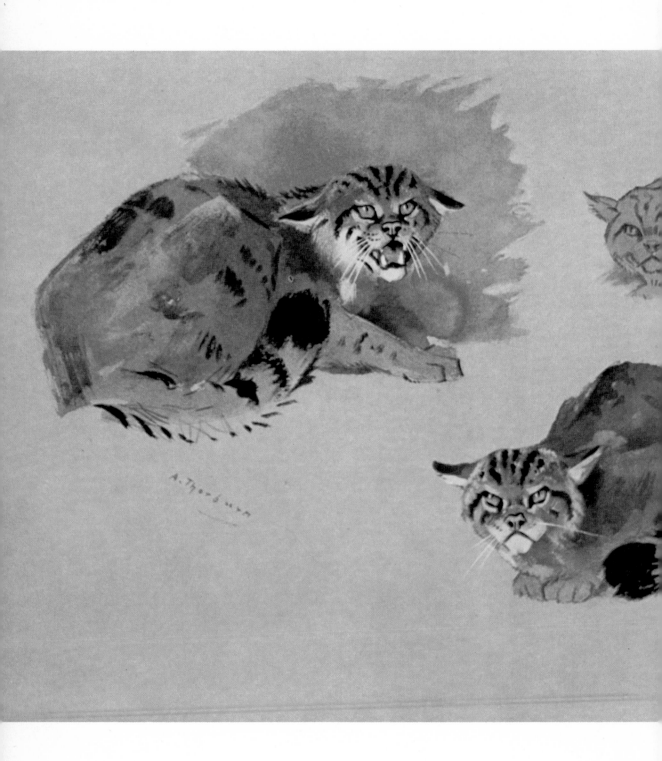

Wild Cat

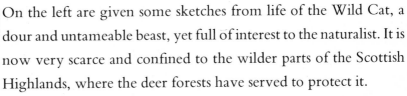

On the left are given some sketches from life of the Wild Cat, a dour and untameable beast, yet full of interest to the naturalist. It is now very scarce and confined to the wilder parts of the Scottish Highlands, where the deer forests have served to protect it.

It may be distinguished from the domestic cat – whose offspring after running wild for a generation or two in the woods often assume the brindled colouring of the genuine wild animal – by its greater robustness of body, the thick and unpointed bushy tail and black soles of the feet.

The principal sketch was used for the picture of the Wild Cat in Millais' *Mammals of Great Britain and Ireland.*
[The line drawing shown below is reproduced from Volume 1, page 46, of Thorburn's *British Mammals,* London, 1920–1.]

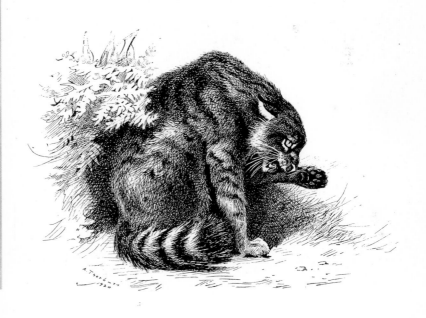

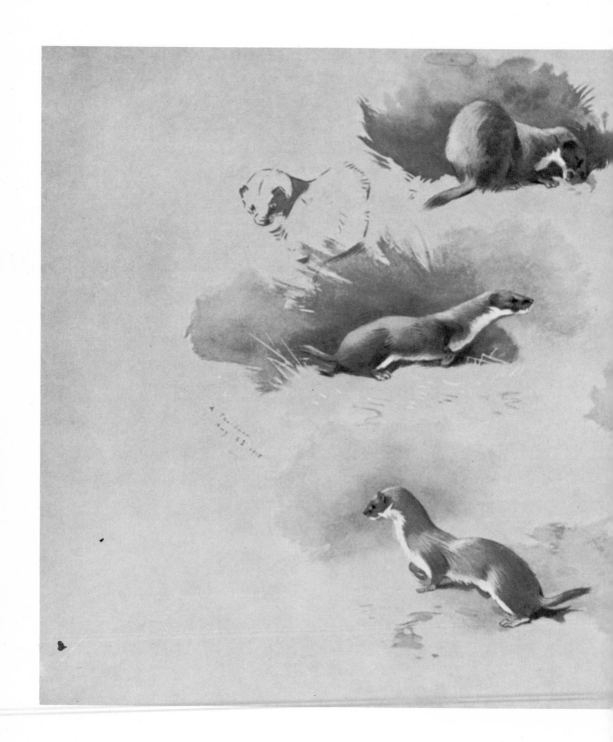

Weasel

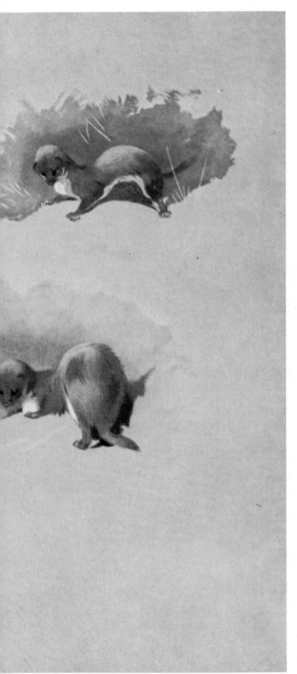

These sketches from life were made from a Weasel which, tempted by a vole already in the trap, found itself caught after eating its victim. After a great display of anger by this unexpected intruder it was safely transferred to more roomy quarters, and was later given its liberty.

Lithe and slim in body, and an expert in killing its prey, this little animal is most useful in ridding a garden of mice and voles, and will also hunt in the tunnels of the mole. Once to my surprise I found one caught in a mole trap after having wormed its head, shoulders and forelegs through the small iron ring, less than an inch in diameter, which acts as a trigger when the trap is set.

Woodmouse

On the right are some sketches from life of
the Common Woodmouse. There are
several varieties of this beautiful creature in
the British Islands, the most handsome
of all being the large Yellow-necked
Woodmouse, which measures from nose to
end of tail about $8\frac{3}{4}$ inches. Another large
variety is that found in the Island of
St Kilda.

Woodmice are easily tamed, and pretty
creatures to watch in confinement, always
keeping their fur in spotless condition, and
spending a good part of their time in
cleansing it. Even the tail is carefully licked
over while held in position by the fore feet,
as shown in the central sketch.
[The line drawing shown below is
reproduced from Volume 2, page 7, of
Thorburn's *British Mammals,* London,
1920–1.]

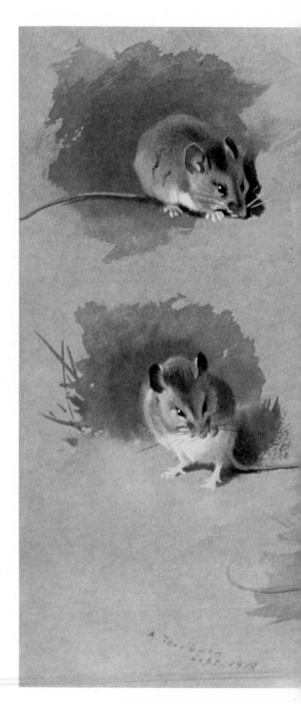

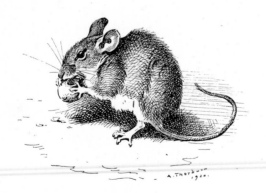

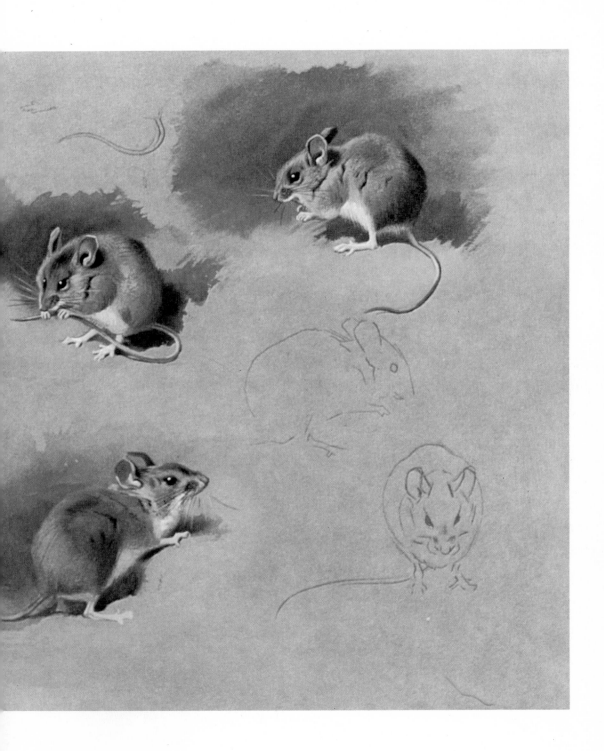

Fox

The studies of the Fox shown below and of the Otter on page 119 were taken from animals in the Gardens of the Zoological Society of Scotland, Edinburgh, and were made for a book on British mammals.

The Fox, though nocturnal in its habits, may often be seen abroad in daylight, but this seldom happens with the Otter. I have only once had an opportunity of watching the latter at close quarters in a wild condition, as it made its way along the banks and among the stones of a stream in Sutherland.

[The Fox shown opposite is reproduced from Plate 11 of Thorburn's *British Mammals,* London, 1920–1.]

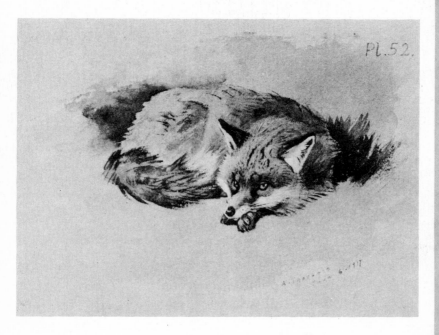

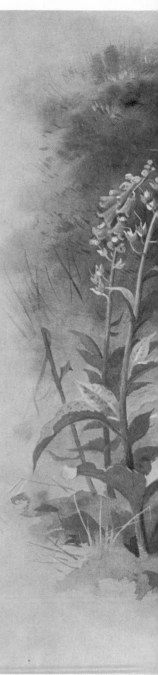

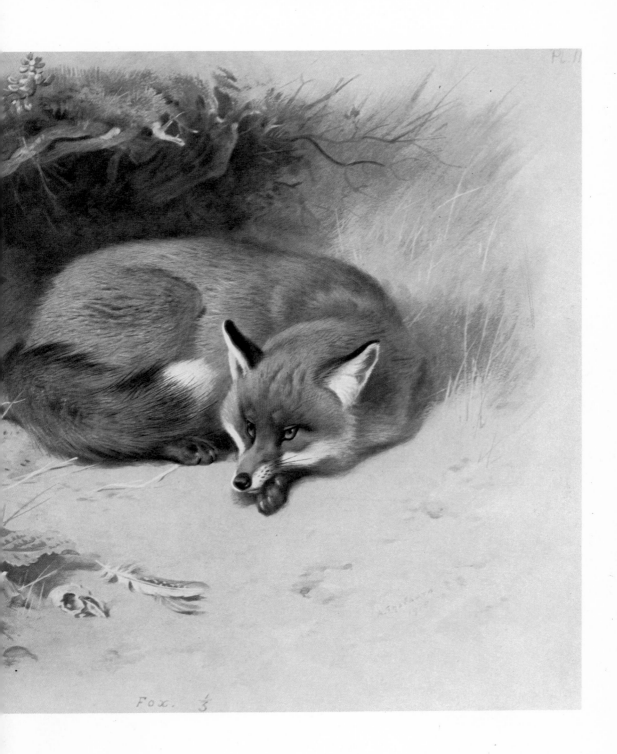

Fox. $\frac{1}{3}$

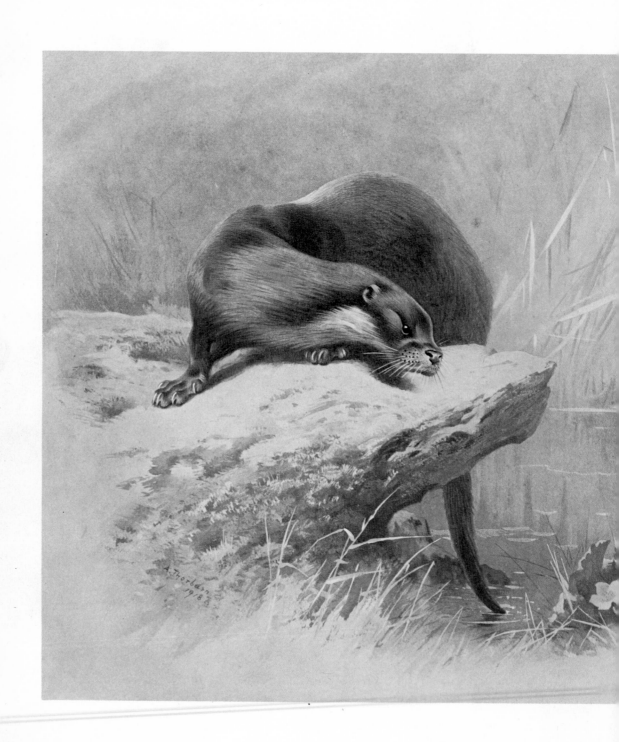

[The sketch of the Otter shown above was made in the Gardens of the Zoological Society of Scotland, Edinburgh (see page 116).]
[The Otter shown on the opposite page is reproduced from Plate 17 of Thorburn's *British Mammals*, London, 1920–1.]

Red Deer

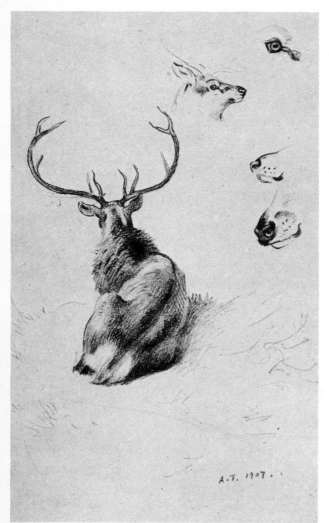 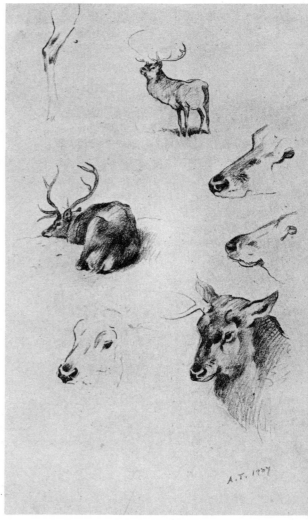

Above are shown studies from life of Red Deer.

[The Red Deer shown on the opposite page are reproduced from Plate 37 of Thorburn's *British Mammals*, London, 1920–1.]

Pl. 37.

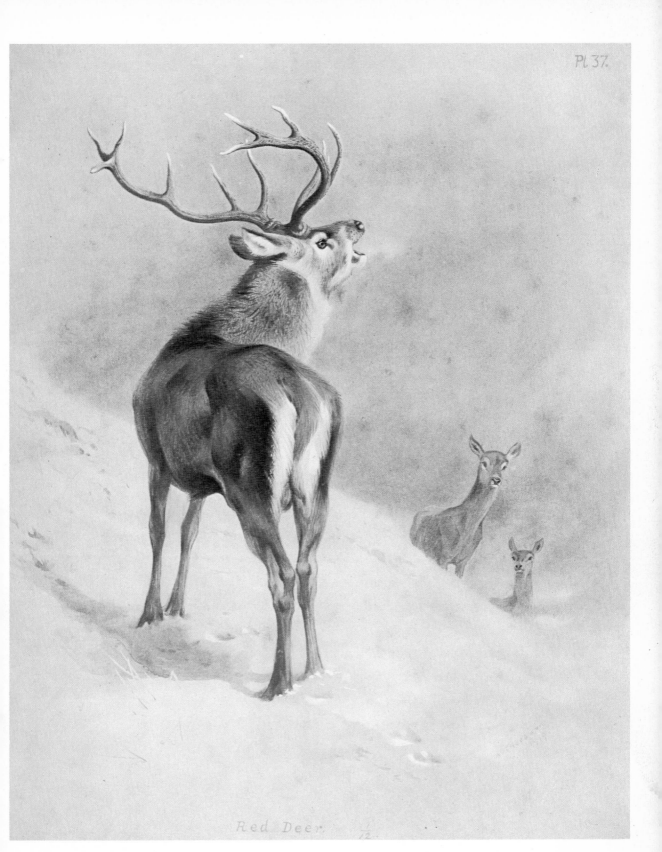

Red Deer. $\frac{1}{12}$.

Wild Cattle

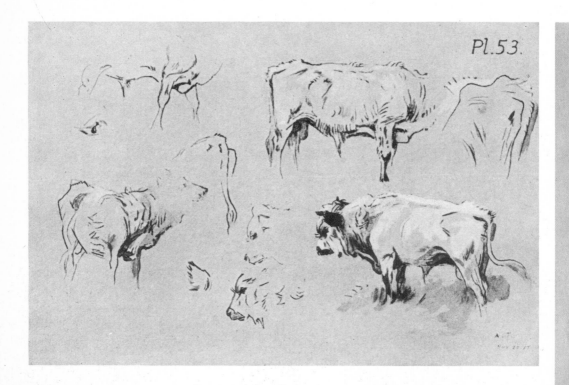

Above are shown studies from life of Wild Cattle.

The origin of the so-called Wild Cattle, now only to be found in a few enclosed parks in Great Britain, is uncertain, though there can be no doubt of their great antiquity. They are probably descended from domesticated animals which had taken to a wild life in the forests before historic times, and were later rounded up and enclosed in parks for their preservation. Few of these herds are now in existence, the best known being the Chillingham, Cadzow and Chartley breeds.

[The Wild Cattle shown on the opposite page are reproduced from Plate 40 of Thorburn's *British Mammals*, London, 1920–1.]

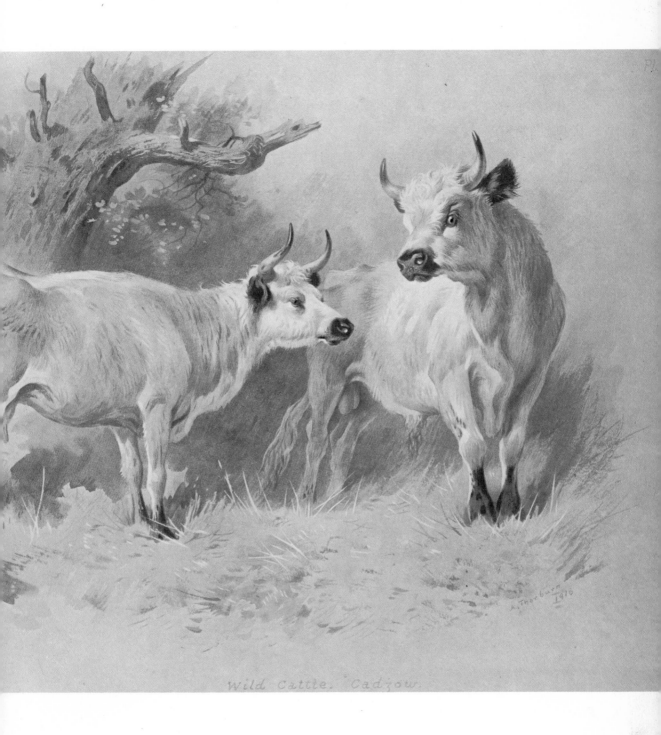

Wild Cattle. Cadjou

Highland Pony

This sketch of the old breed of Highland Pony or Garron, was made many years ago in a Sutherland deer forest. On the animal are shown the deer saddle and breeching required for bringing home the stags, no easy task on a rough and steep hill-side.

Ptarmigan Hill, Sutherland

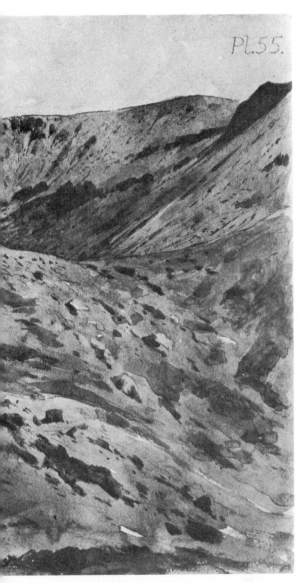

Pl.55.

This landscape sketch gives a view of the 'Red Corrie', Glasven, and shows a typical bit of ptarmigan ground.

The birds make a home for themselves on these barren hills, where they shelter among the lichen-covered stones and rock, so closely resembling their plumage in colour.

On the lower slopes grows the beautiful Alpine plant, the Cushion Pink, *Silene acaulis*, decked with its rose-coloured flowers in early summer.

Eagle's Hunting Ground

The sketch given here was taken high up on a Highland deer forest, and shows the hunting ground of the Golden Eagle, where he takes his toll of the Grouse and Ptarmigan.

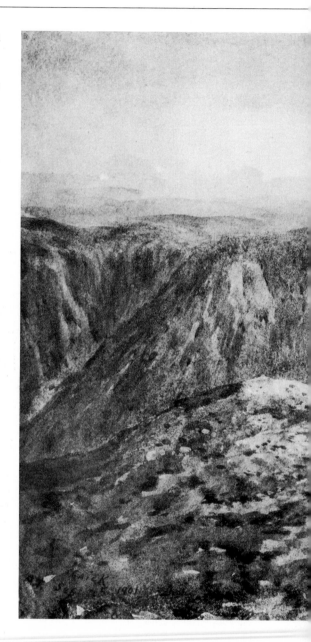

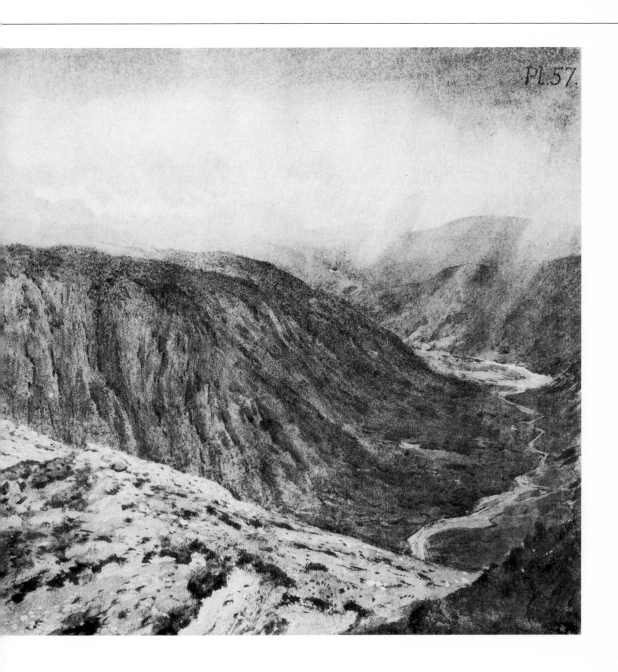

Pl.57.

129

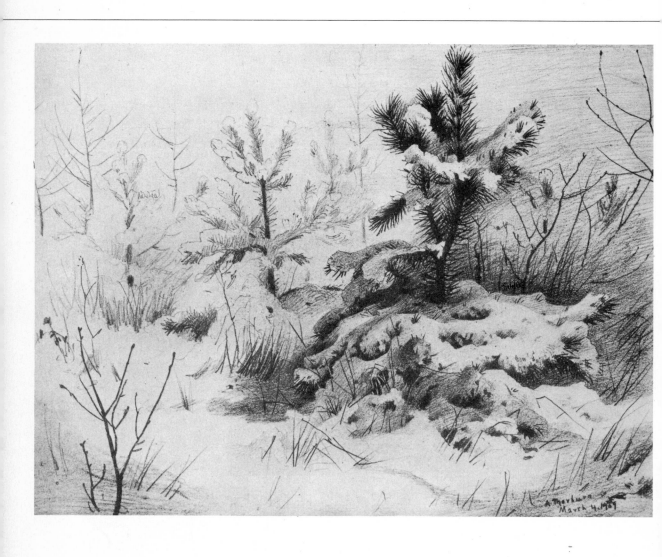

Snow-Covered Furze and Pines

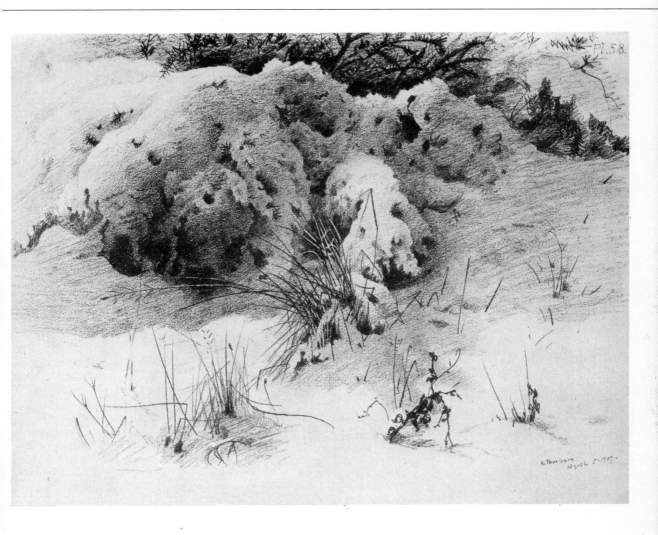

These two sketches, taken after a heavy snowfall, were made as a background for Pheasants in winter.

Germander Speedwell,
Dandelion and Plantain

This Plate shows sketches in colour of three of our common wayside plants, the Germander Speedwell on the left, the Dandelion in the centre, and the Plantain on the right-hand side.

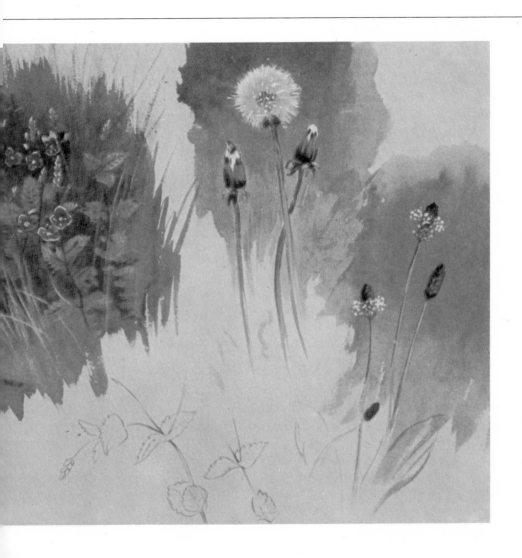

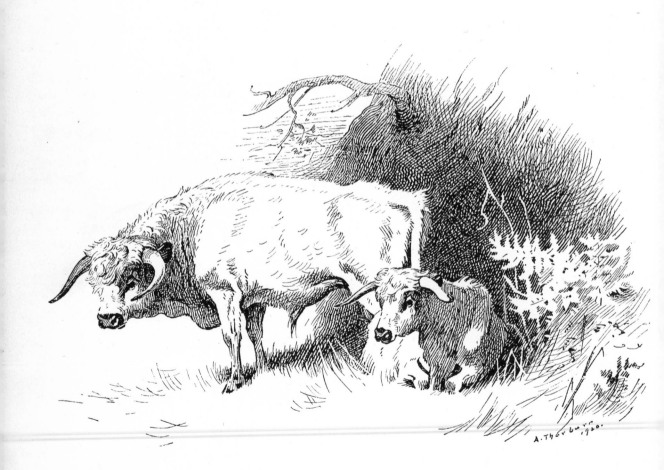

Index

References in bold type are to illustrations. Other references are to the text.

ADVANCE PRAISE FOR

Spain and Portugal Today

"Wise a w about post-
Franco insight with
political e experienced
teacher y student of
contemp

 nd Literature,
 e, Puerto Rico

"I wish and Portugal.
It comb things got to
be the v Iberia so that
the jour

 ert J. Phillips

"As a te e need for a
book tha t lies behind
the word r picture of
contemp evolved over
the centu

 z McLean,
 New York

"As an delighted
with th book. My
husband ally, have
witnesse impressed
with the Spain that
the auth

 a Zarzuela

Spain
and Portugal
Today

Studies in Modern European History

Frank J. Coppa
General Editor

Vol. 32

PETER LANG
New York • Washington, D.C./Baltimore • Bern
Frankfurt am Main • Berlin • Brussels • Vienna • Oxford

Julia L. Ortiz-Griffin
and William D. Griffin

Spain
and Portugal
Today

PETER LANG
New York • Washington, D.C./Baltimore • Bern
Frankfurt am Main • Berlin • Brussels • Vienna • Oxford

Library of Congress Cataloging-in-Publication Data

Ortiz-Griffin, Julia L.
Spain and Portugal today / Julia L. Ortiz-Griffin and William D. Griffin.
p. cm. — (Studies in modern European history; v. 32)
Includes bibliographical references and index.
1. Spain—Politics and government—1975– . 2. Portugal—Politics
and government—1974– . I. Griffin, William D. II. Title. III. Series.
DP272 .O784 946.083—dc21 2001050303
ISBN 0-8204-4031-0
ISSN 0893-6897

Die Deutsche Bibliothek-CIP-Einheitsaufnahme

Ortiz-Griffin, Julia L.:
Spain and Portugal today / Julia L. Ortiz-Griffin and William D. Griffin.
–New York; Washington, D.C./Baltimore; Bern;
Frankfurt am Main; Berlin; Brussels; Vienna; Oxford: Lang.
(Studies in modern European history; Vol. 32)
ISBN 0-8204-4031-0

The paper in this book meets the guidelines for permanence and durability
of the Committee on Production Guidelines for Book Longevity
of the Council of Library Resources.

© 2003 Peter Lang Publishing, Inc., New York
275 Seventh Avenue, 28th Floor, New York, NY 10001
www.peterlangusa.com

Printed in the United States of America

Table of Contents

Chronology
of Spain and Portugal

1469. Marriage of Ferdinand of Aragon and Isabella of Castile begins the process of unification in Spain.

1492. First voyage of Christopher Columbus begins Spanish exploration and conquest of North and South America. Conquest of Granada marks end of Moslem rule in southern Spain. Expulsion of Jews reflects policy of ethnic and religious "purity" in Spain.

1494–1559. Wars of Italy. A struggle between Spain and France that ends in Spanish military and political domination of Europe.

1497. First voyage of Vasco da Gama to India marks beginning of Portuguese commercial and political domination in the Far East and in coastal regions of Africa.

1500. Portuguese discover and lay claim to Brazil.

1519–22. Spanish ships make the first circumnavigation of the globe and establish Spanish claim to the Philippines.

1560–1660. The height of Spanish political and cultural dominance, often referred to as "the Golden Century" (Siglo de Oro).

1580. Philip II of Spain invades Portugal, beginning 60 years of Spanish control of that country's global empire.

1587–1604. Spain at war with England, the centerpiece of the Catholic-Protestant struggle in which Spain seeks to halt the progress of the Reformation.

1618–48. Thirty Years' War, in which Spanish political and military decline lead to ultimate defeat by France, independence of Portugal, and first loss of overseas territory.

1700. Death of Charles II, last of the Spanish Habsburg line, leads to the War of the Spanish Succession, involving most of the European powers.

1713–14. A prince of the French Bourbon dynasty acknowledged as king of Spain (Philip V).

1755. Great Lisbon earthquake devastates the capital of Portugal and is followed by the dictatorship of the Marqués de Pombal.

1789. Beginning of the French Revolution, the effects of which will eventually disrupt the regimes of both Spain and Portugal.

1807. Troops of the French dictator Napoleon Bonaparte invade and occupy Portugal. Members of the royal House of Braganza flee to Brazil.

1808. Napoleon gains control of Madrid and northern Spain, replacing the Bourbon monarchy with his own brother, Joseph.

1808–14. Peninsular War resulting in the expulsion of the French from Spain and Portugal.

1820–23. Spanish liberals gain power, establishing constitutional government.

1824–26. Collapse of colonial rule in Spanish America (except for Cuba and Puerto Rico) and Portuguese Brazil.

1828–38. Civil wars in Spain and Portugal in which conservatives (Carlists and Miguelites, respectively) oppose accession of young queens (Isabella II and Maria II) who are supported by liberals. In each country, the liberals prevail.

1838–68. An era of unstable government, bitter liberal-conservative disputes, military coups, and relative economic stagnation.

1868. Queen Isabella II of Spain is overthrown by rebel generals, who then seek a foreign prince to replace her. An Italian duke briefly ascends the throne but soon resigns. A republic is proclaimed by radicals but cannot sustain itself. A new Carlist revolt breaks out in the northern provinces.

1875. Alfonso XII, son of Isabella, is proclaimed King of Spain, as the least-disruptive solution for the country.

1885–98. Period of political stability in Spain, during which liberals and conservatives alternate in power and the democratic features of the constitution are made irrelevant. There is industrial development in the northern provinces, but growing radical violence accompanies it.

1889–1910. Portugal experiences a similar stabilization of political tensions and economic growth, accompanied by a new policy of exploiting the African colonies. However, Portugal also sees a growth of republican sentiment directed against the ruling family (assassination of the king in 1908).

1898. Spain is defeated in a war with the United States, losing Cuba, Puerto Rico, Guam, and the Philippines. The virtual disappearance of the empire leads to a period of introspection and re-assessment among intellectuals (the "Generation of '98") and intensified demands for reform among radicals.

1910. After the ouster of King Manuel II, a republic is proclaimed in Portugal.

1923–30. Following a humiliating defeat of the Spanish forces in Morocco and in response to growing socio-economic unrest at home, King Alfonso XIII confers dictatorial powers upon General Miguel Primo de Rivera.

1928–32. Emergence of António de Oliveira Salazar as political strongman in Portugal. First as finance minister, then as prime minister, he restructures the national revenue system and moves on to create an authoritarian regime, combining elements of the Italian fascist concepts with Portuguese Catholic traditionalism.

1931. Alfonso XIII leaves Spain in the aftermath of elections that favor the parties of the Left. The Second Spanish Republic is proclaimed.

1933. Proclamation of the "New State" in Portugal. Under this regime, although a symbolic presidency continues, the republic is transformed into a dictatorship, with Salazar ruling the country for the next thirty-five years.

1936–39. Spanish Civil War, precipitated by a revolt of army commanders opposed to the Republic's increasing concessions to radical and autonomist demands. The military rebels are supported by Carlists, monarchists, and a wide range of conservative groups. The Republic rallies some units of the armed forces and the national police as well as the party militias of the anarchists and various Marxist organizations. Long-standing class hatreds produce acts of revenge and numerous atrocities.

General Francisco Franco emerges as the leader of the "Nationalists" and receives armed assistance from the German and Italian dictatorships. Although volunteers from many countries arrive to aid the Loyalists, Western democratic governments decline to intervene, and the Soviet Union's aid to the Republic is limited by calculation of its own advantages.

1938. Although the Salazar regime in Portugal is generally supportive of the Spanish Nationalists, some Portuguese residents of border districts give aid and shelter to fleeing refugees as the Republic begins to collapse.

1939. With the defeat of the Republicans, General Franco assumes the position of leader of the Spanish State, establishing a dictatorship that will last until his death in 1975.

1939–45. Second World War. Spain remains neutral although Franco is clearly sympathetic to the Axis Powers. Salazar also proclaims neutrality, but he eventually allows American and British air forces to use the Azores for patrol operations.

1940. In the aftermath of the Civil War, Franco consolidates his power by creating a one-party system in which the "National Movement" (built around the Fascist-like Falange) holds all government offices.

1945–55. The Franco regime is ostracized for its pro-Axis sympathies but gradually brought back into the international system by American Cold War policy needs. Portugal, never as resented as Spain, soon becomes a regular participant in Western affairs.

1955. Spain and Portugal become active members of the United Nations.

1960–68. Salazar seeks to develop Portugal's national wealth by intensified exploitation of natural resources in the African colonies. Resistance movements in these territories are met with military force, and Portugal embarks upon a series of African campaigns that create growing bitterness and financial strain at home.

1965–70. Franco begins a process of political and economic "liberalization" that produces growing boldness among the critics of his regime and a rising standard of living.

1968. Salazar suffers a paralyzing stroke and can no longer carry out his duties although he remains nominal prime minister.

1970. Salazar dies and is replaced as head of government by his associate Marcelo Caetano.

1971–74. A slowdown in the Spanish economic "boom" provokes disputes among hard line and moderate cliques within the Franco government as the leader's declining health raises questions about the future.

1974. Revolution of the Carnations in Portugal. A bloodless military coup, symbolized by the red flowers inserted in the soldiers' gun barrels, overthrows the Caetano government, and within a year, a provisional administration has opened negotiations for ending the war in Africa (a major cause of the army's revolt) and granting independence to the colonies.

1975. Death of Franco. He is succeeded by the Bourbon prince (a grandson of Alfonso XIII) he groomed to restore the monarchy. King Juan Carlos I soon makes clear his commitment to democracy rather than Francoism.

1976. Portugal emerges from a period of political instability, establishing a democratic constitution.

1978. Adoption of a democratic constitution in Spain. The cortes, elected by universal suffrage and working with a prime minister who can command a majority of its votes, will henceforth include all political persuasions.

1981. Reactionary groups within the army and police seize the cortes chamber and threaten to topple the new parliamentary system. The king, putting aside his merely symbolic duties as chief of state, rallies the support of the nation and demands the obedience of the armed forces to the constitution. The collapse of this coup marks the end of any serious threat to the "new Spain."

1982–96. The Socialist Party, under Felipe Gonzalez, wins three successive national elections in Spain. Moving toward an increasingly centrist position, Gonzalez leads Spain into the NATO alliance, which his party had previously opposed. His economic policies are a mixture of socialist theory and pragmatic capitalism. Although presiding over a new "boom" in national prosperity, and a rejection of all restraints on personal liberties, he gradually loses support through his inability to deal with autonomist demands.

1986. Portugal admitted to the European Union in recognition of a decade of economic and political stability.

1996. Socialists win Portuguese national elections, taking the presidency (Jorge Sampaio) and the prime ministership (Antonio Guterres).

1996–2001. Jose Maria Aznar, leader of the Popular Party (conservative) becomes prime minister and is subsequently reelected with an increased majority. Spain, now a member of the European Union, commits itself to an active role in world affairs, including a special involvement in Iberoamerica. Like his socialist predecessor, Aznar is bedeviled by economic instability and controversies over regionalism.

1999. Portugal hands over its last remaining colony, Macao, to China.

2000. Portugal and Brazil celebrate the 500th anniversary of the discovery of Brazil.

2001. After a brief cease-fire, the Spanish government is forced to resume its conflict with the Basque nationalist organization, ETA, which has been carrying on a campaign of terrorist violence for more than 30 years.

Despite the political convulsions of its twentieth-century history, Spain's cultural achievements lead some to speak of a new "Siglo de Oro." Spain produced five winners of the Nobel Prize for Literature: Jose Echegaray (1904), Jacinto Benavente (1922), Juan Ramon Jimenez (1956), Vicente Aleixandre (1977) and Camilo Jose Cela (1989) as well as major poets such as Antonio Machado and Federico Garcia Lorca. The philosopher-essayists Miguel de Unamuno and Jose Ortega y Gasset won international renown, as did the expatriate George Santayana (Jorge Ruiz de Santayana). Among artists, Pablo Picasso, a founder of Cubism, towers above all others, though the painters Joan Miro and Salvador Dali make important contributions to "modern" art as does the sculptor Eduardo Chillida. Composers of distinction include Enrique Granados, Manuel de Falla, Isaac Albeniz, and Joaquin Rodrigo, and the composer-cellist Pablo (Pau) Casals is honored on both sides of the Atlantic. So, too, are performers like the tenors Placido Domingo, Jose Carreras, and Alfredo Kraus and sopranos Monserrat Caballe and Victoria de los Angeles. Among film directors Luis Buñuel was one of the giants of twentieth-century cinema and was followed in the post-Franco era by the acute Carlos Saura and the outrageous Pedro Almodovar (winner of an Academy Award). The twin burdens of cultural isolation and political repression weighed heavily on Portugal during most of the twentieth century. The pioneering modernist painter Amadeo de Souza Cardoso received his due recognition only in the 1990s. The Nobel Prize for Literature was awarded to the maverick communist anticlerical novelist Jose Saramago only at the end of the century (1998), making him the first Portuguese recipient of this

honor and acknowledging not only the virtues of his work but the felicities of his language.

PART I

Spain

1

Out of the Valley: The Transition to Democracy

High upon a peak in the Guadarramas, a huge cross thrusts heavenward. Below it, a vast basilica has been carved out of the mountain and richly adorned with mosaics, tapestries, and statuary. Here, in the *Valle de los Caídos*—Valley of the Fallen—the decree of *El Caudillo* created a monument and mausoleum for the dead of Spain's bloody Civil War. Early in his reign, when he sought a final resting place for José Antonio Primo de Rivera, founder and protomartyr of the Falange, Francisco Franco was rebuffed by the royalist guardians of *El Escorial*, the monastery-palace reserved for the remains of monarchs. More powerful than any king since Philip II, who built the Escorial, Franco resolved to create a monument that reflected his own greatness and the victory of his cause. Grandiose rather than grand, morbid rather than moving, the Valley of the Fallen came to symbolize the introverted, isolated preoccupation with the past that characterized the Franco era. Only when *El Caudillo* died at the end of 1975 and was himself buried—a general among soldiers—could Spaniards begin a slow, painful emergence from the valley of repression and suspicion in which they had dwelt for so long. Amidst the threat posed by political factionalism, violent separatism, and restless militarism, the Spanish people would push on into the next decade before they saw the light at the end of the tunnel that had led them out of this grim valley.

The Legacy of Francisco Franco: The Falangist Regime

Writing of the society that evolved during the four decades of *El Caudillo's* rule, the sociologist Victor Pérez-Díaz describes it as borrow-

ing from a variety of historical periods. "The Francoist state tried to combine what it considered an up-to-date version of a medieval parliament with some features of sixteenth-century imperial Spain, including the characteristic concessions to the preeminence of the counter-reformist Catholic church, and the trappings of nineteenth-century European colonial powers and contemporary fascist regimes."[1] Looking backward may afford valuable historical perspective. In the case of Spain, however, it produced merely backwardness.

The medieval kings had created parliamentary institutions to serve their own purposes of undermining local magnates and warlike nobles, and, when these purposes had been accomplished, reduced the institutions to a nullity. The *Cortes* of the late Middle Ages was made up of affluent supporters of the regime—"ricos hombres" (rich men) and "hidalgos" (gentlemen)—and the church. The fourth house of that parliament contained delegates from the towns who were drawn from the local power brokers. Imitating the work of Ferdinand and Isabella, Franco shaped a legislature that favored the great landowners and special interest groups like the military and the clergy while ignoring the concept of representative democracy. Fearing the disruptive potential of modern political parties, he amalgamated the various forces that had joined him in waging the Civil War. Royalists, clericals, right-wing Nationalists and money-men were all obligated to pay allegiance to a single superparty, of which Franco was the maker and leader. This National Movement preempted authentic political dialogue and permitted the legislature no function beyond that of rubber-stamping despotic decrees.

Like the medieval monarchs, Franco was obsessed with the consolidation of his nation-state. Ironically, the 5 centuries that had passed since the era of the Reyes Católicos had failed to achieve their goal of extirpating regionalism. During the Civil War, Franco had experienced firsthand the determination of both Basques and Catalans to spill their blood in defense of their distinctive identities. These persistent separatist tendencies were the object of *El Caudillo's* constant preoccupation, all the more so because of the dangerous example which they posed to other regions. The Francoist state, with its endless stream of propaganda for the ideal of national unity and its internal warfare against dissident elements, bore a striking resemblance to the Spain of the 1400s. Even the preoccupation with purity of blood that had induced Ferdinand and Isabella to expel Jews and Muslims from their territory found an echo in the frequent references to the homogeneity and integrity of the Spanish people.

The absorption of Francoist Spain with bygone glories was still more evident in its commitment to the chauvinistic and military spirit of the six-

teenth century. The era of Philip II (1556–98) was perceived as a Golden Age when Europe stood in awe of that monarch's grand strategies and unbeatable armies. Then as now, the country was hated by its neighbors, but in those days it was feared. The regular evocation of famous generals, dazzling victories, and ruthless campaigns reinforced the ego of an army that accomplished little and frightened no one outside of its own borders. The Franco regime, unconsciously or not, modeled itself on the authoritarian dictatorship of King Philip whose absorption in the minute details of government gave him total control over every aspect of national policy. Like the self-righteous monarch, Franco made a virtue of the arrogant exclusivism that set him apart from his contemporaries among chiefs of state. More ominously for the country, he paralleled the so-called "Prudent King" in his neglect of both industrial development and agricultural modernization. The rulers of Spain in its Golden Age had run Spain deeply into debt to finance their wars of imperialism, and in the process had let the national infrastructure and the fundamental economy decay. Franco, with much less justification, had allowed a similar deterioration throughout much of his reign.

If the rhetoric of the Franco era reflected the grandeur of a long-vanished Golden Age, the special status of the Catholic church in this era gave it some of the vigor and self confidence that had characterized Counter-Reformation Catholicism. The church in Spain was unapologetically committed to traditional values and practices. Just as their predecessors had made no accommodation with Protestantism, the members of the Spanish hierarchy were aggressively antimodern. Modernism comprised not merely the conventional heresies associated with Darwin, Marx, and Freud, but a whole range of secular attitudes and lax disciplines that had crept into Catholicism itself in other parts of the world. As much a dimension of the state as it had been in the seventeenth century, the Spanish Church exercised wide influence in matters of public morality, literary and artistic censorship, and the educational process. It was especially charged with preserving the structure and sanctity of the family, and its interpretation of woman's role in society emphasized her subordination to a patriarchal system in all aspects of private and public life.

In selecting the various historical guises in which it preferred to manifest itself, the Franco regime chose to ignore the eighteenth-century Bourbon dabbling in enlightened despotism, and to reflect instead their more consistent opposition to the Enlightenment. Like the Spanish censors of the 1790s who had sought to keep all news of the French Revolution out ot their country, Franco's advisers feared the forces of nationalism and liberalism unleashed by the *philosophes* and their successors.

Like the French dynasts who learned nothing and forgot nothing, the Franco dictatorship chose to ignore the disasters that befell Spain as it lost the greater part of its colonial empire in the 1820s and its most significant remnants in 1898. Down to the very end of his life, *El Caudillo* clung to the fragments of Spain's African dominion. The fantasy of Spain as a nineteenth-century colonial power, on a par with France and Britain, was no more than that. She had been despised then for her tyranny, her retention of slavery, and her sheer ineptitude in management. Long before the catastrophe of the Spanish-American War, she had been dismissed as a great power and thrust out of the mainstream of international relations. Yet the Franco regime continued to pose as a serious participant in the great affairs of the day, just as the floundering administrators of a hundred years before had deluded themselves with images of greatness.

Even in the context of the twentieth century, the Spain of Francisco Franco exhibited an air of outdated irrelevance. It was arrayed in the trappings of Fascism, a political philosophy whose chief exemplars were dead and gone by 1945. Lacking the brutal efficiency of Nazi Germany, and even the bravura showmanship of Mussolini's Italy, Franco's Spain could display little of Fascism's political heritage beyond a confused attempt at corporate ideology and a murderous employment of police tactics in which the Spanish security forces needed little instruction from outside practitioners. Although despised by many for his links to the fallen dictators of World War II, Franco was adroit enough to take advantage of the constant preoccupation with the possibility of World War III. Like many pseudofascist rulers, he presented his anticommunist credentials as a justification for internal repression and a basis for American patronage. The United States's desire for Cold War allies permitted the Franco regime to emerge from its pariah status and to gain a certain measure of international respectability and financial stability. Nonetheless, the persistence of the Falangist panoply, even to the last, lent the Spain of the 1970's the character of a living museum in which even the contemporary artifacts seemed the products of a bygone era.[2]

Among all the archaic, frightening, or simply outlandish institutions and attitudes that constituted the legacy of Francisco Franco, one, in particular, offered more than mere curiosity value. It offered, in fact, what many would come to perceive as Spain's greatest hope for survival and revival. This was the plan for succession laid down by *El Caudillo* himself and carried through perhaps more by a reflexive act of obedience to the dead dictator than by a sense of genuine commitment to his plan. With the accession of Prince Juan Carlos to the vacant throne of Spain, the nation was given

an opportunity to make a peaceful and positive transition. Was this a genuine gift from Franco, demonstrating his fundamental patriotism or a cruel posthumous jest? The Spaniards would soon have to decide the answer to this question.

El Caudillo Is Dead, Long Live the King!: Juan Carlos and the Constitution

Almost without exception, foreign commentators predicted a power struggle, probably escalating to armed violence, when Francisco Franco's long final illness came to an end on November 20, 1975. They failed to understand the degree to which the groundwork had been laid for a peaceful transition. Although officially banned, opposition parties had not only maintained their underground existence during *El Caudillo's* rule, but, in fact, escalated their activity as his time drew to its obvious close. Alliances had been forged among seemingly incongrous groups. As early as July, 1974, the *Junta Democrática* had brought together the Communist Party, the Labor Party, the Socialist Popular Party, the Socialist Alliance, and the Liberal Right and the Liberal Monarchists. This "Democratic Front" was balanced by a *Plataforma de Convergencia Democrática* ("Platform of Democratic Convergence) formed some months later, which comprised Christian Democrats and Social Democrats as well as various regionalists and "monarchist" groups, in addition to the Socialist Workers Party (*Partido Socialista Obrero Español* or PSOE) and some other factions of the extreme Left. Moreover, nearly a month before the dictator's death, all of these clandestine organizations agreed upon a joint manifesto in which they laid down their common objectives for post-Franco Spain. These included amnesty for political exiles and release of political prisoners as well as a recognition of the legitimate aspirations of regional groups and local interests. Most important of all, these parties committed themselves to a plan for democratic evolution that would culminate in a new constitution and a new direction for the Spanish people.[3]

But it was Franco himself who had made it possible for all of these ideologues to accomplish more than the striking of political postures. The Law of Succession that he had laid down operated smoothly and efficiently through a meeting of the *Cortes* at which the President of the Council of State proclaimed the accession of Prince Juan Carlos to Spain's long-vacant throne as King Juan Carlos I. By restoring the monarchy from the half-life in which it had remained since the fall of the Republic in 1939, Franco had himself assured a succession that could command the tolerance if not the enthusiastic support of the broadest possible range of Spaniards.

The young king immediately displayed his understanding of the delicate balance necessary in the period of transition. Although taking an oath of office that pledged to maintain the principles of government laid down under the Franco regime, he chose the most moderate of three candidates for Prime Minister submitted to him by the Council of State: Carlos Arias Navarro. The latter, while a veteran of the late regime, in turn appointed a cabinet that included reform-minded figures. These subtle signals of an openness to change were aimed at offering hope to progressives without exciting a panicky reaction among the old guard. The problems of the Arias Navarro administration would arise largely from overeagerness on the part of reformers, who wished to rush ahead recklessly into the kind of drastic changes that traditionalists were not yet ready to accept.

By March 1976, the government was confronted by a united opposition bloc of political activists as well as street demonstrations that mobilized workers and students. The king, striving to legitimize his ministers' program of reform, announced that priority would be given to amnesty to political prisoners and validation of political parties while warning against the dangers of radical violence. His assurances eased tensions, and the promised legitimization of political organizations came during the spring, followed by an amnesty that summer.[4]

The transitional task of Arias Navarro was now over. The king replaced him in the summer of 1976 with Adolfo Suárez, whom he considered better suited to the vigorous pursuit of a reform program. While visiting the United States for its bicentennial celebrations, Juan Carlos affirmed to a joint session of Congress his commitment to a new birth of democracy in Spain, thus speaking more boldly abroad than he had so far ventured to do at home.

For all his rhetoric in Washington, Juan Carlos, once back in Madrid, continued on a course of gradualism. The new Prime Minister, Suárez, was a man who, although more vigorous and enterprising than Arias Navarro, had a similar Francoist pedigree, having served as secretary of the National Movement and as a member of the old regime's legislature. On the other hand, he had for some years supported the cause of legal reform and regional rights. Once again, there was a delicate balance struck between the main political tendencies, with each side finding what it wished to find in this new leader. Suárez proved to be the ideal instrument of the royal program of measured change. Essentially conservative, he nevertheless excluded from his ministry the most reactionary elements of the past while proclaiming his commitment to a "New Monarchy" that would satisfy the legitimate expectations of Spain's people.

The essential mechanism for the transformation of the Franco state into the New Monarchy was put in place in September 1976, when the *Cortes* passed a basic law of reform by a solid majority. A new two-chamber legislature was established, comprising a 300-seat *Congreso* and an Upper House (*Senado*) that included 207 elected members and 41 senators appointed by the King.[5]

The accelerating pace of change did not go without adverse comment from politicians of the extreme right and certain factions within the military leadership, who saw their special status being eroded. Without the backing of the late dictator, however, they could not nerve themselves for a move against the evident will of their new sovereign and the popular majority that he obviously commanded. The moment for decisive action by the far Right to halt the destruction of their power base had, in truth, already passed, although they still clearly possessed the capability of making trouble.

Nothing could offer greater proof of the irreversible course of change than the legalization, in April 1977, of the Communist Party. Despite initial opposition from conservative elements in Spain, and dark warnings about Soviet influence, the self- confidence of the new Spanish leadership and the insistence of other political parties that the Communists must share in legitimization carried the day. A vital role in this re-admission of Francoism's bitterest enemy to the political community was played by Santiago Carrillo, the party secretary, who made clear his commitment to a patriotic variety of Marxism and became one of the leading exponents of the new concept of Euro-Communism. Foreign journalists, always eager to predict impending trouble, predicted that the violent antagonisms of the Civil War era would be revived when Dolores Ibarruri, the famous La Pasionaria of the 1930s, returned from decades of exile. Their expectations of excitement fell flat, however, when the venerable firebrand was marginalized with the title of Communist Party President, while the pragmatic Carrillo held to the course of modernization. Clearly, Spanish Communism was not destined to precipitate the blood bath that had so ardently been anticipated.

With the entire spectrum of Spanish politics now eligible for participation in the process, elections for a constituent *Cortes* were held in the spring of 1977. During the campaign, the communists and old-line socialists tended to cancel one another out, while the PSOE, headed by the wealthy Andalusian lawyer Felipe González, who adroitly combined dynamism and moderation, forged ahead on the political Left. The extreme Right, fragmented among discredited heirs of Falangism, lost voters to *Unión Centro Democrática,* headed by Adolfo Suárez, who emphasized fis-

cal conservatism and a commitment to the democratization policy of the New Monarchism. Once again, the predictions of doom offered by foreign journalists proved false. Despite the threats posed by rising inflation and a series of strikes and vehement protests, and despite the ever-present question of resurgent regional aspirations, the elections passed without significant violence, and Spaniards exercised their restored democratic rights responsibly.

Of the nearly 80 percent of eligible voters who chose to cast their ballots for the constituent assembly, some 34 percent supported the UCD of Suárez and 29 percent the PSOE of González, with the rest scattering their votes among the 50 other parties, large and small, that had taken the field. Essentially, Spain had achieved a near-balance between two major parties, one socialist with its base in the cities and the region of Andalucía, the other conservative, basing its support in rural areas throughout the rest of Spain. Moreover, despite their labels, neither of them was so wedded to ideology as to be incapable of cooperating on major issues of national progress. It was now possible to move ahead with reform that aimed at national development without total reconstruction of Spanish society. Nearly a year of debate, discussion, and planning followed the establishment of the constituent *Cortes,* producing by October 1978, a proposal that contained enough to satisfy most of Spain's political groups, while not entirely pleasing any of them. The proposed constitution declared Spain to be a democratic and parliamentary monarchy with a bicameral legislature comprising a chamber of deputies and a senate. It affirmed the unity of Spain and the authority of its central institutions, while recognizing the autonomous rights of thirteen regions. In December 1978, over two thirds of Spain's voters took part in a referendum on the constitutional plan, and nearly 90 percent of them voted in favor.[6] Of all the constitutions that had emerged from Spain's turbulent political history since the famous document of 1812, this was the most widely supported. Despite many apprehensions at home and abroad, the horrendous historical record of political passions, the lack of experience in democratic procedures, and the incipient threat of socioeconomic disruption, the Spanish people had cast an unambiguous vote for the New Monarchy and a new pattern of national life. Had they truly rid themselves so quickly and so easily of *El Caudillo's* legacy?

Ballots and Bullets: Defeat of the Reactionaries

For all his success in shepherding the constitution through the process of negotiation and approval, Prime Minister Suárez was still confronted by daunting problems. During 1978–79, he was faced with an inflationary process, a decline in productivity, widespread unemployment, and the

unenviable status of presiding over the "worst economy in Europe." Once again, drawing upon his skills in conciliation and collaboration, he managed to bring the opposition parties into an agreement, the Pact of Moncloa, by which they supported a program of austerity. Gradually, the rate of inflation was lowered, the decline in the value of the peseta was halted, and foreign investments began to flow into the country.

Sporadic labor unrest persisted, however. Nowhere was it more violent than in the Basque region, where the extreme nationalist terrorists who had plagued the Franco government renewed their activity. Taking advantage of socioeconomic stress to build popular support, ETA gunmen and bombers killed dozens of policemen, public officials, and innocent bystanders during this period. Still, by the end of 1979, a grant of considerable regional autonomy to the Basque and Catalan areas resulted in the victory of moderate nationalist parties and an easing of tensions. Moreover, Spain's progress in resolving both its economic and political difficulties was recognized by conditional approval of its application to enter the European Community, although a ten-year period of probationary adjustment was imposed.

Scarcely had Suárez succeeded in pacifying the autonomist demands of the Basques and Catalans, when a new source of regionalist agitation emerged in Andalucía. This southern area of the country, though lacking the linguistic and cultural distinctiveness of the northern provinces, had a character of its own, and economic problems which fueled restless demands for self-government. Throughout 1980, the PSOE under the leadership of Felipe González championed the Andalusian cause as a device for attacking and undermining the Suárez administration. With the PSOE controlling Andalucía as well as the municipal councils of all the major cities, González was increasingly well positioned to bid for the premiership.

By the beginning of 1981, Adolfo Suárez's talent in calming fears and averting crises had failed. Unemployment had surged up to 14 percent and the Basque terrorists were once again on a rampage, while moderate regionalists were abandoning their moderation. Criminal activity, quite apart from terrorism, was escalating and the liberalization of laws was being blamed by social conservatives for producing the country's ills. Rallies against the introduction of divorce intersected with strikes by the police who refused to go on patrol unless given a free hand to deal with troublemakers. Even the prime minister's initiatives in foreign policy, notably his bid to enter NATO, were denounced by the PSOE and other parties of the Left. Early in February, Suárez announced his intention to step down in favor of Leopoldo Calvo Sotelo. On February 20, this nominee, thanks to the defection of some conservatives from the coalition, failed

to obtain the majority necessary for confirmation, and a second vote to fill the premiership had to be scheduled.

On February 23, 1981, as the *Cortes* met to reassess the leadership question, and as the whole country watched the session on television, the legislative chamber was invaded by armed civil guards. The colonel commanding these military policemen announced that the meeting was suspended and that all those present would be detained at gun point pending the arrival of a "competent military authority" to take charge of the government. The people of Spain, and, indeed, the whole world, were now witnessing the spectacle of an army coup. Such an event had been predicted ever since the death of *El Caudillo*, to the point where those who warned of this danger to democracy had come to seem like boys crying wolf, and now that which had appeared to have become impossible was actually happening. The fundamental institutions of the new Spanish democracy might at any moment be riddled by bullets along with those delegates who represented the aspirations of the Spanish people.

The full extent of the military plot remained unknown, and some aspects of it have never been fully revealed. The key personality in evidence was Lieutenant General Jaime Milans del Bosch, commander of the Valencia district. He declared a state of emergency, invoking the name of the king, and began preparing his troops for a move on the capital. Other generals were either committed to follow his lead or watching sympathetically to make their own moves as circumstances developed. The situation was, in fact, quite similar to that which had prevailed in July 1936 at the beginning of the Civil War when local garrison commanders chose to either throw in their lot with the rebels or defend the republic.

It was not the republic which required defending now, but the New Monarchy, and the monarch himself came to its defense. Juan Carlos responded immediately to the coup attempt by denouncing its perpetrators and repudiating their use of his name. He called upon the entire nation to rally to the support of the Crown and the Public Peace, and displayed throughout his address a calm dignity which reassured citizens at the same time that it reproached potential mutineers. By his firm, decisive response to the incipient coup, the king deprived it of any claim to legitimacy and renewed his personal dedication to the democratic process. Confronted by this unequivocal royal disapprobation, General Milans Del Bosch ordered his troops back to their barracks, and his network of supporters relaxed their trigger fingers and slunk away. In the *Cortes*, the gunmen who had held the legislators prisoners for hours realized that they had been abandoned by their patrons and surrendered their weapons to loyal police units.

On February 27, more than three million Spaniards took to the street to demonstrate their indignant rejection of military dictatorship and their gratitude to the king for exercising his role of commander-in-chief in a constitutional and patriotic manner. When, a few days later, Calvo Sotelo was finally confirmed as prime minister, the most notable feature of his cabinet was the absence of a military man. It was no longer felt to be desirable or necessary to put a general at the head of the Defense Ministry.[7]

The conservative government had scarcely survived the crisis of February 1981 when it was subjected to a series of attacks on its foreign policy for favoring membership in NATO and on its domestic program for failing to cope with rising unemployment. Furthermore, its attempts to balance the demands of regionalists against those of "unitarians" ended by satisfying neither side, although new grants of autonomy were made to Cantabria, Castilla-la Mancha, Aragón, Valencia, Murcia, Navarra, and Canarias. Beset by policy differences and blamed for the lenient sentences given to the Civil Guard mutineers, the UCD broke up into three factions, and it became impossible to avoid a new election.[8]

On August 27, 1982, the king signed a decree dissolving the parliament. During the campaign that followed, the UCD floundered unsuccessfully in its attempts to regroup its components and forge new alliances, while the PSOE made grand promises of stimulating economic growth, reducing unemployment, and following a cautious policy with regard to NATO. The Socialist victory exceeded even their own most optimistic expectations, giving them 46 percent of the vote, while the strongest of the new right-wing groups, the Alianza Popular, secured only 25 percent and the Communists shrank to less than 4 percent. On November 26, 1982, Felipe González was chosen as prime minister, and a freely-elected socialist government was installed. Spain had completed its transition from military dictatorship to parliamentary democracy. The ghosts of the Fallen had been left behind, and the Spanish people had stepped forth from the shadow of the Valley.

2

Toward a Politics of Rational Exuberance: Political Stabilization

"Down with intelligence! Long live death!" This was the slogan with which General Millan Astray (Franco's military mentor) sent his soldiers into battle. Such an exhortation was in the long tradition of Spaniards who found no vice in extremism and no virtue in moderation. From the religious fanaticism of the Middle Ages through the racial purifications of the Golden Age to the anarchist murders of the "ruling class" at the turn of the century, Spaniards had demonstrated their exuberant allegiance to some grand vision of the world by outbursts of bloody violence. This demonization of the "other" culminated in the Civil War of 1936–39 when Spaniards slaughtered one another amidst scenes of unspeakable cruelty while invoking the sacred name of some party or region. In the aftermath of Franco's death, the Spanish people had to struggle to contain the passions that had been repressed during his dictatorship. Many on the Left hailed the electoral triumph of the socialists in 1982 as the beginning of a true revolution while those on the Right prepared to sell their lives dearly. During three successive general elections, the masses renewed the mandate given to Felipe González, still hoping that he would abolish all their troubles, while the propertied classes clung to paranoid fears. Finally, in 1996, González would be cast aside as a failed messiah and dire warnings of neofascist counter-revolution would be heard. Throughout these years, the violent rhetoric of separatism and the arrogant assertion of unity at all costs would inflame emotions and precipitate bloodshed. The survival of Spain clearly lay in a commitment to the middle way that so many other countries had already found. Spaniards had too long allowed their love for

the dramatic gesture to express itself in manic passions. Could they instead accept the restraints of rational exuberance?

Socialism Loses Its Luster: Triumph and Decline of the Left

When the socialists came to power in Spain in 1982, the more superficial foreign observers invoked images of the Civil War era and predicted that Spaniards could never confine themselves to the normal give and take of modern European politics. More perceptive commentators, however, noted the air of solemnity, of repressed excitement or grave concern that was evident everywhere in Spain. They speculated on whether this restrained response indicated the calm before a storm of political passion or a new degree of maturity among Spaniards who were prepared to give the democratic process a chance.

Certainly Felipe González seemed to possess all the qualities of a leader who could transform Spain, at long last, into a "people's paradise." Still in his early forties, brilliant and articulate, with those "charismatic" qualities that were now in demand throughout the Western world, he had vowed to cure Spain's ills and elevate her place among the nations. Yet those who paid close attention to his campaign promises had noted an emphasis on economic matters rather than social issues. Moreover, his eagerness to distance himself from the doctrinaire Marxism of the communists had raised some doubts as to just what principles his PSOE really stood for.

Once firmly in office, González proceeded to shape a program that left socialist principles sidelined, waiting for a revolution that never came. In the name of "pragmatism" he cultivated domestic industry on a firmly capitalist basis, favoring solid administrators and substantial investors while terminating state subsidies to marginal enterprises. Public agencies were privatized or sharply curtailed, and foreign partnerships were energetically promoted. The watchwords were confidence, progressivism, and development. Word went out that Spain offered a positive business climate. Money, much of it borrowed, poured into the country, and there was much talk of a "booming economy." Unemployment fell, although never as much as González had promised it would, but pockets of idleness and poverty remained, particularly in the south. Members of the working class grumbled, but were assured that the new wealth that was being generated would trickle down to them eventually.

On the international stage, where he had rapidly become a star performer, González completed negotiations for Spain's admission into the European Community (soon to be redesignated the European Union). Already by 1986, he had convinced his skeptical partners that Spain pos-

sessed the financial sinews to maintain its place among them without pursuing the economic extremism that they had all feared might emerge from his triumph. Blandly discarding his party's earlier opposition to NATO membership, he advocated full Spanish participation in that defense pact. He arranged a successful referendum in 1986 to confirm the adherence to it that had been given so tentatively five years before, but soothed nationalists by negotiating the closing of the United States' bases in Spain.[1]

Thanks to his adroit balancing of gestures that pleased both ends of the political spectrum with promises to be fulfilled at a later date, González won a fresh mandate in office and vowed to lead the country to bigger and better achievements in the 1990s. As the new decade approached, however, the prime minister's charms began to pall. The shrinking agrarian sector raised protests about official neglect, while urban industry languished, unable to sustain the rapid growth attained in the mid-1980s. Workers and intellectuals both complained about the increasing dependence of Spain on foreign cash, whether in the form of investments, European grants, or tourist expenditures. Ironically, the Right also grumbled about the way in which González had transformed Spain into a Third World country, dependent on hand-outs and tips.

The inevitable tendency of power to corrupt had by now infected the PSOE government, with graft running rampant. The blessings of a free press so longed for by the Left in the days of Franco, now brought down upon the heads of socialist ministers a stream of investigative reports and revelations of fraud. The end of censorship in all its forms had also unleashed a stream of pornography and a general tolerance for vice that scandalized the puritanical survivors of the old regime. For them, González had proved less of a Stalin than a Caligula, turning their beloved country into a cesspool of depravity.

Workers might complain with increasing bitterness over their blighted dreams, conservatives might rant against the corrupt permissiveness of the socialist bureaucrats, yet the most ominous development came from the ranks of Spanish youth, who were increasingly turning their backs on the political process. All over the country, groups of young people could be seen lounging about, idle and indifferent. These *pasotas* were often equated with the American hippies of the 1960s, but they lacked the idealism and community spirit that so often redeemed the negative characteristics of the earlier youth movement. In truth, these *pasotas* represented no movement at all, but a cynical rejection of what they saw as a treacherous, self-indulgent clique of political opportunists. Like the betrayed workers, these youths sneered at the transformation of González's party activists into bourgeois,

newly rich office holders. Like the discontented Rightists, they derided the vulgar permissiveness that had allowed them to strike their cynical posture. The increasing nihilism evident among this sector of the population boded ill for the future.[2]

Shaken by the elections of 1993, González seemed unable to regain his political balance. A flare-up in Basque terrorism, fresh scandals at the highest level of his administration, and incipient stagnation in the economy deprived him of what was left of his majority. In March 1996, his government gave up its struggle, and the erstwhile messiah yielded to a far less charismatic rival.[3]

The Aznar Approach: Conservatives in Power

José María Aznar was, indeed, almost the exact opposite of his predecessor. His roots lay in the right-wing politics of the late Franco years. His philosophy, both personal and public, was conservative. His appearance, rhetoric, and personal life were undramatic, to say the least (and saying the least was what he preferred in most cases).[4] Yet his opposition to the socialism of González had been neither vehement nor dogmatic. His ties with the Franco regime had not compromised him irredeemably nor was his conservatism of the most reactionary stripe. His low-key approach to issues offered little excitement, but suggested a better likelihood of attaining modest goals than the flamboyant oratory of the socialist leader. For many Spaniards, the time had come to substitute pragmatism for promises.[5]

During his first year in office, despite increasing difficulties with his coalition partners, the Catalan regionalists, Aznar could claim positive achievements, particularly in the area of economic stabilization and financial security. Privatization, pursued at a steady—but hardly threatening—pace, seemed to be working after the false starts of earlier days. The Prime Minister's mantra, repeated on every occasion, at home and abroad, was "Spain is doing well." The colorlessness and restraint of his slogan provoked amusement, but its fundamental truth could not be denied. It embodied the rational exuberance that Spain had so long needed in order to make steady progress. By mid-1997, however, signs of strain had become evident. The ongoing investigation of ethical lapses and possible criminal misdeeds under the previous administration was poisoning parliamentary life. While some of Aznar's supporters undoubtedly sought partisan gain from the revelation of Socialist malfeasance, the government had a clear responsibility to carry out investigation and prosecution when the law had been violated. Yet the PSOE felt persecuted, and Felipe González, eluding any personal blame for his ministers' transgressions, became more bitter and uncooperative than ever. A novel barometer of Spain's political tempera-

ture was now available in the popular television program "The Puppet News." Beginning in the latter days of the González regime, it had frequently lampooned the incumbent prime minister as a boastful figure in Superman costume or a sinister Mafia boss giving orders for the elimination of rivals. By the spring of 1997, the Aznar administration had become the prime target. This tremendously popular show, modeled on similar satirical productions in Britain and France, drew a huge audience for its 5-night-a-week perspective on current events. The 40-odd latex puppets included painfully accurate caricatures of the prime minister, his wife, and many of his cabinet members. (The king was omitted, the director said, less from respect than because he "didn't make much news.") Aznar, although presented as a lumpish and dreary character, evidently inspired a certain affection among viewers, and he himself registered no public complaint about being ridiculed. Some of his ministers, on the other hand, were less comfortable with freewheeling satire in an open democracy. The secretary general of the ruling Popular Party, for example, asserted that the program was aimed at weakening support for his party and promoting an alternative political agenda. The conservative newspaper *ABC* went so far as to accuse the program of being "Socialist propaganda" aimed at presenting all conservative politicians as "fools and illiterates." It even suggested a program of "counter-puppets" to restore objectivity. What was heartening about all this was the evidence that, despite a somewhat deficient sense of humor, the conservatives were prepared to respond to buffoonery with something other than violence.[6]

During the latter part of 1997 and throughout the following year, problems and distractions mounted for the Aznar administration. These ranged from setbacks in economic and financial progress to an environmental disaster in the spring of 1998, when a major spill of toxic waste in the south precipitated rage and finger pointing. Foreign relations problems included difficulties in sustaining Spain's participation in Balkan peacekeeping and a flare-up of the old Gibraltar quarrel with Britain. Under these circumstances, Aznar welcomed the opportunity to invoke a mood of positive and inspirational nostalgia by commemorating the twentieth anniversary of Spain's Constitution in December 1998. Speakers and writers hailed the spirit of those strenuous but constructive political dialogues that achieved a peaceful transition from Francoism to democracy. There, they asserted, lay the model for a healthy political interplay, in which consensus and compromise maintained a rational and positive environment. Citizens were encouraged to visit the legislative chamber in which the foundations of the new Spain had been hammered out, to sit in the seats occupied by their elected representatives, and to gaze at those bullet scars on the ceiling made

by the military renegades of 1981. If all the arguments and all the violence that Spain had survived for the last two decades were capable of being overcome, these visitors were told, then so, too, were the setbacks of today. Newspapers approvingly quoted a venerable survivor of the Civil War and Franco's prisons, who declared himself happy to see the final triumph of true liberty in his country.[7]

As the century drew toward its end, Spain stepped boldly forward into the new environment of "Euroland." Despite the hard work that had been necessary to meet the European Union's rigorous standards, she was one of the 11 countries to adopt the Euro as the official unit of currency in January 1999, anticipating the elimination of the peseta. For a nation that had been a virtual outcast only three decades before, Spain had come a long way.

At the same moment that he was presiding over these formalities, the prime minister, in his characteristically "hermitlike" manner, was planning a reconstruction of his administration. Perhaps moved by the fact that all the European Union governments except those of Spain and Ireland were in the hands of socialists, he had determined upon a move to the political center. At the end of January 1999, Aznar shuffled his cabinet and the leadership of his Popular Party, bringing a number of prominent moderates into key positions. He explained this unanticipated "voyage to the center" as necessary to consolidate votes and to adapt his party to new times. He declared: "*Ya no somos lo que éramos*"—We are no longer what we used to be.[8]

For all his skill in reinventing himself and his party, for all his good fortune in surviving political storms and smoothing troubled waters, Aznar had still to confront the fundamental problem that had vexed Spanish politics for generations. Long before Franco launched his "crusade," long after he went to his grave, and persisting through every political regime and philosophy that tried to govern Spain, the question of national unity remained unresolved. Would Spain, in the new millenium, be one country or a collection of "little fatherlands?"

The Patria Chica Problem: Regionalism

Politically fragmented throughout the Middle Ages, Spain was among the first of the European nation-states to transform itself into a centralized monarchy. Centuries before the Germans and the Italians emerged from the fractured environment of "particularism" or regionalism, the Spanish sovereigns had integrated the dominions of Castile and Aragón into a functioning unity. Yet a strong sense of loyalty to, and identification with, the "little fatherland" persisted through the centuries. In the case of Cataluña

this manifested itself in several revolts and a persistent exaltation of cultural nationality. As for the Basques, they continued to assert the special claims arising from a unique linguistic heritage. Even after the traditional 7 Basque provinces were divided between Spain and France, the phrase *Zaspiak Bat* (literally "Seven One") emphasized a national spirit transcending arbitrary frontiers.

The exigencies of the Civil War led both sides to yield ground on the supposedly settled question of local rights. Separate administrations were recognized in the Basque and Catalan regions by the Republic, while Franco's "Crusade" rewarded the Carlist militia of Navarra with a lesser degree of autonomy. After 1939, *El Caudillo* placed the strongest emphasis upon national unity, ruling through provincial bureaucracies that, as the saying had it, scarcely dared repair a hole in the road without approval from Madrid.[9]

This was the historical background against which the *Patria Chica* problem of the post-Franco era surged up as the most inflammatory political issue confronting the Spanish people. The whole course of the country's modern history had presumed unification at the expense of regionalism. Assertions of distinctive local identities had been condemned as reactionary, unpatriotic, or downright revolutionary. Aside from a brief flowering in the northern parts of Spain between 1936 and 1939, regionalism had been harshly repressed. As is so often the case in politics, however, denial and demonization bred resistance. Regionalism, denied a moderate outlet, festered into radical "state's rights" agitation. In the case of Cataluña, it sparked a militant separatism, and in that of the Basque provinces, it precipitated a nationalist terrorism.[10]

To be sure, late twentieth-century Spain was not unique in experiencing the disruptive forces of political miniaturization. Reversing the flow of modern European history, many nations have undertaken to devolve political and economic power to a greater or lesser degree. Germany, never truly unified except during the years of Hitler's dictatorship, has reestablished its federal structure. Italy, united after generations of national aspiration, has created regional legislatures and continues to deal with a strong separatist movement in its northern districts. Even France, like Spain consolidated by the end of the Middle Ages, has conceded a modicum of local autonomy and wrestles with the ongoing activism of Breton and Corsican nationalists. Russia's federal label is flouted by ethnic rebels in half a dozen "republics." Britain, after trying for nearly 500 years to integrate the peoples of the "Celtic Fringe," has conceded a Scottish parliament and a Welsh assembly, as well as trying to resolve the perennial Irish Question by sponsoring a "council of the Isles." In this context, Spain's regionalism

appears far from eccentric. It has, however, generated an often irrational emotionalism and a disruptive violence that poses a special threat to the fragile political democracy of the post-Franco period.

Those who set about framing the constitution during the period 1975—78 understood quite clearly that the question of regional autonomy was one of the most critical issues facing the new Spain. Basque nationalists had been carrying on a terror campaign for more than a decade, displaying an increasing sophistication in technique and ruthlessness in tactics. The 1973 assassination of Admiral Luis Carrero Blanco, who ranked second only to Franco in the regime, was merely the most spectacular of many blows struck by ETA (*Euskadi ta Askatasuna* or "Basque Homeland and Liberty"). If further terroristic acts by this group and imitative violence by other regionalist organizations were to be avoided, it was necessary to address the *Patria Chica* problem in a decisive way within the fundamental document that would henceforth guide Spanish political life. As finally presented to the Spanish electorate in December 1978, the constitution proclaimed the unity of the Spanish nation. Its wording unambiguously stated that the central government retained authority over law and justice throughout the entire country. It declared that separatist movements were illegal. However, the new constitution also recognized administrative autonomy in 13 designated regions. These regions (later increased to 17) included not only the most persistent and militant claimants to self rule, but also a number of areas where less strident allegations of a "special character" had been raised. The majority of these autonomous units had, in fact, no particular history of traditional sovereignty or recent aspirations to special status. Some commentators saw the constitutional recognition of regional authority in this form as an attempt to blur the distinctions between full-fledged separatism and a preference for local management of day-to-day business. These critics suggested that the constitution was merely aimed at rearranging the provinces that had existed under Franco's regime and trivializing the Basque and Catalan demands by putting them on a par with areas that had never done or said anything to show a desire for autonomy. As one observer phrased it, "When everybody is somebody, then nobody is anybody."[11]

In the debates immediately preceding and following the adoption of the constitution, the matter of regional autonomy assumed a centrality and intensity that would persist for the next two decades. Conservative legislators inveighed against any use of the term "nationalities" on the ground that it contradicted the fundamental requirements of Spanish unity. Members of the *Partido Nacionalista Vasco* (PNV) protested that the constitution did not recognize a fundamental Basque sovereignty that lay in the

hisitoric identity of *Euskadi*. With passion ranging from ferocity to mere crankiness, spokesmen for half a dozen other regions added their criticisms and expectations to the ongoing argument.

During 1980, with relaltively moderate parties controlling the Basque and Catalan regional legislatures, the demands of Andalucia occupied center stage. Despite the belated and, some felt, rather fanciful claims of this southern region, the support that they received from the PSOE under Felipe González made the future of Andalucía seem almost as urgent a problem as that of the northern nationalities. The exhaustion of Adolfo Suarez's resources in managing this controversy and the seeming threat of national dissolution helped provoke the Civil Guard mutiny of 1981 and the threat of a military coup that lay behind it. With that danger passed, thanks largely to the king's intervention, the accession of González in 1982 seemed to promise a new era of enhanced regionalism.

The long tenure in office of Felipe González gave satisfaction, as it turned out, only to the most easily satisfied advocates of autonomy. Despite the prime minister's earlier exploitation of local discontent, he showed himself less sympathetic to the principle of regionalism than he had been when leading the opposition. Andalucía did, indeed, secure some enhancement of its self-government rights, justified on the basis of its distressed agrarian economy. A few other regions, by taking the path of negotiation and compromise, also improved their position *vis-à -vis* the central administration, even if only marginally. But González, despite conciliatory gestures, could not satisfy the perennial reminders launched at him from Barcelona that the Catalan people were "a special case." Their regional government, the *Generalitat,* could be counted upon to hold the line against extremism, and only an occasional outburst of political violence from small radical factions hinted at the potential of nationalism too long denied.

It was the Basque provinces that gave the most grief to the González regime, just as they had to all those which preceded it. A seemingly endless cycle of violence, compared by foreign observers to the contemporary "troubles" in Northern Ireland, dragged on through the 80's and into the 90's. The same pattern of abortive initiatives, broken cease-fires, and failed compromises led journalists to draw parallels to a "United Kingdom" waging war on "terrorists" who thought of themselves as "freedom fighters." Extreme Basque nationalists, far from rejecting this image, freely proclaimed solidarity with the Irish Republican Army and occasionally exchanged ideas and equipment with it. Like its opposite number in London, the Madrid government found itself increasingly tempted to fight fire with fire. As the total of bombings and shootings by Basque extremists grew, antiterrorist measures were intensified. Police powers dating

back to the Franco days were revived, and the limits placed on arbitrary arrests, abuse of prisoners, and other draconian measures during the late 1970s were suspended. The very rationale of political terrorism lay in its ability to undercut and ultimately destroy the democratic institutions of a liberal state. In Spain, where these institutions were so new and so fragile, the danger to constitutional law was particularly grave. Prime Minister González's subordinates, with or without his knowledge, frequently resorted to drastic and even illegal methods in combating ETA. Assassination by police agents was sometimes directed not only at leaders of this terrorist organization but at its civilian sympathizers or "innocent bystanders." Ultimately such tactics, amounting to the conduct of a low-level civil war in Spain, could well have proved fatal to the survival of the constitutional monarchy. As it was, the revelation of misdeeds by some of González's highest-ranking colleagues, and his own refusal to come to terms with the cancer eating away at the body politic, forced him out of office in 1996. Despite all his positive achievements and international approval, he had joined the list of victims of "victims." Whether slain in the streets of Bilbao or politically annihilated in the halls of parliament, more and more Spaniards were perishing every year in the struggle over regionalism.

The premiership of José María Aznar, despite positive signs at its commencement, has failed to escape the dilemma of its predecessor. The Catalan leader Jordi Pujol was drawn into an alliance with Aznar's government, while most of the other regional champions were won over to a policy of restraint. Even the Basques, after a particularly outrageous series of assassinations, in which popular politicians were cut down merely for expressing moderate opinions, were obliged by massive public protests to call a halt to violence. Yet, as the twentieth anniversary of the constitution approached, the whole issue of unity versus regionalism flared up again. In the summer of 1998, Pujol held a meeting with "nationalist" leaders from the Basque Provinces and Galicia. They issued the so-called "Declaration of Barcelona" in which the three regions demanded a revision or "revised understanding," of the constitution so as to recognize the principle of *plurinacionalidad*. While Aznar struggled to contain this new disruption, parliamentary spokesmen for the PSOE demanded clarification of just what the declaration signified. Clearly, although González himself had played the regional card before leading his socialists to power, he now wished to present himself as the champion of unity and portray Aznar as weak on the regional question. Vexed by these criticisms and by Pujol 's persistent ambivalence and exasperated by the opportunistic emergence of Galician claims, Aznar was most troubled by the persistent undercurrent of Basque extremism. While ETA agreed to a cease-fire in September 1998, dissident

nationalists continued to issue provocative statements or even indulge in isolated acts of violence.[12]

By March 1999, Aznar was convinced that ETA was merely laying the groundwork for a new onslaught. During a visit to Paris, he persuaded French authorities to crack down on Spanish Basque leaders living within their territory. Although occasional sweeps had been made in earlier years, the French were generally reluctant to stir up trouble among their own Basque citizens by taking harsh action against exiles from south of the Pyrenees. On this occasion, however, the French arrested the leader of ETA's military wing, Javier Arizcuren-Ruiz (also known as Kantauri) and 5 of his associates. French police declared that all 6 were armed when taken into custody and maintained that they had been under surveillance for some time in the various French towns where they resided. "Kantauri," under investigation for 18 murders, was also said to have planned an abortive 1995 assassination plot that targeted King Juan Carlos and his family[13]. Speaking after a luncheon with the president of France, Aznar declared that these arrests represented "the success of Franco Spanish cooperation in the fight against terrorism." Aznar followed up on this French initiative by repeating his willingness to extend the temporary cease-fire into a permanent halt in hostilities as long as it was understood that there could be no compromise on the question of Spanish national unity. Aznar ignored the outcry over the arrest of the 6 militants and went on to introduce a piece of legislation that offered increased indemnity to victims and survivors of Basque terrorism. The official records listed 800 dead and 3,000 wounded since 1968, and although some payments had been made to victims or their families by earlier government initiatives, the April 1999 bill considerably increased the amount of compensation to a total of $272 million. Thus Aznar sought to negate socialist attacks on his alleged weakness at the same time that he showed a humanitarian and conciliatory approach to the undeclared civil war.[14]

There can be no doubt that the *Patria Chica* problem has spun out of control during the post-Franco period. For the Basques and Catalans, abused and oppressed under the dictatorship, an excess of passion might be understood, if not excused. As for most of the other claimants to special privileges or "recognition of national identity," their pretensions were more disruptive than legitimate. It has been suggested that a hierarchy of claims might be established in order to separate plausible issues of regional concern from mere frivolous posturing. Thus, the linguistic peculiarities of Galicia and the economic difficulties of Andalucía might merit them a status slightly lower in the range of autonomy than Cataluña and the Basque Provinces, but above the recognition accorded to Navarra, Valencia,

the Balearics and the Canary Islands (which can claim distinctive histori-
cal or geographical characteristics), the remaining 9 regions have little
valid basis for enhanced autonomy. Such relativistic regionalism, however,
while attempting to combine the principles of merit and need, risks pro-
voking jealousy. Even regions that have shown little interest in special sta-
tus and remained content under a unitary government might become
aggressively competitive if ranked low in the pecking order of prestige or
perquisites. All efforts to rearrange the parameters of regional privilege seem
likely to provoke increased rather than diminished resentment, and at the
end of the day, the intractable claims of Cataluña and the Basque home-
land defy simple solution. Without these two regions in contention, it
might be possible to simply abolish the regions, except in some bland
touristic sense, and proclaim total unity once and for all. But no such
option can now be considered seriously.

For many Spaniards, section 8 or the constitution opened a lamenta-
ble Pandora's box by reviving regional claims that had been suppressed for
centuries. For others, such as Jordi Pujol, the Catalan leader, the
Constitution "*no abre la puerta al reconocimiento de la plurinacionalidad
del Estado.*" In other words, it is either too permissive or not permissive
enough. The political commentator Alejandro Muñoz-Alonso, writing in
the newspaper *ABC,* has tried to resolve this contradiction by declaring
"*seamos serios.*" He reminds us that Pujol avowed himself quite happy with
the Constitution in 1978, based upon the model of Italian regional auton-
omy, as a sufficient guarantee of Catalan distinctiveness. Although the past
20 years have, in fact, seen Cataluña go far beyond those modest privileges,
Pujol nevertheless now raises new and unrealistic expectations. Muñoz-
Alonso insists that it is what unites Spain that is important, not the recog-
nition of "plurinacionalidad." In his view, the *aspectos heterogeneos* that Pujol
wants emphasized in the constitution must be subordinated to the *aspec-
tos de homogeneidad.* This homogeneity is a concern that must preoccupy
all serious rational people amidst the cacophony of political debate[15]. The
philosopher-sociologist Julián Marías has denounced as "absurd" the
nationalist interpretation given to the constitutional concept of the *estado
de las autonomías.* He warns that Spain is not a plurinational state, but a
unique nation with regions that possess distinctive personalities that each
contributes as valuable members of the Spanish whole. He warns against a
tendency to tribalism that is destructive both to its individual enthusiasts
and to the country as a whole. Marías says that when a region "*se encastil-
la en sí misma, se mira al ombligo y se aisla, se empobrece*" ("when a region
locks itself away in an ivory tower, it passes the time contemplating its own
navel, and by isolating itself, becomes impoverished"). Marías calls the

nationalist interpretation of the *Estado autonómico* absurd because it extends the idea of cultural distinctiveness beyond rational limits. He stigmatizes the Barcelona Declaration in which Basque, Catalan and Galician nationalist parties insist upon the juridic and political recognition of the *"realidades nacionales"* of the three regions as a "tremendous blunder." He says it is a contradiction of reality, and reality is "what the world must respect above all other things."[16]

Can the nationalist enthusiasms and the ideological passions unchained by the demise of Francoism be restrained by rational, realistic considerations? In the Valley of the Fallen the fortieth anniversary of the basilica's opening was marked by a bomb explosion near *El Caudillo's* tomb. Police attributed the incident to a small Marxist guerrilla band called the *October 1st Anti Fascist Resistance Group*. This was, perhaps, the beginning of a new round of political violence emerging from the embers of extremism. Or, perhaps, it was an isolated reminder of the danger of irrational exuberance.[17]

Scepter, Sword, Crozier: Institutions

The foundation of the Spanish nation state that emerged from the Middle Ages rested upon three institutions: the monarchy, the army, and the church. The sovereign was not merely the symbolic, but the effective head of the nation. The army maintained and extended its boundaries. The church legitimized its actions and sanctified its mission. As the concept of a Catholic world empire that had inspired and perpetuated Spain's global outreach faded during the nineteenth century, the validity of these institutions and the respect that they commanded from the people of Spain diminished. Mediocre monarchs, failing generals, and a self-absorbed clergy contributed to the malaise that afflicted the state. After a century that included republican revolutions, colonial disasters and civil wars, Spaniards under Franco felt themselves oppressed by these institutions rather than sustained by them. In the aftermath of the dictatorship, the political and social future of the nation would once again be determined by the relationship that evolved among king, soldiers, priests and citizens.

Yo, el Rey: Monarchy

As he sailed into exile in 1952, Farouk of Egypt predicted "soon there will be only five kings left in the world: the four in the deck of cards and the King of England." In some respects, the last of the pharaohs has proved a shrewd prophet. The British sovereign (the very one who came to the throne that same year) is still in place. A dozen dynasties have come tumbling down in Asia, Africa, and the Middle East during the last half of the twentieth century. To be sure, the institution of monarchy has achieved

a certain stability in Europe. After the fall of 4 emperors and a score of German petty potentates at the end of the First World War, and the ouster of half a dozen kings following the Second World War, only Greece has bidden a final farewell to its ruler in recent decades. But the surviving European monarchs are essentially figureheads, preserved as much for their touristic value as for any useful purpose.

What sets the Spanish monarchy apart is its unique position as a political institution re-created in the very epoch when thrones were being toppled or their occupants trivialized. Furthermore, far from being a marginal figure, the king of Spain is, both personally and institutionally, a vital force in the functioning of the State.

The Spanish monarchy, it must be remembered, has gone through more ups and downs than most before arriving at its present position. The great rulers of the Golden Age created modern Spain and ruled with absolute power. When Felipe II wrote not his name but the proud inscription *Yo, el Rey* at the foot of decrees, he embodied not merely his own personal authority but the supreme and enduring character of kingship. "I, the King" was a phrase reflecting the perpetual centrality of the monarch in the Spanish realms. By the time the present dynasty arrived in Madrid at the beginning of the eighteenth century, Spain's great days had passed, and lesser demands soon begat lesser rulers. The first of the Spanish Bourbons, Felipe V, deteriorated mentally and often took to his bed, lying with arms crossed on his chest. To the requests of ministers for his royal signature, he responded: "Go away! Can't you see that I'm dead?"[1] This image prefigures the conduct of his successors over the next 200 years. With few exceptions, they manifested a political ineffectuality that amply justified their people's ongoing search for alternate institutions. Spain experimented with military dictatorship, revolutionary republics and even rival dynasties. That they kept coming back to the Bourbons had less to do with loyalty than with frustration.

Against this background, the 10-year hiatus between the end of the Civil War and Franco's decision to re-assert Spain's monarchical identity was understandable. The Spanish state that he had founded rested upon the defeat of republicans and radicals, but not all of his conservative supporters favored the return of the Bourbons. Even those who avowed themselves monarchists were divided between adherents of the Carlist line of pretenders and those who recognized the count of Barcelona as King Juan III following the death of his father, Alfonso XIII, in 1941. Indeed, Don Juan, as he was usually called, had accompanied his father into exile in 1931, reached his maturity in England, and was regarded by many monarchists as tainted with liberalism. For these monarchists, the question

of restoration was best left in abeyance. Well understanding how these divisions weakened the monarchist cause, Franco in 1949 recognized the throne without designating its occupant.

The Law of Succession confirmed that Spain was a monarchy, with Franco as regent, and gave him the right to designate his successor as head of state. He then proposed to Don Juan that his sons, Juan Carlos and Alfonso, be educated in Spain, as befitted princes of the royal family. Don Juan was reluctant to hand over their upbringing to *El Caudillo* but realized that children born in Italy and resident in Portugal needed to establish roots in Spain if dynastic claims were to be taken seriously.

When Juan Carlos and his brother (who died not long after) traveled to Madrid, the question of succession was transformed into a 25-year-long game in which Franco assured his continuance in power by playing off father against son, liberals against conservatives, clericals against Falangists, and monarchists against republicans. For a time, he even encouraged speculation that he would found his own dynasty by arranging the marriage of his granddaughter to a rival prince. In the meantime, Juan Carlos, who had been born on January 5, 1938, in Rome, the son of the Count of Barcelona and a princess of the Neapolitan Bourbon line, was passing rhrough a series of schools under the oversight of "governors" designated by *El Caudillo*. He spent two years at the military academy, and one year each in at its naval and air force equivalents, receiving commissions in all three branches. He then passed through a course of study at the University of Madrid designed by eminent academics, who served as his private tutors, guaranteeing that he would not actually mix with his fellow students. In addition, he spent at least a month in each of the ministries, learning the principles and mechanics of government at the hands-on level. Throughout this period, he was carefully supervised by the regime and presented to the public in tightly controlled circumstances. His increasing isolation from his father was emphasized by his official designation as "Prince of Spain" rather than "Prince of Asturias" (the traditional title of the heir to the throne). Although Juan Carlos evidently chose his own bride, his marriage to Princess Sofia of Greece in 1962 clearly required the approval of the head of state as well as the head of the family. Juan Carlos became a *pater familias* himself with the birth of Elena in 1963, Cristina in 1965, and Felipe in 1968. But until almost the last moment of Franco's life, the future of the Bourbon dynasty remained in doubt.[2]

Despite all the intrigue and rumors that had surrounded the future of the Spanish Monarchy during the previous three decades, the accession of King Juan Carlos I in 1975 passed off with a smoothness and lack of drama that surprised much of the world. Long accustomed to keeping his

own counsel and appearing to be all things to all parties, the new sovereign moved with a mixture of tact and firmness to assure his position. His father and those who still clung to the claims of dynastic proprieties were reconciled to the way that the facts of life had emerged. The Carlist pretender, Prince Carlos Hugo, was induced to abandon the by-now tenuous claims that his branch of the House had pressed since the 1830s. With the army and church prepared to support order during the period of transition, the Falangists accepted the inevitable and were gradually defanged. The new constitution of 1978 secured the king's position as the centerpiece of a democratic monarchy, and his perceived role in halting the military coup of 1981 secured his position in the minds and hearts of all but the most skeptical.

What sort of monarchy has evolved in Spain during the decades since this Second Restoration of the Bourbons? The king, of course, has set the tone, and if he were to be characterized by a descriptive phrase it might be that applied to one of his remote predecessors, *El Prudente,* "The Prudent One." Even his name, with its unprecedented use of a double designation, avoids the question of his father's claim to be Juan III and the assertions of various pretenders to be Carlos V, VI, or VII. As Juan Carlos I he represents a discrete combination of originality and tradition. The king is a serious and sober figure. Although he is known to be a hearty and sociable individual among friends, his public image is one of unsmiling dignity. A devoted driver of fast cars and boats, he avoids being photographed in the risk-ridden settings that evoke memories of numerous fatal accidents among members of his family. He makes the expected visits to military and industrial facilities (not an onerous chore, for he is an enthusiast of technology), but he leaves the patronage of charities and cultural institutions to his consort, understanding that in Spain some things are still perceived as masculine concerns and others as "women's work." He advises, and even occasionally warns, political and military leaders, drawing upon his steadily growing fund of experience, without visibly overstepping the bounds of his position. He instinctively rejects the temptation to live in the grand style and has chosen the small (some would even say cramped) palace of *La Zarzuela* on the outskirts of Madrid as his customary home rather than the grander precincts of the Oriente Palace in the city, which is reserved for special occasions. A vacation home in Mallorca and a lodge in the Pyrenees for skiing trips complete the roster of royal residences. All in all, the king and his family cost their country less than virtually any other dynasty in contemporary Europe.[3]

Unlike the extended and scandal-plagued House of Windsor, the most visible collection of "royals" during this period, the Bourbons of Spain are

relatively few in number and orderly in their private lives. Aside from a few members of the older generation who remain discretely in the background, the public has had to deal with a king and queen who seem to understand the proper balance between dignity and remoteness and three children who appear perfectly "healthy" and normal. It must be admitted that the Spanish media have, except for occasional aberrations, been far more restrained in their treatment of the king and his family than have their opposite numbers in Britain. During 1989–1992 the alleged romance between Felipe, Prince of Asturias, and a young Spanish gentlewoman was followed with much enthusiasm by the media (perhaps contributing to the end of the relationship), and one newspaper even hinted at a friendship between Juan Carlos and a Swiss lady. The later 1990s, however, have been characterized by a return to restraint and a respectful acceptance of the fact that the royal couple are about as close as anyone in their position can be expected to be. Their daughters are making them grandparents, always a source of further respect in Spain. Princess Elena married Jaime de Marechalar, now duque de Lugo, a Spaniard of aristocratic lineage, and the lively Princess Cristina chose Iñaki Urdangarín, a Basque sportsman, who has been named duque de Palma de Mallorca. Prince Felipe, whose earlier run-in with reporters made him somewhat hostile to the media, has once again been singled out for attention over a supposed friendship with a lady of noble Spanish-German background. As the heir apparent whose marriage plans, or lack of them, bear directly on the hereditary succession and the future of the monarchy, the Prince of Asturias is likely to remain in the spotlight to the extent that unseemly instrument is allowed to focus on the House of Bourbon.[4]

Despite the desire of Juan Carlos to be a prudent king, even at the risk of appearing overly discrete or even colorless, there are those in Spain who suspect him of ulterior motives. Some irreconcilable souls on the left believe that his modesty of manner and respect for democracy amount to nothing more than a screen for authoritarian ambitions. It has even been whispered that the military intrigue of 1981 was actually carried out with the king's blessing, and was only halted by him when it began to fall apart due to the incompetence of its leaders.[5] Such a theory, if backed by real evidence, would undercut the whole basis of public support for the monarchy. Public opinion polls have shown that a large majority of Spaniards believe that Juan Carlos is a firm supporter of democracy and that he saved the country from a slide back into Francoism in 1981. Should the idea of a once and future conspiracy involving the king with reactionary elements ever be proven, or even gain wide acceptance, the future of the Bourbons would be perilous indeed. Barring such an unlikely shift in public opinion,

Spain's democratic monarchy shows every likelihood of remaining a solid, essential, pillar of the state.

Ghosts of the Alcázar: Army

In the heartland of Castilla, on a hill overlooking Toledo, stands the Alcázar. This massive citadel, half fortress, half palace, was defended by a few hundred rebel soldiers during the early days of the Civil War against forces loyal to the Republic. The besieging "Reds" sought to force surrender by threatening to kill the captive son of Colonel Moscardó, commander of the Alcázar. To authenticate their threat, they put young Luis on the telephone, so that he could speak to his father. When the youth said that he would be shot unless the citadel was yielded, the colonel responded: "If it be true, commend your soul to God, shout *Viva España* and die like a hero. Goodbye my son, a last kiss." Luis replied: "Goodbye father, a very big kiss." When the Loyalist militia leader came back on the line, Moscardó told him: "The Alcazar will never surrender" and hung up[6]. This incident, endlessly retold, contains elements dear to the heart of the Spanish officer corps. There is the warmth of family feeling, outweighed by patriotic commitment, the courageous embrace of martyrdom, the touch of fanatic defiance, and above all, a preoccupation with honor, which must be preserved, no matter what the cost.

The history of the Spanish Army is filled with moments of high honor, bound up both with military glory and painful reversals. The great days of the all-conquering *tercios* had come to an end with the French victory at Rocroi in 1643, but the sons of Spain had soldiered on around the world until the French had once again routed them in 1808. Napoleon's invasion in that year, however, had led to the birth of a new Spanish army drawn from the most disparate sources and committed to the liberation of their country in six years of desperate struggle. The nineteenth century officer corps, the heterogeneous product of this war, became a socially and politically autonomous group. It owed its primary allegiance to its own interests, which on occasion even superseded the oath to uphold the monarch. Although professing their dedication to national unity and traditional institutions, the officers increasingly came to interpret honor in the context of corporate perquisites.

The loss of most of Spain's overseas possessions, culminating in defeat by the United States in 1898, produced a curious fatalism and reduced the warrior instinct to an almost ritualistic preoccupation with form. The surrender of San Juan, Puerto Rico, and Santiago, Cuba, as well as that of Manila in the Philippines, all took place after token resistance to preserve

the fiction of honor in the reality of failure. The aftermath of the Spanish-American War (which had the advantage of eliminating the navy, once and for all, as a potential rival), the officer corps continued to pursue its grand vision of itself.

Although Spain was kept out of the First World War by competing pro-British and pro-German factions, the army was heavily engaged in Morocco. Here, in 1921, it suffered a catastrophic defeat at the hands of indigenous rebels. The local commander, General Silvestre, although realizing that he had overextended his campaign in the area around Anual, yielded to his superiors' repeated calls upon his military honor and pursued operations beyond any hope of success. In the end, he redeemed himself by dying by his own hand. His soldiers, however, died at the hands of enraged Berbers, with as many as 8,000 shot and hacked to death as they fled in panic through the desert. When a parliamentary inquiry into the origins of the Anual affair impinged too severely upon the army's honor, the charismatic General Primo de Rivera took power in 1923 and, enjoying the king's backing, ruled as dictator for the next 7 years.[7]

So thoroughly had the officer corps transformed itself into a distinct institution, answerable to no particular party or faction, that it allowed the monarchy to be replaced by a republic in 1931 without lifting a finger to protect Alfonso XIII. It was not until the new regime began implementing drastic cuts in the grossly inflated upper levels of the Army (which had 1 general for every 300 enlisted men), that the army turned hostile to the Republic. Had the reformers not attempted to reduce the bloated military hierarchy, the officers would presumably have found service to the new order to be perfectly consistent with their oath to the old. By 1932, military honor had been so affronted that an abortive plot was hatched to overthrow the Republic; it laid the groundwork for the uprising of 1936.[8]

From the siege of the Alcazar to the final victory three years later, the "crusade" carried on by General Franco and his associates was declared repeatedly to be a struggle for God and Fatherland against the iniquitous forces of Bolshevism. Despite this rhetoric, the Spanish officer corps was animated throughout the Civil War by a sense of offended honor and disrupted privilege. Certainly most officers shared the values of the conservative elements in society and opposed concessions made to regionalism. Yet neither Crown nor Church motivated them as much as the need to protect themselves against unrestrained reformism.

The Spanish army emerged from the Civil War with more combat experience than any but the most fanatical lover of bloodshed could have wished. It was, at least, spared the new horrors of the Second World War

which began almost immediately, though some infantry and air units served in Russia as a token of gratitude from Franco to Hitler. From 1945 to 1975 Spanish soldiers saw little active service beyond the Foreign Legion's skirmishes with Moroccan tribesmen. For the officer corps, the period of Franco's rule was a golden age of corporate prosperity rather than military achievement. They were rewarded for their commitment to *El Caudillo* by lavish bestowals of promotions and perquisites. Thousands of cadets, taken on during 1936–39 were given permanent commissions, swelling the corps to unprecedented size. Serving officers occupied the armed forces ministries and many civilian departments as well. Once a young man graduated from the military academy at Zaragoza, he was guaranteed virtual lifetime employment with regular promotion and a clearly defined career track. Pay, especially at the higher ranks, was generous, and benefits, such as special housing, elite schooling, and lavishly appointed clubhouses were additional marks of favor. In a country where the absence of a functioning monarchy had dimmed the prestige of aristocratic titles and capitalist magnates were relatively few, the officer corps enjoyed an unusual level of prestige. Coupled with their political influence and the absence of public criticism, their position made them the strongest pillar of the state. Puffed up with pride, they equated advantage with honor, looking upon themselves as the only true guarantors of national unity. Taking their disproportionate share of the military budget for granted as the rightful due of the country's warrior nobility, they gave little thought to the deterioration of the army's fighting capacity. The swollen ranks of the officer corps meant that only a few enlisted men could be kept under arms. Stocks of weapons deteriorated without proper maintenance; equipment left over from the Civil War became increasingly obsolescent, and acquisition of new technology was impossible. Exclusion from both the Soviet and the democratic camps in Europe during the Cold War added to Spain's military isolation. The bruised ego of the officer corps was somewhat soothed, to be sure, by the patronage of the United States, which was more tolerant than Europe of Franco's fascist affiliations. American naval and air bases were established in Spain and some only moderately outmoded planes and vessels were handed over. Despite these modest gains, the country remained essentially a third-class military power, having more in common with Latin American dictatorships than with modern European nations.[9]

With the death of Franco came a flood of change. The Suárez administration, despite the general perception that it would be timid about challenging the Army's privileges, succeeded in persuading a few intelligent generals that the true path of honor lay in a commitment to professionalism and modernization. It gave its full backing to a series of reforms that

facilitated the retirement of senior officers and instituted a rational plan for recruitment and promotion. The first steps were taken towards improving the proportions and capacities of the armed forces. The officer corps seemed overwhelmed by the pace and extent of these innovations, although somewhat reassured by the new King's supposed sympathy with their interests.

The constitution of 1978, particularly in title 8, specified the status and mission of the armed forces in the post-Franco epoch. The armed forces, it declared, consist of *el Ejercito de Tierra, la Armada y el Ejercito del Aire.* Their collective responsibilities were "to guarantee the sovereignty and independence of Spain and to defend its territorial integrity and the constitutional order." Thus, the army was not singled out for a special status but simply treated as one branch of the armed forces. Its duties were limited to those traditionally undertaken by the military services of democratic countries. There was no recognition of any special role in defending national unity or dignity. The officer corps could not help but feel a certain uneasiness over other constitutional provisions regarding the rights of individuals to organize, petition, and even refuse military service altogether. The implications for maintenance of discipline, to say nothing of an adequate flow of conscripts, were serious. Furthermore, serving officers were excluded from parliament, and, by extension, from government offices, while the absolute superiority of the civilian government over the armed forces was clearly laid down. There was some consolation, to be sure, in the specification of the king's role as commander-in-chief and in the detailed provisions for suspending civil law in the face of terrorism and national emergencies. All in all, the constitution, to the extent that it stood unchallenged, effected a profound change in the self-image of the army.[10]

It was not until 1981 that those who feared and resented the diminution of the army's position struck back. Whatever the intricacies of his relationship with senior commanders may have been, the king emerged from the attempted *coup* as the defender of democracy and the man who persuaded the generals to respect the constitution. Once this crisis was past, reform could continue, even to the point of creating a unified ministry of defense under a civilian politician, replacing the separate ministries of army, navy and air force. The González administration, by securing Spain's admission into NATO, made the military subject to salutary criticism from their new partners and facilitated the steady upgrading of their technical capacities. There is no doubt that the scathing reviews to which the Spanish defense apparatus was subjected were painful. The army, it was pointed out, was five times the size of either the navy or air force (each of which had about 40,000 men), yet was itself too small for the functions of national securi-

ty. Arms and equipment were so far from being state-of-the-art as to be pathetic. Generals and colonels clogged the corridors of command without performing any useful service. Subjected to the clear cold light of assessment by their professional peers, Spanish officers were forced to acknowledge that massive improvements were necessary. They became, for the most part, willing collaborators in the ongoing process of transformation.[11]

By the opening phase of the Gulf War in 1990, much had already been accomplished. Perhaps more important than the organizational and physical reconstruction of the Spanish military was the openness with which its activities were discussed. Politicians, press and public all felt free to express opinions—sometimes admiring, sometimes amused—about the performance of the small naval contingent sent to the Middle East. Spain had already participated in a number of United Nations peacekeeping operations, including missions in Namibia, Angola, Haiti, and Central America before it undertook a supporting role in the former Yugoslavia. Spanish troops carried out significant assignments in Bosnia during the later 1990s as part of the international stabilizing force.[12]

During the NATO air war against Yugoslavia in 1999, the Spanish air force made a token contribution of 6 planes to the campaign. In the NATO occupation of Kosovo that followed the Serbian retreat, Spain was assigned the district around Istog (in the Italian zone), and some 1,200 troops were in position by July 1999[13]. Ironically, these soldiers, who were welcomed with cheers and flowers by the local population, were drawn from the fourth *Tercio* of the *Legión Española*, the same Spanish Foreign Legion that had once been the terror of North Africa and the nucleus of Franco's 1936 insurrection. These one-time "Bridegrooms of Death" were now called upon to be angels of mercy.

Most commentators agree that the Spanish army (followed dutifully by the other services) has made remarkable progress in the transition from what it was under the Franco regime. Although much remains to be done, its integration into NATO has led to modernization of both materiel and mentality. The relative speed and comparative ease with which the army has moved away from its former condition is, perhaps, more understandable if one recollects that Spanish officers were a privileged body, but not truly a power-wielding group under Franco. The political authority remained in the hands of the Falangist Party but more particularly in Franco himself. As both a soldier and a politician, he understood how to exploit both institutions without ever surrendering his ultimate control. What the officer corps enjoyed under Franco was precisely what it had sought throughout its modern existence: recognition of its dignity and practical benefits for its

members. It is to be hoped that the Spanish Army at the end of the twentieth century has accepted the idea that honor can repose in a mixture of professionalism and patriotism by which the soldier protects the state without dictating to it. Once this realization has permeated the military mind, the ghosts of the Alcázar will no longer haunt the public life of Spain.

Acts of Faith: Church

In a small town not far from Madrid, a man is building a cathedral. Once a monk, he was separated from his monastery after developing tuberculosis and sent home to die. But he lived and for more than thirty years has been demonstrating his gratitude to God by constructing a place of worship—not merely a chapel or church, but a lofty structure whose towers rise above the fields left to him by his father. Unlike the cathedral builders of the Middle Ages, he is a self-taught artisan who copies his designs from books and magazines and has only casual assistance from local boys or occasional volunteers. Catholic authorities do not know what to make of him, or his enterprise.

Over the centuries Catholicism has often had difficulty in understanding the Spanish mind. Although some historians insist upon the Catholic essence of Spain, holding that religious impulses are an integral part of the national character, the leadership of the Universal Church has frequently found Spaniards to be baffling or embarrassing. Their tendency to extremism, to passionate piety or rage, a fanaticism that can degenerate into rabid anticlericalism, has some times seemed more pagan than Christian.

Unlike such medieval societies as those of France, England, and Germany, where the hierarchy championed papal authority against the crown, Spain preempted religion as the justification for its wars of unity. The *Cruzada,* which culminated in the conquest of the Muslims and the expulsion of the Jews in 1492, was paralleled by the creation of the Inquisition as an instrument of royal power. The ongoing purgation of alien elements and the ruthless extirpation of Protestant ideas during the 1500s likewise represented the exercise of secular power rather than the triumph of clerical influence. Even the role of Spain as "Sword of the Counter-Reformation" and its evangelization of the Americas were manifestations of royal policy as much as demonstrations of religious zeal. Priests who spoke out in favor of the Amerindians or criticized the government in Spain were silenced, and the popes of the sixteenth century found themselves reduced to virtual puppets of the Spanish Habsburgs. The Concordat wrung from Valencia-born Pope Alexander VI in the 1480s and the *Patronato* that conceded Spain control of New World missions a few years later effectively sidelined the papacy. In effect, the Spanish Catholic church

was coopted at the beginning of the early modern period as an instrument of royal control. It became, along with the monarchy and the army, one of the pillars of the state, but held its position at the sufferance of the others.[14]

During the seventeenth and eighteenth centuries, as Rome disentangled itself from its obligations to Spain and adapted itself to changing global circumstances, the Spanish church became more than ever a preeminently national agency, co-operating with, and endorsing, the state. In the turmoil of the Napoleonic invasion and its aftermath, the church emerged as a champion of the most reactionary political doctrines and suffered the consequences when the Liberals gained control after the First Carlist War. In 1837 the Spanish Catholic church was stripped of its privileges and despoiled of its landed property. Even the reversal of fortune that came later in the nineteenth century failed to make up for its loss of material possessions, which could not be restored after being sold off to bourgeois proprietors. The clergy were compensated with an annual stipend and the cash settlement made to the Church as a whole transformed the bishops into money managers in a capitalist environment. Thus, the Spanish church at the beginning of the twentieth century was obliged to the state for the salaries of its priests and to the financial magnates for the continuing profitability of its stock portfolio. Whatever might have been the individual sentiments of Spanish clergymen, they were generally regarded as friends of the ruling classes. Moreover, with the rise of radicalism in its various forms, they were perceived as the enemies of the people. Although many priests and even some bishops were prepared to coexist with the Republic during the early 1930s, there was a widespread presumption that the Church was fundamentally disloyal to the new order.[15]

When the army rebels challenged the republic in the summer of 1936, its self-appointed defenders formed workers' militias which launched a campaign of terror against supposed allies of the military. Twelve bishops, 283 nuns, 5,255 priests, 2,492 monks and 249 novices were killed, often in circumstances of barbarous humiliation and cruelty. Hundreds of churches, convents and other ecclesiastical buildings were burned or ransacked while others were turned into militia barracks. Libraries, manuscript collections, and religious artifacts were frequently committed to the flames by furious proletarians who forbade mere looting and insisted on total annihilation. These horrors inevitably drove many of the clergy into alliance with the Francoists, though in some areas, such as the Basque provinces, the people remained loyal to the priests and the priests remained loyal to the Republic. Abroad, Catholics were aghast at the atrocities inflicted upon their co-religionists, and prelates denounced the abominations being visited upon the faithful. The Vatican, which had frequently been exasperated with

the reactionary remarks flowing from the Spanish hierarchy in recent decades, could scarcely fail to join in the condemnation. The "Martyrdom of Catholic Spain" became a preoccupation of the papacy during the next several years, and it was felt necessary to excuse or ignore the barbarous behavior of nationalist forces and its approval by certain Spanish clerics.[16]

During the Civil War political and social antagonisms that had built up over many generations exploded in a fury of slaughter and destruction. Although the word "Catholic" was frequently employed as a badge of honor or an epithet of loathing, the institutional church had, in fact, scarcely any part in the ghastly violence that swept the country. It is evident that the crimes committed by both sides had little to do with faith. Instead, they were motivated by the rage of the disadvantaged against the advantaged, of the privileged against the unprivileged. The worst sin of the Church had been opportunism. Having accepted the status of pillar of the state forced upon it by the secular powers, and having cut itself off from the modernizing tendencies of twentieth-century Catholicism, the Spanish church had accepted the role of accomplice in the process of corruption that led to 1936. It was, in truth, a bystander—though, perhaps, a guilty bystander.

During the 10 years that encompassed the Civil War and the Second World War, the leadership of the church in Spain became thoroughly identified with the regime of Francisco Franco. It experienced both the benefits of official status as the "Established Church" and the hostility which such a position generated. While many Spaniards filled the pews and flocked to the seminaries out of genuine fervor or perceived advantage, others were confirmed in their bitter resentment or contemptuous indifference. The emergence of the Cold War gave both Franco and his clerical sympathizers a new legitimacy in the eyes of the world. Spain, proclaiming itself solidly anti-Communist and staunchly Catholic, was accepted by the United States and its allies as a bastion of stability in a troubled Europe, despite the bad odor that still lingered about the dictatorship. The Vatican, as ever ambivalent about a nation that pretended to be more Catholic than the pope, nevertheless had to accept the survival of the Faith in Iberia under such conditions as part of God's plan.

In these circumstances, Franco and Pope Pius XII concluded a concordat in 1953 that affirmed the dictator's effective control over the appointment of bishops. In return, the Church was granted a long list of privileges. While Franco had renewed the payment of stipends to the clergy and funded the reconstruction of churches in the immediate aftermath of the Civil War, he now committed generous additional sums to the building and embellishment of ecclesiastical structures and the conduct of religious

activities. The Church was exempted from taxation. Catholic universities were assisted, and instruction in the Catholic religion was made mandatory in the elementary schools. The Church was given de facto control over censorship of the media, while receiving exemption from scrutiny of its own publications and radio broadcasts. The police were obliged to yield control to the local bishop in criminal cases where a clergyman was involved. Only marriages performed by a priest were recognized as valid for persons baptized as Catholics, and laws already passed by Franco forbidding contraception and divorce were confirmed.[17]

During the 1960s, the reforms spurred by the Second Vatican Council caused problems both for the Spanish hierarchy's relationship with Rome and for the firmness of its control over its own flock. The Spanish church began to be seen once again as out of step with the rest of Christendom, and voices of criticism were increasingly raised among both laity and clergy. These dissenters within the Spanish church were often identified with the political factions that sought to position themselves for the post-Franco era. Hard-liners, who would no more yield on traditional points of dogma than they would accept any weakening of *El Caudillo*'s authoritarian system, were opposed by a rising generation, who felt that Spain's Catholic heritage must be renewed and re-interpreted if the Faith were to play any part in the transformation that had to follow the death of the chief of state.[18]

As King Juan Carlos and his ministers guided the nation through the early months of the post-Franco era, the church, like the army, watched and waited to learn how its position as pillar of the state would be affected by the change in regime. Foreign observers, and even many closer to the immediate process, could scarcely believe that these privileged bodies would accept such a substantial diminution of their status. Yet, in the event, the hierarchy submitted even more tamely than the military leadership to the new order. This was not surprising for those who understood the true condition of Spanish Catholicism, whose advantaged role had always been tied to the sufferance of the ruler. Unlike the army, whose *pronunciamientos* had at least the potential of violence to support them, the bishops' fulminations had no real force beyond what the government chose to give them.

As the framing of the Constitution proceeded during 1977, the church's agents learned that it was proposed to utterly ignore the special role of Catholicism that had been enshrined in Franco's legislation. Far from being recognized as the official religion of the country, it would be entirely omitted from mention in the Constitution. The bishops pressed vigorously for acknowledgment in the forthcoming fundamental law, and the final text did contain a minimal reference, whose perfunctory phrasing was small compensation for the prelates' efforts. The Constitution states flatly

that Spain has no established religion, but adds that "the authorities shall take into account the beliefs of Spanish society and maintain the appropriate relations of cooperation with the Catholic Church and the other denominations." After 500 years, this was all that the law allowed to soothe the wounded pride of Spanish Catholicism.[19]

What were these "other denominations" with which the Church was now placed on a footing of mere equality? Although the number of religious believers other than Catholic tripled during the first decade of the post-Franco period, it still totaled less than 1.5% of the population. In addition to a handful of Protestants (disproportionately numerous in Cataluña), there were 15,000 Jews and some 200,000 Muslims (most of both groups being immigrants from Morocco). Spain is thus still and overwhelmingly a "Catholic" country. But how many members of this nominal majority are actively Catholic? By the usual measurement of observance, less than half are "practicing" members of the faith. During the 1980s, the number attending Mass at least one a month dropped from 53 percent to 43 percent and appears to have dropped even lower during the past decade. Sacramental and religious practice was lowest among the affluent and the young. Only half of student-age Spaniards considered themselves "religious" in surveys during the 1990s. Deprived by changing laws of its ability to censor morals and regulate conduct, the church found itself surrounded by a "sea of pornography" and immorality. Without the special powers hitherto assigned to it, the hierarchy was in danger of being marginalized as Spaniards enjoyed new freedoms. Sermons directed against "licentious behavior" and "alien values" increasingly fell on deaf ears.[20]

As late twentieth-century Spain moved into the market place of ideas, the hitherto insulated Church found itself obliged to compete for the attention of a flock that had always been restless if not rebellious, but now threatened to simply drift into indifference. Some Catholic thinkers advocated a populist outreach. Well back into the middle years of the Franco regime there had been advocates of an approach that embraced the proletariat and emphasized the human face of Christianity. Spain, like other countries of Western Europe, had seen experiments with "worker priests" who had lived among the laboring class in an attempt to bond with them. Such endeavors, as had been the case in other countries, had excited the suspicion of conservatives and achieved only limited success. Still, Spain's rank-and-file clergy had always been drawn primarily from the lower social orders, and even in the worst of times individual priests who avoided subservience to the ruling elites had been able to maintain the respect and affection of their parishioners. This residual good will had not disappeared entirely, even during the period when the prelates had fraternized so blatantly with dictatorship.

A distinctly different approach was taken by supporters of *Opus Dei*. This organization was founded in 1928 by a Spanish priest, Monsignor Josemaría Escrivá de Balaguer. Between the publication in 1939 of his most celebrated work, *Camino*, and his death in 1975, the organization had gained some 70,000 members in over 70 countries. A religious order of unusual structure, *Opus Dei* ("Work of God") consists of several categories of membership. Only about 2% are ordained priests and many in the lower echelons are ranked as mere supporters or "cooperators." It is the class of "numeraries" that attracts the most attention. These are men and women vowed to poverty, chastity, and obedience who live in communal residences and practice certain personal devotions and disciplines. Unlike traditional monks and nuns, however, they dress in ordinary civilian clothing and spend their days in a wide variety of secular jobs. In Spain, they are usually graduates of a network of *Opus Dei*-operated schools and possess advanced adademic credentials. They have penetrated into the governmental and business leadership of the country, although perhaps more successfully during the Franco regime (when they held five cabinet posts and dozens of university chairs) than lately. Because one is never quite sure whether or not the executive or official with whom one is dealing is a member of *Opus Dei*, they have been compared to Freemasons or various secret societies past and present. The worldwide Church is far from uniform in its reaction to *Opus Dei*. While the papacy has favored it in recent decades (Monsignor Escrivá was raised to the honors of the altar within an unprecedented eighteen years of his death), liberal Catholics have criticized its "reactionary" tendencies, its clandestine procedures, and even the alleged personal flaws of its founder. Ironically, the Jesuits (also a product of Spanish ingenuity at their beginning) are among the strongest opponents of this new order, although they have been criticized over the centuries for the same sort of devious practices and political intrigues. In Spain, *Opus Dei* denies that it has sought to perpetuate the spirit of Francoism in the post-Franco era. While undoubtedly conservative in their general inclination, its members seem to favor an accelerated modernization of the Spanish economy. Their sympathy with industrial capitalism has enabled them to work comfortably with the governments of both Left and Right. Furthermore, they have combined a continuing appeal to elite elements in society with an adaptability to the outward forms of democracy. Some shrewd commentators believe that *Opus Dei* is neither as menacing nor as innocuous as it may seem to uninformed observers.[21]

At the beginning of a new millennium, Spain is still officially 99% Catholic. Statistically, the church is still a solid pillar of the state. But to

gauge its true solidity, one must look beyond the factional maneuvers of Jesuits and "numeraries," cardinals and "worker priests." One must become aware of the complex mosaic of a constantly changing religious environment. Choosing pieces at random, that mosaic includes the ardent paraders during Holy Week in Seville and Cádiz; the last three surviving nuns being sent away from a convent in Espinosa de Henares, which their bishop has closed for lack of new vocations; the *alcalde* of the venerable pilgrim city of Santiago de Compostela offering public prayers for the cessation of terrorism and invoking the name of the king's infant grandson, Felipe Juan Froilán, the last being the name of Galicia's patron saint and local hero; hundreds of new converts to Jehovah's Witnesses being baptized by total immersion in stadiums from Madrid to Barcelona, the latest of more than 100,000 who have chosen this new faith in recent years; thousands of Spanish gypsies traveling to Rome to cheer as the Pope canonizes Ceferino Jiménez Malla, a gypsy who protected his parish priest and suffered martyrdom during the Civil War.[22]

In the midst of all this, a village Quijote labors on building his cathedral. The infirmities of age make his labor more difficult, he says, but he presses on with his work, for the glory of God. Perhaps it is upon individuals like him that the church's foundation rests most securely, because in his obstinacy he is more Spanish than Catholic.

The Running of the Bulls: The Economy

Over the past 500 years Spain has gone from the vast wealth of its Imperial Age to the penury of the early twentieth century, when a handful of magnates presided over a nation of degraded peasants and exploited laborers. Emerging from the deepest gloom after midcentury, the country has experienced a series of booms followed by jarring reversals of fortune. Although successive governments have boasted of "modernization" and predicted prosperity, the economic indicators have remained questionable. Indeed, the Spanish economy reminds one less of the optimistic "bulls" of Wall Street than the bulls that charge down Pamplona's *Calle Estafeta* during the annual festival of San Fermín. Crowds of half crazed enthusiasts run along with them, frequently being trampled or gored amidst the wild cheers of the onlookers. Intoxicated, delirious from lack of sleep, ravaged by pickpockets and muggers, the revelers disperse after a week, poorer but no wiser. Just so, far too many Spaniards have been caught by promoters and fantasies of easy riches, only to find themselves robbed of any lasting reward. In the end, the best gauge of Spain's economic prospects in the third Millennium may lie in her ability to marshal those natural and human resources in which the true wealth of a nation resides.

Gloom and Boom: Budgetary Problems

An eighteenth century English traveler in Spain, brooding upon the condition of the country, quoted Shakespeare: "Is all thy greatness shrunk to this little measure?"[1] In the day when the Bard had penned those words, England was fighting for its life against the seemingly overwhelm-

ing wealth and power of Spain. Within two hundred years, however, she had declined so far as to be an object of pity to one of her hereditary enemies. The gold and silver of the Indies had been mortgaged away to finance failed wars in Europe, and domestic industry had been allowed to languish while the puny shadow-kings of the later Habsburg dynasty had plunged the nation ever deeper into debt. Virtually all manufactured goods had to be imported, and those that were sent on to America were so marked up in price that the colonists preferred to deal directly with the manufacturers through smuggling. Overseas revenues shriveled as steadily as did overseas loyalties, and the Mother Country withered while her restless children prospered amidst dreams of revolution. The new Bourbon dynasty attempted economic reform, developing a mine here and importing a foreign expert there, but these efforts were too little and too late. After another hundred years had passed, scarred by the final loss of the Americas, ruinous wars and political blunders, Spain had sunk to an undreamt off depth. One commentator described the country as no more than a few oases rising from a desert.[2] In the north, outposts of industry had been established around Barcelona and Bilbao. In the center, where once vast herds of sheep had roamed the plains of Castilla, Madrid rose in the midst of a wasteland. In the south, peasants toiled for masters in an agrarian regime as backward as it was brutal.

By the eve of the Civil War, the poverty of the masses and the benighted arrogance of both factory owners and landlords had bred a deep class hatred that had festered for centuries before the successors of Marx had appeared to hand out labels like socialism and anarchism.

After three years of manic self-laceration, an exhausted Spain had nothing to show for its settling of scores beyond more ruins and 100,000 corpses. When the outside world next turned its gaze upon the country, following the distraction of a wider and bloodier war, it was not to exhibit compassion or offer assistance. Spain had not been a partner of the victorious Allies and could hope for no share in the reconstruction funds of the Marshall Plan. Unlike defeated Germany and Italy, which were rehabilitated and revived by the victors, neutral Spain qualified for nothing but contempt. Her "Fascist" government was denounced in the United Nations and excluded from membership, while a moral and material boycott against her was imposed. Franco's Spain was proclaimed a pariah and left to stagnate in the gloom of abandonment.

Far from being chastened by international condemnation, the Falangist ideologues saw their country's situation as a splendid opportunity to validate their theories of economic autonomy. Spain, in their view, would be a self-sustaining agrarian state, proud, if poor, in its righteousness. Their

experiment was a disastrous failure. Even after United Nations sanctions were lifted in the 1950's, the national economy continued to decline. The agrarian sector, supposedly the foundation of national policy, deteriorated from even the low level of productivity it had reached at the end of the Civil War. Incapable of attaining significant export earnings—and sometimes incapable of feeding themselves—farmers began leaving the land and drifting into the cities. There they found neither employment nor adequate public assistance. Soon the long-established slums were extended by erection of crude shanties in which the new urban poor swarmed in squalid hopelessness. These displaced peasants could not convert themselves into factory workers in an environment of industrial primitivism, in which obsessive protectionism, oppressive regulation, and a shortage of capital for modernization of plants left Spanish businessmen trapped in commercial circumstances that were already obsolete at the turn of the century.[3]

By the late 1950s, with foreign exchange reserves vanishing, inflation soaring, and discontent swelling among workers and students, Franco was ready to replace his failed Falangist doctrinaires with technocrats who brought to key economic ministries not only expertise but the spiritual motivation of *Opus Dei*. This religious movement saw the growth of material prosperity, particularly in the industrial sector, as an avenue to salvation rather than socialism. They believed that a population that was both productive and well rewarded for its productivity would become more, rather than less, Catholic. As the new decade began, the technocrats instituted a stabilization program that combined cutting government expenditures and curbing inflation with a risky program of austerity that deprived the masses of what little benefit they derived from the existing system. In a pattern that would become all too familiar in many parts of the world during the remainder of the century, citizens were asked to "bite the bullet" and "tighten the belt" in order to achieve an ultimate improvement in their lives. Many workers could not wait out this new experiment and chose to seek employment abroad, from where their remittances began to make an impact on the languishing economy. So, too, did the heavy foreign investments that Spain now encouraged, as it swept away Falangist restrictions on trade and bureaucratic impediments to the influx of capital.

These economic reforms saved the Franco regime. Between 1961 and 1973, the so-called *años de desarrollo* (years of development), the country enjoyed a growth cycle that had everything to do with the creation of wealth and nothing to do with democracy. No one could deny the impressiveness of Franco's achievement. Spain reached a remarkable growth rate of 7 percent per annum, attaining it more rapidly than any postwar country except Japan. Per-capita income doubled, then doubled again, until it had

reached the $500.00 level by 1964, officially moving Spain out of the classification of "developing" (i.e., Third World) nation. These "miraculous" years saw Spain reach the rank of ninth among the world's industrial producers, after a generation of manufacturing virtually nothing. To be sure, *El Caudillo*'s role had been essentially that of a manager replacing failing players with new talent, but in a dictatorship consistent support from the top is essential, and even his harshest critics could not deny him a share of the credit for what the new team had achieved.[4]

The boom years were even more impressive for their impact on Spanish standard of living. Health and nutrition levels rose dramatically, along with standards of sanitation and medical care. Housing stock increased in availability and quality, ownership of domestic appliances grew as more money flowed into the pockets of the working class, and amenities hitherto reserved only to the wealthy, such as telephones and automobiles, became commonplace. If the goal of *Opus Dei*-inspired administrators had been to win the support of the masses for the current leadership by gratifying their material aspirations, that goal had certainly been attained.

But Spain's economic boom, like Franco himself, was living on borrowed time. The "miracle" would not have been possible, despite the ingenuity of the technocrats and the hard work of the proletariat, had not Western Europe as a whole been experiencing a general boom. Money had become available in northern Europe for investments, holidaymaking, and development loans precisely when Spain was positioned to take advantage of these opportunities. Moreover, the expansion of trans-Pyrenean economies had created a demand for Spanish "guest workers" whose earnings, sent back to the mother country, helped significantly in balancing Spain's trade deficit. Spain had come very far indeed during the 1960s, escaping from the stigma of "non-European" economic backwardness, yet she still stood on the lowest rung of the Continent's economic ladder. When the general downturn came in the early 1970s, the external conditions that had facilitated her success no longer existed, and Spain's own particular boom quickly collapsed. The gloom surrounding Franco's death in late 1975 was not simply the result of official mourning. It gripped the Spanish people with regard to their economic future. Democracy might now be entering by one door; was prosperity leaving by another?

Democracy arrived, and—to the surprise of many—triumphed. The establishment of the constitutional monarchy in place of the dictatorship, the prolonged debated over the constitution itself, the arguments about regionalism, and the failed military coup of 1981 absorbed the public attention during the years immediately following Franco's death. Inevitably, the downturn resulting from external economic factors was also a major

topic of political tension. The rise in unemployment and the widespread decline in living standards that soured the upbeat mood of the late 1970s could not be ignored. Yet Prime Minister Suárez and his rivals managed to stave off both economic and political catastrophe. Since none of them could offer a fully worked out plan, they relied on smoke and mirrors to persuade the public that all would be well. Structural tinkering and temporary expedience kept the country afloat economically during this crucial time of transition. In 1982, with the worst of the constitutional conflicts settled, Spanish voters gave the socialists a mandate to bring back the boom times.[5]

Keeping Up Appearances: Pursuit of Affluence

The results of the parliamentary election that brought Felipe González and his Socialist Party to power in 1982 were awaited with great eagerness and celebrated with tremendous joy throughout Spain. Even those who had voted for the defeated conservatives or the remnants of the ultra-Left were excited by the results. Spain, it was said on all sides, had achieved the final stage in its democratic process. Through a "bloodless revolution" at the ballot box, the rear guard of Francoism had been dismissed and an authentic reform government installed. One did not have to be a socialist supporter to share in a highly emotional moment of historical drama.

On a more prosaic level, those of all political persuasions who had experienced the deepening recession of the past decade, and who had realized the inability of Adolfo Suárez to do more than prop up the deteriorating economy, looked for a new departure. Whatever they thought about socialism in the abstract, they hoped that it would bring fresh ideas and fresh approaches to remedy Spain's profound problems. González had, after all, campaigned under the slogan *Cambio* meaning that "change" would be his watchword and his methodology. There was a flurry of activity as the new administration took office, with decrees issued, agencies set up or abolished, public funds pumped into lagging areas of the economy and some lowering of the unemployment level. But, as months gave way to years, the optimism and expectation began to fade. Critics on both ends of the political spectrum accused González of being more flash than substance, of making promises without delivering performance. Even the rank-and-file members of his own party were becoming disillusioned. Few of them had expected "red radicalism" to sweep across the country once their party was in power, but the leadership echelon seemed to have lost touch with the masses and to be more interested in distributing the perquisites of office than in relieving the distress of the workers. Socialist intellectuals spoke increasingly of a party that had abandoned its roots and was taking on the

airs of a bourgeois bureaucracy. "Marx has been given a shave and a hair-cut" and now moved comfortably among the gentry. He looked accept-able, acted acceptably, and accepted the values of capitalism. Not only had González failed to deliver "change" on a scale of breadth and depth that his followers had a right to expect, but he had retreated from a number of positions that he had staked out when in opposition. Once against NATO membership, he had found much to be said for it. Formerly a critic of American policy in general and American bases on Spanish soil in partic-ular, he had grown more accommodating. His loyal adherents praised him as flexible and non-doctrinaire; his detractors sneered at him as an opportunistic chameleon.[6]

This process of disillusionment reached its low point in 1986, as unem-ployment peaked at over 20 percent (up from 16% at the beginning of González's term). The policy of "industrial reconversion," that was sup-posed to eliminate unproductive (largely state-subsidized) enterprises pre-cipitated violent protests from the workers. When the steel mill at Sagunto became the scene of a bloody clash between factory hands and police, the clock seemed to be turning back, not merely to the Franco era, but to the anarchic days of the early thirties. Laid off workers, few of whom were cov-ered by any benefit plan, quickly fell into destitution. What kind of social-ist government was this?

González and his ministers had to exert all of their powers of persua-sion to convince labor leaders and business men that "austerity" was an essential preliminary to revive prosperity. It was necessary, they insisted, to prove to the European Economic Community that Spain possessed a lean, productive industrial base, free from inflationary tendencies and bloated payrolls. Once Spain had been accepted into the "club," all good things would materialize. Job security, unemployment compensation and attrib-utes of affluence enjoyed by workers in Northern Europe could be grant-ed. Reluctantly accepting this "no gain without pain" formulation, union chiefs risked the revolt of their constituents by signing on to continued sup-port of the government.[7]

Much to his relief, González was able to maintain a political and eco-nomic balance long enough to survive the 1986 election (against a still-incoherent opposition), and to receive the coveted ticket of admission to the European Community. Now he could preside over a new economic "boom," bigger and better than that of the 1960s.

During the period 1986–1992, Spain's rate of economic growth out-stripped that of any of its new European partners. After 13 years of reces-sion, the country was more than ready to pursue the wealth that most of its neighbors were already enjoying, and that frenetic pursuit created an

environment of materialism in which traditional values, to say nothing of socialist principles, fell by the wayside.

During these years, Marx was not only trimly barbered, but elegantly reclad in British tweeds, a Parisian silk tie, and (of course) fine Spanish leather shoes. Socialist bureaucrats, who filled some 40,000 government jobs, craved an up-scale lifestyle to compensate them for their years in the wilderness. Party chieftains hob nobbed with bankers and even intermarried with the aristocracy.

It was not only the domestic elite that was embraced by the González entourage. Laws were modified to encourage foreign investment or even total take over of Spanish businesses. Companies that had been in the hands of a single family for generations were sold to overseas corporations so that the heirs might join the ranks of the "beautiful people" who thronged to the fashionable clubs and restaurants of Madrid or smiled out from the glossy pages of magazines.

While Spain's gross domestic product rose by some 40 percent during the "boom" years, the material prosperity reflected in this growth was unevenly distributed. González delegated the management of his economic program to ministers drawn from a neo-Keynesian faction within his party. They pursued a policy of government support and intervention that favored the creation of wealth on a large scale, in the expectation that it would trickle down to the lower ranks of society. The rich unquestionably got richer, and the upper echelons of the middle class expanded. But the large number of workers displaced by industrial reconfiguration and continued decay of the agrarian sector had no share in this new affluence. The social safety net that existed throughout the rest of Europe was largely lacking in Spain, and the promises made during the period of austerity to remedy this defect were forgotten during the boom time.[8]

The government's massive expenditure on infrastructure development during 1990–91 was, in part, an acknowledgement of how its skewed policy had failed to help the working class. However, a more specific impulse was provided by the grandiose vision of 1992 as the "year of Spain." González, who saw the quincentenary of Columbus's voyage as a perfect opportunity to enhance his own prestige on the global stage, was prepared to commit resources that might have been more prudently spent in other dimensions of the economy. Not only did he envision a lavish World's Fair at Sevilla (his home base), but he had also secured the selection of Barcelona as the venue for the 1992 Olympic Games. Furthermore, Madrid was named as the European Cultural Center for 1992. This latter honor, annually bestowed by the European Union, had often been given a pro forma response by the city in question. For Madrid, González determined, noth-

ing but a magnificent display of pomp and power would serve. By the end of the year, despite the generally favorable reviews given to the Barcelona games, the results of this over reaching ranged from disappointing to catastrophic. Many of the great construction projects had proved abortive or remained uncompleted. Tourists were often unhappy with the management of events and exhibits; a riot in Seville on the eve of the World's Fair opening in which police shot down demonstrating workers hardly suggested the post-Franco ideal. Intellectuals, sour as ever, found symbolism in the fate of a sailing ship that replicated the first vessel to circumnavigate the globe: it sank in harbor as soon as it left the dock.[9]

The "Year of Spain" marked the beginning of the end of the González years. He had created a grand façade not only in 1992 but throughout the preceding decade. Preoccupied with his country's image abroad and his own at home, he had shared the wealth among a broader range of privileged individuals without any serious attempt at redistributing it. His broken promises to the workers, which had provoked major strikes as early as 1988, were repaired by clandestine and partial payoffs to key unions. The boom was running downhill as he went into a new election in 1993, and he emerged from it with a decreased majority that forced him to take coalition partners. In the end, however, it was the massive corruption within his administration that finally dramatized its hypocrisy and exhausted the patience of the voters. Financial scandals combined with revelations of murders carried out by police against Basque dissidents that shocked even the most ardent advocates of national unity. Although González denied any knowledge of the death squads operating under the direction of his senior security officials, he could not evade responsibility for the multiple malfeasance of his subordinates. Forced to resign in 1996, he left not only a legacy of dishonorable dealings but a far more worrisome heritage of economic improvisation.[10]

José María Aznar, as prime minister since 1996, has attempted to apply moderate conservative policies in place of what had turned out to be moderate socialist policies under González. Like his predecessor, he showed no appreciation for the thinking contained in the contemporary American slogan, "It's the economy, stupid." Neither administration exhibited a willingness to do more than play games with statistics and generate rosy promises.

While congratulating himself on the bonanza económica that Spain has enjoyed during his term, Aznar has favored the preservation of wealth in a relatively limited segment of society and has even initiated programs that would shift money from such areas as unemployment benefits and pension

support to the encouragement of entrepreneurism. He remained undisturbed by the decline of activity in the Spanish stock marked during the first half of 1999 and the flow of capital back into real estate investment, a pattern that had discouraged economic growth in the past and bade fair to perpetuate the existing class of magnates.

For their part, the socialists proclaimed their ideological commitment far more vigorously than during their decade of dominance. While agreeing that the country is in an "expansive phase," they declare that it is reprehensible for Aznar to tilt the economy so as to favor the "haves" while Spain remains at least 6 percent below the European Union norm in social expenditures. Felipe González, no longer cowed by his earlier political embarassments, now vehemently points out that his rivals have cut back on unemployment insurance to the point where it covers only 30 percent of workers (glossing over the fact that he had never made any serious attempt to raise the coverage much beyond 50 percent). His great crusade, however, is focused on the matter of pensions. In a national debate similar to that raging in the United States over social security, the socialists insist that the government must extend the scope of the pension system and supplement the existing level of payments so as to give the poorer segments of Spanish society a viable income in their old age. González and his associates declare that a government pledge to provide cost of living allowances is woefully inadequate, and Aznar responds that his opponents are irresponsible when they seek to turn the pension system into a political weapon. The trade unions have generally sought to achieve practical results rather than ideological points, and have emphasized the importance of strengthening pensions without allowing the issue to become a purely political one.[11]

Quite apart from these questions, Aznar has shown himself curiously ambivalent on immigration policy. While attempting to restrict the access of overseas (particularly African and Middle Eastern) immigrants to Spain, he has made provisions for finding them housing and basic welfare benefits and given at least lip service to the socialists' talk about the need to integrate the elements of Spanish society. That many of these newcomers have difficulty in finding employment is an economic problem that the administration chooses to evade.[12]

Aznar lost ground in the 1999 mid year elections, and continues to be chided by the socialists for his lack of "redistributive ambition." Having failed to display much energy in this direction when in power, González scarcely commands enough credibility to expect the early ouster of his opponent. Indeed, both major blocs threaten to become irrelevant in their failure to address the fundamental economic circumstances of Spain.

Both leaders, when in office, have been more concerned with keeping up appearances than achieving essential policy goals.

The Wealth of a Nation: Resources

At the beginning of the twentieth century, it was the fashion for Spanish writers to lament past glory and present poverty. Antonio Machado, for example, pictured "*Castilla miserable, ayer dominadora, envuelta en sus andrajos*" (Castile, dominant yesterday, now miserable, wrapped in rags). He spoke of Spain as a "*madre en otro tiempo fecunda en capitanes, madrastra es hoy apenas de humildes ganapanes*" (once a mother who gave birth to many leaders, now the harsh stepmother of mere drudges).[13] Now , as the century draws to a close, others perceive a crueler truth: Spain's glory was not poetically transient, it was economically artificial. Julián Marías, in his *Understanding Spain* (1992), says: "And then there is the question of wealth. Despite all the 'hymns of praise to Spain,' the country has never been naturally rich; the aridity of its climate, the mountainous terrain, the inadequacies of its rivers for irrigation and navigation, all this has caused its primary economy to be modest—to say the least." He goes on to observe that the great influx of gold and other overseas resources during the imperial heyday was expended on external political projects that left Spain in the same state of "austerity and modesty, verging on penury" that characterized the country before her age of expansion. By the nineteenth century, following the devastation of the Napoleonic invasion and the loss of her colonies, Spain was thrown back upon resources so exiguous as to leave her the poorest state in Western Europe.[14]

What then are the actual natural resources of Spain? Her forests, chiefly confined to the northern regions, are sparse and of little use for timber production. Her minerals are numerous and varied, including such exotic items as wolfram and manganese, but those that could prove of major commercial benefit, such as iron and coal, are in short supply, while petroleum and natural gas are lacking. Her arid central plateau provides grazing for sheep which, along with other livestock, feed the nation but do not constitute a major export. The coastline fringing this central mass, through centuries of ingenious irrigation, sustains a healthy production of olive, orange, and wine-grape crops which are profitable but scarcely a sufficient base for a national economy. Spain's rivers are virtually unnavigable, and her seaports are comparatively few. Her own coastal waters provide cod and a few other fish, but her marine resources have proved inadequate in recent decades, and have forced her fishing fleet to range far from home, leading to maritime clashes with countries all the way from Ireland to Canada.[15]

And what has Spain done to preserve these "modest and austere" resources? In recent years there has been a string of natural disasters, including droughts and floods, forest and bush fires, and even earthquakes. These were, to be sure, unavoidable, but the response to them has generally been slow and bureaucratic. Little has been done, either, to preserve Spain's dwindling stock of wildlife. Once numerous animals such as bears, lynxes, imperial eagles and black storks, as well as various fresh water species have been driven to the point of extinction by negligent management of habitats.[16]

The most spectacular example of the country's incapacity in dealing with environmental preservation has been the Doñana Affair. Early in 1998, a reservoir of toxic materials produced in the operation of a zinc mine in southern Spain collapsed, sending its poisonous contents flooding into a nearby stream, and, in turn, into a major river. The latter carried it into the precincts of the Doñana nature preserve, one of the largest and most ecologically complex national parklands in Europe. Despite a worldwide outcry and prompt assurances from the government that all would be put right, the devastation of the natural environment, the death of fauna as well as flora, and the ruin of agricultural operations along the length of the river had not been materially repaired by the first anniversary of the event. Instead, fingerpointing among officials, disputes about payment for cleanup (to say nothing of how the cleanup would be effected) and attempts to assign blame to the Canadian mine operators and their Swedish backers continued to consume the energies of the government.[17]

Writing in *ABC*, a newspaper usually sympathetic to the regime, Jaime Campmany lamented that "Spain is again in the news thanks to a catastrophe produced by the greed of some businessmen and the negligence of our politicians." He derides the facile assertions of the environment minister that all would be put right and that the Doñana preserve was safe, insisting instead that it would be at least three decades before the damage done by the massive toxic waste spill was repaired. Moreover, he denounces the event as merely the most spectacular example of environmental malfeasance in a long line of instances, proving that Spain was caught between the institutionalized forces of "shoddiness and irresponsibility." Too many important things here are done badly, he insists, and too much negligence blundering and corruption goes unpunished. He reminds his readers that, not too long before, hundreds of wildfowl in the same Doñana were killed by reckless use of pesticide, and no follow-up investigation took place. It went the same way with the collapse of storage tanks in Melilla, the terrible floods in Extremadura, and construction disasters in Cataluña. There

was indignation and then no subsequent accounting. "We Spaniards," he complains, "clap our hand to our head every time there is a new foul up, and then forget about it." Campmany concludes a litany of environmental folly, frauds, and forgetfulness with the bitter accusation "*y no pasa nada*"—and nothing happens.[18]

Clearly, the Spanish government's handling of its natural resources reveals grave problems, not merely of policy but of mentality. But the wealth of a nation includes human resources as well. How have these been treated in recent decades?

Spain has a long history of respect for education, undercut by inadequate provision for obtaining learning. During the Franco era, generous allocation of funds and a desire to raise literacy to the general European level led to striking improvements in the Spanish educational system. Basic education up to age 14 was mandated by law in 1970, and a system of parallel tracks leading to either university admission or an advanced vocational certificate were laid down. These initiatives were refined and extended during the 1980s, particularly under the Socialist regime. Nevertheless, serious deficiencies remained. Perhaps the most fundamental was the neglect of preschool training. While many pupils began classes at age 6 with a solid foundation, others had been left to the vagaries of an unregulated nursery system that often provided little more than childcare opportunities for working parents or recreational diversion for untutored toddlers. A significant proportion of Spanish school children thus were never able to catch up with the educational demands made upon them after age 6 and became a permanent population of underachievers. Furthermore, the government's relationship with private schools remained disorganized and improvisational. Such schools (half of them church-operated, half run by commercial entrepreneurs) were responsible for educating about one-third of Spanish children and were allowed to do so to spare the budget the expense of building new state schools and paying their staffs. Yet the private institutions were left largely to their own devices in matters of standards and curriculum, even though receiving government subsidies. Because such schools could refuse admission to children in their area who did not meet the qualifications laid down by their proprietors, such children often had to be bused to distant public schools where there were enough seats to accommodate them. In addition, the vocational track was unable to produce, either in terms of quantity or quality, enough technicians and skilled craftsmen to meet the demands of the economy. While the comparative failure of vocational education in Spain had something to do with the traditional Spanish disdain for manual labor as distinguished from professional or "white collar" employment, the undue complexity and

illogicality of the program drove away many potential recruits. For example, although basic schooling ended at 14, no one was permitted to take a job until 16. Family pressure and personal desire combined to drive many youths into a "black market" of low-paid marginal jobs in service industries offering little income and no security.

It was not until 1990 that the González administration launched its grand design for reconstruction of the educational system. In a series of measures that were scheduled to be implemented over the next decade, the government assumed full responsibility for standards of preschool training, created a new structure for pre-university education, and modernized the curriculum throughout the entire course of this program. Children were to have a primary education between the ages of 6 and 12 and secondary training between 12 and 16. At age 16 they were given improved opportunities for enhancing their academic preparation to pursue university admission or to acquire up-to-date and marketable vocational skills. Under this "reform" legislation, the Spanish government has assumed full responsibility for compulsory education up to age 16, taken on oversight of all training within that age group, whether public or private, and mandated such "modern" subjects as English language training from age 8, environmental studies, drafting, and business management. The González government even took on and essentially defeated the Catholic bishops' objections to what they saw as the latest of a series of attempts to weaken their influence over Catholic youth and eliminate moral training from the schools. It remains to be seen how the overall plan of reform will work itself out in practice[19].

Like the system of primary and secondary education, Spain's university-level education constitutes a vital component of its human resource structure. Here, too, the reality must be distinguished from the propaganda, and the positive results of reform from mere churning of the existing mixture. The Franco regime accompanied its genuine effort to expand the availability of basic schooling with support of higher education. It increased the availability of places in existing universities and provided financial assistance to the ablest prospective students. However, despite his flirtation with liberalism in his latter days, *El Caudillo* maintained a tight supervision on what was taught and how the professors conducted themselves in the classroom and had no compunctions with regard to academic freedom.

The major reforms that created the Spanish university scene at the end of the twentieth century were initiated after the Socialist victory of the 1980s. Not only were the vestiges of thought control abolished, but a major effort to expand the availability of university training was undertaken in the spirit of egalitarianism. Access to higher education was facilitat-

ed by multiplication of tuition grants, easing of the barriers to university admission, and an increase in the actual number of universities. To medieval creations like Salamanca and the *Complutense de Madrid,* nearly a dozen new institutions were added, bringing the grand total to 41. The attendance was increased five-fold to well over one million. The González administration could boast that a higher percentage of its citizens attended universities than was the case in most other European countries.

Despite these positive images, however, the reforms left numerous flaws in the Spanish system of higher education. An experiment with open admissions during Franco's days had proved unworkable and was replaced by a plan of qualifying examinations, which in turn was supplanted by what amounted to a compromise between the two methods of selection. The number of students seeking access to the universities far outstripped the number of available places during the 1980s, with the most desired institutions drawing students out of all proportion to the less prestigious schools. Here again, the government vacillated between requiring that a student attend the university nearest to his home, and allowing him to seek admission to whatever program seemed best suited to his academic aspirations. Although 4 or 5 more universities were scheduled to open by the start of the new century, overcrowding and dissatisfaction with available options seemed likely to persist. Another problem grew out of the lenient policy that permitted students who failed a course to repeat it as many times as they wished until they could finally attain a passing grade in that particular subject. Statistics (not readily available from the government) show a pattern of prolonged academic affiliations, with the majority of students taking more than twice the expected number of years to complete their university training. As a result, since so many Spaniards prolong their "college days" well into their 30s, the proud assertion that 30 percent of eligible Spaniards attend universities is somewhat misleading, for it implies that the percentage relates to the 20 to 24 age group. Clearly, many young people of the traditional collegiate age are not actually collegians, while many pushing on to middle age have become perpetual students. The González administration seems to have been more concerned with its social mission to provide equal access to all levels of education than with the consequences of overloading and clogging the university system. If students were compelled to extend their stay because family and financial constraints limited the number of classes they could attend, the situation might be justified. But the evident inability of many students to pursue serious studies or to complete their work in a reasonable time has drawn criticism from educators of all political persuasions, who insist that the attempt to push everybody through to a university degree has devalued such degrees. The debate over whether

the true goal of a university education is to train the elite of society or to "uplift" all of society echoes similar controversies in other countries, including the United States.[20]

One is left with serious doubts about Spain's management of its most valuable human resource—the youth who will provide the means of preserving and increasing prosperity. In every dimension of a free enterprise society, the skill, dedication, and enlightened imagination of a nation's workforce constitutes its true wealth. To take just one example—although it is among the most important underpinnings of the Spanish economy—the tourist industry is fundamentally a human resource-based enterprise. It is all the more important in a country that lacks abundant natural resources. Whether at the level of vocational school graduates or university-trained professionals, Spain needs to have the best and the brightest presenting its touristic riches to visitors from abroad. The country cannot afford to ignore the need for the best possible people in this area any more than it can ignore the issues raised by infrastructure neglect or environmental degradation. Just as with tourism, so with every other industry within the Spanish economy: a coherent deployment of what Spain possesses is essential. It is not necessary to exceed, or even match, every other European country in each economic dimension but rather to present the best that Spain in particular has to offer through a well-conceived and well-executed policy of maximizing the nation's unique potentials.

If the leaders of the new Spain cannot grasp the importance of developing their nation's true resources, all their posturing and boasting about the economy will be, like the running of the bulls, so much sound and fury, signifying nothing.

5

Cambio de Programa todos los Miercoles: Society

"New Show Every Wednesday," proclaims the marquee of a local movie house. Like the exotic proliferation that has flooded theaters long accustomed to bland and censored fare, change has swept over Spanish society in the post-Franco era. The "new show" has meant an openness in expression and action that many have found stimulating and others frightening. The warnings of the church that freedom does not equate with license have been ignored and the State has hesitated to apply sanctions that may be deemed undemocratic. Along with new opportunities for self-fulfillment, new dimensions of crime and corruption have been opened. Women have sought to develop new roles for themselves, but traditional family hierarchies and relationships have been thrown into disarray. The tide of change has elevated many to a level of prosperity and self-realization beyond the hope of earlier generations, but it has not lifted all boats, and many find themselves sinking or cast away on the shores of neglect. With the rush of modernization seeming to offer a new program every week and society constantly taking on the attributes of its European neighbors, some are compelled to ask "Who am I?" "What am I?"

Vicious Circles: Crime and Vice

In 1868 the authoritarian prime minister General Ramón Narvaez was urged by a chaplain, during his last illness, to forgive his enemies. "No need to forgive them," the general replied complacently, "I've had them all shot."[1] Such, in fact, was the philosophical underpinning of the Old Regime in Spain. Law and order was maintained by a brutal resort to vio-

lence, and the liberal or conservative label attached to any particular government signified little about its attitude toward its enemies. The murderous methods of Franco's administration were distinctive only in their scope and continuity.

Far from being destroyed, the Spanish inclination to individuality, defiance, and disruption was merely repressed during the period 1939–1975. The power of the military was more pervasive than ever, and the police, who had benefited from the tutelage of their German colleagues, more oppressive.

With the dawn of democracy came not merely civil liberties but criminal opportunities. In Western societies that enjoyed a mature democracy, standards had evolved over the span of several generations, achieving a consensus on the boundaries of personal liberty and civic responsibility. Spanish society, however, responded to the sudden end of a repressive and censorious system with the immature excesses of an adolescent emancipated from parental control.

Among the less serious, though more visible, manifestations of this new environment was the rush to sexual display in the media and films. Rapidly progressing from daring, if limited, displays of hitherto forbidden body parts in magazines to outright pornography, the artists, photographers, publishers, and producers took what seemed an almost juvenile delight in flouting long-established standards. Their audience (overt or covert) congratulated itself on living in a "modern society" that had espoused sophisticated European attitudes. "Reactionaries" lamented moral decay, delinquency, and rise of venereal disease. Figures regarding the increase of assaults on women and the growth of prostitution were inconclusive, although the latter institution had long been established, and even tolerated, in Spain.[2]

What was indisputable was the growth of addictive behavior. Like most Europeans, Spaniards had been heavy smokers ever since tobacco first made its way from their colonies in the New World to a welcoming market in the Old. During the 1980s and 90s, as evidence mounted for the devastating impact of this habit upon public health, and their peers in other countries began heeding the American warning against nicotine addiction, a significant proportion of newly disposable income went to increase and upgrade Spanish tobacco consumption. A fine Cuban cigar seemed to be the constant companion of every male inhabitant of Madrid, Barcelona, and Bilbao. Despite published reports that smoking caused an average of 44,000 deaths a year during the 1980s, Spaniards remained unmoved in their devotion to tobacco.[3]

Alcohol, too, was a familiar presence in Spain throughout history, but inordinate consumption had been checked by everything from high taxes to social disapproval. The new era brought excess in this sphere as well. Excess disposable income, an influx of exotic beverages, and the celebration of personal freedom led to a steady rise in the rate of drinking. Here again, excess was perceived as a mark of prosperity and the right to choose one's own lifestyle. Imported liquors seemed to replace domestic vintages as the preferred drink of the new elite. Wine and beer were consumed in ever-increasing quantities by those who preferred to celebrate in patriotic style. During the first decade of "freedom," 60 percent of all traffic deaths were attributed to drunken driving, and the policies on traffic management, breath-testing, and similar measures to control intoxicated drivers were barely beginning to be implemented by the late 1990s. The 20,000 deaths attributed to the direct physical consequences of excessive long-term consumption of alcohol were likewise seen as the price of guaranteeing personal liberty.[4]

Gambling in all its forms was likewise accelerated by the new spirit of "do as you will." From the hugely popular national lottery to the card playing and dice-rolling of the local tavern, Spaniards laid out more and more of their income on dreams of affluence. Fueled by media images of celebrities and newly-rich businessmen enjoying "the high life," ordinary Spaniards cast aside traditional restraints of prudence and decorum to yield to betting mania. The extent of Spain's gambling enthusiasm is well illustrated in a 1991 study which calculated that Spaniards spent a net total of 913 billion pesetas ($8.8 billion). This was equivalent of one sixth of their expenditure on food, one third of their clothing purchases, and (perhaps even more pertinent) one-and-a-half times their total outlay on drinking and smoking. At about the same time the *Economist* calculated that they allotted only 10 percent to insurance coverage of the income they spent on lottery tickets.[5]

More alarming than all the other new manifestations of addictive behavior was the upsurge in drug abuse. It was also the most novel development, for while Spaniards had always indulged, to a degree, in smoking, drinking, and gambling, they had not shown a predilection for illicit drugs. Perhaps inevitably, the worldwide epidemic of addition, fueled by a global pattern of growing and smuggling, touched Spain as it touched all European countries. The casting aside of traditional restraints and formal prohibitions that accompanied the onset of democracy intersected with this pernicious phenomenon of the late twentieth century, with tragic results. Recreational drug abuse became fashionable among the newly privileged,

and was perceived by youth as a hallmark of the international "pop" culture. By 1990 the minister of health was reporting serious levels of drug experiment and addiction with at least 80,000 persons addicted to heroin. Unofficial estimates put the figure at 100,000, and asserted a rising rate of cocaine use. These sources suggest a rate of drug abuse per 1,000 of the population higher than that of the United Kingdom and the Netherlands and only slightly lower than that of the United States.[6]

An environment of excess bred serious health problems in post-Franco Spain that demanded substantial outlays by the Socialist government to cope with the need for expanded hospital and clinic facilities.[7] Excess also bred vice and the growth of a criminal network to cater to its exorbitant demands. Criminal activities, accompanied by violence and corruption, grew during the 1980s. During the same period, however, the means of coping with this growth diminished. It was not that the number of police declined but rather that the effectiveness of the force at Spain's disposal deteriorated. Spain continued to have one of the highest proportions of police to civilian population in Europe, but the post-Franco revulsion against authority in general, and its uniformed agents in particular, led to a diminution of police powers. Moreover, responsibilities were divided. Municipal police forces hired and managed by localities, were charged with the maintenance of urban order, and they varied widely in quality. The police in Madrid and several other larger cities inherited the prestige, but also some of the unpopularity, of their predecessors under the dictatorship. Furthermore, the separation of the investigative and the security branches often hampered their efficient performance. The legendary civil guard, a paramilitary force dating back to the early nineteenth century, continued to be responsible for rural patrols, protection of the borders, and a host of miscellaneous duties. These contingents, with overlapping jurisdictions, competing commanders, and regional sensitivities, were often less capable of dealing with the rise of criminal activity in post-Franco Spain than their numbers might suggest.

Respect for the law and its guardians was also diminished during the 1980s by a series of scandals relating to police corruption and police brutality. The employment of the civil guard and other "nonpolitical" units in the struggle against terrorism sometimes led to bribery, beatings, or even summary executions. When police cooperated with the army or special intelligence agencies, their zeal occasionally led them beyond constitutional limits. Worse yet, evidence gradually emerged that some of this arbitrary violence was ordered by high-level security officials. Charges that the socialist government had perverted police powers in the struggle against Basque nationalists helped bring down Prime Minister Felipe González.

Such accusations and revelations continued to beset the security forces and their leaders on through the end of the 1990s.[8]

Perhaps even more disquieting, because more systemic, were the problems confronting the administration of justice. Equality before the law and ready access to courts were enshrined in the new constitution. The government was pledged to maintaining an independent judiciary, and mechanisms were erected to assure that judges were free from political interference. Yet, within a few years of the establishment of the new order in Spain, pledges were being broken and mechanisms were being subverted. Both at the national and regional levels, in keeping with one of Spain's less attractive traditions, courts were being treated as an extension of the executive power. Worse yet, political patronage and financial considerations were allowing some Spaniards to be "more equal" before the law than others. Aside from the impact of favoritism and corruption, there was also the simple fact that the courts were horrendously clogged with cases going nowhere. An upsurge in crime (much of it related to drug dealing) and a massive resort to litigation by those who wanted to demonstrate their new freedom to quarrel with everybody left the judicial system overwhelmed. Even lawyers who personally disdained corruption found themselves obliged to recommend bribery as the only hope of getting their clients on to a fast track to a hearing. So overloaded did the justice system become during the 1980s that illegal activities were turned into a way of life for those who were convinced that they would never be brought to account. Violations of building codes, unauthorized construction, and other offenses against real estate laws became the norm. Offenders could simply mock those who were the victims of their outrageous practices by sneering "so, sue me!" Shady characters who lived one step ahead of their creditors proliferated, maintaining a lavish lifestyle without ever having to pay their debts.

During the 1990s efforts were made to cleanse and expand the justice system, but these, along with plans for a modernization of the prison system, were very slow to produce results. Exasperated Spaniards became increasingly cynical, endorsing the old saying that "justice delayed is justice denied." They did, however, recognize that not all judges were evil or idle. Baltasar Garzón became one of the most popular men in Spain in 1999 as he launched a demand that the Chilean ex-dictator Augusto Pinochet be handed over to Madrid for trial as a human rights violator during his term in office. Garzón also sought extradition of Argentine *junta* members who had been responsible for atrocities during the "Dirty War" of the 1970s. A picturesque and flamboyant character, Garzón further endeared

himself to the public by his willingness to annoy, and even defy, the political leaders of the Aznar administration.[9]

Despite occasional bright spots, the picture presented to the world at large and to foreign investors in particular was not an encouraging one. Some commentators were moved to compare the mixture of widespread vice, corruption and bureaucratic lethargy presented by post-Franco society with the situation in post-Soviet Russia. References to "lack of transparency" and "legal labyrinths" were made by those who had experienced the negative environment of the "new Russia" and were quick to point out similarities in the "new Spain." Admirers of Spain responded that things were far worse in Moscow than in Madrid; but Spain has had twice as much time to put its house in order, and patience, both foreign and domestic, was wearing thin.

"Why Can't Women Be More Like Men?": Feminism

Spain has produced notable women. The whole world remembers Isabel, patroness of Empire, Teresa of Avila, saint and mystic, Carmen, the fiery (though fictional) seductress, and *La Pasionaria,* strident champion of resistance and revolution. But they are outnumbered by the millions of women who bore pious given names like Angustias, Remedios, Amparo, and Consuelo, and endured the burdens of their sex through centuries of domestic repression and social violence. These latter are the women of Spain who lived and died in obscurity, leaving the public stage to their arrogant and often violent menfolk, while they accepted the supporting roles of mother, wife, and daughter. For all but a few women, propelled to the forefront by power or passion, Spanish tradition demanded meek subordination eased only by the consolation of faith.

The movements for "women's rights" that swept the United States, Britain, and much of Europe at the beginning of the twentieth century left Spain largely untouched. It was rather through the political process that brought the Republic into existence in 1931 and the ideas that survived its fall eight years later that women found their voice. Even during Franco's conservative dictatorship, a heightened self-consciousness and assertiveness kept the rising generation of Spanish women ready for new opportunities. When the period of constitution making began in the late 1970s, they were ready to stake their claim for emancipation and equality.[10]

As early as the spring of 1976, women were marching in Madrid to insist that they be accorded full equality in the new order of things. They were both derided for their unseemly behavior and admired for their courage in asserting their claims. This ambiguous reaction from a traditionally male-dominated society continued to be reflected in the debates over

the formulation of the constitution. Women had, after all, taken up male responsibilities during the Civil War and many widows had become the breadwinners in their families. Had they not proved their abilities beyond the home and earned a voice in the councils of the nation? As the new party alignments emerged in 1977–78, women's voices were heard in the decisions on fundamental concepts and rights. When all was said and done, the constitution of 1978 accorded equality to all Spaniards and full civil rights without distinction as to gender.[11]

Although women might now claim the vote and pursue legislative seats or even Cabinet membership, there was still much to be done in the realm of marriage and family status. In the ongoing arguments over the full emancipation of Spanish women, a multitude of conflicting assertions were made by the church, miscellaneous "moralists," pragmatic campaigners for specific rights, and ardent feminists. Militants in Europe and the United States applauded the uncompromising writings and parliamentary rhetoric of Lidia Falcón and those who shared her belief that a specific feminist party was the best vehicle for achieving equality. Many Spanish women, in contrast, preferred to continue working under the aegis of the major parties, particularly the socialists. When Felipe González and his PSOE came to power in 1982, they supported a series of laws recognizing a woman's freedom to shape her own life without subjugation to a male "overseer."[12]

The most oppressive restrictions on women had been imposed during the Franco era in the so-called *permiso marital which* gave total power to the male head of the household. The principle of absolute control over a woman's personal life, and even her comings and goings outside the home, was challenged and repealed during the closing days of the Franco regime in one of the most dramatic of the "liberal gestures" made by *El Caudillo's* reformist advisors. But the remnants of the *permiso* remained to be cleared away. By the middle of the 1980s, it was accepted that women had the right to retain ownership of any property that they brought into a marriage, to earn money, sign contracts, make investments, and dispose of their personal possessions without the husband's consent. Furthermore, they were entitled to a share of jointly acquired property or wealth should the marriage come to an end. An abusive husband was no longer able to hold his victim captive, for the law now recognized her right to seek sanctuary and to demand official intervention against him. The parental power over minor children, once vested exclusively in the father, was now recognized as a joint authority and responsibility. Even the unequal standards applied to the issue of adultery were changed so that they no longer gave the husband relative freedom to take a mistress while subjecting the wife to instant social sanction.[13]

During the 1980s, the achievement of a secure legal status for women was followed by an attempt to enhance educational and employment opportunities. In the universities, where female students had been a distinct minority, young women became a majority in most of the faculties other than engineering and architecture. They also flooded into the world of business, including communications and overseas trade. The proportion of female physicians and lawyers rose rapidly. Women soon were granted cabinet positions, appointed to judgeships, and elected to mayoral offices. There was even an upsurge of women in the realm of popular culture, ranging from artists and entertainers to a female bullfighter. Perhaps most dramatic of all, women were admitted to the civil guard and the armed forces, including the academies that turned out future officers. After prolonged legal wrangling and public debate, they were even given the right to risk their lives in armed combat.[14]

Despite all the evidence of expanding equality of opportunity, women still found practical difficulties in gaining access to jobs. Even during the 1990s, they constituted a smaller percentage of the total workforce than in most European countries. There continued to be a reluctance to hire them and a readiness to discharge them at the first sign of economic slowdown or personal difficulties. Unemployment remained higher among job-seeking women than among men. Old prejudices and assumptions continued to undercut legal equality as far as hiring practices were concerned. Indeed, some conservatives have argued that the flow of women into the ranks has made it harder for all workers to find steady employment, although the statistics cited can be interpreted in various ways. Certainly there is a respectable percentage (between 15 percent and 20 percent) of executive and managerial positions allocated to women in Spanish corporations, but they tend to be concentrated in areas related to health services, pharmaceuticals and other "soft" industries rather than spread across the entire spectrum. The "glass ceiling" seems to be less of a problem than the narrow passageway and the too-readily opened exit door.[15]

Greater sexual freedom and increased access to employment outside the home for women have affected family relationships. Sociological analysis reveals a continuing resistance to shared responsibility for household duties and a reluctance to surrender male dominance in the family, despite insistence by younger couples that they are "progressive" in such matters. Although there is a higher proportion of child-care services available to Spanish working mothers than in many other countries, they nevertheless stretch themselves thin by trying to cover traditional family roles and new outside responsibilities, with evident damage to traditional family structures. Surveys show an increased rate of estrangement between parents and chil-

dren and a growing tendency of youth to "live their own lives" even when they cannot afford to move out of the parental home as early as they would wish. The once-familiar image of the multigenerational Spanish family gathered in a restaurant for a holiday celebration or in a public park for a festive outing is growing less common. The family itself, according to some commentators, may be a vanishing institution. The birth rate has shrunk to among the lowest in Europe, with the assigned reasons ranging from a desire to improve economic status to a cultural shift in which large families are perceived as "old-fashioned."[16]

Happy families may all be alike (provided they stay small), but each unhappy family is unhappy in its own way. The rate of domestic violence in Spain has grown steadily in recent decades, as has the dissolution of marriages. Whereas annulment, with church approval, was formerly the only means of terminating a failed alliance, divorce has now become readily available. A divorce law was drafted in 1977, soon after the end of the Franco regime. Legislation comparable to that in effect in the rest of Europe was not passed until the early 1980s, after much debate and strong opposition by the traditionalists, both lay and clerical. Although the divorce option is now available, many estranged wives prefer a form of legal separation for financial reasons and because of the social stigma still attached to being a "divorced woman." A growing number of children have been forced to experience this pattern of family break-up. Their disillusionment with the institution may be reflected in the recent decline in the national rate of marriage.[17]

Critics of women's "emancipation" have had no trouble in extending the list of family values that they consider to have been degraded by the new freedom and equality. They cite polling data that indicate majority approval for abortion rights, free availability of birth control, and general defiance of the church's teaching on sexual matters. They also cite statistics on rising drug use and blame this and other evidence of increased juvenile crime on the absence of working women from the home. Conservatives have pointed to the prevalence of the most "liberal" attitudes among urban youth and urged every effort to preserve the "moral purity" of young people in rural areas.

Those with a literary turn of mind envision the experience of Spanish women in the last quarter of the twentieth century as a perilous attempt to preserve a balance between the idealized insipidity of Dulcinea and the dynamic vulgarity of Aldonza in Cervantes' great tale of pseudochivalry. The true danger for Spanish women is that they may become duplicates of his principal male character, Don Quijote, pursuing impossible dreams and achieving nothing that endures.

Class Dismissed?: Social Structure

Spain, like England and France, entered the modern age with a legislature based on its class structure. Parliament was satisfied with two "houses"—lords and commons; the Estates-General included clergy, nobles, and the "third estate"—that is, everybody else. The *Cortes* of Castile, however, found it necessary to include four "arms"—the clergy and the townspeople (though not the countryfolk), the *ricos hombres* and the *hidalgos*. These last were a peculiar group, poised socially somewhere between the "rich men" who constituted the great land-owning aristocracy, and the ordinary people. Some historians equate the *hidalgos* with descendants of younger sons of noble houses who had sunk down from their exalted origin; other scholars see them as a distinct class of petty nobles, and still others regard them as mere upstarts pretending to the rank of gentry. Regardless of their precise origin, the persistence of this class, whether as *hidalgos* (literally "son of something") or under the designation of *caballeros* (horsemen or knights) reveals a climate of mingled pretension and social insecurity that survived into the twentieth century. Through the incessant disruptions of Spanish life during recent generations—including the rise and fall of monarchy, dictatorship and democracy, and precipitate integration into the international system—Spaniards cling to their old concern about who one is and where he fits into the hierarchy.

The traditional hallmark of aristocracy, a lineage extending back to the warlords of the medieval Spanish kingdoms who earned their titles by battling the Moors (and each other), has faded with time, and new bases have been found for earning royal favor. The titled Spaniard of today is as likely to be a retired politician or a notable author as the descendant of some magnate of the *Siglo de Oro*. Former Prime Minister Suárez is now a *duque,* while the novelist Camilo José Cela was made a *marqués* as well as a Nobel laureate. Moreover, Spain's distinctive rules of inheritance permit a man who marries the eldest daughter of a noble with no sons to inherit his father-in-law's title (which would ordinarily become extinct in other countries). Thus, the monarchy of democratic Spain neither eschews titles of nobility entirely, like Norway, nor preserves the venerable exclusivity implied in the old phrase *un grande de Castilla*. The bearer of a title may be a blue blood of the most antique pedigree or a shopkeeper's son who has made the right moves. The idea that a king implies a ruling class of courtiers, paladins, and viceroys is invalid in the context of contemporary Spain. Some of the title-bearers are the owners of great estates and command princely revenues, but they do not constitute a ruling class. Many of the old families have fallen on hard times and must eke out a modest living by ingenuity and creative

financing. The "beautiful people" whose smiling images fill the pages of "high society" magazines are just as likely to be entertainment luminaries or captains of industry as members of the certified aristocracy.[18]

Like the *hidalgos* of an earlier day those contemporary Spaniards who aspire to become *ricos hombres* hunger for respect. Many of them are among the entrepreneurial beneficiaries of Spain's modernized economy. Their European, or even transatlantic, connections give them a sense of personal importance and stimulate their claims to elevated social status. In the same way, those members of the bureaucracy and intelligensia who were formerly content to grub out a living on a modest wage and to confirm their rank with necktie and frayed white collar are now pressing their claims to elite status. They point out that Spain could not sustain its transition to "global" identity without the business skills and brainpower of the trained, educated experts. It is this meritocracy, its members contend, that will guarantee Spain's modernity and viability as she enters the new millennium. The "men of knowledge" (and their female associates) can often scarcely conceal their scorn for the remnants of the old nobility, with their coats of arms and stables of fighting bulls. Yet the businessmen and engineers, professors and scientists are by no means adverse to political power, political office, or political rewards. These new *hidalgos* envy those above them whom they affect to despise and secretly despise those below them whom they claim to regard as the salt of the earth.

The majority of the Spanish people must work with their hands. Despite the blurring of distinctions created by modern technology, most of them still need to labor in stained overalls or uniforms that identify their lowly rank. Whether they belong to the industrial proletariat or the much-reduced agricultural sector of the economy, they still bear the traditional stigma attached to manual labor. The old Spanish snobbery that honored those who lived by their brains (or at least their wits) and looked down upon those who had to sweat for their daily bread has not disappeared. It must, however, be veiled in rhetoric about social equality and democratic principles. Workers who were formerly disenfranchised or ordered how to vote by their employers must now be courted by politicians. The use of organized demonstrations, strikes, and boycotts can no longer be dismissed as mere anarchism or broken up by military force. Yet the persistent weaknesses of the Spanish economy still leave a significant proportion of the population in straitened circumstances, and this failure to share in prosperity has been taken as a sign of innate social inferiority, and, perhaps, moral deficiency.

Below the poorest workers and the working poor is a level of Spanish society that now consists almost entirely of "outsiders." Gypsies, although

their ancestors may have lived in Spain for many generations, are marginalized. Immigrants, mostly from North Africa, whether they are legal residents or undocumented aliens, are likewise regarded as intruders. Overseas observers and tourists may imagine the Spanish gypsy to be a carefree character who plays his guitar, dances, and generally behaves in a picturesque and amiable manner, doing nothing more questionable than telling fortunes. The opinions held by the higher echelons of Spanish society are quite different. Gypsies, who constitute about 1.4 percent of the total population, are commonly believed to have criminal tendencies and become the usual suspects in everything from petty theft to drug dealing. A recent study financed by the European Union focuses on the situation of gypsy women, but reveals much about the circumstances of this community as a whole. One out of four female convicts is a gypsy, despite the fact that they constitute such a tiny minority within the citizenry as a whole. The authors of the report do not hesitate to compare this disproportionate incarceration to the rate of imprisonment in the United States, where blacks are said to number as many as half of all convicts although they make up only 13 percent of the total population. Almost all of the gypsy women interviewed for this study were convicted of theft or drug peddling. The majority was functionally illiterate and 62 percent mentioned other family members as having passed through the prison system. Urban, poor, the object of social and employment discrimination, about half of them had become drug addicts. The authors of the report also documented many instances of police harassment, presumptive detention, and abuse by local authorities as well as a tendency by the courts to assume that gypsies were "bound to be guilty of something." The gypsies were rarely granted bail in advance of trial and were usually given longer sentences than others convicted of comparable offenses, apparently on the theory that keeping them in jail would "keep them out of trouble."[19] While such recent and detailed statistical information is not available for the male sector of the gypsy population, anecdotal evidence suggests that their situation parallels that of the women.

In February 2000, what the international press characterized as race riots broke out in the Southern region of Spain, around Málaga and Almería. Here more than 100,000 North African immigrants had crowded into shanty towns during the previous few years to tend the greenhouses that produced vast quantities of vegetables for the markets of Europe. Earning the scanty wages disdained by native Spaniards, they endured an almost total lack of public services and the mounting hostility of their neighbors, who complained of a new Arab invasion. After 2 Spanish workmen were killed in a fight and a woman was robbed and murdered, mobs

rampaged through the Moroccan settlements, beating the immigrants, burning their shacks and several makeshift mosques, and vowing to annihilate the "moors." The targets of this violence demanded police protection and when it was slow in appearing, rallied their compatriots, who make up at least a quarter of the workforce in the region, in a general strike that cost the agricultural industry millions of pesetas in lost sales. While the government belatedly responded with proclamations of shame and disgust over the anti-immigrant violence and a pledge of reconstruction funds for damaged or destroyed property, the episode merely highlighted a growing and still unresolved problem. Although only 2 percent of Spain's population is foreign-born, the recent increase in illegal immigration, mostly via improvised craft crossing the narrow straight between Spain and Morocco, has created tensions similar to those in many other European countries. While gypsies have earned a certain grudging acceptance near the bottom of the social scale by the mere length of their residence in the peninsula, these newcomers, for all the contribution they make to the shrinking pool of unskilled labor, have been met with fear and loathing. In an essentially homogeneous environment the introduction of an alien culture and religion, resonant of Spain's long struggle to expel the "moors" in bygone centuries, has created profound antagonism. Official demands for tolerance and even integration on the basis of permanent residence have been greeted in many quarters with shock and opposition. Some Spaniards point to the enduring problem created by marginal communities of non-Westerners that have built up during recent decades in such countries as France, Germany, and Britain. The rage directed against the North African immigrants in and around the village of El Ejido may well prove to be the first episode in a new dimension of class conflict.[20]

In a society as static as that of Spain, the surge of modernization that has overtaken the nation during the past three decades has had an impact more akin to that striking post-colonial societies of the Third World than the rate of evolutionary change common elsewhere in Europe. Although the broad outline of social hierarchy still permits one to recognize a set of magnates at the top, of restless *hidalgos* beneath them and a mass of common folk at various levels of disadvantage shading down to the bottom, contemporary Spain formally pretends to be a classless society. Upward mobility has been dazzlingly rapid for some. Frustration and failure have been the lot of many others, whether they made the trek from hinterland to suburban slum or lingered in the dying environment of remote villages. When Basques, Catalans, and a dozen other "nations" proclaim their special status while "foreigners" are denounced by all, it is difficult for the world to know what exactly is meant when someone proclaims "I am a Spaniard."

It is also increasingly difficult for a Spaniard to know where he stands within the shifting social patterns of his own country.

6

Images in Shadow and Sunlight: High Culture

The rising sun of Spain cast its rays over the cultural environment as well as the political landscape of Renaissance Europe. Its writers and artists inspired those of other countries. The Spanish image fixed itself in the general consciousness. But with political decline came an erosion of cultural influence. By the nineteenth century, Spain was merely providing picturesque settings for French novelists and Italian composers. Spanish men of letters and painters exerted little influence beyond their own borders. Then came a new era of international impact. Authors such as Echegaray and Benavente earned the Nobel Prize; Picasso and Dalí reshaped the techniques of painting. Twentieth-century Spain seemed to be regaining a role as a major force in the literary and artistic world. Suddenly war and dictatorship thrust Spain back into the shadows. Intellectuals preferred not to know what was happening there: they could not imagine that it offered anything worthy of their respect.

The post-Civil War years were, in fact, a time of complex creativity. Alongside writers who followed an approved line, there were those who pursued their own convictions and responded in a variety of ways to the challenges of authoritarianism and the temptations of self-exile. As this period came to an end, many of these independent thinkers emerged to face a new freedom of expression, providing a transitional inspiration to a rising new generation of novelists, poets, and playwrights. Among the painters, sculptors and architects, as well, the vicissitudes of the Franco era and the opportunities of the new democracy bred a complicated set of responses. Along with an energetic phalanx of filmmakers, these men and women are leading Spain back into the sunlight of contemporary culture.

The Found Generation: Literary Excellence

For most of the world, the history of Spanish literature began with Cervantes and ended with Lorca. When the Andalusian poet and playwright was murdered in 1936, during the opening days of the Civil War, the event was taken as a plunge into a mindless barbarism. The years of the Franco dictatorship were viewed from outside Spain as a dark night of the soul in which all creative instincts were suppressed and no artistic expression worthy of attention was achieved. The truth, however, is far more complex and impressive. When the nation emerged from the twin shadows of political isolation and cultural boycott, its intellectuals were discovered alive and well. Instead of some hideous gap left by a lost generation, the written word experienced a found generation. More precisely, it encountered several overlapping generations of Spanish writers who had defied, deceived, or simply worked around the dictatorship in order to preserve and extend their country's literary achievement.

The most senior members of the "Found Generation" were already adults when overtaken by the horrors of the 1936—39 war. They include Vicente Aleixandre, Antonio Buero Vallejo, Camilo José Cela, Carmen Conde, José Luis Sampedro, and Gonzalo Torrente Ballester. One can also identify what has been called a "wounded" cohort, born in the 1920s and still in their teens during the war. Writers shaped by this traumatic adolescence include Juan Benet, José Luis Castillo Puche, Miguel Delibes, Carmen Laforet, Carmen Martín Gaite and Ana María Matute. Still another subset of writers born in the 1930s were little more than toddlers when the catastrophe burst upon them. Some of these "children of the storm" are Fernando Arrabal, José María Carrascal, Lidia Falcón, Juan Goytisolo, Juan Marsé, Francisco Umbral, and Manuel Vázquez Montalbán.[1]

All of these writers would, in turn, influence and inspire those born in the 1940s and 50s who would grow up under the Franco regime, but come of age as it was near its end. Their interaction with the rising generation reinvigorated both groups and preserved the vitality of Spain's literary tradition despite the indifference or rejection offered by the wider world.

Speaking of the Franco years, Antonio Buero Vallejo insists that Spanish literary life did not go into abeyance or knuckle under to censorship. "If you are a good writer," he declared, "you will write, no matter what stands in your way. Only those who had no real talent blamed the dictatorship for their silence. With the onset of democracy, they still had nothing to say."[2] Francisco Umbral affirmed this, quoting with approval his old friend César González-Ruano: "Since the censors had forbidden the use of the word 'thigh,' writers were forced into discovering forty ways of say-

ing it without actually using that word. When you have a rich vocabulary and you know how to say things, it is not necessary to use a particular term; you can find another word or suggest the same thing."[3] Again and again, the censors were tricked and trumped by the ingenuity and wit of writers who knew many ways to say what they wanted and could replace a crossed-out sentence by something even more striking or scandalous without the sluggish minds of their antagonists being able to catch up with them.

In 1977 the Nobel Prize for literature was awarded to the surrealist poet Vicente Aleixandre. This sickly recluse had remained in Spain through-out the Franco years and was hailed as the sole shining light amidst the darkness of that period. Indeed, the Swedish Academy of Letters described the award in clearly political terms of reference "The Civil War came and from his bed he listened to the bombs exploding. When it was over and his friends and fellow writers went into exile, they had to leave the invalid behind . . . but mentally, too, he survived the Franco regime, never sub-mitting and thus becoming a rallying point and key figure in what remained of Spain's spiritual life."[4] These words reflected the received wisdom of northern Europe on the recent history of Spain. The new democracy that had lately emerged there was supposed to be springing miraculously from totally arid ground, and even as they honored Aleixandre, the Nobel Committee affirmed that he was the only flower in an intellectual wasteland.

The truth, as one might expect in literary matters, is far more complex. Some writers, notably Rafael Alberti, went into voluntary exile, not return-ing until after the death of Franco. In sharp contrast, Antonio Buero Vallejo, like Alberti, a painter who would turn to literature, remained in Spain. To be sure, his presence was at first involuntary, for he was con-demned to death as a Republican supporter in 1939 and spent six and a half years of a commuted sentence in prison. It is all the more striking that he chose to launch a new career, as a playwright, upon his release. By the late 1940s, his work was being staged, and during the next decade he was already winning national drama awards. Far from conforming to the taste of the regime, he pursued his philosophical and social interests with an adroit skill that conveyed his commitment to human values while eluding the clumsy interference of the censors. *Historia de una escalera* (Story of a Staircase) first produced in 1949 won him the Lope de Vega Drama Prize. His *En la ardiente oscuridad* (In The Burning Darkness), first staged in 1951, he uses the device of blind characters to hint at the political envi-ronment then prevailing. *Un soñador para un pueblo* (A Dreamer for a People) in 1959 and *El sueño de la razón* (The Sleep of Reason) in 1970, were among a series of plays that maintained an undercurrent of dissent during the Franco years. A succession of awards for his dramatic output was

followed by membership in the Spanish Royal Academy in 1971. His honors and achievements continued during the post-Franco era, with the National Drama Prize in 1980 and the Miguel de Cervantes Prize in 1986. His work for the theater continued unabated until a week or so before his death in May 2000.[5]

Like Buero Vallejo, Carmen Conde was shocked and agonized by the Civil War, which transformed her from a naive young woman into, as she has said, a true adult. But she and her husband (and fellow writer Antonio Oliver Balmás) remained in Spain during the war because "we did not want the victor to get the spoils." Her work as an educator was paralleled by a series of more than fifty books, including collections of poetry and memoirs. Her combination of art and integrity was recognized by her election in 1979 to the Spanish Royal Academy, the first woman to achieve that distinction.[6]

Also notable among those who had begun their literary careers before the Civil War and continued to develop their craft under the adverse conditions of the dictatorship were José Luis Sampedro, an economist by profession whose sensitivity and commitment to social decency transcended the brutality of the era in such novels as *La paloma de cartón* (The cardboard dove, 1952) and *Un sitio para vivir* (A Place to Live, 1958), and Gonzalo Torrente Ballester, drama critic and playwright turned novelist who ventured into American academic life in the late 1960s but soon returned to Spain to take up his confrontation with Spanish life in the waning years of the Franco regime. Both men, like Conde, continued to achieve distinction after the triumph of democracy, with Torrente receiving the Miguel de Cervantes Prize in 1985 and Sampedro's election to the Spanish Royal Academy in 1990.[7]

For writers who were adolescents during the Civil War, the option of self-exile scarcely existed. Instead, they shaped their lives to live within the authoritarian system of the post-war decades without succumbing to its oppression. Miguel Delibes originally pursued a discrete career in commercial law, and taught the subject for some nine years until a growing interest in writing led him into journalism. He rose to editor-in-chief of the newspaper *El Norte de Castilla* but was forced to resign in 1963 due to political pressure. While he had attempted unsuccessfully to trick and evade the censors of the media, he had better luck as a writer of fiction. Devoting his attention fulltime to a series of novels, he won virtually every prize that Spanish literary life had to offer and was admitted to the Spanish Royal Academy in 1974, just as the Franco era was coming to an end. As he has recalled, "I struggled with censorship constantly, and on this front the effort bore its fruits." Each successive novel gained him wider latitude

for boldness of subject matter and treatment. Awarded the newly created Prince of Asturias Prize after the establishment of democracy, Delibes continued to be the focus of national admiration for his artistic skill and his persistence in speaking his mind. From *La sombra del ciprés es alargada* (The Shadow of the Cypress Is Long) in 1948, through the *Cinco horas con Mario* (Five Hours with Mario) in 1966, and *La mortaja* (The Shroud) in 1970, and on to *Madera de héroe* (The Stuff of Heroes) in 1987, and *Pegar la hebra* (To Start a Conversation) in 1990, Delibes has enhanced his reputation as one of Spain's major twentieth-century authors.[8] His contemporary José Luis Castillo Puche likewise combined journalistic evasion of censorship with more audacious excursions into fiction. In *El vengador* (The Avenger, 1956), *El perro loco* (The Mad Dog, 1965) and *El libro de las visiones y de las apariciones* (The Book of Visions and Apparitions, 1977) Castillo Puche conveys a sense of the moral ambiguity, anarchic conflict, and claustrophobic confinement of the Franco years. Despite his having supported the Republic and questioned the morality of the victors, he gained numerous literary awards during the 1950s and 60s, but truly came into his own with the accolade of the National Literature Prize in 1982.[9] Perhaps the most individualistic member of this generation, Juan Benet was born in 1928 and trained as a civil engineer. He followed that profession throughout his life, insisting that he was just a man who presided over public works during the week and wrote on Sundays. One critic has said of him: "A master of his craft, Benet builds with a firm hand a bridge or a novel, a road or an essay." Beginning in his thirties, he turned his mind to a variety of novels, short stories, essays, and plays. Perhaps inevitably, his work included a series of four related novels dealing with the Civil War, culminating in *Herrumbrosas lanzas* (Rusty Spears, 1980). His *Una meditación* (1969) was published in the United States as *A Meditation* in 1982. It has been called "one of the most important novels of the postwar era and one of the most lyrical works of the last 30 years." For all the talk of lyricism, however, the veteran engineer remained both pragmatic and ironic with one of his last novels, *La construcción de la torre de Babel* (The Construction of the Tower of Babel, 1990).[10]

Among the female writers who were in their teens during the Civil War, three women in particular stand out. Carmen Laforet, produced a first novel, *Nada* (Nothing) in 1943, portraying life in postwar Barcelona, with its grim and grimy existence, its strange individuals dogged by constant food shortages, and a young protagonist whose curiosity and optimism stand in sharp contrast to the surrounding apathy. The youthful author immediately became notorious and abandoned her studies to pursue a literary career. Several more novels followed, but by 1970 she had become

disillusioned with critics and journalists and virtually abandoned the pen in favor of an obsessively private life.[11] Carmen Martín Gaite and Ana María Matute both moved away from the social realism that constituted the predominant approach of Franco-era writers. Gaite experimented with themes that explored the borderline between actuality and imagination, while Matute pursued an interest in worlds of fantasy. From *Entre visillos* (Behind the Curtains), which won the Nadal Prize in 1957 through *El cuarto de atrás* (The Back Room), which won the Prince of Asturias Prize, in 1988, recognizing more than three decades of distinguished work, she transcended the political dividing line of the mid-1970s.[12] Of Ana María Matute, Gautier said that her work "depicts the disintegrated world of the postwar years, but it also reflects a cosmic world in which her protagonists look up toward heaven with moonlight in their eyes." In books like the award-winning *Fiesta al noroeste* (Fiesta in the Northwest, 1953), and *Los hijos muertos* (The Lost Children, 1958), which won the National Crítica Prize and the Miguel de Cervantes Prize in 1958, she revealed her understanding of the interaction between the child and the adult. *Los soldados lloran de noche* (Soldiers Cry By Night) was honored by the Spanish Royal Academy in 1969. It was part of a trilogy that began with the *Primera memoria* (First Memory, 1959), a novel about children thrust into the adult world by the Civil War and concluding with *La trampa* (The Trap, 1969) in which the children of the earlier narrative have grown up. Among her publications of the post-Franco period, *Solo, un pie descalzo* (One Bare Foot, 1983) is particularly notable.[13]

Born in the 1930s and still schoolboys in the early days of the Franco regime, Francisco Umbral, Manuel Vázquez Montalbán, and Juan Marsé began their working lives when the dictatorship was already emerging from its most repressive phase, the first two as journalists, the third as a jeweler.

Marsé, a Catalan who was compelled to undergo his schooling in the Castilian language, was as much inspired by world literature, read in translation, as by the conventional Spanish classics. After trying his hand at short stories, he became a full-time novelist. Beginning with *Encerrados con un solo juguete* (Shut in with a Single Toy, 1960) and continuing through *Esta cara de la luna* (This Side of the Moon, 1962), and the prize-winning *Ultimas tardes con Teresa* (Last Afternoons with Teresa, 1965), he went on to produce *Si te dicen que caí* (The Fallen, 1973), described by Guatier as "One of the best Spanish novels of the 1970's." During the post-Franco years, he continued to present his strong images of opposition to repression and life on the margins of society in such books as *Confidencias de un chorizo* (A Thief's Secrets, 1977), *Un día volveré* (Someday I'll Return,

1982), *El fantasma del cine Roxy* (The Ghost of the Roxy Theater, 1985) and *Teniente Bravo* (Lieutenant Bravo, 1987).[14]

Unlike the low-key Marsé, Umbral has displayed a flamboyant literary and personal style that has gotten him into trouble with the authorities and the critics ever since the 1960s when he provoked the censors under the inspiration of Delibes at the risk-taking newspaper *Norte de Castilla*. Beginning with a bold reevaluation of the writer Mariano José de Larra in 1968 and continuing through what he calculates, with typical exaggeration, as more than 75 books and a million articles, he has touched upon biography, literary analysis, political issues, and fictional themes in a wide range of novels. In the last days of the dictatorship, his rising prominence was confirmed by the Nadal Prize (1975) for *Las ninfas* (The Nymphs), the concluding novel in a cycle of four in which he traces experiences of childhood and youth. His willingness to confront the larger implications of what has been called the Spanish tragedy is revealed in *España como invento* (Spain as Invention, 1984) and *Memorias de un hijo del siglo* (Memoirs of a Child of the Century, 1986).[15]

Manuel Vázquez Montalbán has published a number of volumes of well-regarded poetry: *Una educación sentimental* (A Sentimental Education, 1967), *Praga* (Prague, 1982), *Memoria y deseo* (Memory and Desire, 1986) and *A la sombra de las muchachas sin flor* (In the Shadow of Flowerless Young Girls, 1973), but he is best known for his narratives featuring the detective Pepe Carvalho, among them *Tatuaje* (Tatoo, 1974), *La soledad del manager* (The Lonely Executive, 1977), *Los mares del sur* (Southern Seas, 1979) and El pianista (The Pianist, 1985). Vázquez Montalbán, like others of the 1930s generation, is strongly inclined to reach out beyond the traditional Spanish setting and literary models to explore the wider world that only became accessible in the later years of the claustrophobic dictatorship. A further reflection of this ever-broadening perspective is his 1990 novel, *Galíndez,* in which he explores the 1963 kidnapping and murder of the New York-based Basque exile Jesús de Galíndez by agents of the Dominican tyrant Trujillo.[16]

One of the most remarkable personalities of the "Found Generation" is Lidia Falcón. The daughter of left-wing journalists, she combined the study of journalism and law with outspoken opposition to the Franco regime, beginning in her student days. By 1972 her activism had earned her a term of imprisonment at the Trinidad Women's Prison in Barcelona for having printed a clandestine pamphlet, which confronted the dictatorship under the title of *La verdad*—"The Truth." In 1974 she was falsely convicted of taking part in a Basque terrorist bombing and spent nine months in the Yeserías Women's Penitentiary in Madrid. Her experience

led her to write a series of exposés about the shocking conditions in women's prisons. Her early career as a lawyer specializing in women's and family issues generated books such as *Mujer y sociedad: Análisis de un fenómeno reaccionario* (Women and Society: Analysis of a Reactionary Phenomenon, 1969), *Cartas a una idiota española* (Letters to a Spanish Idiot, 1974), and *Es largo esperar callado* (The Long Silent Wait, 1975). Far from being satisfied with the end of the Franco oppression, she redoubled her activities with a feminist assault on the patriarchal institutions that survived the transition to political democracy. Her writings of this period include *La razón feminista, I:La mujer como clase social* (The Feminist Reason, I: Women as a Social Class, 1981) and *La razón feminista,II: La reproducción humana* (The Feminist Reason, II: Human Reproduction, 1982). She is the founder and editor of the magazine *Poder y Libertad* (Power and Liberty) and has aided the publication of other feminist works through her *Vindicación feminista* (Feminist Vindacation). In pursuit of equal rights for women, she initiated the Confederación de Organizaciones Feministas, known as COFEM-FEMEX (the additional letters representing the Euskera, or Basque, equivalent). A poet, playwright, and novelist as well as lawyer, politician, and international champion of women's issues, this Renaissance woman summed up her public life thus far in *Memorias políticas (1959–1999)*, an autobiographical narrative in which she recalls her early struggles against censorship, the persecution and tragic exile of her comrades, her own imprisonment and then moves on to the still-flawed environment of Spain today, a country in which the repressive power of elites and the irrelevant trappings of monarchy still stir the indignation of this unreconstructed revolutionary.[17]

Special mention must be made of three writers of particular distinction, or at least notoriety, who shared the experience of their fellow Spaniards during the Franco years. The most senior of these, or certainly the best known abroad, was Dámaso Alonso, poet and scholar who broke with his Imagist style in the startling *Hijos de la ira* (Children of Wrath, 1944). This collection of poems has been described as follows by G. G. Brown: "The poems pour out a torrent of rage, revulsion, and despair, expressed in long, tumbling lines of free verse and in a vocabulary of violence, ugliness, and rottenness. They contain no specific protest, either political, social, or metaphysical, but constitute a raucous cry of horror, inspired by the spectacle of the world as Alonso saw it in 1944, a spectacle which as he himself said, made him suddenly sick and tired of elegant aesthetic exercises."[18] Alonso spent the next several decades essentially concentrating on linguistics and philological study, surviving into the post-Franco years as a "grand

old man" of Spanish letters. In sharp contrast was the short dazzling literary career of Luis Martín Santos, a psychiatrist whose novel, *Tiempo de silencio* (Time of Silence, 1962), has been hailed as a remarkable breakthrough in literary form and subject matter. Brown speaks of this novel as exuding "an artistic exuberance and self-confidence rarely to be met within the sober documentary fiction of post-war Spain."[19] Whether or not Martín Santos was about to lead a new departure in Spanish literarture, as some have suggested, must remain unknown, for he was killed in an automobile crash in 1964 at the age of 39. José Gironella seemed likely to become the ultimate chronicler of Spain's twentieth-century experience. His novels *Los cipreses creen en Dios* (The Cypresses Believe in God, 1953), *Un millón de muertos* (One Million Dead, 1961) and *Ha estallado la paz* (Peace Has Broken Out, 1966) trace the origins, course, and aftermath of the Civil War with what, at least to many foreign readers, seemed to be an authoritative thoroughness. His fellow countrymen were less accepting. Some dismissed the books as more like treatises than novels, and others felt that he was too sympathetic to the winning side. For whatever reason, Gironella, despite his substantial production, "failed to fulfill his potential."[20]

No figure loomed larger among Spanish writers of the Found Generation than Camilo José Cela. A man of massive talents and massive personality, he disdained self-exile or emotional withdrawal and defied the efforts of censors and the sniping of critics with equal bravado. Born in 1916, he fought on the Nationalist side in the Civil War, but, it has been said, spent the rest of his life making up for that choice. His most famous novel, *La familia de Pascual Duarte* (The Family of Pascual Duarte) was published as early as 1942 and has appeared in countless editions and a multitude of translations over six decades. Some have called it the best known, if not the greatest, Spanish work of fiction since *Don Quijote*. An unsparing self-revelation by the murderous peasant of the title, it shocked by its mixture of brutality and humanity. In *La colmena* (The Hive, 1951), he offers an intricate portrayal of contemporary life in Madrid, interweaving some 300 characters struggling with the frustrations and oppressions of the Franco dictatorship. Variously called the founder of a new school of social realism or the father of *tremendismo* (an emphasis on violence and grotesque imagery), Cela disdained categories and labels, turning over the years to a wide variety of themes and approaches. A self-confidence amounting at times to arrogance and an audacity that seemed always to escape the usual fate of the reckless fascinated the public and kept the authorities off balance. It might have been said that there were two Celas. One was the author of the travel acount *Viaje a la Alcarria* (Journey to the Alcarria, 1948), the

member of the Spanish Royal Academy (1957), and the editor of the respected literary review *Papeles de Son Armadans* (1956—1979). The other was the author of the multivolume *Diccionario Secreto* (Secret Dictionary), whose eleventh volume appeared in 1972, a compilation of "unprintable" but well-known words and phrases, described by some contemporaries as "disgusting" and "appalling."[21]

After the death of Franco, King Juan Carlos marked the esteem in which Cela was held by inviting him to join the drafting committee for the Constitution. As Cela tells it, his proposals were too democratic (or perhaps too outrageous) to win acceptance from his more staid colleagues, but, within a few years, the monarch honored him again with a title of nobility.[22]

Cela continued his prodigious output, which would total more than 100 books, including *Rol de cornudos* (Catalogue of Cuckolds, 1976), *Mazurca para dos muertos* (Mazurka for Two Dead People, 1983), for which he received the National Prize for Literature, *El asno de Buridán* (Buridan's Donkey, 1986), *Nuevo viaje a la Alcarria* (New Journey to the Alcarria, 1986), *Cristo versus Arizona* (1988), *El asesinato del perdedor* (The Assassination of the Loser, 1992), and *La cruz de San Andrés* (The Cross of Saint Andrew, 1994).

In 1989, Cela was awarded the Nobel Prize for literature. He received the press with an air of cheerful aplomb, flanked by his large and equally complacent cat and his smiling young female companion. A frequent interviewee on television and the press, he could always be counted on for provocative opinions and unorthodox perspectives that alternately delighted and shocked his countrymen. When asked about his reputation as "enfant terrible" and "nonconformist," Cela insisted that nonconformity is in the best tradition of the greatest Spanish writers. Quevedo, one of the masters of the Siglo de Oro, raised the flag of nonconformism, according to Cela and he sees himself not as a rebel but as a traditionalist in that splendid tradition.[23]

When an interviewer asked him about his plans, following the award of the Nobel Prize, Cela replied, "I am going to keep writing, which is what really matters to me. Winning the prize was an important step for me, but not the end in itself: the only end is death."[24] Perhaps even more indicative of his feelings about literature is a remark he made shortly after presiding over a television production of *Don Quijote*. "*Don Quijote*," he declared, "is a perfect work," of which he had made the most respectful adaptation. In Cervantes' protagonist, it may be that Cela sees something of himself, a man who honors tradition, but is forever riding off on bold quests and new adventures.

The Boundaries of Barataria: Literary Excess

The Found Generation was joined by those who had been "lost" in the late 1970s. Rafael Alberti, who left Spain with his "fist clenched," as he said, returned with his "hand extended in friendship."[25] Jorge Guillén, the poet, left his American academic exile. Pedro Salinas and Juan Ramón Jiménez, both men of great renown in modern Spanish literature, had died during their long years abroad. But there were others, young enough and fit enough to make their journey home, who chose not to do so. Fernando Arrabal and Juan Goytisolo had settled in France, becoming not merely expatriates, but ostentatious cosmopolites. Although Arrabal was frequently identified by this time as a French author, he continued to write his plays in both languages and to regard himself as a Spaniard. Like him, Goytisolo mingled a fascination with medieval Spain with a commitment to bold experimentation in literary forms. Although making occasional visits to their native land, they both preferred to think about it at a distance.

For the most part, however, there was a readiness to integrate the literary world of the Franco era with that of the new democracy that surprised and confused many foreign observers. Their model of a deep cleavage between pro- and anti regime writers was only gradually abandoned, as they discovered the essential integrity of those who had maintained their personal dignity and devotion to art during the years of censorship. Members of the "Found" generation continued their activity during the post-Franco decades, although some of the senior ones gradually disappeared from the scene. Often, like Gonzalo Torrente Ballester, who died in January 1999, at the age of 88, still dictating a page a day, they simply refused to give up writing until they were forced to give up life. The youngest ones, like Francisco Umbral and Manuel Vázquez Montalbán, remained as productive and popular as ever over the post-Franco decades, while Ana María Matute surprised many by publishing a vast and fascinating saga of medieval fantasy that she had been working on for some 25 years. She confessed to a private superstition that if she ever completed it, she would die, but, as she remarked cheerfully, here it was at last and she was still around to take pleasure in its enthusiastic reception.[26]

The "oldtimers" were joined by a steady flow of fresh talent—writers born in the 1940s and 50s. Most of these shared the outlook of Eduardo Mendoza, who told an interviewer from the United States: "The Spanish novel is the same as ever, although it has gone through consecutive periods of evolution. For instance, we now have reached a plateau and we question many things. Times of crisis are very productive. We are ready to follow new paths, come up with new answers, experiment with an invigorating

vitality." Mendoza himself, with his interweaving of the detective story and the picaresque tradition, his openness to international audiences (and the prizes he won from French and Italian juries), and his success in transforming his novels into films, was a prime example of his own characterization of contemporary Spanish writers.[27]

Justo Jorge Padrón, a lawyer turned poet, is another representative of this new breed. He has delved deeply into the mystical roots of poetry, yet transcended his Spanish background to become a bridge between Spanish and Nordic literature. Along with his many books of original poetry, he produced a translation of Vicente Aleixandre's work into Swedish, and went to Stockholm to accept the Nobel Prize for literature on behalf of the ailing Spanish master. Intimately involved with the worldwide study of the mystical forces behind poetry that the Spanish philosopher Fernando Rielo initiated, Padrón, who had spoken before the United Nations on this subject, is a major exemplar of the new internationalism that has attracted Spanish authors.[28]

An even more striking example of this new cosmopolitanism among younger Spanish writers is presented by Julián Ríos. Formerly a student in France and England, he has emerged since the late 1970s as one of the most intriguing experimental writers in Spain, often referred to as the Spanish James Joyce. Ironically, but perhaps inevitably, he has set his major novels in London, which he finds to be a fantastically polyglot and complex metropolis. His novel *Larva: Babel de una noche de San Juan* (Larva: Midsummer Night's Babel, 1983) was hailed in the 1985 Book of the Year of the *Encyclopaedia Britannica* as "the most disturbingly original Spanish prose of the century" and "an instant modern classic" whose eccentric arrangement of text on right hand pages and commentary on the facing pages fascinates literary critics.[29] The Barcelona literary review *Quimera* spoke of *Larva* as "one of the most anticipated works of the last decade, an orgiastic text, a feast of words, a narrative and linguistic achievement that discovers new territories for the Spanish language."[30]

The success of two other writers of the post-Franco era, Rosa Montero and Antonio Muñoz Molina, illustrates the increasingly flexible boundaries of the Spanish literary world. Coming from modest social backgrounds and lacking the traditional literary grounding, these two products of the 1950s graduated from newspaper work and concert management, respectively, into novel writing almost accidentally. Once finding their true *metier* they have been passionate and prolific authors. Montero has written, among others, *Crónica del desamor* (Chronicle of Indifference, 1979), *Amado amo* (Beloved Master, 1988), *Temblor* (Tremor, 1990), *Amantes y enemigos* (Lovers and Enemies, 1998) and *La hija del canibal* (The Daughter of the

Cannibal, 1998), while Muñoz Molina's novels include *Beatus Ille* (Happy the Man Who, 1986), *El invierno en Lisboa* (Winter in Lisbon, 1988) and *Plenilunio* (Full Moon, 1997). Montero has become identified at home and abroad as a feminist writer, although she insists that she does not consider herself such. She writes about women, she says, but does not limit herself to their problems or an interest in exclusively female characters. Muñoz Molina believes that there is a palpable difference between the writers of his generation and those like Cela and Matute who represent an older tradition, saying: "Our literature is less parochial and more connected to the rest of the world than theirs."[31]

There can be no doubt of this global connection. Even the literary prizes awarded by Spanish juries reflect it. A number of these awards were created before, or during, the Franco era, but they have proliferated in the heady atmosphere of the new monarchy. They include the Miguel de Cervantes Prize, created in 1976, and the Prince of Asturias Prize in 1980, the former often referred to as the Nobel Prize for Literature of the Hispanic World and the latter established by the king and queen in honor of their heir and bestowed by the prince himself. They have been joined by a host of special prizes offered by publishing houses, cultural institutes and private foundations. Cervantes Prize recipients include such Spanish American writers as Carlos Fuentes (Mexico), Juan Carlos Onetti (Uruguay), Ernasto Sábato (Argentina), and Guillermo Cabrera Infante (Cuba). The Peruvian Mario Vargas Llosa and the Mexican Juan Rulfo have gained the Prince of Asturias Prize. Vargas Llosa has also won the Premio Menéndez Pelayo and the Uruguayan Mario Benedetti has been granted the Queen Sofía Prize for Iberoamerican Poetry. In addition to the lingering effects of the so-called "Boom" in transatlantic writers that began in the 1960's, Spanish judges have increasingly recognized such non-hispanic authors as Günter Grass, also a recipient of the Prince of Asturias Prize.

Publishers as well as readers have turned increasingly to foreign authors. Their choices are by no means limited to those writing in Spanish. Recent lists of "best sellers" include such imports from the United States as Danielle Steele, Tom Clancy, John Grisham, Frank McCourt and the late Harold Robbins. Not only are British and French thrillers eagerly read, but the newly internationalized Spaniard is urged to purchase such series as "Classics of the European Union," in which he can find Spanish translations of everything from Finland's *Kalevala* to the works of Luxembourg's favorite son, George Rodenbach.

Some Spanish literary critics have attempted to maintain their focus on the new writers in their own country. One recent "Best Books of the Year" list, for instance, cited new works by Rosa Montero and Antonio Muñoz

Molina as well as rising stars like José Manuel Caballero Bonald and Miguel Sánchez-Ostiz (who has written more than 25 books in 15 years). Other champions of Spanish literature continue to celebrate the traditional classics. A marathon reading of *Don Quijote,* organized to commemorate the anniversary of Cervantes' death, drew scores of readers and hundreds of listeners in Madrid and equally enthusiastic admirers of Spain's greatest writer in half a dozen other cities. Not merely academics but enthusiasts ranging from government officials to sports stars gave eloquent testimony to the continuing appeal of the Knight of La Mancha and his faithful squire Sancho Panza.[32] The continuing reverence for Luis de Góngora was demonstrated in December 1997, when a commemoration was held, not merely of the great author but of the seventieth anniversary of a famous commemoration held at Seville in 1927, when such twentieth-century luminaries as Federico García Lorca, Rafael Alberti, Dámaso Alonso, and Jorge Guillén gathered to mark the tercentenary of the great Sevillian poet. The event was a homage not only to this master of the Golden Age but also to the enduring literary tradition that had preserved and expanded Spanish literature.[33]

There remains, nonetheless, a real question as to whether or not the distinctive characteristics, the particular identity, of Spanish literature can be preserved in an age of pan-Europeanism, global outreach, and encroaching vulgarization.

As early as 1980, Spanish writers such as Goytisolo, Benet, and Marsé were complaining about a straightjacket of social realism which had survived the death of Franco, creating a narrative tradition of stories about bored workers, written in a boring way, that bored the reader. For them, the attempt of Martín Santos to introduce a Joycean manipulation of words and scenes represented an aborted new departure that they were eager to bring back to life. Not only did they declare the subjects of Civil War and dictatorship to be "paleolithic" and meaningless to young Spaniards, they also insisted that post-Franco politics were unworthy of their interest. Instead, they committed themselves to experimentation. Many intellectuals were disenchanted with the cautious pace of change under the restored monarchy. Vázquez Montalbán pointed out, "The transition to democracy has happened in a very unesthetic manner . . . There has been no catharsis, no revolution as in Portugal. So the transition itself is not a theme in literature. There is nothing there to stimulate us."[34]

The "culture industry" quickly adjusted itself to the new opportunities and financial realities of the 1980s. A number of smaller publishing houses, such as Seix Barral, which had often taken risks in circumventing cen-

sorship in the old days, now found themselves in difficulty or even forced out of business. Others, like Planeta, cultivated "innovative" and "exciting" writers, or encouraged well-known novelists to launch "experiments." They also sought out foreign authors. José Manuel Lara, Jr., heir to a family publishing empire that includes Planeta, was particularly enthusiastic about the atmosphere that he found in his frequent journeys in Latin America. "America is such an exciting, live continent, and Europe is such a dead continent . . . If you live in America, you live novels in the street, there is a vital force and excitement."[35]

With the mounting vogue for overseas talent, the demand for novelty and exoticism, and even a distracting recrudescence of Catalan, Basque, and Galician literature, it was hardly surprising that a certain inferiority complex should emerge among writers in the Castilian tradition.

This malaise was still evident at the beginning of the 1990s as the poor performance of the socialist regime, the corruption and confusion in high places, and the deterioration of social values continued. Even younger and successful writers like Muñoz Molina complained: "Today's Spain is a big disappointment. On the one hand, I cannot forget that we finally enjoy freedom, but, on the other hand, many of us who, in the 1970s, had such high expectations during the advent of democracy have been disillusioned by the current state of affairs. It seems that Spain is turning into a nation with little dignity and too much corruption." Preoccupied with the Common Market and obsessed with its showcase planning for the Discovery Quincentenary, Spain was, in the opinion of Muñoz Molina, rushing forward without a clear vision. The country should take time to reflect on where it had come from and where it was going.[36]

At an international gathering in the summer of 1999, Nobel Laureate Camilo José Cela announced, rather slyly, some tentative and flexible opinions on Spain and the Spaniards. They were, he said, unlike anything found among all the other nations of the West or the East. There is nothing like Spain—its values are very high and unique. These values are irreducibly Spanish and they have produced *La Celestina*, Cervantes, Velazquez, Goya, Unamuno, Picasso, and Falla. In all of these, he insisted, there was an ultimate "something" that was distinctively Spanish. The virtue that identified and vivified all these great examples of Spanish culture was disobedience, a quality that when carried too far could become revenge seeking, and be transformed into the Spanish vice of envy. He remained positive in his feeling about contemporary Spain, a country which ground up its people, people who would turn out all right if you left them alone.[37]

On the literary scene at the end of the century, Cela was more ambivalent, acknowledging some good young writers but speaking too of certain gaps or even a wasteland. As for himself, he confessed that his forthcoming novel, *Madera de Boj,* was a pretty good piece of work, although one could not be sure of such things. In any event, he intended to go on writing till he had nothing more to say, which, he implied, would not be any time soon.[38]

In one celebrated episode of *Don Quijote,* the peasant-turned-squire, Sancho Panza, is rewarded for his services to the Knight of La Mancha by being given the governorship of Barataria. The whole affair is, of course, an elaborate hoax played by aristocrats who have arranged for his imaginary realm, with a full cast of "subjects" over whom Sancho is to preside. The joke is undercut by the surprisingly shrewd and sensible judgments, which the naive ruler of Barataria hands down in his brief tenure of office. Derived from "barato," a word signifying "cheap," the name Barataria has been used since Cervantes' day, in the literature of various countries, as a synonym for a society built upon corruption, fraud, or delusion.

The question may be raised, as some of the negative opinions expressed during the last two decades suggest: Is Spain becoming a Barataria? Particularly in its literary culture, there have been tendencies toward faddish experimentation, shock for shock's sake, and arbitrary exoticism that undercut the national character of Spanish writing. Contempt for a perceived "canon" of great authors, for all traditional forms and styles, for anything that might be deemed "reactionary" has proliferated. Many have tried to "break the mold" by seeking subjects and settings that take the reader as far as possible from the "boring" environment of contemporary Spain. Readers, seduced by mere novelty, and enchanted by the glittering images of the United States projected on their television and cinema screens, have demanded a different approach to literature. Frequently, they have abandoned literature entirely in favor of glossy picture magazines and polemical newspapers. Thoughtful Spaniards are entitled to wonder whether they are being pushed to the borders of Barataria. Will Spain lose what is distinctively its own? Will Spanish literary traditions and cultural distinctiveness be subsumed into an international style that follows the latest trend down the money trail?

Do Not Disturb Velazquez: The Arts

As in literature, so in the fine arts, the standard dictum in surveys of contemporary Spanish history is that all of the country's creative spirits fled into exile in 1939, leaving behind a vast wasteland. Once again, the truth is more complex.

The achievements of Spanish composers and musicians began to regain worldwide respect in the early years of the twentieth century, with the work of Albéniz, Granados, and Falla. Less generally known were the compositions of Roberto Gerhard and his pupil Joaquín Homs, who introduced various cosmopolitan influences, including the atonalism of Schoenberg. The surrealists of the 1950's, Luis de Pablo and Cristóbal Halffter and others of their circle were heavily influenced by Stockhausen. Joaquín Rodrigo, whose most famous work, the *Concierto de Aranjuez,* was first performed in 1940, followed a more traditional path. His twenty six works for the guitar, among a total of more than 200 compositions, helped transform the guitar into a central instrument on the concert stage. His career helps disprove the notion of aridity in the Spanish musical life of this period and counterbalances the highly publicized self-exile of the Catalan cellist Pau (Pablo) Casals.[39]

During the immediate post-Franco period, the free environment had a paradoxically negative impact on serious music in Spain. Madrid, which had ranked with other major European cities as a center for operatic and orchestral performances, saw its theatrical venues reduced by more than half as commercial pressures transformed them into shopping centers and movie houses. The unusual number of Spanish performers, including such famous singers as Placido Domingo, Monserrat Caballé, José Carreras, and Teresa Berganza, critically praised dancers and musicians, and major conductors like Jesús López Cobos and Rafael Frühbeck de Burgos were forced to spend the greater part of their time outside of Spain due to lack of sufficient outlets for their talents at home.

The situation has gradually improved, beginning with the recognition accorded in the 1980s to such distinguished figures in Spanish classical music as Joaquín Rodrigo (died in 1999) and the guitarist Andrés Segovia (died in 1984), both of whom were granted titles of nobility by the king. Subsidies for the promotion of regional orchestras and the restoration of concert halls in provincial cities became more generous. The Teatro Real in Madrid was extensively refurbished and reopened in 1998 with a gala honoring the king's birthday that featured Domingo and Carreras as well as Luciano Pavarotti, the third of the famous "Three Tenors." Barcelona, which had spearheaded a renewed attention to Spain's musical heritage during its hosting of the Olympic Games in 1992, also undertook a lavish reconstruction of its Opera House. In these latter projects, Placido Domingo, with his worldwide connections and his special fondness for Barcelona, was a major factor.[40]

Despite the global visibility of some of their expatriate "stars," Spaniards retained a particular affection for one of their own who had always main-

tained the closest ties to his own country. Alfredo Kraus, who graced Spain's opera stage since the 1950s, despite periodic tours throughout Europe, Latin America, and the United States, remained an active vocalist until his death in 1999 at age seventy one. Madrid's Opera House was draped in black on this occasion, but the singer had received an even more impressive tribute a few years earlier. In December 1997, the Auditorio Alfredo Kraus de Las Palmas de Gran Canaria had been inaugurated. The son of an Austrian engineer who had settled in the Canary Islands, Alfredo Kraus had become the most revered native son of this outpost of Spanish empire. The creation of this theater, designed by the noted architect Oscar Tusquets, represented not only a personal tribute to the man but an illustration of the new flowering of music in Spain.[41]

A significant part of the vocal scene throughout this period of renewal has been the country's commitment to *zarzuela,* the Spanish version of light opera or operetta. Since its supposed origin in the seventeenth century in performances held in the gardens of a royal residence, this distinctive musical genre has passed in and out of fashion but is clearly alive and well at the beginning of the twenty-first century.[42] Domingo, Kraus, and other major figures in grand opera also took pleasure and pride in performing in the generally sunnier and more romantic works of the *zarzuela* repertoire, which has endured in the Spanish American lands and the United States as well. In an era when everything from productions of *Porgy and Bess* and performances by Carlos Santana to the massed voices of the Mormon Tabernacle Choir is heard on Spanish stages, it is consoling to traditionalists that this most Spanish of musical creations should be holding its own.

There is ample evidence that the new era in Spanish music has produced a fine crop of composers. In December 1997, *ABC* published a musical supplement in which it featured the outstanding young composers of the day. It provided brief career sketches of thirteen men and women who had already earned distinction by the breadth of their studies, the prestigious awards they had garnered, and the successful productions that had established their rising reputations at home and abroad. The list included José M. Sánchez-Verdú, Jesús Torres, Alicia Díaz de la Fuente, Sergio Blardony, Francisco J. Martín Jaime, David del Puerto, César Camarero, Taré Darias, Xavier de Paz, Joseba Torres, Pilar Jurado, Mauricio Sotelo, and Jesús Rueda. Many of these young people are the pupils of distinguished Spanish composers of an earlier generation. The energy and optimism reflected in their work offer high hopes for both continuity and fresh achievement in the Spanish musical tradition.[43]

After generations of resting on the laurels of its baroque palaces and cathedrals, Spanish architecture began a new departure in the mid-nineteenth century with the Catalan movement known as *Modernisme*. After the demolition of Barcelona's medieval walls in 1854, the expansion of its population and the influx of new, industry-based capital stimulated the growth of the city and the activity of such architects as Idelfons Cerda, a civil engineer who planned a new urban environment on a grand scale in the 1870s and 1880s. His successors in the embellishment of Barcelona included Lluis Domenech i Montaner (1850–1923), Antoni Gaudí (1852—1926), and Josep Puig i Cadafalch (1867–1956). As one commentator says, "Barcelona, in its imaginative re-creation of civic space, came to rival Paris or Vienna." The most widely recognized of these masters, Gaudí, became internationally famous for the exotic naturalism of his *Sagrada Familia* cathedral, with its unusual structure and its ornamentation evoking the city's maritime history.[44]

In the great tradition of Catalan architects, Antoni Bonet Castellana pursued his career through the Franco period and beyond. Influenced not only by the Barcelona environment but also by his studies with Le Corbusier, he undertook a number of commissions abroad, especially in Latin America, but carried out most of his best work in Spain itself. From the 1960s onward, Bonet Castellana moved gradually from the design of villas and residential communities along the Catalan coast to the creation of skyscrapers in Barcelona and Madrid, in which the tensions of urban life and commerce are reflected in his structural designs and choice of materials as well as his "intense Spanish integration of sunlight and shadow." Perhaps his most notable achievement was the circular tower of the constitutional Tribunal in Madrid built between 1973 and 1980.[45]

The fine art of architecture has continued to flourish in Spain during the 1990s. At the Olympic Games of 1992 in Barcelona, Ricardo Bofill's neoclassic buildings, Oriol Bohigas's Olympic village and Santiago Calatrava's communication tower overlooking the principal stadium were all much admired by international visitors.[46]

Undoubtedly the best known of contemporary Spanish architects is Rafael Moneo, a winner of the Pritzker Prize, architecture's equivalent to the Nobel Prize. His international projects include the new cathedral in Los Angeles and the Museum of Fine Arts in Houston as well as the Museum of Modern Art in Stockholm. At home, he was chosen to design the long-debated extension to the Prado that would permit display of many of its stored masterpieces. Moneo's guiding principles include a discrete, almost unobtrusive integration of new structures into the site, a concept particu-

larly evident in the Stockholm and Madrid galleries.[47] This, of course, is an approach that contrasts strongly with the dramatically "different" building created for the Guggenheim Museum's new branch in Bilbao, an enterprise reflecting American sensibility conceived by an American architect.

Most of the latest crop of Spanish architects are less deferential in their treatment of the setting than Moneo. They tend to share the American flare for the dramatic and the new. These were common traits noted in an *ABC* article published in November 1997, which surveyed the "under forty" architects who have already made their mark as prizewinners and direction setters in their profession. They include Emilio Tuñón, Luis Moreno Mansilla, Beatriz Matos, Alberto Martínez Castillo, Iñaki Ábalos, Juan Herreros, and Alejandro Zaera Polo.[48]

In architecture, as in music, Spain is clearly reasserting its claim to a substantial place in the enrichment of European civilization, not so much through some miraculous recovery after a prolonged drought as by the renewal of a distinguished tradition preserved over the generations.

The art of film has had its ups and downs in Spain. The most famous name among Spanish directors, that of Luis Buñuel, has been alternately praised and damned for his artistic use of imagery, on the one hand, and his blasphemously expressed detestation of Catholicism on the other. Born and educated in Spain, Buñuel earned his early notoriety in France, where, in collaboration with his fellow Spaniard Salvador Dalí, he made the surrealist masterpiece *Un chien Andalou* (1928) and *L'Age d'or* (1930). By 1932 he had turned to the documentary form, with *Las Hurdes,* a grim portrayal of Spanish poverty that was banned in his native land. The late 1940s found him in political exile and artistic eclipse. Using Mexico as his base, he gradually won his way back to critical acclaim, with such films as *Viridiana* (1961), *Belle de Jour* (1966), *The Discreet Charm of the Bourgeoisie* (1972), and *That Obscure Object of Desire* (1977). By the time of Buñuel's death in 1983, newly democratic Spain had learned to live with the gratification of having produced a master director and its persistent embarrassment over what he had chosen to say about Spain.[49]

The story of Buñuel aside, most of Spain's cinematic activities have been relatively low-key. Although a nation of enthusiastic film goers (with a higher proportion of weekly attendance than any other country in Europe), the Spaniards favored relatively insignificant romances and comedies.[50] Neither the Republic nor the Franco regime made the effective use of film as propaganda that was so widely demonstrated in the Soviet Union, Germany, and elsewhere. *El Caudillo,* himself a movie fan, who actually dabbled in scriptwriting, allowed domestically produced films and foreign imports to

distract his subjects rather than to indoctrinate them. All, however, were subject to censorship on moral and ideological grounds.[51]

As in other branches of the arts, the filmmaking activities of the early post-Franco period were marked by a mixture of disarray and frustration. A plethora of mild pornography and silly farces scarcely suggested that creative genius would now surge up from out of a repressed generation. Gradually, particularly with the coming of the Socialist administration in 1982, a policy of generous government support began to produce more substantial films. The collaboration of the director Carlos Saura and the choreographer Antonio Gades resulted in such interesting films as *Bodas de sangre* (Blood Wedding, 1981), *Carmen* (1983), and *El amor brujo* (Love the Magician, 1985).

The intervention of such members of the González team as the film "tsarina" Pilar Miró and the culture minister Jorge Semprún were important for increasing subsidies to filmmakers and establishing limits on the number of foreign films that could be shown in Spanish theaters. Bureaucratic entanglements, budgetary wrangling, and personal rivalry, however, took their toll. There were complaints about the favoritism shown to Carlos Saura, whose *El Dorado* turned out to be the most expensive film ever made in the country, as well as a box-office failure. The intellectual advisers of Prime Minister González were accused of being elitists who enabled "eccentric" directors to turn out films seen by few and understood by none. Both the owners and the patrons of the movie houses raised a constant clamor for access to more films (mostly from Hollywood), preferring the sight of international stars (even with dubbed voices) to the artistic efforts of their compatriots. Spain, in short, found itself, like most countries in Europe and elsewhere, culturally besieged during the 1990s by the process of Americanization.

Despite the problems of the Spanish film industry in the last decades of the twentieth century, official efforts at support of the native product continued, as did the creative work of actors and directors. The lure of fame and fortune abroad drew many, at least intermittently, to the bright lights and big money that lay beyond Spanish borders.

The most internationally visible Spanish filmmaker of the post-Franco era has been Pedro Almodóvar. During the 1980s he gained attention with a series of colorful productions involving picturesque characters, improbable situations and vivid settings that broke with the Spanish tradition of dark and gloomy imagery. By 1989 his *Mujeres al borde de un ataque de nervios* (Women on the Verge of a Nervous Breakdown) had achieved a box-office breakthrough in the United States, and several of his actors, especially Antonio Banderas, had become marketable overseas. Almodóvar's

path led him in March 2000, to the Academy Awards ceremony in Los Angeles where his *Todo sobre mi madre* (All About my Mother) won the Oscar for best Foreign Film. Like Don Quijote, Almodóvar comes from the province of La Mancha, and his exuberant, slightly incoherent, acceptance speech must have reminded some in his audience of the more outlandish doings of the Don, particularly when he was led away from the podium by Banderas in the role of an elegant Sancho. Some European critics spoke ill of Almodóvar in the aftermath of his triumph, questioning the merits of his film or the overall talent of the director. Relatively little was made of the award by American commentators. Nevertheless, Almodóvar announced that he would soon begin making *El chico del periódico* (The Newsboy) in the United States, with larger financial backing than is usually to be found at home.[52]

Although the standard capsule history of Spanish filmmaking consists of Buñuel and Almodóvar (with, perhaps, a parenthesis for Saura), numerous other moviemakers have been active in recent years. Among them are: Victor Erice, Mario Camus, José Luis Borau, Fernando Trueba, Alejandro Amenábar, Antonio Giménez Rico, Isabel Coixet, Pablo Llorca, Angel Fernández Santos, and Jaime Chávarri. Above all, there is Manuel Gutiérrez Aragón, undoubtedly the most prolific of the "children of Franco" generation of directors, who began in the late 1970s with films characterized by exotic fantasy and has subsequently developed a more realistic style, without abandoning his distinctive artistic and moral stance.[53] One or more of these talented artists may well emerge within a few years as the supplanter of Almodóvar. Indeed, the reigning monarch of Spanish directors might be well advised to remember the first Spaniard to win the Best Foreign Film Oscar. In 1983, José Luis Garci, a director previously not particularly well regarded in Spain, was declared the best filmmaker of the world outside the United States for *Volver a empezar* (Begin the Beguine). Spanish moviegoers had been unimpressed by the sentimental plot and its Cole Porter theme music, factors that possibly won the hearts of the American jurors. Garci proved unable to build upon his sudden fame. His subsequent films attracted little public interest or revenue for his producers. The reputation of a director can flicker and fade like the images on the silver screen.

Even without invoking the prehistoric painters in the caves of Altamira or the masters who adorned medieval Iberia, one can readily justify Spain's artistic claim upon the world's gratitude. El Greco and Velázquez, Zurbarán and Murillo, Goya and Picasso, Miró and Dalí, and a host of others have, over the centuries, provided a consistent record of achievement even when the nation's talents sometimes flagged in other cultural fields. Whether drawing creative individuals from other lands or sending her own children

abroad to refine their skills and exhibit their mastery, Spain bred and fed more than her share of painters and sculptors. Even during the Franco era, the regime clearly understood the importance of the artistic treasures that Spain housed and the inspiration that its mixture of light and shadow continued to provide. Less censored and better supported than those in other dimensions of the arts, Spanish painters and sculptors made a relatively smooth transition from the days of dictatorship to the dawn of democracy.

The Prado, one of the world's greatest museums, had long suffered from an embarrassment of riches, forcing it, by the late 1960s, to keep the bulk of its collection in storage or temporarily banished to provincial galleries. Despite the tentative nature of its approach to "modern art," reflected in some awkward disputes over particular exhibitions, the Franco administration finally committed itself to the development of the Museo de Arte Contemporáneo to house twentieth-century paintings and sculptures. Within a few years of the reestablishment of the monarchy, the Reina Sofía Art Center had emerged as yet another venue for Madrid's overflowing collections. When Picasso's famous evocation of Civil War horrors, "Guérnica," went on exhibition there in 1992, it marked the full blossoming of the Reina Sofía as one of the capital's great art venues. In the meantime, plans had been made to move a large part of the Prado's "hidden" treasures to a newly constructed annex near the original building. Last, but by no means least, the Villahermosa Palace, a short distance from these other museums, was undergoing a transformation as the repository for Baron Heinrich von Thyssen's vast assemblage of paintings and sculptures. When this nobleman's huge hoard had grown too extensive for his Swiss residence, it became the object of lively international competition. To ensure that her native land should acquire it, the Baroness (a former Miss Spain) undertook a mission of cultural patriotism that resulted in the 1988 "loan" of the greater part of the collection to Madrid. In 1993 the permanent transfer of the Thyssen collection to the Villahermosa (with some medieval items diverted to Barcelona) was agreed. Although some grumbled over the price—$315 million—it was, in fact, a bargain by almost any rational calculation. Madrid had now become, unquestionably, one of the art capitals of the world. Nor was the González regime negligent of other regions, which received notable transfusions of funding for museums and acquisitions. The "branch" of New York's Guggenheim Museum that rose during the late 1990s in the hitherto dingy port city of Bilbao carried this process on into the Aznar era.[54]

While Spanish taste down to the last decades of the twentieth century had followed that of most Europeans, who preferred the art of earlier centuries to that created in their own time, a dramatic shift took place during

the 1980s. Early in 1983, a government-sponsored International Festival of Contemporary Art (known more popularly as Arco-83) opened in Madrid. Within days, it was the most popular attraction in the country. By 1984, Spain had become passionate over contemporary art, with over 20 percent of the population visiting a public or private gallery once or twice a month. This enthusiasm continued on through the 1990s, despite all of the distractions and diversions of that decade. Commentators differed widely on the cause of this phenomenon. Cynics attributed it to the search for art as investment that swept the developed world in these flush times. Others talked of a pent-up desire among Europeans in general, and post isolation Spaniards in particular, to know more about recent art achievements. There was also the thought that painting and sculpture were the most innately appreciated of all the arts among Spaniards, who now had made a belated shift in taste from the Old Masters to the new masters.[55]

Who, then, were the most notable of these new masters in the eyes of their fellow countrymen and art critics abroad? In the realm of sculpture, two names stand out: Eduardo Chillida and Juan Muñoz. Eduardo Chillida, a Basque born in 1924, was, appropriately, given a retrospective exhibition at the newly opened Bilbao Guggenheim Museum, whose curator declared him to be "one of the three pillars of sculpture in the twentieth century," placing him on a par with Brancusi and Giacometti. He was among the earliest recipients of Japan's Imperial Prize, putting him in the company of sculptors such as Serra and Segal and painters like de Kooning, Johns, and Hockney. He first came to international attention in 1972, during one of the Franco regime's early, tentative encounters with modern art. His *"Meeting Place III,"* an eight-ton piece, designed to be hung from a Madrid overpass, was rejected on grounds of public safety, an excuse which led to charges of cultural repression and boycotts by other artists. During subsequent decades, Chillida emerged as one of Spain's most prolific and popular artists, earning multiple commissions at home, elsewhere in Europe, and the United States. Although some of his creations are on a modest scale, he has had a clear preference for monumental work. The best known of his sculptures is the "Peine del viento" (Wind Combs, 1977). Set dramatically on the rocky Basque coast near his native San Sebastian, its outstretching combs or fingerlike projections evoke an interaction between land and water, wind and wave. Over the course of his long career, Chillida has worked in iron, steel, wood, alabaster, cement, clay, paper, stone, and plaster. His ultimate project, already some years in the planning, is the hollowing-out of a mountain, so as to create a vast open space eleven stories high and equally as wide, into which light will be admitted through openings at the mountain's peak. A mountain in the Canary Islands has

already been selected and preliminary approval obtained from the local authorities. Although evaluations by engineers and objections from environmentalists remain to be dealt with, the aging sculptor's dream of achieving his ultimate piece of carving, one which embodies the perfect space, moves closer to attainment.[56]

Juan Muñoz, a Castilian born in 1956, contrasts sharply with Chillida, not only in his regional and generational identity but in his assertive and self-congratulatory personality. Unlike the quiet and retiring Basque, Muñoz has proclaimed himself the only Spanish sculptor whom anybody knows outside of Spain and he has been generally dismissive of his countrymen's tastes as well as their institutions.[57] For all his brusqueness and bravado, Muñoz is frequently acclaimed as the best sculptor of his day, and his work is widely displayed in museums throughout Europe and America. Perhaps most often discussed is his "Wasteland" (1986). From papier-mâché, paint and rubber, Muñoz has constructed a scene in which "a forlorn bronze figure perches on a low, wall-mounted shelf." As the viewer approaches this silent reclusive figure across a "wasteland" of geometric designs, he discovers that it is a ventriloquist's dummy, representing, it seems, man's inability to communicate. This and other works, with their isolated figures of dwarves, ballerinas and men in dunce's caps, suggest a prevailing melancholy which, Muñoz has said, is intended to evoke "not nostalgia, but the unbearable."[58]

Somewhat more conventional in his approach, but certainly a sculptor of distinction, is Julio López Hernández, a leader of the so-called "Madrid school." Born in 1930, he has worked in bornze, clay, and wood. His full-length reclining figures, such as "Primavera" (Spring, 1973) have earned him the Premio Nacional de Artes Plásticas and membership in the prestigious Academia de Bellas Artes de San Fernando.[59] Nor are rising figures lacking among the youngest generation of sculptors; Francisco Lleiro, David Lechuga, Susana Solano and Cristina Iglesias have earned the most praise and offer the most promise.[60]

The giants of twentieth century Spanish painting lingered just long enough to provide inspiration for their successors without overawing them: Picasso died in 1973, Miró in 1983, and a much-diminished Dalí in 1989. Antoni Tapiés has been a dominating force throughout the latter half of the century. Born in Barcelona in 1923, he abandoned a planned legal career in 1946 to become a founder member of the Catalan Avant Guard group of artists known as the *Dau al Set*. He drew inspiration from surrealism to produce collages of commonplace debris (string, rags, and torn canvas) smeared with paint. By the early 1950s he was holding one-man exhibitions and winning recognition abroad. By 1957 he had moved on to "informal-

ism" as a founder of the El Paso group. Although he was no admirer of the Franco regime, the nature of Tapiés' materials and subjects did not bring him into direct confrontation with the censors. Adding a Spanish presence to the general postwar movement of abstract expressionism, he provided the kind of "prestige export" that the government welcomed. One of his best-known works of the period is "Ochre" (1963). Integrating a stark surface of sand and asphalt with daubs of black and white paint, the artist produced an abstraction of his own memories of the Civil War period and its aftermath with hints of a "haunting beauty" with the "transcendence of life over circumstance" that critics continue to praise.[61]

While Tapiés and a few of his contemporaries, such as Manolo Millares, preserved a comparatively free field for painters during an otherwise illiberal era, the advent of a completely open society in Spain has naturally produced a multitude of wide-ranging experiments by artists of varying talents. Reputations have risen and fallen during the 80s and 90s as efforts to outrun the most advanced exponents of the avant guard have been counterbalanced by champions of the most conservative traditions. While it is still difficult to judge who among these new painters will achieve the status of a Tapiés, much less a Picasso or Miró, certain of them have attracted more than passing attention. Antonio López García has drawn upon the works of the Spanish Old Masters to create images which have been described as "never straight, photographic portraits, but complex meditations on time, the inertia of life, and the presence of death."[62] Mercedes Gómez-Pablos in her "updating" of Velázquez paintings has combined images of Infantas and their servants with blue insertions of abstract urban scenes that integrate past with present. Josep Guinovart, a Catalan contemporary of Tapiés, and alternately his colleague and competitor, has continued in the tradition of the "informalist" school in such works as his "Nom I blat," an abstraction of paint on wood of the type more esteemed in the nationalist circles of Barcelona than in the fashionable galleries of Madrid. Gerardo Pita Salvatella, on the other hand, represents a reaction against abstraction; his portrayal of scenes and objects from everyday life suggests the "hyperrealism" that some have dubbed "photographic realism." Luis Gordillo has carried abstraction to the point where he has been denounced as "sick," "pathological," producing something conceived in a state of mental agitation or hysteria. Gordillo has responded that he is a "formalist," but one to whom it is very painful to be quiet, living, as he does in a time of "banal artistic democracy" which he must resist.[63]

Leaving these and a thousand other flowers to "bloom and contend" on the contemporary art scene, the Aznar government sought to reestab-

lish a reliable base of art appreciation by lionizing Velázquez upon the 400th anniversary of his birth. Throughout 1999, the "Year of Velázquez," major exhibitions were mounted at the Prado and elsewhere and a massive excavation was carried on in the center of Madrid to locate his remains. The painter had been buried with the full honors of the Spanish Royal Court in 1660, but the chuch of San Juan in which he reposed was razed to make way for a public plaza in 1809 during the intrusive reign of Joseph Bonaparte. No one now knew where his bones rested. The central government ordered digging operations in the plaza, which turned up great quantities of archeological matter but no identifiable coffin. The regional authorities, not to be outdone, produced a mummy from an unmarked crypt in a nearby church which, they insisted, was that of Velázquez. Rival bureaucrats issued competing statements, politicians weighed in with accusations about a sinister scheme to create an underground parking garage or simply waste money, and the media followed the whole process with alternating spasms of melodrama and mockery. At the end of it all, no authentic remains could be produced. The reaction of the Spanish people ranged from that of a laborer working on the "dig" who said with a shrug, "if Velázquez turns up, he turns up," to the protest of the writer Francisco Ayala, who pointed out that no one knew or needed to know where Cervantes was buried.[64]

It would be well if the "Year of Velázquez" experience served as a salutory lesson for the guardians of Spain's cultural heritage and the promoters of its cultural future. The treasures of the past require preservation and respect without the kind of hyperactive episodes that show more touristic or commercial motivation than scholarly concern. Do not disturb Velázquez. His reputation is secure. While he sleeps with the weight of the centuries upon him, Spain needs to focus upon the decades ahead and the painters, poets, and performers who may bring a new Golden Age.

Passing Time: Popular Culture

Spain is an "old country that feels new—transformed in a few years from a backward almost Third World nation to a super-slick Eurostate."[1] Such is the opinion of a recent commentator. Like all facile generalizations, this one is itself misleadingly "superslick." Yet it contains a kernel of truth when applied to popular culture. Spain's greatest writers, composers, artists and architects of today, like their predecessors, exist within the European mainstream. It was only when one moved down from the level of high culture into that of low (or "popular") culture that one found what was distinctively Spanish. To a large extent, this is still the case. Ordinary Spaniards continue to pass time in a variety of ways that are peculiar to their country. Still, the passing of time has accelerated in the last quarter of the twentieth century. Traditional activities have been changed by the demands of expediency, the intrusion of novelties, and the loosening of long-established restraints. The archetype of Spanish recreation, bullfighting, no longer occupies the central place in the nation's sporting life, an honor now largely conceded to soccer, that most universal of games. The ever-multiplying means of passing his increasing amount of leisure time now tempt the average Spaniard with a host of publications ranging from the romantic to the pornographic as well as mass-appeal television and cinema that offer a global array of trivia. With the passing of time, the nature of popular pastimes could, in truth, draw the Spanish people into a homogenized Euro-culture.

Traditional Activities: Folk Heritage

What were the traditional leisure-time activities of the Spanish people? Many non-Spaniards could come up with a few stock answers: taking a *siesta* in the middle of the day and eating late at night, dancing and singing *flamenco,* and attending *fiestas* that seem to involve statues of saints and a lot of fireworks. Unlike most stereotypes, these foreign perceptions are not particularly negative, nor are they particularly inaccurate, even today. Still, the traditional activities of the Spaniards are yielding, in many cases, to external influences.

The *siesta,* for instance, has come under attack from the European Union, as the other 14 members take a much shorter lunch break than the traditional 3 hours accorded to Spanish workers for a meal and a sleep period. The idea of Spaniards going home between 2:00 P.M. and 5:00 P.M. and returning to work until 8:00 P.M. or 8:30 P.M., once regarded abroad as quaint, is now frequently derided as an eccentric nuisance. Moreover, the shifts in Spanish society that have created traffic congestion in downtown areas and suburban residential patterns have made it difficult for many employees to make the round trip without it turning into a hectic rush— to say nothing of the fact that younger Spanish wives are often working outside of the home themselves, leaving no one to cook the midday meal for a returning spouse. Employers, newly converted to bottom-line philosophy, have thrown their weight behind the anti-*siesta* movement. People who are serious about working do not take *siestas,* warns one personnel director ominously. Suggesting that this warning has been taken seriously, a recent survey found that only 25 percent of Spaniards took a daily *siesta* ; even fewer follow the once-customary practice of actually going to bed. An executive of the mattress company that took the survey sadly observed that the *siesta* had become a mere cliché, since people simply did not have time for it. Most of those who did, the poll found, were members of the older generation, and lived in the warmer provinces of the south. Pro-*siesta* advocates may be fighting a rear-guard action but have done their best to maintain the notion of a more leisurely, family-enhancing lifestyle. They have even sought evidence of a shift in overseas attitudes. The newspaper *El Mundo,* in a 10-page section devoted to the issue, cited research proving that rest periods in the workday had been found medically and mentally beneficial. In its 1999 examination of the question, the paper listed major American corporations that were trying out the concept of "power naps" by providing sleep lounges. The headline proclaimed "It's proven—the *siesta* is beneficial, and if in the United States they are starting to discover it, here it continues to be part of the national heritage." But the champions of tra-

dition seem to be fighting a losing battle, with the new corporate culture dismissing the advocates of the *siesta* as mere defenders of laziness. The three-hour break has in many instances being cut down to two, with the threat of worse to follow. Those who are traditionalists (or simply tired) are striking back. They are everything from "closet nappers" to snoozers in their own parked cars. Entrepreneurs are filling this emerging niche by setting up nap lounges in downtown areas where weary businesspeople can get a neck massage and a half-hour sleep in ergonomically designed chairs. Peering into a room of these blanket-wrapped blissfully unconscious adherents of the old order, one obtains a snapshot of Spain in transition.[2]

Spaniards are much more passionate about their food than their *siesta*. Although McDonalds and its clones have penetrated the country, they are held at bay by a persistent love for the freshest of fruits and vegetables, the wide variety of regional specialties in meat and seafood, and a preference for leisurely meals stimulated by good wine and animated conversation. The demands of tourism have compelled some hotels and restaurants to offer an "international cuisine" and to serve meals at hours that conform to foreign norms, but most Spaniards still cling to their traditional dishes and, distinctively, to the practice of dining at 10:00 P.M. or 11:00 P.M. Some visitors, particularly Americans, have learned to ask for *paella* (which they regard as the Spanish equivalent of spaghetti and meatballs) but are surprised to find that this rice-based dish has a multitude of local variations. They are even more surprised to discover that the true national dish is properly the meat stew called *cocido* in Madrid, *potaje* in Andalucia, and *escudella* in Catalonia.[3]

The most sophisticated of travelers will seek out such superstars of international cuisine as *El Buli*, a restaurant located in a spectacularly remote combination of mountain and Mediterranean scenery northeast of Barcelona. World class by general concensus, its relative inaccessibility separates the genuine gourmet from the mere "beautiful people." Leaving this and other internationally praised venues to the elite, less affluent (or less pretentious) Spaniards seek out their old favorites among country inns and neighborhood cafés that cling to the tradition of good food and fellowship. Here they will be found not only late at night but on those special days when whole families, from grandparents to very young children, gather for a festive meal. These folk are long past the time when they were distinguished by a lean and hungry look. Except for those ladies of fashion who cultivate an anorexic image, Spanish people of the present are enjoying their new prosperity and the plenty that it permits them to set on their tables without succumbing to food faddism.[4]

Of *flamenco,* it has been said that "the majority of its artists and enthu-siasts come from the poorer fringes of society, where life's experiences have taught them to be fiercely independent, proud, and skeptical. Above all, they share a profound sense of suffering." Flamenco's origins have been traced (with more enthusiasm than precision) to pre-Roman times, and every imaginable influence—Byzantine liturgy, Gregorian chant, Jewish and Muslim prayers has been detected in its vocalizations. The Arabic phrase *felang mengú* (wandering peasant) has been suggested as the origin of the word *flamenco* itself. Eighteenth-century documentation reveals its wide spread presence in Andalucía and the increasing participation of gypsies in both performance and composition. By the early 1800s informal schools of instruction were found in various parts of Spain, as the musical form moved northward. Traditional dances such as the *fandango* were incorpo-rated into performances to intensify the emotional impact of the words. By the beginning of the twentieth century, the guitar had replaced earlier Muslim and Christian musical instruments as the quintessential accompa-niment to *flamenco,* generating a whole new range of expression. Changing patterns of population and recreation have led to periodic forecasts of *fla-menco*'s demise. Lorca in the 1920s was already predicting its death, and fresh obituaries were being published in the 1950s. Yet *flamenco* lives on through the dedicated efforts of masters like the late Antonio Mairena and his disciples, who have organized competitions, passed on their techniques and principles, and guided the rising generation between the twin threats of ossification and vulgarization. There are those who claim that "true" *fla-menco* was irretrievably injured by efforts made during the later years of the Franco regime to transform it into an authentic manifestation of Spanish nationalism, using it for propaganda purposes rather than sustaining it against changes in musical fashion. Others complain about the falseness of performances designed to entertain tourists and warn against specious "shows" staged in high-priced venues for the benefit of gullible foreigners. There is certainly some basis for both of these criticisms, and the present-day distortions and commercialization often have a lineage directly trace-able to the political salesmanship of the *Caudillo*'s time. Nevertheless, there are plenty of genuine exponents of *flamenco* performing in contem-porary Spain. For example, in a grand festival held in Jerez in April 1998, the whole panorama of contemporary *flamenco* was on display. The "pure" or "orthodox" school of performance was represented by such notables as "Manolete" from Granada, Milagros Mengíbar from Seville, and Antonio *"el Pipa"* from Jerez. Avant-garde approaches, mingling a variety of artis-tic concepts with the fundamental *flamenco* line, were offered by Carmen Cortés and her ballet company who based their choreography on Wilde's

Salomé, and performances staged by Antonio Canales derived from Lorca's play *La Casa de Bernarda Alba* and Picasso's painting "Guérnica." Another grand gathering of performers was held in Madrid to pay homage to Ricardo Freire, the composer and administrator who had done so much to protect *flamenco* and its artists from exploitation. Participants included such contemporary stars (whose very nicknames are characteristic of *flamenco*) as "Serranito," "Menese," "Chaquetón," "Rancapino," "Tomatito," "Pepe Habichuela," "El Güito," "Juan Habichuela," and "La Tati," as well as "Manolete" and Antonio Canales.[5]

By the late 1990s, the renewal of *flamenco* had carried it throughout Europe, where it attained a particular vogue in France and Germany, and to the United States and Spanish America, which offered enthusiastic receptions to visiting performers and produced their own crop of would-be dancers. When Dolores Jiménez Alcántara (known professionally as *La Niña de la Puebla*) died in June 1999, at the age of ninety, *flamenco aficionados* spoke of her career as encompassing the whole modern history of the art. A native of Seville (where her father, like Figaro, was a singing barber), and despite the early onset of blindness, she began her public performances as a child, gradually evolving a style that followed the *"dulce"* approach without losing the essential *flamenco* emotions of loss and longing. Forming a *"flamenco* opera" troupe, she performed throughout the country in the 1930s and 40s in bullrings and theaters, continuing her appearances until the final decade of her life. Married to a singer, she bore children who followed her into the tradition of *flamenco.* A gold medal awarded by King Juan Carlos for her singular contribution to the arts marked both the survival and the renaissance of the genre to which she had devoted her life.[6]

In the repertoire of stock images evoked by the word "Spain," the *siesta* and the *flamenco* are both exotic and a bit off-putting. Most people outside of that country, after all, do not go home to sleep in the middle of the day, much less spend the night singing agonized lamentations punctuated by furious heel-stomping. But who does not love a party? The very word *fiesta* has been appropriated into many foreign languages, and Americans with no tincture of Spanish heritage apply it to everything from cruise lines to clearance sales. Yet Spanish *fiestas* have evolved over many centuries and continue to change as well as to flourish in the present day. They can include the bizarre (a word that may be of Basque origin) as well as the joyous, the shocking as well as the amusing. The word *fiesta* itself, variously translated as "festival" or "party," is general enough to include a multitude of activities, ranging from the celebration of national holidays to the commemoration of patron saints, the perpetuation of regional customs, or the

glorification of local heroes. The officially recognized national holidays are: New Year's Day, the Feast of San José (March 19), Holy Week and Easter, Labor Day (May 1), Corpus Christi, the King's Birthday (June 24), Santiago Day (June 25), National Day (December 6), Immaculate Conception (December 8), and Christmas. In addition, many church holidays are observed nationally or in particular regions on an unofficial basis.

Spain is a land filled with shrines and sanctuaries and with municipalities large and small whose patron saint demands particular recognition on his or her feast day. Thus, there is a seemingly endless succession of communal pilgrimages to holy sites and local celebrations featuring processions, parades of holy images, and rituals commemorating events that occurred so long ago as to have taken on a semi-mythical character. The Feast of the Three Kings on January 6 (which, until recently entirely overshadowed Christmas) is marked in many regions by the public circuit of the three local citizens chosen to portray the Magi. Greatly honored by their selection, these men often spend lavishly from their own resources as they travel about in splendid costumes accompanied by their retinues, distributing gifts and paying their respects to the authorities at churches and public buildings. In other locations, holidays are marked by the parading and frolicking of *gigantes* and *cabezudos* (giants and "big heads"), grotesque figures, as much as 10 or 12 feet tall, often centuries old, that alternately delight and frighten spectators. Elsewhere mounted bands of "Moors" and "Christians" engage in mock battles, galloping about in "antique" regalia that may owe more to vivid imagination than to historical accuracy. Toledo, Valladolid, and Saragossa are lavish in their observances, but they are outdone by the cities of Andalucía: Granada, Córdova, and above all, Seville. Since the sixteenth century Andalusians have been staging their grand displays of piety and passion to compensate, some cynics have suggested, for their acceptance of Muslim domination during the Middle Ages. Holy Week in Seville is famous for its processions of barefoot penitents, lashing themselves with whips, robed and hooded members of confraternities bearing aloft gilded statues and reproductions of scenes from Christ's Passion, and volunteers from the city's parish churches propelling the *pasos,* or floats, upon which their own church's treasured relics and images are arrayed. These constant comings and goings in the streets of Seville are accompanied by the solemn beating of drums, the wailing salutes of gypsy *saetas* and the enthusiastic cheers of spectators as they greet a favorite icon or recognize passing comrades. The solemnity and sobriety of Holy Week are modified by snacking and sipping along the side streets adjacent to the grand parade routes and by the triumphal salutes rendered to the Resurrection on Easter Sunday.

Even the most emotional and enthusiastic of religious celebrations operates under certain restraints of reverence. Spain has, however, an abundance of secular *fiestas* which permit a greater exercise of imagination and license. Some of them are actually counterfoils to church celebrations. *Carnaval,* which precedes the onset of Lent, anticipates the austerity of that season and the penitence of Holy Week by encouraging abandoned sensuality among those who are determined to have a last fling before gloom settles in. Many of Spain's local *fiestas* derive not from saint's days but from the traditional *feria,* originally a cattle fair where livestock was sold, goods and equipment inspected, and old acquaintances renewed. The same city of Seville that so dramatically parades its piety on Good Friday is full of ladies and gentlemen on horseback during the *feria* season, showing off their finery to applauding crowds, who then flock to amusement parks, public dances, and midnight fireworks. These *fallas,* often based upon intricately constructed figures, such as animals and demons that explode with a huge bang and a horrific scattering of sparks, are an ever-popular feature of *fiestas* all over the country.

Amidst all the good-humored revelry of the *fiesta,* there is sometimes a dark side. An undercurrent of violence and cruelty can be detected in certain localities, often reflecting a callous disregard for personal dignity or a mocking contempt for those who are singled out as "different." These attitudes often reflect the medieval origins of particular celebrations and an archaic sensibility out of line with modern values. Brutality is particularly evident in the treatment of animals. In some towns this goes beyond bullfights and "running of the bulls," where there is at least a certain parity between man and beast. Bull-baiting, including a custom of tricking bulls into charging off piers into the sea, suggest little respect for the brave *toro.* Other animals, depending on the locality, are baited or abused, or even in certain places torn to pieces as part of the *fiesta* games. Animal rights activists have grown more ardent in their demands for the elimination of such practices, but have often been repulsed by adamant defenders of tradition.[7]

Franco was, not surprisingly, unmoved by demands for changes in these "old ways." He did, however, warn against "breezes from foreign shores corrupting the purity of our environment." One can imagine his shock at the recent arrangements made to mark the "Jacobean Year," a series of festivities in Galicia, honoring their patron St. James. In addition to such novelties as "audiovisual presentations," the organizing committee was able to treat its constituency to the Rolling Stones, Metallica, Elton John, and the bluesmaster B.B.King. Whatever "pollution" was introduced into Spain by these foreign mischief-makers, the audiences they drew were evi-

dently much larger than those who came to hear indigenous performers. Far more painful to champions of traditional pastimes were the opportunities offered during the New Year's *fiesta* marking the transition from 1999 to 2000. Nightclubs in Madrid and other cities advertised an amazing variety of sex shows, amateur stripteases, and freewheeling licentiousness. Even the ritual of eating twelve grapes at midnight to mark the coming of the New Year was given a contemporary touch of sophistication by one venue, which offered the chance for nude couples standing in a pool to carry out the grape-eating ceremony in a particularly titillating fashion. For those who preferred to celebrate at home, there were games such as a version of Monopoly (*El Chino*) which took players on an interactive tour of the vice dens of "Chinatown" and one in which participants were dealt cards illustrating positions from the *Kama Sutra* to carry them into the new year.[8]

The Sporting Life: Bullfights and Soccer

Spaniards love to make noise. It has been said: "Where there is no noise, there is no life, and a Spaniard flees from tranquility."[9] And what better place to shout at the top of one's lungs, cheer on favorites, denounce opponents, and generally raise a racket than a sports event? It is a thoroughly satisfying way of passing time, and their preferences in sports afford them maximum opportunity to raise a tumult. Certainly this is true of bullfighting.

There is, to be sure, the question of whether bullfighting is a sport or a show. The aspect of spectacle and ritual leads some to argue that it should be considered within the *fiesta* tradition. They are often scheduled as a part of a town's *fiestas* or even as the culminating event of the major feast of the year. Yet, in their ability to arouse communal enthusiasm, to excite passionate praise or reproach toward the "players," and to guarantee endless arguments or historical analysis among *aficionados,* bullfighting is analogous to a sport. For centuries it was Spain's national pastime. Long before Spaniards had any other diversion from the daily grind of work and war, the *corrida* was their source of entertainment, providing both immediate distraction and a fund of endless discussions between events.

Legends about the origin of bullfighting are many and fanciful, including references to the bull vaulters of ancient Crete and the Etruscans who passed on their "games" to the Romans. When, precisely, the combat between man and bull was introduced into Spain and what role the Muslim invaders of the country played in the process are unclear, but it is known that by the late Middle Ages high-ranking nobles of the Christian kingdoms were breeding bulls on their estates and staging fights before the members

of the royal court. Under the patronage of kings and lords throughout the Golden Age, the *corrida* began to take on a professional—and commercial—character in the early eighteenth century. By its closing decades, the first superstar had appeared in the person of Pedro Romero, the greatest *matador* ("killer") of all time, who, between 1771 and 1799, slew more than 5,000 bulls. By the early 1800s, schools had been established for the training of what were increasingly referred to as *toreros,* no longer mere killers, but artists whose training included the esthetic aspects of the conflict between man and beast. During the next 100 years youths all over Spain aspired to careers as *toreros,* and the breeding of bulls with the distinctive pedigree that guaranteed a bloodline of natural-born fighters was carried on in partnership by the great landlord magnates and a shrewd class of manager-entrepreneurs who ran the *plaza de toros* in every Spanish town. In the aftermath of the Civil War, the *corrida* fell into a seemingly irreversible decline. Much of the old breeding stock had died off and empresarios were staging fights between "cowardly bulls" and incompetent novice *toreros.* Franco tried to keep the sport alive as part of the national heritage as well as a source of distraction for his subjects, even staging a major *corrida* now and then specifically to undercut a scheduled demonstration or workers' protests. By the time of *El Caudillo's* death in 1975, his efforts to exalt bullfighting seemed to have produced an opposite effect, and 30 years of corruption, gross commercialism, and changing public taste had thrown the survival of the sport into doubt. To the delight of many, if to the disgust of animal rights advocates, there has been a marked recovery during the last quarter of the twentieth century. A new and more "valiant" strain of bulls has been developed, improved training and standards of performance have been inculcated through a revival of the old *torero* academies, and the *corrida* is holding its own. Although Madrid maintains pride of place with its great offering of grand spectacles during its patronal *fiesta* of San Isidro (to say nothing of possessing the largest bullring and the finest training school in the whole country), most other towns of any size have their own schedule of confrontations. These *corridas,* though perhaps on a smaller scale than those of Madrid, involve the customary series of encounters during the cool hours of the evening as each *torero* in turn, assisted by a retinue of *picadores* and other helpers, maneuvers the bull adroitly through a series of increasingly close encounters, finally arriving at the "moment of truth" in which he must deliver a fatal thrust with his sword or receive a potentially mortal goring. A sufficient number of young Spaniards drawn by the glamour of the traditional "suit of lights" worn by the *torero,* as well as a prospect of fame and fortune, still seek out this dangerous career. Occasionally a woman, such as Cristina

Sánchez, will attempt to assert herself in this bastion of male prowess; in her case gender discrimination was given as the cause for her premature retirement. Foreigners, too, have been inspired by the writings of Hemingway or motion pictures to come to Spain to learn the skill of bull-fighting. One or two Americans and even, more recently, a Russian, have had a certain degree of success.[10]

The *corrida* seems likely, then, to endure, despite criticism of its blood-ier aspects. Those who deny it the designation of "sport" say it is merely a pageant in which the bull is doomed from the start. Newspapers con-tribute to the impression by constantly referring to the *corrida* as a "spec-tacle." Even its apologists speak feelingly of its historical character, as shown in art, music, and literature. Whether appalled or thrilled, the spec-tator continues to be drawn to the *plaza de toros* by a spirit of dreadful antic-ipation that has persisted for more than 600 years.

Those who wish to dismiss the claims of the *corrida* declare flatly that Spain has only one sport: soccer. While its lineage is nowhere near as long as that of bullfighting, soccer has certainly established its primacy in recent decades. Like most countries in Europe, Spain experienced a gradual infil-tration of this sport after it appeared in something like its modern form in late nineteenth-century Britain. Its simple rules and minimal equipment, which have made it the game of choice among poor people around the world, inevitably appealed to Spanish boys. For most of them, the sheer cost of obtaining instruction and outfitting made bullfighting a hopeless dream. By the end of the Civil War, Spanish soccer had come into its own. By the 1950s, Spain was already exhibiting its prowess on the sports grounds of Europe. Her premier team, Real Madrid, won the European Cup every year between 1956 and 1960, an unparalleled record of victories. Franco, despite his desire to give a patriotic boost to bullfighting, was obliged to encourage soccer because of its undoubted value in burnishing the nation-al image. He thus found himself contributing to the decline of the old pas-time and the rise of the new. The post-Franco era has seen a steady rise in soccer mania. Spanish teams rank high in European and World Cup com-petitions and, within their own country, rivalries among cities and regions are intense. Perhaps the most deeply felt of these rivalries is that which pits Real Madrid against the Barcelona Football Club, in which a strong dose of Catalan nationalism reinforces the sporting vendetta against a Castilian team. Yet Spanish clubs, like those of most major European countries, are as likely to have nonnative players as local men. A pan-European, and even global pattern of acquisitions, accompanied by large payments of fees to the original contract-holder is the norm, and star players are as much sought after and (relatively) as well paid as American sports heroes. Spaniards, like

their peers elsewhere in Europe, have become avid readers of soccer coverage in newspapers and magazines (including publications exclusively devoted to the sport). They take full advantage of heavy television and radio coverage but prefer to attend games in person, so that they can bellow their approval or lament setbacks, wave banners, and generally throw themselves into enjoyment with the kind of abandon that even the *corrida* cannot stimulate. Less likely to travel abroad for matches than other fans such as the British or the Germans, they have not acquired a reputation for the hooliganism that mars many international games, despite the vehemence of their partisanship at home.[11]

Between the zeal of the soccer fans and the dedication of the bullfight *aficionados* there is not much time or attention left for other sports. As in other parts of Europe, there is some interest in basketball, and a few people have even looked into baseball. Water sports and, in the Pyrenees, winter recreations have their followers. Recently, long distance bicycle racing modeled on the Tour de France has been introduced, although it has not yet excited either the intermational involvement or the national enthusiasm that one finds north of the Pyrenees. Golf picked up some enthusiasts in the 1980s thanks to the international success of Severiano Ballesteros and José María Olazabal. But the victory (under somewhat specialized circumstances) of Sergio García over the famous Tiger Woods in August 2000, does not indicate more than a marginal status for golf in Spain. Like tennis, where players such as Arantxa Sánchez Vicario and Conchita Martínez uphold national visibility, golf is an "elite" sport that attracts comparatively little attention.

The general preoccupation with soccer and the support given to it by both government and the media have provoked some backlash. A recent letter to the editor of *ABC* offered a vividly stated minority viewpoint: "I've been reading about a stadium erected in Seville for the Campeonato Mundial de Atletismo. After that general athletic competition is over they are going to tear it down and replace it with a football stadium. More football! What kind of civilization would it be in which they celebrated painting and ignored literature, music, film? What kind of culture would it be in which they promoted the study of physics and abandon mathematics, chemistry, geography, history, etc.? Something like that is happening in our society with one "king sport" that soon will be called "only sport." In the hands of the great economic and political powers it is an elephant trampling on any little ant of a sport that dares grab a crumb from the pie of government funding or public support. Are we going to begin seeing children born with spherical heads, hairless and covered with black pentagonal markings?[12]

An American reader of this letter must feel a certain sympathy. How could he get along without baseball *and* football *and* basketball *and* hockey *and* tennis *and* golf *and*, for that matter, soccer—to say nothing of 20 other widely followed enliveners of his time? In Spain, however, the author of this letter represents a voice crying in the wilderness. Spaniards are quite satisfied to pursue their sporting life, whether it be at the stadium or the *corrida,* without any apparent fear that their children will be born with globular craniums or bulls heads.

Media Madness: Television and the Press

In the spring of 1968, before Soviet repression swept across the East again and assassins' bullets struck down more American leaders, millions of Europeans gathered around television sets for more gratifying news. They were waiting to see the Eurovision Song Contest. Those who could not afford their own sets sought invitations from prosperous friends or gathered in festive meeting places. Those who lived in regions not yet reached by the Magic Medium sighed more bitterly than ever for the blessings of modernization. Cultural elitists might sneer at the phenomenon, but, for the past decade, it had become a European institution—combined with some of the trappings of Hollywood's Academy Awards. Performers from all the major Western European countries rendered in turn the song chosen to represent the latest in their popular culture. Critics would remember later on the bizarre antics of a musical group from Yugoslavia (what could one expect from a Communist country that refused to stay decently hidden behind the Iron Curtain?). Yet it was the Spanish entry that excited the most comment. There was nothing startling about the performance itself: an attractive woman named Masiel sang a song that was titled, English-speakers were told, "You Give Me Love." It was not even a matter of astonishment that the song won the top prize. What was remarkable was that Spain had been in the contest at all.

Delighted Spaniards felt that their nation had taken a giant step on to the contemporary scene. After thirty years of rejection by much of Europe and obsessive introversion by the Franco regime, a law had been passed in 1966 opening the way to what they felt sure would be a freer, wider contact with the world. A Spanish victory in the Eurovision contest was doubtless but the first step in a grander intellectual experience.

The Law of Press and Printing had replaced prior censorship with freedom to publish, though maintaining a range of fines, suspensions and even closures if a publication offended against standards of decorum, or threatened the fundamental principles of the regime. Even in 1968, how-

ever, journalists had already learned ways of evading sanctions, and authors as well as songwriters were poised to take advantage of the liberalization they sensed was coming. Television, though trailing behind with such innocuous fare as the song contest, was making its own distinct contribution by opening a window upon less rigid societies. Conservatives, struggling for power with "moderates" within the government, warned of the "moral dangers" that liberalization would unleash and predicted an outbreak of "media madness" in days to come.

Another ten years would pass, however, and the Francoists would be dead or fled before the constitution of 1978 spelled out the principles of free expression that would henceforth prevail in Spain. Article 20 stipulates among the protected rights of all citizens "the right to freely express and disseminate thoughts, ideas, and opinions by word, in writing or by any other means of communication." It also secures the right to "literary, artistic, scientific, and technical production and creation." Access to the media is guaranteed to all political, ethnic, and social groups. The constitution does recognize that consideration must be given to "honor, privacy, personal reputation and to the protection of youth and childhood." Article 20 also declares that "the confiscation of publications and recordings and other information media may only be carried out by means of a court order."[13]

To those who anticipated "madness" in the media, the new environment on the radio waves must seem the strangest of all. Franco, like his allies in Nazi Germany and Fascist Italy, had understood the medium's potential for propaganda. During the Civil War, Gonzalo Queipo de Llano, the "radio general," had harangued listeners on both sides of the battle line with exhortations and threats in the name of the National Crusade. He had warned beseiged Madrid that the Nationalist forces had 4 columns advancing on the city and a "5th column" within it, ready to strike when the moment was right. Franco's radio thus gave twentieth-century Europe an enduring contribution to the lexicon of subversion and revolution. During the period of his dictatorship, the *Generalissimo* continued to display a talent for on-the-air propaganda by limiting the public's access to information and seeking to manipulate minds according to the doctrines of the National Movement. By the time of his death more than 200 stations were proclaiming the official viewpoint.[14]

What has happened to Spanish radio in the subsequent twenty five years has been "madness," not in the sense of rampant immorality or degeneracy, but in the break-up and diffusion of the state monopoly into private ownership shared by a multitude of corporate investors, some of whom are

based abroad. As the post-Franco government sold off state-controlled stations, they were acquired by businessmen, local governments, church-based institutions, publishing houses, sports complexes, and ethnic programmers. As a result, a listener turning the Spanish radio dial today will hear an eclectic mix of soccer matches (breathlessly described), popular music (much of it imported from overseas), and sonorous reports of the latest political scandals or terrorist bombings by newscasters who seem to be announcing the imminent end of the world. Depending on the strength of one's receiver one may pick up baffling messages in Basque, Catalan, Galician, or even Valencian—counterblasts to Castilian that were taboo in Franco's day. The tone is more chaotic than corrupting. The amount of airtime that is still under state control has steadily decreased, and political messages represent lively competition of opinions rather than traditional propaganda. There is, perhaps, less serious discussion or solid information than one could obtain on radio stations in other European countries, and 'high culture" is clearly less accessible to radio listeners than in, for example, France or Britain. Spanish radio, in short, has made the transition from preaching the approved doctrine of an authoritarian state to providing the entertainment and basic coverage of current events that one would expect as a minimum contribution of the medium to life in a democratic society. Yet, while avoiding the moralists' predictions of licentiousness or ranting radicalism, it has not evaded the accusations of blandness or mere triviality.[15]

Like its counterparts throughout the western world, however, Spanish radio has been increasingly overshadowed by television. Still a novelty in the 1960s, and strictly censored until the end of Franco's regime, television has become the medium of choice for most Spaniards. Their choice, as the prophets of doom anticipated, has often tended to the indecent and the outlandish, though more often than not to the merely silly. Those who have observed the excesses of post-Soviet television in Russia, with its crass materialism and gross vulgarity have been reminded of the rush to the bottom that characterized Spanish television in the first flush of freedom. As the transformation of a state monopoly into a range of competing private networks spawned commercials and commercial motivations, programmers often assumed that the most appealing subject matter involved comedy and sex in various combinations. Like their peers in the film industry, their thinking often reflected juvenility rather than sophistication. The gradual shift to greater depth and breadth of television programming during the 1990s may reflect the discovery that the lowest common denominator is not necessarily what the public wants or deserves. Conservative elements remain ready to decry the "degradation of standards" and the

"moral degeneracy" that television has promoted in contemporary Spanish society, particularly among its younger members. Objectively, the contemporary crimes, follies, and vices that afflict the nation are probably no more attributable to this "cool" medium than they are in the United States. As many American commentators have pointed out, their television industry continues to preside over a "vast wasteland" of mediocrity and stupidity. The trouble with Spanish television probably stems from a similar inability to achieve the great potentials of the medium within the perceived framework of its audience's lowbrow tastes. Spain has had less than half the time to experiment freely with television that has been available to the United States. It is not surprising that the country should still be trekking through its own "wasteland." There may be hope that it will take less time to reach the far side of the desert.

The print media in post-Franco Spain offer examples not only of the much-feared "madness," but also of a surprising sobriety. Under the authoritarian regime, newspapers and magazines were, of course, heavily censored. Even the relative liberalization that began in the 1960s was of more benefit to the journalists than the readers. This running warfare between the writers attempting to outwit official censors through verbal juggling and doctrinal dodging now looks more like playful sparring than a major contribution to public information. What is certain is that few of the newspapers that enjoyed a national circulation before the restoration of democracy have survived that development. Only *ABC* continues to be a major player. Once regarded as the staunch organ of monarchism, it is now more correctly described as conservative, for the monarchy, once restored, has turned out to be rather different from what monarchists had expected. *La Vanguardia*, with its base in Barcelona, has taken on more of a regional character, though it is not a Catalan organ. *El País*, which came into being shortly after the death of Franco, has surged to the forefront of Spanish journalism, with an international recognition that is challenged only by *El Mundo*. The visibility and credibility of *El País* have been enhanced by the loosening of its ties to the Socialist Party in the post-González period. None of these papers are intensely partisan, however, and the relatively moderate tone that all of them maintain, along with an increasingly pan-European outlook, gives them a stature that most of their predecessors could not attain. At the regional and local levels Spaniards have a wide choice of papers, including those in the principal non-Castilian languages. Tabloids, except for those devoted exclusively to sports, have had a troubled existence, less because of their excursions into scandal and sexuality than the periodic shortfalls of funding. Many provincial newspapers that were controlled

by the central government during the dictatorship were later sold off, some of them even before Franco's demise. In the process, some miniature newspaper empires were built only to collapse after a few years. Foreign media magnates, of whom the most universally recognizable is Rupert Murdoch, have also taken shares in some of these redistributions of Spanish press holdings, sometimes as part of radio and television acquisitions in the country. One of the paradoxes of the Spanish media scene is that the circulation of all Spanish newspapers adds up to a figure proportionately lower than that found in any other member of the European Union except Portugal. Explanations for this phenomenon range from the lingering heritage of censorship and illiteracy to the notorious inroads made by television throughout the contemporary world. It has been suggested that readership is more extensive than circulation because of the old custom of passing a single copy of a newspaper around among dozens of friends and neighbors. Furthermore, television news tends to take its lead on breaking stories and extended coverage from the newspapers rather than pursuing its own initiatives. Nevertheless, newspapers cannot live by prestige alone, and it is all the more striking that the major dailies have managed to maintain their integrity and avoid the excesses of "pop" journalism.[16]

Spanish magazines have proliferated during the past several decades, and it is in this field that "media madness" has perhaps the most relevance as a genuine concern. Some of the early products of the era of press freedom were aggressively pornographic, exhibiting a range of illustrations and articles that touched all of the forbidden areas that the most alarmist members of the clergy had envisioned and some that even the most fanciful had never imagined. Yet, like many other publications in every field from auto mechanics to numismatics, these early avatars of free expression soon disappeared because of insufficient revenues. While it costs much less to start a magazine than a newspaper, the audience is, in most cases, too limited for the publication's long-term survival. Thus, Spanish enthusiasts of periodical journalism have shared in the general experience of their brethren overseas. Jaded and fickle readers and skeptical bankers have done more than the prophets of moral doom to keep Spanish magazines from infecting the minds of large segments of the population. A few periodicals, such as *Interview*, have managed to keep the cause of nudity alive in their pages while devoting most of their attention to aggressive popular reporting and celebrity exposés. *¡Hola!*, the most durable and profitable of all the mass-circulation magazines, has achieved its success not through prurient appeal but through breathlessly chronicling parties, wedding receptions, and miscellaneous aspects of high life among the Spanish elite and the international "stars."

Any discussion of traditional media (in which phrase even television must now be included), whether in Spain or anywhere else in the developed world, risks becoming irrelevant in the age of the Internet. Global communication, diffusion of information, and individual exchange of ideas has become ever more threatening to the hegemony of press, radio and even television. Spain has been caught up in the whole range of manifestations, whether at the level of newspapers like *El País* going on the Internet or in the increasing assimilation of popular culture to the infinite possibilities of the World Wide Web. In the end, Spain may escape its own variations on "media madness" only to become caught up in the pernicious results of what some have likened to a global disease. Regardless of the dangers, most commentators agree, Spain cannot afford to be left behind in the process of creating the global information age. Good as well as bad consequences are certainly possible, but what, many persist in asking, will be left, within a few years, of a distinctively Spanish popular culture?

Spain in the World: International Relations

From the periphery of Europe, from the outer edge of the Roman Empire, for centuries a captive nation outside the mainstream of Christendom, Spain surged forth during the Renaissance to master the Continent, dominate international relations, and spread her culture among distant lands and peoples. Then, like a great tidal wave gradually receding, she lost her hegemony, abandoned her empire and turned in upon herself. The Spain of today is once again asserting herself in the world, not with the irresistible rush of a pent-up force, but with a mixture of eager curiosity and rational aspiration after her long isolation. The new Spaniards want to be good neighbors within the European community, cooperative participants in global enterprises, and supportive elder advisors to those who were once their colonial subjects. Thus, the present role of Spain is to assure a place in the world that lies somewhere between the chauvinistic arrogance of the Golden Age and the decadent introversion of its recent past.

Being Good Europeans: The European Union

Over the centuries, Spain was successively lionized and demonized by the rest of Europe. During the Franco period she was ostracized. The governments of the Left despised her as the ally of Nazi Germany and the slave of a fascist ideology. Conservative administrations were scarcely less suspicious, despite an increasingly strong endorsement from the United States. There was no serious question of admission to NATO, much less the evolving European community. Even after the beginning of the transition to democracy in 1975, Spain's relations with the rest of Europe remained tentative.

The career of Javier Solana encapsulates the transition that has taken place during the last two decades of the twentieth century. Trained as a physicist, Solana was in his early thirties and an ardent socialist, when the death of Franco opened up Spanish society to new directions. With the coming of the Gonzalez regime he rose rapidly in the confidence of the premier, serving in several ministerial capacities, ranging from education to foreign policy advisor. More doctrinaire than his chief, he opposed the presence of American military bases on Spanish soil as a legacy of Franco's alignment in the Cold War. He also spoke out against the early flirtations between democratic Spain and the North Atlantic Treaty Organization.[1]

Whether through persuasion or pragmatism, Solana was converted to the line that Gonzalez chose to follow in the later years of his administration. By 1995, the erstwhile opponent of Spain's entry into NATO had not only become an active promoter of that membership, but the favored candidate for Secretary General. The circumstances were complex, involving the fiscal improprieties of an incumbent and the perceived unsuitability of an American-backed candidate, as well as the support given by socialist leaders who held the balance of power in NATO's councils at this moment. Solana's socialist record was by no means so welcome in Washington. Such Republican luminaries as Senators Dole, McCain, and Helms opposed his appointment because they did not want a "Leftist" in this strategic position. Solana, however, proved himself during the implementation of the Dayton peace accord on Bosnia (where Carlos Westendorp, a Spanish diplomat, had already played an important role). By 1999 he was an obvious choice to assume an even more prestigious role, that of coordinator of foreign and security policy for the European Union. His new position proved no sinecure, for it involved presiding over the ouster of Serbian forces from Kosovo and the establishment of a European-supervised protectorate in that province.[2]

Spaniards would not be their normal selves if they did not exhibit a mixed reaction to the international renown of their native son. Some political and media critics questioned his preparation for the successive offices he occupied during the 1990s and disputed his decisions. Most of Solana's countrymen were nevertheless clearly gratified by the high visibility accorded to one of their own. The media, somewhat randomly referring to him as "chancellor" or "secretary general" of Europe, pointed out that his senior military commander in NATO was General Ortuño and the chief of staff was General Bretón, both of them distinguished members of a Spanish army that had been despised by most of Europe in the not-too-distant past. Spanish soldiers of all ranks were once again contributing to the good order and stability of the Continent. A Spanish statesman was

operating at the highest level of leadership in the expanding structure of European unity. Even the Aznar government, though exhibiting some behind-the-scenes jealousy, could not deny this happy outcome of the González initiative or dare to undermine the achievements of a former socialist cabinet minister.[3]

Gratified as all but the most introverted Spaniards may be at the enhanced status of their country in the European community, there is a nagging political and diplomatic issue that still vexes relations between Spain and one of the most important fellow members of both NATO and the EU. Although various international agreements commit the nations that belong to these organizations to avoid boundary disputes, Spain and Britain have never fully resolved the Gibraltar Question. Ever since British troops raised their flag over this "rock" at the southern tip of Iberia in 1704, sovereignty has remained an issue. From the War of the Spanish Succession at the beginning of the eighteenth century, to the political upheavals at the end of the twentieth, Spanish patriots have regarded this chunk of land as rightfully theirs. It has been besieged by Spain and her allies at various times and was under serious military threat from Hitler before his attention turned eastward. Flare-ups of the Gibraltar Question affected Princess Diana's honeymoon voyage in 1981 and spoiled King Juan Carlos' vacation plans in the 1990s. For all the irritation caused by these episodes, Spain has chosen to leave the ultimate resolution of her claims on Gibraltar for some time in the indefinite future. A series of referenda have shown a consistent majority of Gibraltarians favoring the maintenance of the British connection, with the economic benefits of being a Crown Colony outweighing any anomaly arising from that status.

A more serious incident during this period grew out of the ongoing struggle in Northern Ireland, which has repeatedly spread into other parts of Europe. Three Irish Republican Army fighters were intercepted after they had crossed over from Spain into Gibraltar, with the alleged purpose of carrying out a "terrorist bombing." Members of an elite British military unit, the Special Air Service, shot the three militants (one of whom was a woman). The innocuously-named SAS had acquired a reputation in the British Isles for ruthless counter-terrorism and was, on this occasion, accused of killing the IRA soldiers after they had surrendered. The circumstances merely added to Spanish indignation over the idea that Britain was fighting its internal wars on Spanish territory. In an ironic postscript to this event, a group of Spanish students on a trip to Northern Ireland several years later, after the conflict had supposedly ended, found themselves in the midst of a bomb blast set off by diehard IRA men. A Spanish stu-

dent and a teacher were among the 29 people killed in this atrocity at Omagh.

While these latest intersections of Spain and Ireland's long history of painful relations with Britain aroused considerable indignation, even events far from Europe stimulated complaints about Gibraltar. The Portuguese cession of Macao to China in 1999 provoked much discussion of the need to end Britain's colonial usurpation of Spanish territory. Although the situations were not exactly parallel, journalists talked pointedly about Portugal's sensitive handling of Chinese feelings and about the amicable arrangements for the transfer that had been worked out over a period of years. Other commentators insisted that Gibraltar was being used as a conduit for drug trafficking and as a center for the "laundering" of criminals' ill-gotten gains, all with the tacit consent and ultimate profit of Britain. The Spanish Foreign Ministry took the opportunity to initiate a proposal for talks on the future status of Gibraltar suggesting that, once the principle of ultimate return had been agreed, the timetable could be extended over as much as a century. Britain, despite the flurry of negative feeling in Spain, made no serious response to this proposal.

In the latter half of 2000, a new source of friction developed when *HMS Tireless*, a nuclear-powered submarine, ran aground in Gibraltar harbor. There was an immediate outcry over the possibility of radioactive leakage. The Madrid government asserted its right to a full recognition of its interests in this matter and was allowed a quietly arranged visit to the site of the damage by two Spanish nuclear engineers. The situation grew more complex when the local government of Gibraltar learned about this visit. The chief minister of the colony, Peter Caruana, had initially shared Spain's alarm over the potential ecological disaster. However, in the intricate maneuvering of Gibraltarian politics, he had no desire to be perceived as an ally of Spain, and the British government had thought it best to leave him "out of the loop" on the matter of inspection. When he received a tip about what was going on, he immediately protested to the London authorities about their secret dealings with Spain. The Crown Colony of Gibraltar, under a constitution dating back to 1969, possesses an elected assembly that reflects the result of popular referenda showing a large majority favoring a continuation of colonial status. Mr. Caruana was clearly afraid of anything that might lead to some sort of agreement to abandon the 27,000 Gibraltarians to Spanish rule. The fact that a proposed new constitution was under consideration gave more urgency to his concern. He was even able to persuade the leader of the legislative opposition, Joe Bossano, to join with him in demanding a clarification of British negotiations with Spain in the *Tireless* affair. It was generally known that the Spanish foreign minis-

ter, Josep Pique, had been in communication with his British opposite number Robin Cook, and the Gibraltar politicians insisted that they be made privy to the correspondence. A whole series of back-and-forth declarations ensued, with the British governor of Gibraltar maintaining that ministerial communications were private but assuring the colonial politicians that there was no question of giving Spain a veto power over naval operations in the area around Gibraltar. Spain weighed in again, urging that the damaged submarine be taken back to Britain for repairs, although it was not clear how this might be safely accomplished.

The argument over *HMS Tireless* shows that Gibraltar remains an ongoing source of trouble between Spain and Britain, even after the passage of 200 years. With its strategic significance less relevant in the post-Cold War era, Gibraltar may be perceived by Britain more as a burden than a benefit. Only the British commitment to the persistently anglophile inhabitants of the colony is likely to keep the Union Jack flying over this outpost. But the erosion of the British commitment to the Unionists of Northern Ireland is seen by some in Gibraltar as an ominous portent. Spain, meanwhile, will find many chances to point out the incongruity of a colonial bastion surviving in the heart of Europe at the end of the Imperial Age, especially when Britain is supposed to be Spain's good friend and ally.[4]

Despite the ups and downs of her own economy during the 80s and 90s, Spain has tried to be a good comrade in the evolution of a pan-European economy. Unlike some recalcitrant members of the European Union, she entered into the monetary system at its very beginning and stuck with it despite the vicissitudes of the euro. The Madrid stock exchange has even indicated its interest in joining the contemplated merger of the London and Frankfort exchanges. Although not on the scale of the French, German and British commitment, Spanish investment has been directed toward the growth of the Airbus consortium even as it announced its bold plan for building a super airliner that would double the capacity of Boeing's 747. Spain has also shared in the EU's turmoil over high gasoline taxes and their impact on fuel prices. During the fall of 2000, Spanish truckers and fishing boat operators joined in the strikes, blockades, and noisy disruptions that spread across Europe as a result of popular indignation over the oil crisis. This shared panic had scarcely eased when Spain was caught up in Europe's spreading fear of "Mad Cow disease." The BSE scare that flared up in Britain several years earlier swept the Continent in November 2000 with evidence of the appearance of this neurological plague in France and Germany. The report of two infected cows in the northwestern region of Galicia precipitated the closing of the Pyrenean frontier and a warning that the human variant of the disease might spread into Spain. Spain's maritime

operations also became a matter for European involvement. Repeated intrusions by Spanish boats on Canadian fishing grounds provoked threats from the Canadian coast guard and a vigorous response from the collective leadership of the European Union. The EU proved less willing to take a strong line, however, on the issue of British fishing vessels operating out of Gibraltar that Spain claimed were poaching on her natural resources. On the ever-tender point of Gibraltar's status, the Union preferred to leave arguments to the two member countries to resolve for themselves.[5]

Spanish cultural involvement with its new European partners has been wide-ranging. Typical of its musical outreach was the program presented at the Expo 2000 in Hanover, Germany. Over a period of several weeks, enthusiastic audiences were treated to performances by the mezzo-soprano Teresa Berganza, the *Real Filharmonia de Galicia* directed by Maximino Zumalave, and several dance companies. Spanish performers were thus able to demonstrate their talents in everything from grand opera to their unique arts of the *zarzuela* and the *jota*. At about the same time, the works of Spain's greatest twentieth century artist, Pablo Picasso, found a new major venue in Berlin, with the acquisition of the Heinz Berggruen collection by the municipal government. Berlin will now have a Picasso Museum, second only in its riches to the *Musee Picasso* in Paris. The collection, exhibited under the title "Picasso and His Time," will be housed in a renovated villa once devoted to the display of classical antiquities. In another corner of Europe, the Parliament Building for the newly revived Scottish legislature was rising. It is the work of the noted Catalan architect Enric Miralles, whose earlier achievements included the Utrecht Town Hall in the Netherlands. Himself the product of a Spanish region with a particularly strong claim to "national identity," Miralles was very anxious to secure this commission, coming as it did from Scotland's reassertion of its autonomy within the British realm. The 45 year-old architect, who had designed everything from Olympic pavilions in Barcelona to a railway station in Japan, stirred controversy with his vision of a "massive upturned boat" as one critic described it. In the great Catalan tradition of provoking controversy, he drew fire not only from aesthetes but from penny-pinchers who preferred to recycle some existing building. Although Miralles died suddenly of a brain tumor in July 2000, the argument over his Parliament House at the foot of Edinburgh's Royal Mile continues. One journalist described it as "the biggest impact Spain has made on Scotland since the invasion of 1719."[6]

A much earlier expedition overseas has been evoked in the attempt by the Valencian regional government to set the record straight about two of its native sons who made a name for themselves in Italy during the

Renaissance. Their family name was originally Borja, and in the Italian form, Borgia, it took on a bad odor in Rome. Pope Calixtus III (1455–1458) and his nephew Pope Alexander VI (1492–1503) have been made the objects of a "black legend," according to Eduardo Zaplana, president of the *Comunidad* of Valencia. He has launched a campaign of rehabilitation which began in Valencia in the winter of 2000 with a major exhibition about the Borgias scheduled to travel to Rome in the spring of 2001. Its major emphasis is on the roles of these popes as patrons of culture. Their shortcomings, particularly those of Alexander VI, are downplayed. The Valencian organizing committee, with Spanish scholarly backing, attributes the negative tales about the former Rodrigo Borja and his children, Lucretia and Cesar, to the malign gossip of a corrupt papal official who had a grudge against the family. Reversing 5 centuries of defamation, particularly when widely diffused by pseudohistorical films, will be a difficult task, President Zaplana and his colleagues admit, but they are determined to press on to vindicate the honor of their homeland and enhance the dignity of Spain in present-day Europe.[7]

Perhaps of more ultimate significance to the cultural interaction of Spain with the rest of Europe than these achievements of particular artists or the projects of historical revisionists was the announcement in June 1999 of a massive new program for an exchange of students between Spanish and other European universities. Under the Socrates Program, up to 14,000 Spanish students would undertake training and research in host universities while young people from member states of the European Union would pursue their academic programs in Spain. Jointly conceived and funded by the EU, participating universities, and Spanish national and regional authorities, the enterprise will ultimately transform the nature of Spanish interaction with the rest of Europe. Since the end of the Franco era, Spaniards have been carrying on the business of "integration" through political, commercial, and personal initiatives. This visionary scheme has the potential for creating a whole generation of intellectual and professional leaders in Spain whose experience will be part of an ordered learning process rather than of hectic random contact. Moreover, in the eyes of a new generation of leaders throughout the European Union, Spain will no longer be an unknown quantity, a strange place surrounded by fanciful, exotic images. It will be a part of their experience, a dimension of their lives as good Europeans.[8]

From Isolation to Internationalism: The United Nations

Amidst the isolation in which Spain found herself after the Second World War, she welcomed the friendship of the United States. Washington,

liking her anti-communist posture and her anti-Soviet rhetoric, leased military bases and even facilitated her entry into the United Nations. As an ally of the American superpower, she was treated with cool correctness by many members of that international body, and with positive distaste by those who ranged themselves on the opposite side in the Cold War. After the death of Franco, many in Spain favored an end to the relationship. Whether from long-suppressed proletarian rage or a simple desire for flexibility in foreign policy, they advocated a nonaligned stance. In 1981 the short-lived government of Leopoldo Calvo Sotelo initiated an application for membership in NATO, prompting the socialists to pledge a reassessment of this pro-American gesture during the following year's election. After his victory, however, the PSOE's Felipe Gonzalez gradually changed his mind about many of his campaign promises, including one that would have marked an overt estrangement from the United States. Although a referendum was held in 1985 on whether Spain should withdraw from NATO, Gonzalez let it be known among his supporters that he no longer favored the withdrawal option. While the NATO connection survived, some analysts believe that the decline in socialist voting strength in the 1986 parliamentary elections reflected a disgust among leftists over this abandonment of the nonalignment principle. In any case, Spain has remained a member of the American-dominated NATO and even declined the idea of opting out of its military control apparatus, as France had chosen to do. On the other hand, an end to the basing of American forces in Spain has been quietly negotiated, an agreement made all the easier by the scandal over the loss of a U.S. nuclear device in Spanish waters.[9]

All of these issues became less relevant when the Cold War ended and NATO was transformed into an essentially European alliance whose future seemed to have less and less to do with the transatlantic members. The European Union became Spain's new arena and instrument for most foreign policy decisions. Perhaps the most striking example of Spain's activism in this regard has been her dispatch of over 2,500 peacekeeping troops to Albania, Angola, Chechnya, Bosnia-Herzegovina, Guatemala, Croatia, Georgia, Moldova, and Nagorno-Karabaj under the sponsorship of the EU, the UN, or the Organization for Security and Cooperation in Europe. There were still moments when a flirtation with Russia recalled the controversy of an earlier time. Ironically, it was the conservative Aznar regime, which, in 2000, welcomed a visit from the new Russian president Vladimir Putin (among the first he made after his election) and which detained his fugitive enemy, Vladimir Gusinsky, when that media oligarch sought refuge in Spain.[10]

In one region, the Middle East, Spain persists in maintaining an independent and vigorous diplomatic outreach. If not a sphere of influence, this area can reasonably be regarded as a sphere of interest. Franco, whose own military career and ultimate accession to power were based in Morocco, continued Spain's long historical involvement with the Moslem peoples of the Mediterranean shores. All of the leaders who have followed *El Caudillo* in office have seen fit to preserve this special relationship. Some of Spain's responses to the wishes of its Middle Eastern partners were relatively easy to make. For instance, when Turkey required Spain to prevent the so-called Kurdish parliament-in-exile from meeting there in 1999, the fact that the event was to be hosted by Basque nationalists assured a quick and effective response. For Madrid, the rebellious Kurds, with their ethnic pretensions to sovereignty, were merely sinister partners of the murderous revolutionaries of ETA. A much more delicate piece of work was undertaken in 1991, when Madrid hosted an Arab-Israeli conference that laid the groundwork for the 1993 Oslo agreement and the launching of the peace process that struggled on over the rest of the decade. Determined to preserve its special status as a European mediator for Arab concerns, Spain has tried to establish a correct relationship with Israel as well, despite the difficulty of this balancing act. A sincere and generous apology made in 1992 for the expulsion of the Jews in 1492 went some way toward easing ancient tensions.[11]

Within the larger framework of Middle Eastern relations, Spain has paid particular attention to the Maghreb—the North African extension of the original Arab conquest that once overran Iberia itself. Prime Minister Aznar launched a particularly important diplomatic initiative in July 2000, when he visited Algeria's president. Agreements were made to send Algerian oil and natural gas to Spain and to provide Spanish advice and assistance on urban security and antiterrorist tactics. Algeria has been wracked since the early 1990s by Islamist violence, and Spain, in combating its own Basque problem, has acquired a certain sophistication in these matters. Some critics of Aznar were disturbed to learn that a side agreement had committed Spain to crack down on the Committee of Free Algerian Officers, which had established a refuge in Spain. This opposition group was portrayed by these critics as carrying on a legitimate campaign against the authoritarian Algerian government, and they found it sinister that Aznar should be allied to such a regime. Others, less ideologically motivated, were worried about Aznar's intrusion into a country traditionally considered a diplomatic and economic preserve of France, its former dominating power. This "poaching," they argued, could disturb EU harmony.[12]

The ties that bind Spain and Morocco are the most intimate of all. Their geographical proximity across the narrow Strait of Gibraltar, their historical links over more than a thousand years of war and peace, and the many socioeconomic issues that still complicate their interaction, make Maghreb-al-Aksa—"the Land Farthest West"—the most special part of the Middle Eastern special relationship. Every effort has been made during the 1990s to keep the connection a mutually satisfactory one. Spanish and Moroccan rulers and statesmen have visited back and forth, with particularly deep condolences and warm greetings being sent by Spain when King Hassan II died and was succeeded in 2000 by his son Muhamed VI. Two major problems, however, continue to bedevil the friendship. One is the status of Ceuta and Melilla, two small Spanish enclaves on the coast of Morocco. Spain at one time controlled much of present-day Morocco, and these cities are seen by many Moroccans as the last remnant of a colonial intrusion. The question flared up in a particularly virulent form during the summer of 1999, when Islamic militants staged a series of demonstrations demanding the surrender of the enclaves, and the Moroccan prime minister went so far as to assert an outright claim. Spanish nationalists, both in the North African territories and in the metropolis responded with militant assertions of their country's historical right to rule those places. The Mayor of Marbella, Jesus Gil, emerged as a leading spokesman for Spain's unchallengeable claim to perpetual control, and was backed, at least indirectly, by Madrid authorities who pointed out that Melilla had been conquered from a local ruler in the 1400s and that Ceuta had been a Portuguese colony annexed by Philip II in the late sixteenth century. Thus, it was argued, Morocco had never ruled these cities and cannot claim them now.[13]

While these "colonial" problems continue to simmer, a far larger challenge to Spanish Moroccan relations is posed by the question of Illegal immigration. During the last decades of the twentieth century, thousands of undocumented aliens have entered Spain, the majority using Ceuta and Melilla or other ports on the North African coast as bases for their crossing of the Mediterranean. Hundreds of others have perished in the sinking of their flimsy boats or have been detained and sent back by Spanish police. While many of these unwelcome arrivals have come from other parts of North Africa or from even more distant places, their use of Morocco as their preferred point of departure has created tensions between Madrid and Rabat. The Spanish parliament has alternately made provisions for the care of the refugees and ordered their expulsion. Spaniards in coastal regions where immigrants have taken root have flared up periodically in racist violence against what they describe as a new Moorish invasion. Most Spaniards, it appears, are not particularly pleased by the report from demographers that

the influx of immigrants has made up for what would otherwise be a net decline in the Spanish population due to a falling birthrate among the "old stock" population. Nor can the Spanish government overlook complaints from fellow members of the EU that Spain is being used as a conduit for illegal aliens wishing to penetrate further into Europe. If these issues with Morocco can not be amicably resolved, Spain may see the failure of her ambition to serve as a bridge between Europe and the Islamic World.[14]

Beyond the dramatic but often disappointing activities of Spanish statesmen on the stage of international diplomacy, commentators point to an accelerating rate of Spanish involvement in global affairs. These events range from the triumph of the first Spanish astronaut Miguel Lopez-Alegria to the achievement of Spanish engineers and entrepreneurs replacing earthquake-shattered structures in Turkey, to the worldwide outreach of the communications conglomerate *Telefonica*. In recent years, Madrid's airport is handling such an acceleration of international comings and goings that expansion is demanded at the same time that local residents are multiplying their complaints about noise and traffic. Spanish women won medals in judo and swimming at the Olympics in Sydney (where longtime President of the International Committee Juan Antonio Samaranch made his final bow). Placido Domingo sang with a Russian opera company in Salzburg and José Carreras sang at a commemoration of the dead of the *Kursk* submarine disaster in Moscow. Spaniards are still thrilled that international musical groups like U2 make Madrid one of their regular stopping points, but they are also delighted that home-grown talents like the Catalan Pau Dones are gaining international recognition. The entire range of Spain's musical achievement in the twentieth century is celebrated at the Strassburg new music festival when recent concerts included works by Albéniz and De Falla as well as Halffter and de Pablo, and performances by contemporary luminaries of *flamenco*. The Old Masters of Spain are still being honored abroad: El Greco's "Christ on the Cross" was purchased at a record price by the Getty Museum in Los Angeles, and Lorca's New York experience in 1929 was commemorated at a conference at Columbia University. The city of Valencia played host to an international conference that focused on violence against women in all parts of the world, and Queen Sofia was honored at New York University and other American institutions for her support of international humanitarian projects. Spain was even able to reclaim some of its lost treasure as a court in the United States ruled in favor of the original owners of 2 frigates and their cargoes of gold that sank off the coast of Virginia in 1750 and 1802, respectively.[15]

In 1975, when the newly-ascended King Juan Carlos decided to send a collection of Goya masterpieces for exhibition at New York's Metropolitan

Museum of Art to honor the 200th anniversary of the American Revolution, he symbolically began a new era of international outreach for Spain that would celebrate its cultural contributions to the world while reasserting its importance as a political presence in the international community. As the king marks his twenty-fifth anniversary on the throne, Spain, both in her visibility and her activity has fulfilled his hopes.

El Mundo Hispanico: Spanish America

At the beginning of the modern age, Spain ruled a great empire. By 1898 she had lost virtually all of it. By 1998 she had made great strides toward regaining it, although under a new guise.

Spanish America remained estranged from the " mother country" throughout most of the twentieth century. Many refugees from the Civil War found sanctuary in such countries as Mexico and Venezuela. Franco's attempts to cultivate closer relations had only limited success, although literary contacts remained significant.

Now there is a New Spain, not across the Atlantic, but in the Iberian homeland itself. Since the peaceful revolution began in 1975, a fundamental aim of Spanish foreign policy has been to reclaim and deepen its relationship with the lands it once ruled. Beginning cautiously, with goodwill missions and cultural exchanges, this Spanish thrust into the Western Hemisphere accelerated dramatically in the 1980s, fueled by the enhanced resources that European unification provided.

A hundred years after she was driven out of her last colonies in the Caribbean, Spain is second only to the United States in annual investment in Latin America and is threatening to oust her old rival from first place. In 1998, U.S. investment in the region totaled $14.3 billion, while Spanish investment reached $11.3 billion. The Spanish government estimates that 1999 investment attained $20 billion. These statistics went a long way to ease the painful memory of Admiral Cervera's defeat at Santiago Bay and Theodore Roosevelt 's triumphant charge up San Juan Hill.[16]

Not all Spanish Americans are delighted by this dramatic reappearance of their old ruler in their midst. Some speak of a "*Reconquista*," evoking the memory of the original Spanish conquest of the Americas in a less than favorable way. The contemporary *conquistadores,* according to certain critics, have replaced swords and muskets with money and mergers. In Chile, for example, residents of the capital, Santiago, find themselves paying their electricity and water bills to Spanish-owned companies, and one of their major banks is now run from Madrid. It gives them a sense, they say, of paying taxes to their former overlords. To be sure, Chile, which fought a short but bitter war against Spanish interference in the late nineteenth century

(some sixty years after the original war of independence) is perhaps more sensitive on these matters than other countries. More recently, the attempt of a Spanish judge to bring Chile's former president, Augusto Pinochet, to Madrid to stand trial for human rights offenses provoked indignation and a boycott of a Spanish-orchestrated regional conference. In other Latin American republics, resentment against the pseudocolonial conduct of the United States is a more relevant source of irritation than ancient wrongs. Most of them are quite content to glory in their Spanish connection, or, at least, profit from it.[17]

Brazil, a former Portuguese colony, is not exempt from the appeal of Spanish charm and money. The campaign of seduction has been relatively recent but conducted on a large scale. From a mere $112 million in 1996, Spanish investment soared to $6 billion in 1998 and Madrid's quest for an ever-larger chunk of Latin America's largest economy seems likely to continue at the same pace. Under the rubric of "Iberoamerican" solidarity, the Spanish government provides what Portugal cannot hope to offer, and the Iberian neighbor can only play the role of junior partner in this transatlantic expedition. The spearhead of Spanish return to South America, the mammoth communications corporation *Telefónica,* which already dominates the continent's Pacific coast from the *Telefónica* Tower in Santiago, has lately acquired much of Brazil's telephone network, including that of Sao Paulo on the Atlantic coast. Spain now controls one out of every four telephones in Latin America.[18]

In November 2000, Spanish media took the occasion of a royal visit to the Dominican Republic to congratulate their countymen on the great things that had been accomplished during the preceding twenty-five years. The king and queen had inaugurated their reign by visiting this, the first outpost of Spain in the New World. Now, in a return journey redolent with symbolism, the firmly established democracy in the mother country could hail the solid victory of democracy in the Dominican Republic. On a more practical level, the monarchs brought with them 60 business executives who concluded a multitude of deals while in the host country. Taking advantage of the privatization program initiated by President Hipolito Mejias, representatives of electricity, tobacco, banking and other corporations negotiated major capital investment that substantially transformed Spain's financial stake in the republic. Spain's share in the national economy had previously been concentrated in hotel ownership; by the end of 2000 the proportion of Spanish investment concentrated in that sector had shrunk to forty percent, while the balance was diversified among a wide range of Dominican industries. The European Development Bank has confided more than eighty percent of the projects it supports in the Dominican

Republic to Spanish corporations, chiefly major banks and construction firms. To relieve the impression of exclusively profit-oriented activity, the press paused to mention that Spain was tied with Japan in the global list of donors for human assistance projects in the Dominican Republic.[19]

While his compatriots negotiated, the King threw the switch to illuminate a restored colonial district in Santo Domingo whose replication of the old days was paid for by Spanish funds. He then addressed the National Assembly to congratulate the Dominican people on their firm embrace of democracy, a political philosophy which Spain as well as the United States could now claim as its own particular gift to the world. Cynics in Spain might suggest that the Dominican Republic was a soft target for this projection of their county's new smiling face in Spanish America. Had not the Dominican Republic actually rejoined Spain for a brief period in the nineteenth century after independence had proved too costly (only to be more or less discarded by the mother country)? Such negative thoughts were, however, lost in the flood of media enthusiasm.[20]

The centerpiece of Spain's Western Hemisphere policy has been its sponsorship of the series of Ibero American Conferences, the tenth of which was held in Panama in November 2000. At these gatherings of chiefs of state and heads of government, the king and his prime minister have alternated between congratulating the nations of the Western Hemisphere on their conversion to practical democracy and promoting the concept of solidarity between Iberia and its transatlantic "brothers." Leaving the crass details of financial agreements and economic development to bilateral negotiations, the Spanish team has emphasized cultural solidarity. Popular entertainers and exponents of "high culture" are constantly traveling from one continent to the other. Students and professors participate in exchange programs. Arts and artifacts are placed on long-term loan. Publishers encourage Spanish writers to introduce "American dimensions." Scientists and medical workers are directed to new opportunities for research and collaboration.

A profoundly symbolic moment in this cultural reunion of Spain and Spanish America came in September 2000 when the *Premio Principe de Asturias de la Concordia* was jointly awarded to the Spanish Royal Academy and the 21 Academies of the Spanish Language in the American republics, Puerto Rico, and North America as well as the Philippines. The Royal Spanish Academy, founded in 1713 by the new Bourbon dynasty on the model of the *Academie Francaise,* became, in turn, the model for the institutions that were founded during the post-independence period in what had been Spain's overseas possessions. Dedicated to the preservation and enrichment of the "mother tongue," these institutions have worked with their

prototype in Madrid to sustain the ties that bind the 400 million Spanish speakers throughout the world. Both in Europe and overseas, the media were filled with glowing encomiums to the Spanish cultural heritage, praise of its vitality, and vows to secure its future greatness. Alongside the steady increase in political and economic cooperation, this glorification of panhispanic identity marked a new stage in Spain's pursuit of its prime foreign policy goal.[21]

There were, to be sure, negative dimensions to the *Hispanidad* policy. Spain's intervention in various Latin American countries at times seemed overly zealous to individual governments, the general public, or both. The king, the prince of Asturias, and various lesser dignitaries seem to be forever turning up in Central American, Caribbean, and South American countries, with an embrace for local magnates and somewhat paternalistic lectures on the virtues of democracy. The irritation caused in Chile by a Spanish judge's pursuit of ex-President Pinochet for human rights violations was echoed when similar judicial actions were initiated in Spain with regard to "dirty wars" in Guatemala and Argentina. The Spanish government, on the other hand, has been far from cordial when unwanted political refugees and undocumented immigrants from Spanish America have taken up residence in the "mother country," and there are frequent complaints in Spain about South American drug traffic taking advantage of the Iberian connection.[22]

Spanish policy in Latin America is, of course, even more likely to irritate the United States than individual countries in the region. When Madrid hosted a conference attended primarily by European allies in July 2000, its ostensible aim was to promote funding for various worthy projects in Colombia. Perhaps inevitably, the contrast was drawn between civilian-oriented aid and the predominantly military assistance that the United States has agreed to provide in the war against Colombian drug lords. The implied, and sometimes explicit, rebuke to this risky support of the army in a country always hovering on the brink of dictatorship could not fail to annoy Washington. Recent Iberoamerican conferences have struck another raw nerve, with Spain's support for a more tolerant approach to Cuba. Spain, like most of its EU partners, is a vocal critic of the United States' trade boycott of the Castro regime. The Communist leader has been respectfully treated by both King Juan Carlos and Prime Minister Aznar and drawn into various cooperative projects, such as the training of Cubans in new technologies of irrigation and water purification. Some Anglo-Americans have been offended by the rather proprietary air assumed by Spanish dignitaries when visiting Puerto Rico, where members of the royal family have been renewing old ties at regular intervals since the 1980s. The

Prince of Asturias even held a miniconference of tribal leaders in New Mexico, another former outpost of empire. Clearly, the Spanish government is not afraid to provoke the U.S. authorities or to be seen poaching blatantly on their preserves.[23]

Of all its external initiatives, including the increasingly important European Union commitment and the Middle Eastern/North African special relationship, Spain regards its Iberoamerican program as the most important. Recalling the imagery of the poet Ruben Dario, the Spanish lion is gathering its long-lost cubs.

Into the New Millennium: The Future

"01/01/01!" was the headline of the leading national daily. The story went on to point out that January 1, 2001, was not only the first day of the first month of the first year of the new century, it was also the first day of the third millennium. Signs displayed above the boulevards in Madrid proclaimed "Happy Millennium." With classic Spanish self-assertion, the official government body set up to arrange observance of this chronological experience brushed aside all claims that for the rest of the world the year 2000 had actually marked the great event. Professor Luis Miguel Enciso, president of the State Society for Transition to the New Millennium, firmly stated: "We have chronological advisers who explained it all very clearly . . . we have always known two things: that the key date was 2001, but that a collection of zeros has such charm and attraction that people would decide on their own that the millennium fell in 2000." The American scholar Stephen J. Gould had told his countrymen, "It does not matter what public sentiment prefers, 1900 was part of the 19th century and 2000 will be the year that concludes the 20th century, and not the start of the new millennium." Gould may have been ignored by revelers in New York's Times Square, but Madrid applauded him as the voice of reason. Spaniards dismissed the vulgar folly of American millennialists as the naiveté of a young nation and tended to view the material excesses of the British festivities in 2000 as the senile dementia of a decaying old empire. Indeed, the imminent demise of London's Millennium Dome was seen by some as a small installment on divine retribution for Gibraltar. Even the French and the Russian attempts to extend the observance over 2000 and 2001 were derided as mere waffling.[1]

The Aznar government created the Society, alternatively known as Spain New Millennium in June 1999 with a budget of $167 million. It was charged with organizing events of cultural importance—as well as some "fun" activities. Disclaiming any desire to create the kind of pompous monuments envisioned in other countries, Professor Enciso and his colleagues planned a series of conferences, exhibitions, and competitions that would unite the ancient and modern dimensions of Spain's distinctive experience. "This is a meeting point between the past and the future," he said, "between science and technology, symbol of the future, and the humanities, symbol of the past and present." Among the most important of these millennium manifestations were an exhibition covering the past 1,000 years of Spanish history that traveled to the European capital, Brussels, and another called "The Keys to 20th Century Spain" that will be housed in the new Arts and Science Museum in Valencia. The latter gave special attention to the Civil War, the Franco dictatorship and the new democratic era in Spain. The Madrid regional government concentrated on the "fun" aspect of the observances, sponsoring performances by such stars as the flamenco sensation Sara Baras and the soprano Ainhoa Arteta. There was also a series of sixty four concerts, collectively labeled "Madrid Thrills." These were particularly oriented toward hailing a new era in which Madrid would reach out to welcome a variety of cultures and forms of artistic expression.[2]

Amidst all this consciousness of moving into the new millennium, where does Spain stand and where is she likely to go? The general election of March 12, 2000, produced results which seemed to answer the political dimensions of this question. Prime Minister Aznar's Popular Party, which had maintained itself in office for some five years with help from Catalan allies, won an outright majority of 183 seats out of the 350 in the Lower House. While not an overwhelming victory, this clearly gave him a freedom of action that he had not previously enjoyed. No one was more surprised, it seemed, than Aznar himself. The consistently uncharismatic leader had never been able to work up much rapport with the public, and even a smile seemed beyond his ability on most occasions. While competent, and even (in some respects) effective, his administration had failed to arouse much enthusiasm. The principal opposition party, however, was scarcely an irresistible force. Following the ouster of Felipe González, the socialists had chosen Joaquín Almunia as their standard bearer. Scarcely more appealing than Aznar, he presented no distinctive face or dynamic personality to counterbalance the bland image of the PP chief. One political analyst, with an eye to the contemporary presidential contest in the United

States, said that Spaniards had a choice between Al Gore and Al Gore. The PSOE tried to add a touch of dynamism and strengthen its questionable Marxist credentials by establishing a somewhat loose alliance with the Communists. This strategy gained them little reliable support on the Left and merely frightened a few moderates into joining Aznar.[3]

Although described in apocalyptic terms as the ultimate moment of truth for Spain's political future, the 2000 election was bypassed by many voters and can hardly be described as decisive. For Aznar, however, it provided an occasion to congratulate his adherents on their triumph and to assert the simultaneous triumph of democracy in Spain. With the twenty-fifth anniversary of Franco's death conveniently at hand, the prime minister wrapped himself in the mantle of national fulfillment. In a speech given a few days after the balloting, he proclaimed, in effect, the end of irrational exuberance and the beginning of a new era of conciliation. He promised to work toward cooperation with his erstwhile opponents and to take Spain into the twenty-first century in a confident and progressive spirit. Issues of domestic policy certainly remained, but traditional socioeconomic disputes, it seemed, had diminished in a period of prosperity.[4]

In less than a year, however, what had only been a small cloud on Aznar's horizon at the moment of victory grew to frightening proportions. The so-called Mad Cow disease that had been reported as infecting a few head of cattle in Galicia developed into a national health crisis. Urgent efforts by EU officials to prevent the spread of infection caused Spain to be added to the list of countries where rigorous inspection and destruction of suspect cattle threatened their national economy. By mid-January 2001, thousands of farmers had blockaded slaughterhouses to enforce their demands for government action to save their livelihood from complete collapse. They claimed that beef consumption had plunged 70 percent since the first cases of BSE infection occurred in Spain three months earlier, and they demanded a plan of compensation to rescue them from bankruptcy. On February 8 over 5,000 farmers, some driving cattle, disrupted traffic in Madrid, calling for compensation for the more than $1 billion they had lost due to the crisis. At an urgent meeting of a parliamentary commission that week, the minister of health and other government officials were subject to harsh questioning by legislators. The socialists were particularly aggressive, seeking to blame the Aznar administration not only for incompetence but duplicity and worse. The rhetoric became heated, with allusions to the scandal surrounding the sale of tainted oil in the 1980s, and the subsequent death or neurological injury of scores of Spaniards. Complicating the BSE issue was the new disclosure that a large quantity

of a contaminated drug had been imported from Britain between 1996 and 97 and distributed to regional hospitals in several parts of Spain. According to hitherto-secret government documents, as many as 2,000 patients might have been infected with the human equivalent of BSE, and it would be as much as ten years before the extent of the damage could be known. Amidst cries of criminal negligence and "cover-up," there was much finger pointing, with the ministers blaming the regional authorities, and panels of medical specialists faulted for advising silence to avoid panic. As the issue of tainted meat threatened to become a pan-European or even international crisis, a particularly Spanish dimension developed with the opening of the bullfight season. The first *corrida de toros* of the new millennium took place in February 2001, opening what would normally be a nine-month series of *fiestas* involving 1,000 confrontations between man and beast. In a typical season, 40,000 bulls would be killed, and their highly-prized meat would generate $10 million in income for those who staged the fights. Without this money, many towns would not be able to put on the *fiestas*. And now, thanks to the BSE crisis, the Ministry of Health was mandating the destruction of all carcasses. Breeders and impresarios who raised the bulls and organized the fights pointed out that no case of Mad Cow disease had ever been detected among animals intended for the *corrida*. Unfortunately, the only test yet devised for the infection involved cutting off the head of the animal under suspicion, rendering it impossible to declare any bull "clean" in advance of a fight. The impact of this situation was both economic and cultural. Unless some non-lethal test is devised, slain bulls must be incinerated immediately after the *corrida,* and the ban on selling the meat may cause the closing of small-town bullrings. Furthermore, the new regulations affect the tradition of awarding a *torero* the ears of a bull dispatched with dexterity and elegance. The custom was for him to parade before the stands of cheering *aficionados* and confer one of the ears upon a favored person. Now the trophy ears must be surrendered to the clean-up crew to be burned along with the rest of the dead animal. Those who had campaigned to end what they regard as an archaic and brutal spectacle may find in this development an unexpected silver lining. For those who cling to "the old days and the old ways," a painful moment of truth may have arrived.[5]

Whatever the validity of Aznar's triumphalism and self-confidence in the aftermath of the 2000 election, the turn of the century left him face to face with the problem of Basque terrorism. The ETA cease fire had proved to be of short duration. A few unproductive meetings between its representatives and those of the prime minister served only to demonstrate the immovable commitment of each participant to long-standing positions.

Bombings and shootings in the north have been extended into central and even southern Spain. As the new millennium dawned, ETA attacks were averaging one a week. An almost ritualistic cycle of killings (usually directed at security officials or politicians) was met by rallies to express civilian indignation and police sweeps—both ineffectual. Statesmen solemnly declared that ETA is fascistic in its determination to kill anyone, including its own Basque countrymen, who does not share its political philosophy. ETA leaders swear to carry on the armed struggle, mindful of a pledge made in 1995 that the Basque homeland would be free by 2002.[6]

Regionalism as an unresolved political issue in Spain is not confined to *Euskadi*. Leaders of regional governments perennially flex their muscles in actions and words that vary from the merely offensive to the alarmingly militant. When Sergio Marqués, president of the *Principado* of Asturias, says "We resolve our problems here, not in Madrid," it need not be taken as particularly threatening. A similar tone from the authorities in Galicia is far more worrisome. When Eduardo Zaplana, regional chief of Valencia, speaks up, his demands are muted by his well-established afiliation with the Prime Minister. The posture taken by those who control the Canary Islands is much more ambivalent and potentially dangerous in an archipelago with a tradition of militant nationalism. The *Generalitat* of Cataluña, while eschewing violence, is still ready to press for the reconstruction of the constitution to further its autonomous ambition and not above flirtations with regionalist mavericks in Galicia and the Basque provinces. Given the political and commercial importance of Barcelona and the endless complexities of its internal politics, some observers regard Catalan aspirations as potentially more disruptive than the outright warfare tactics of Basque extremists. In this atmosphere, it was not all that remarkable when the political minions of Prime Minister Aznar "jumped all over" the leader of Aragón early in 2001. Regional President Marcelino Iglesias had proclaimed his intention to boycott the government's controversial Hydrological Plan. His offense was compounded by his membership in the opposition socialist block. Cabinet ministers and regional chiefs loyal to Aznar competed with one another in demonizing Iglesias, whom they denounced as "stupid," "disloyal," "bolshevik," "demagogic," and "lacking in solidarity." They warned that if his behavior continued and spread, it would have grave consequences for Aragón and all Spain. While Iglesias insisted that the diversion of water from the Ebro River would impair Aragón's agricultural activity, and his critics insisted that the plan would benefit the entire Spanish economy, leaders of the Socialist Party claimed that the whole affair was being provoked by Aznar as a scheme to weaken

regional autonomy and strengthen the central power. The concept of "unity" remains, for Spaniards, as elusive and indefinable as ever.[7]

Twenty-first century Spain, still bedeviled by regional issues at home, continues to pursue its well-established policies abroad. Mexico finally acquiesced in the extradition of the Argentine ex-officer Ricardo Miguel Cavallo so that the implacable judge Garzón can try him in Spain for atrocities against Spaniards and others in the 1970s. El Salvador is the latest recipient of the mother country's generous attention to the needs of her ex-colonies: Madrid dispatched transports bearing scores of specialist fire-fighters, sniffer dogs and earth-moving equipment within hours after the devastating earthquake of January 2001 (a catastrophe followed by an almost as severe earthquake a month later). In these, as in earlier instances, the United States could only look on in surprise and suspicion. Washington was also discomfited by Spain's complaints over the use of depleted uranium as a component in American bombs and tank shells used in Balkan operations. Like Portugal and half a dozen other European countries, Spain claimed that sickness and death among its soldiers was probably caused by the radioactive leakage of these weapons.[8]

While Spain was forming a common front with her European brethren over the alleged effects of American military actions, her favorite son in the EU administration was creating friction among the allies. As *El País* headlined the story on January 23, 2001, "Solana ferociously criticizes the foreign policy of the EU as a 'bureaucratic and inefficient exercise.'" Taking his job as coordinator of foreign and security policy seriously, the tough-minded Javier Solana accused the leaders of the Union of indecision and evasion in matters that required clear thinking and clear speaking. In a 7-page memorandum to the 15 government leaders, he warned against a tendency to cling to the old consensus approach in developing strategy and chided them for their preference for bland, vague public pronouncements. While the document was intended strictly for the eyes of the top leaders, it was leaked by someone in the Danish government and quickly became the talk of the entire span of European media, from Dublin to Stockholm. Although Solana was clearly doing what he had been hired to do, namely develop a unified line for the diplomatic and military policy of the fifteen-member organization, it remains to be seen whether the high-handed approach and brusque warnings of this self-confident Spaniard will carry the day.[9]

Far less controversial than Solana's attempts to dictate strategy to a dozen clusters of proud generals and politicians was the plan announced at the beginning of the new millennium for the adoption of a new system of evaluation and grading by Spain's universities. The intention was to inte-

grate the method of computing and awarding credits for university study with that employed elsewhere in the European Union. The result will be improved interchange of students, rapid assessment of data by institutions in various countries, and the integration of Spain's scholars into a pan-European system of higher education. When fully functioning, the new system will facilitate the movement of Spanish professionals and specialists across national frontiers, thus enhancing their employment opportunities and easing their ability to access the latest technological instruction. As the new century proceeds, it may be the travels of young scholars rather than the expeditions of young soldiers that will count for more in Spain's true Europeanization.[10]

Although it appears confident and even assertive in its domestic and international political policies, the Spanish government is less at ease on socio economic questions. A European Union meeting convened in Sweden in January 2001 to discuss issues of employment equality and social security concluded that Spain fell short of the norm in provision of jobs and pensions for women. The country would have to increase the number of women in the workforce by 3.2 million within the next 10 years to meet the goals set by the Union. Accustomed to trumpeting the constitutional and political gains achieved by women since the advent of democracy, Madrid was obliged to make a somewhat uncomfortable and unsatisfactory response. Minister of Labor Juan Carlos Aparicio suggested that Spain's relative shortcomings in this area would not seem so serious once the 13 additional countries currently under consideration for EU membership were admitted. Not only did this argument appear to be of questionable relevance, considering the anticipated delay in admitting many of the candidate nations, but it suggested also a hope to look less bad rather than a determination to do better. There was some grumbling in Spain, too, over highly publicized statistics showing that Madrid provided only one-seventh of the European average in the entire range of family services. Some Spanish commentators complained that it was unfair to judge Spain by the level of social programming in which the cradle-to-grave welfare philosophy of Sweden and other northern countries skewed the calculations. Spain's fiscal and economic development needs, it was argued, could not permit this kind of family support program for the time being, especially when the employment projections for the next few years seemed worrisome. Feminists and advocates of children's rights, on the other hand, urged an early and vigorous commitment to achievement of the EU standards. Many of these activists also took the occasion to remind the public about the alleged deficiencies of the Spanish justice system with regard to women. Only a few months earlier, more than 2,000 supporters had ral-

lied around Teresa Moreno Maya as she began serving a fourteen-year prison term for killing her abusive husband. They have turned her case into a symbol of what they see as anti-female law enforcement that persists after twenty five years of democratic reform.[11]

Clearly related to the future of women, children, and the family in general were new data revealed about questions of human reproduction in Spain. The male population, Spaniards were told, was experiencing a significant level of sexual dysfunction in the age cohort whose contribution to the future of the nation was most important. Sterilization, as an alternative to birth control methodology, was on the increase. Late marriages, already a recognized trend, had resulted in a disproportionate number of girls being born (a phenomenon verified in other countries). Although the official census figures would undoubtedly confirm that Spain had reached the 40 million level in population, people were asking where the next generation of Spaniards would come from. Whom, for instance, would these "extra women" marry? In this context, the influx of immigrants, most of them non-European, assumed new urgency. The government's ambivalent response to parliamentary inquiries, security challenges, immigrant rights marches, and anti-immigrant onslaughts offered little guidance as to the demographic decisions that the country would make in the new century. And what was one to think of the United Nations' demographic projection, which declared that Spain was going to lose nearly a quarter of its population by 2050, with the median age of Spaniards rising to 55, making them the oldest nation in the world?[12]

Wherever the Spaniards of the future are going to come from, it is certain that they would have to be participants in the scientific and technological revolution that will be sweeping the twenty-first century world. As they recovered from millennium euphoria, those who are striving to maintain the impetus of national involvement in major research projects raised a public clamor over a slowdown in government funding of their work. In a variety of fields, from genetics to communications, Spanish scholars and scientists had moved to the cutting edge of investigation. Now they were being forced to curtail or delay their activities. The Madrid authorities, sensitive to the maintenance of an international reputation for investigation and discovery that they had been at pains to build up in recent years, have responded with explanations that temporary delays in delivering grant money resulted from bureaucratic shifts following the 2000 election. They promised that the funds were in the pipeline and that those who had been complaining would soon be able to resume their research at full speed.[13]

As the twentieth century gave way to the twenty-first, Spain's literary wars were still being fought by aging Young Turks who were challenging

what they still described as archaic ideas. The winner of the Cervantes Prize for the year 2000 was Francisco Umbral, 68, who described his victory as the triumph of the new Spain over the old Spain. As a journalist and self-proclaimed "Man of the Left," he considered the long-delayed award of this most prestigious of prizes as a victory for people who, like himself, had opposed the Franco regime. The secret balloting had favored more conservative nominees at first, but his allies had finally carried the day, he assured newspapermen. Among those on hand to hail his victory were such veterans as Miguel Delibes and Camilo José Cela. Cela himself was soon caught up in another controversy when he made some dismissive remarks about homosexuals. He became the object of numerous written and verbal attacks in which he was denounced as notoriously ignorant and crude as well as fascistic. His detractors reminded anyone who had forgotten that he had fought on Franco's side during the Civil War and had gotten away with a great deal during the dictatorship despite his controversial writing. The octogenarian author remained oblivious to all of these barbs, still at work on his latest novel. Writers of the youngest generation with claims to innovative approaches to literature grumbled that it would be many years yet before they could win the kind of attention that these "dinosaurs" still gained as they endlessly refought the battles of the 40s and 50s. Much more to their taste was *Invasores de Marte* ("Invaders from Mars"), a January 2001 anthology of horror and science fiction stories whose editor, Javier Calvo, wrote in his preface about exploring the sewers and hidden places of the human mind. The Spanish and Latin American contributors were playing upon fears and crossing boundaries in a way that post-1975 intellectuals generally find more stimulating than evocations of Civil War quarrels. More gratifying to the avant-garde was the induction ceremony of the Valencian architect-engineer-sculptor Santiago Calatrava into the Royal Academy of Fine Arts. The ceremony, in November 2000, broke with tradition when the honoree abandoned the customary practice of making a speech of gratitude by showing a self-made video to the assembled academy members. The film, titled *Movimiento*, was intended to convey the convergence of his work with the other arts, including painting and music. Variously described as pretentious and brilliantly creative, the presentation was strikingly at odds with the conventional expressions of humility and respect for one's elder brethren. The distinguished composer Cristobal Halffter spoke politely about the "ethical" nature of Calatrava's work. Others left the ceremony obviously baffled or annoyed. Younger commentators agreed that Calatrava had "shaken things up" or "let in a bit of fresh air."[14]

An attempt to build a bridge between the present generation and the issues and thinkers of the past was made in November 2000 with the convocation in Madrid of an international conference: "Art, Education and Society in Ortega y Gasset." The aim of the conference's organizers (which included the ministry of education and culture and the University of Madrid) was to make the life and thought of José Ortega y Gasset (1883–1953), philosopher, professor, journalist, politician, and internationalist, better known to his twenty-first-century countrymen. The conference, meeting in coordination with the appearance of a new edition of his complete works, sought to broaden the respect that Ortega y Gasset enjoys among intellectuals into an awareness of the significance of this classic figure among present-day students. The philosopher, whose best-known work, including the *Revolt of the Masses* was published in the 1920s, advocated an integration of Spain with Europe that conflicted with many of the tendencies current in his own time. His wide travel and teaching experiences in other countries (including the United States), both before and after the Civil War, broadened his global perspective. His admirers see him as an extremely important inspiration for those who seek to adapt post-Franco Spain to the environment and challenges of the new millennium.[15]

The constant allusions in cultural circles to the need for new directions in a new phase of world history is fortunately balanced by a multitude of missions that Spain has undertaken in the millennial period to preserve her historical heritage. These include projects as grand as the architectural reconstruction of the oldest portion of Toledo and as focused as the renovation of one of El Greco's most important paintings ("*El retablo de doña María de Aragón,*" 1600). The Alcázar of Seville, one of the grandest achievements of the Moorish period, is being refurbished. The galleries of the Prado are being expanded. The Archeological Museum has added exhibits which display an additional three centuries of Spanish artifacts, carrying the story of Spanish handiwork down to the mid-1800s. The status of Spain's venerable windmills as a treasure of vernacular architecture has been acknowledged by a commitment to repair and protect what is left of these "giants" that Don Quijote famously confronted. At a different, but perfectly legitimate, level of historical concern, the survival and extension of the noble vintages of Rioja have been undertaken in a collaboration of wine producers and government agencies that will permit the wider diffusion and recognition of yet another type of Spanish classic.[16]

A contrasting view was offered by Juan Goytisolo. Just turned seventy, the writer addressed an audience of editors and readers in February 2001 following the publication of his latest book, *Pájaro que ensucia su propio nido* (Bird That Dirties His Own Nest). The title was an ironic use of a dia-

tribe hurled against him by those who resented his criticisms of Spanish government and society. Perennially at odds with the prevailing state of affairs in his native land, Goytisolo, after living for many years in France, settled in Morocco, becoming the first major Spanish literary figure in over a thousand years to be fluent in Arabic. His support of the "Moors" in immigration disputes has made him more controversial than ever. In his lecture, Goytisolo berated the "self-censorship" of publishers and journalists and the prevalent worship of the "market god." Speaking of his January 10 essay in *El País* titled "*Vamos a menos*" ("We Are Becoming Less"), he said that many people had told him that they shared his opinions, but no one had ventured to discuss them publicly. He went on to criticize a new form of repression, in which the authoritarian regime of the past was replaced by an unspoken agreement to praise the new regime and maintain a "positive" consensus at all costs. Far from becoming more liberal, or even restrained, the church was creeping back into a position of influence under Aznar's patronage. Refuting those who accused him of being bitter after being passed over for the Cervantes Prize, he declared that he would never accept it because of some of the other people to whom it had been given. In a sweeping overview of Spanish cultural history from the Middle Ages to modern times, he contrasted the vibrancy and openness of earlier writers with the narrowness and negativism of the present. He rejected the academic classifications of literary critics, describing himself as an autodidact who ranged freely over setting and subject in his literary career. Contemporary Spain was, for him, a place which badly needed cultural activists who would rain on the parade of egotism that passed for national pride.[17]

Cultural analysts might sound their upbeat or downbeat notes, but the year 2000 provided a propitious conjunction of anniversaries that reminded Spaniards of the link between a glorious past and a promising future. The 500th anniversary of the birth of Spain's greatest king, Carlos I (who is perhaps better known under his alternate identity as the Holy Roman Emperor Charles V) was celebrated throughout 2000. The principal venue of these observances was in Seville, where a wide variety of paintings, furniture, armor, religious artifacts, documents, and memorabilia revealed the many-faceted nature of the great monarch's career. In a life that spanned the first half of the sixteenth century, he built upon the unifying achievements of his grandparents, Fernando and Isabel, extended the dominions of Spain throughout the world, and sought to create a united Europe. Carlos/Charles was born in what is now Belgium, and the international relevance of his anniversary was marked by the migration of this grand exhibition to that country toward the close of his 500th anniversary year.[18]

Even as Spaniards and other Europeans were absorbing the implications of one monarch's reign, they were brought face to face with another king marking a much more recent anniversary. Twenty-five years after taking the oath of office as Spain's first constitutional sovereign of the post -Franco era, Juan Carlos I gave an extended interview on Spanish television recounting with intensely personal reflections and reminiscences his experience in presiding over the transition from the days of dictatorship to the days of democracy. The queen and their children joined in with their individual comments and feelings about the quarter century that came to an end in November 2000.

The king recalled his doubts and fears as he prepared to take the oath of office in 1975 and spoke feelingly of how those emotions were replaced by a calm confidence that the two Spains, so long at odds, were now reconciled. His whole reign, he said, has been dedicated to deepening and perpetuating that reconciliation. There had been moments of great tension and danger, most notably the attempted military coup of February 1981. But much of his work had been carried out in the more mundane enterprise of traveling about the country, promoting a sense of shared nationality and democratic purpose. Ironically, the advice that Franco had given him when he was a young man—"make yourself known to the people,"—echoed that of his grandfather, Alfonso XIII. The king who never reigned—Juan Carlos's father—had passed this dynastic injunction on to him: "The royal family must be nomads. They must travel about the country seeing and being seen by the people. Above all, this is the duty of the king." The great task of the royal nomad has been to promote unity in the face of disruption. "If we stand together, united," declared Juan Carlos, "we can defeat terrorism."[19]

For all that has been accomplished in Spain during the era of democracy, for all the achievements of the Spanish people in rebuilding their place in Europe and the world, for all their pride in their heritage, and their progress in the modernization of their society, their unity as a nation and their image in the sight of other nations depend upon their triumph over terrorism. At the First International Conference on Culture and Peace, part of Spain's solemn observance of the new millennium, the king spoke less personally but with a no less intense concern. "Peace is only possible and lasting," he said, "in a political context of democratic principles that assures political, economic, and social development." This context "in the national and international environment must be based in real and effective democracy for all citizens in the application of the Universal Declaration of Human Rights." The king went on: "Peace is a culture, and, as such, it

needs to identify with something substantial, that we can all share and whose form we can like. That ultimate reason can only be the dignity of the individual and his inalienable rights." Whether or not King Juan Carlos I reigns for many years to come and whether or not the restored monarchy outlasts his reign, a listener commented that these are words that Spain cannot afford to ignore and that it would do well to live by.[20]

On April 26 1937 the Basque market town of Guernica was bombed by Franco's German allies. Hundreds of its people were killed. On a hillside overlooking the site of the atrocity, a memorial by Eduardo Chillida was erected fifty years later. The tall, semi-abstract sculpture, titled "Our Father's House," was dedicated with the hope that it would inspire those who "seek to end the slaughter of innocent civilians everywhere."[21]

On January 27, 2001, Ramón Díaz, a 51-year-old civilian cook employed by the Navy, was killed by a bomb that had been planted under his car. Police attributed the killing of Díaz, who left a wife and 2 children, to the Basque group ETA, who had chosen an "easy target" to make up for the failure of several earlier car-bomb attempts. Thousands of people across Spain turned out for a silent protest against this first assassination of the year. The distinctive Spanish rhythm of life and death goes on into the new millennium.[22]

PART II

Portugal

A View from the Tower: Politics

Where the Tagus flows into the Atlantic, overlooking the estuary from which Portugal dispatched its fleets of exploration and conquest, guarding the approach to the capital, Lisbon, stands the Torre de Belem. Constructed in the early 1500s, at the height of the nation's prosperity and power, it recalls the reign of that most aptly named of all monarchs, Manoel the Fortunate. Beneficiary of a century of bold maritime initiatives and blessed by the loyal service of brave captains, Manoel I was not merely a lucky king. He was also a shrewd diplomat who maintained a close dynastic alliance with Spain and a cunning businessman who understood both the necessity of overseas ventures and the value of commercial treaties. A patron of the arts who gave his name to the Manueline style in art and architecture, he erected this tower to serve both as a fortress and a work of art. The gun embrasures and crenellations of the five-story structure are adorned with the same emblem of the Order of Christ that was emblazoned on the sails of his caravels. The Moorish curves and cupolas of the tower reflect the on-going influence of Portugal's Islamic neighbors. Five hundred years after its builder and his achievements have faded away, the tower stands as a memorial to his grandeur and an evocative reminder of the fortunes and misfortunes that have passed over Portugal.

A visitor to the Torre de Belem who is willing to exercise his historical and visual imagination can recreate the scenes that have been played out over the generations at no great distance from this tower. Ships can be seen entering the harbor bearing the riches of distant Asia. Splendid palaces and churches rise in Lisbon in an era of luxury and extravagance. Castilian sol-

diers marching to the city in 1580 impose a sixty-year dominance during which Spain's enemies ravage Portugal's colonies. Lisbon is free again, under the Braganzas. Afonso VI sails off to exile and mysterious death in the Azores. The fabulous riches of the Amazonian interior arrive to finance the Versailles-like palace of Mafra. The great earthquake of 1755 topples down the sanctuaries during the hour of Mass and the altar candles set the city ablaze. Mad Queen Maria I is spirited away to Brazil by an English fleet as French cavalry men top the rise overlooking Lisbon. Wellington and his Anglo-Portuguese army march forth to drive Bonaparte back across the Pyrenees. Plague and poverty oppress a population unable to cope with the industrial age. Brazil's most exotic plant of all, the monarchy planted there by the Braganzas, is uprooted in a bloodless revolution. Twenty years later, the Portuguese representatives of that dynasty are shot down in the heart of their own capital. One young prince survives to become Manoel II—and last. In 1910 the ultimate successor of Manoel the Fortunate bids farewell to the Tower of Belem to take up his residence in a country home at Twickenham. A ramshackle republic, seeking international respectability, joins the Allies in 1916, and thousands of conscripts march past the bemused but applauding crowds to shed their blood meaninglessly on the Western Front.

From Revolution to Revolution: Dictatorship

Antonio de Oliveira Salazar was born in Vimieiro, far from the historical and political currents of Lisbon, the son of a farm manager, and destined for the priesthood by a mother who delighted in his intelligence and diligence. Although commentators have made much of the fact that he was born on April 28, 1889, a week after Adolf Hitler, there was little resemblance between the early life of the two future dictators. In 1908 Salazar announced that he was going to pursue a legal rather than a clerical career. He enrolled at the venerable university of Coimbra. By 1914 he had earned a law degree, and within four years had won an academic appointment. A brief venture into parliament in the early 1920s convinced him that the chaos of contemporary public affairs was not the place to make a name for himself, and he soon returned to teaching. Although Salazar's early writings are essentially prosaic treatises on accounting methods, he gradually acquired a reputation (steadily inflated by his own self-promotion) as a brilliant economic thinker. By 1926 he was being offered the finance ministry and rejecting it because his conditions for service were not promptly met. When a desperate government repeated the offer in 1928, he held out for total control over all aspects of public expenditure, and his demands were met. Through a combination of brilliant improvisation and ruthless author-

itarianism, he balanced the budget and made himself Portugal's indispensable man. In 1932, the president of the moment, realizing his own limitations, appointed Salazar prime minister with virtually unlimited power, a position he would hold for the next 36 years. Although some historians have, once again, pointed to the parallel with Hitler, who became chancellor of Germany in January 1933, Salazar had very little in common with the Fuehrer or, for that matter, with Mussolini or Franco. A pragmatic rather than dogmatic executive who understood the limitations in which Portugal found herself during the 1930s, Salazar combined Catholic cultural values and socioeconomic conservatism with the kind of nationalistic evocations that had to take the place of vanished glory. Although he founded the National Union as his "official" party in 1930 and crafted a new constitution in 1933 to enshrine his so-called "New State," the corporate models upon which they are based fall short of full fascism. While understanding the importance of such interest groups as the church and the landed proprietors, he allowed them only limited access to power. In the same way, the army was made to understand that it had to operate within a framework of budgetary and foreign policy reality. Unlike the German, Italian, and Spanish strongmen, Salazar had no experience in frontline combat and no real empathy with soldiers, whom he treated as well-paid civil servants. Intellectuals chafed under censorship and leftists experienced harassment from the new secret police, but most Portuguese seemed to accept relative efficiency as well as modest improvements in the country's infrastructure and industrial production as a justification of Dr. Salazar's harsh medicine. Despite Portugal's evident sympathy with the Franco leadership during and after the Civil War, her neutrality in 1939—45 was not seen in as dark a light as that of Spain. Lisbon served as an escape route for refugees (not to mention a base for intelligence operations by all nations), and Salazar eventually made the Azores available to the United States as an air base. Thus, while Spain was treated as a pariah following the Second World War, Portugal was admitted as a charter member of NATO in 1949. American subsidies and rising prosperity elsewhere in Europe led to steadily expanding investment and an impressive growth in the country's economy through the 1950s.[1]

Just as Salazar seemed to be casting aside the lingering odium of pseudo-Fascism and emerging as an international elder statesman, he fell afoul of the rising tide of anticolonialism. As a new member of the United Nations (1955), Portugal was confronted by harsh criticism and aggressive pressures to dismantle her empire as Britain and France were already doing. Salazar's reply that the latest revision of the Portuguese constitution made the African and Asian outposts overseas provinces rather than

colonies was greeted with derision and denunciation. Ironically, the one thing that had sustained Portugal's national pride through a century of decline and made her more than an insignificant country stuck away in a corner of Europe now threatened to sink her new-found prosperity and optimism. Salazar had committed precious resources to developing the overseas territories, extracting their natural wealth, and encouraging settlement by European families. The thrust of his policy had been to turn a liability into an asset, transcending the incongruity of a 35,000-square mile backwater ruling more than 800,000 square miles of mineral and agricultural potential. His greatest legacy to his nation was to have been the conversion of the world's oldest surviving colonial empire into a truly global "New State."[2]

History's greatest reversals of fortune sometimes begin with trivial, or even farcical, episodes. In 1961 the Portuguese enclave at Ouidah, on what once had been the Slave Coast of West Africa, was the object of demands for departure from the newly independent nation of Dahomey (now Benin). The two Portuguese officers resident in Fort St. John the Baptist packed their suitcases, set fire to the buildings of their compound and withdrew with as much dignity as they could muster, leaving the local fire brigade to rush about dousing the flames while a policeman climbed up the flagpole to replace Portugal's banner with that of the new owner. India also chose 1961 to escalate its rhetorical onslaught against Portugal's retention of Goa and a few other scraps still remaining from the days of Vasco da Gama. After 15 years of intransigence, Salazar had to yield to force of arms as the Indian army crushed a token resistance and occupied "Portuguese India." Between 1961 and 1964 Portuguese Africa went from cries for independence to armed insurrection, supported by the Organization of African Unity and assisted by a wide range of experts in "wars of liberation," ranging from Algerians and Cubans to East Germans and Chinese. By the latter year, Angola, Mozambique and Portuguese Guinea were in a state of insurrection, while the archipelagoes of Sao Tome e Principe and Cape Verde Islands were also simmering with liberation sentiments.[3]

For Salazar, any concession to anticolonialism was unthinkable. The material resources of Portugal were poured into the repression of revolt in the overseas provinces, disrupting the economic development programs at home that his more progressive advisors had been promoting. The expenditure of human resources was even more lavish. Over 200,000 men were mobilized to serve in the maintenance of the empire, with 1 out of every 4 males in uniform, and the term of compulsory service doubled to 4 years. In the midst of this African war, the dictator suffered a stroke, remaining

incapacitated from 1968 until his death in 1970. The "genius" who had ruled the nation for 40 years was laid to rest in the National Pantheon in Lisbon, but his crusade went on.[4]

Marcelo Caetano, a long-time associate of Salazar and a fellow academic who had served as rector of the University of Lisbon, succeeded him as prime minister. Despite gestures toward domestic reform, Caetano remained committed to the colonial struggle. While an elite cadre of permanent staff officers enjoyed the comforts of Lisbon and assured their civilian chief that they could see light at the end of the tunnel, contingent after contingent of youths was shipped off to the combat zones. Foreign observers noted the eerie similarity between Portugal's campaigns and the contemporary American operations in Vietnam. Naval vessels patrolled the coasts, attempting to halt arms smuggling or were pushed upriver into the interior to block rebel crossings. Planes and helicopters bombed villages and incinerated fields. Ground troops floundered through jungles and swamps pursuing ever-elusive bands of guerrillas. Fortified villages were created, within which loyal tribesmen were sheltered. Four years after Salazar's death, the fight to win the minds and hearts of Portugal's African subjects dragged on, consuming nearly half of the annual budget and alienating an ever-growing proportion of the population at home.[5]

On April 25, 1974, The Caetano regime was overthrown. The streets of Lisbon were thronged, not by rioting workers or disaffected taxpayers but by soldiers of the Republic under the command of junior officers who had become disgusted with the bloody futility of "imperialism." The Armed Forces Movement, a committee of leftist captains and majors had determined upon a bloodless coup to replace an administration that they perceived to be totally discredited as well as mindlessly destructive. Some higher-ranking officers had given indications of support during the first months of 1974. Plans were laid, signals were agreed upon (certain songs of metaphorically expressed dissent), and the key players moved quickly, quietly, successfully. Scarcely a shot was fired as units that had been pledged to the cause took over key positions, and by the end of the day the triumphant soldiers were displaying flowers in their rifle barrels. The Revolt of the Carnations, as it came to be known, had begun the transformation of Portugal. The leaders of the old regime stepped down, almost wearily, as if they were glad to go. General Antonio Ribeiro Spinola, a disillusioned former field commander in Africa and a covert backer of the rebels, stepped forward to take charge of a provisional government. Nearly a hundred desk-bound generals and colonels were dismissed from the war ministry. It was announced that negotiations would be opened to end the fighting over-

seas, and the nation was told that the troops would soon be brought home. Portugal was laying down the burden of history.[6]

After The Professor Has Left the Classroom: The Coming of Democracy

Under Salazar, said one of his successors, the nation had been "as tidy and quiet as a cemetery."[7] Now it seemed as if all of those who had played dead were up and rushing about. Everyone demanded change, but a score of factions each offered a different version. Banished politicians returned to Portugal and tried to organize parties, most of which promptly split among contending cliques. The communists, the only group to have retained a semblance of discipline during the dictatorship, demanded power. While government offices shut down, workers declared impromptu strikes, and the "Young Captains" who had launched the insurrection quarreled among themselves, General Spinola was sworn in as president of the Republic. Although his criticism of the war in Africa had led to his dismissal and made him an icon among dissidents, he now opposed any early grant of independence to the colonials. He soon revealed the fundamentally reactionary traits that he had developed as a liaison officer with the Franco regime and a volunteer serving with Hitler's forces in Russia. By the beginning of 1975 he was ready to launch a coup against the coup. His effort failed miserably, however, and he was forced to leave the country. Notwithstanding all the political turmoil, the first truly free elections in nearly 50 years were held, as promised, on April 25, 1975, the first anniversary of the Revolution. To their surprise and chagrin, the communists won less than 13 percent of the vote, and the socialists led the poll with 37 percent. While approving the nationalization of banks and insurance companies and the transformation of some of the great land holdings in the south into collective farms, the electorate was clearly inclined to follow a middle path. Neither rumblings of opposition from the traditionally conservative northern provinces nor even another coup attempt by the more radical members of the Armed Forces Movement were able to divert the revolution to the extremes of Right or Left. Purged of its most fractious elements, the revolutionary council completed the work of revising the constitution. The April 1976 elections, held under the new constitutional system, confirmed the dominance of the Socialist Party, with its leader Mario Sóares as prime minister. Another professional soldier, General António Eanes, assumed the presidency.[8]

While Portugal was consolidating its post-revolutionary situation, Spain had bidden farewell to the Franco regime (November 1975). During the period of 1976–82, both countries were engaged in the delicate process of

completing the transition to democracy. Unlike Spain, whose new king provided a stabilizing element, Portugal had long since broken with its monarchical heritage. The main line of the Braganzas had become extinct in 1932, and the claims of the Miguelite line did not offer a serious option. On the other hand, the role of the Spanish Army was still a matter for public concern (at least through 1981), while the Portuguese military, having veered as sharply to the Left as the country was willing to go, had exhausted its political potential. The granting of independence to the colonies in 1975 was followed by rapid repatriation and reduction of the armed forces. Within a decade the troop strength shrank from 217,000 to 62,000. In 1982 the revolutionary council, representing the continuing oversight role of the officers who had made the Revolution, was disbanded. Just as the Spanish Communist Party developed into a rather innocuous player in the post-Franco era, so its Portuguese equivalent failed to fulfill its early potential. As the communists revealed themselves to be little more than paper tigers, Portuguese Rightists, like those in Spain, found no plausible target for their rhetoric. With extremists marginalized, socialist governments could take office in both countries by 1982 without stirring much excitement either at home or abroad. Moreover, the Portuguese socialists, like their Spanish peers, tended to moderate their doctrines once they had assumed the reins of power.[9]

Clearly, Portugal's most critical moments were over, but problems remained. There had been 6 governments between 1974 and 1976; there were 10 between 1976 and 1986. This represented progress, of a sort. Yet no single party could capture the majority in the Assembly or guarantee the success of its program. It was only by the reluctant recognition that all the Portuguese people must pull together to extricate themselves from poverty and isolation that a consistent line could be followed. In 1977 Portugal applied for admission to what was then the European Community. A rigorous plan of fiscal retrenchment and economic self-discipline was laid down for her. By 1986 the requirements had been met and admission to the European Union was granted. Mário Soares, the socialist leader who had played a critical part in steering his country through a difficult decade, now became president of the Republic, the first civilian to hold that position in 60 years. Reflecting a shift to the political center, the Social Democratic Party (Portuguese Marxism's moderate half-brother) contributed the new prime minister, Aníbal Cavaco Silva. The latter sounded the energetic and demanding note that would be the signature of his administration when he declared that "Portugal needs to do in ten or twenty years what other countries achieved in a century." With more than a little help from their friends in the European Union, the country's leadership

team set a remarkable record of economic growth and social development. Even more essential, they secured the continuing political stability of the democratic process. The coalition fell apart in 1996, when the dynamic young socialist Antonio Guterres captured the prime ministership. Cavaco Silva then made a bid for the presidency but was defeated by the Socialist mayor of Lisbon, Jorge Sampaio. Sampaio and Guterres were returned to their respective offices in the 2001 elections. Although both the president and the prime minister are Socialists, they belong to different factions within the party, thus, in a sense, continuing the balance that existed during the 1980s. Such a balance has compelled politicians to exercise moderation and cooperation in guiding the fortunes of the nation. Nevertheless, when a good opportunity presents itself, Portugal's political factions do not hesitate to air old grievances and reiterate their distinctive visions for the future.[10]

On April 25, 2001, the National Assembly solemnly marked the twenty-fifth anniversary of the constitution as well as the twenty-seventh anniversary of the Carnation Revolution. Each party leader made the obligatory salute to the military rebels of 1974 and the constructive achievements of 1976. The conservative spokesman, however, complained that the current socialist regime had been too lenient in its recent treatment of left-wing "terrorists" of the late 70s and early 80s. The ruling socialists responded with the assertion that their party had taken appropriate action to punish extremism. Parties to the left of the socialists highlighted lack of reforms after a quarter century of supposedly marxist government. The communists proclaimed themselves the consistent champions of those ideals for which the revolution had been launched. Factions gathered under the banner of the Left bloc warned against the pernicious economic consequences of globalization, which would undercut the achievements of the revolution. Environmentalists joined in to demand more attention to "green" issues in the name of preserving the true benefits of revolutionary change. The Social Democrats used most of their allotted time urging electoral modification, as befitted the largest opposition party, which had to appear practical and businesslike. President Sampaio concluded the parliamentary session by reminding everyone of the need for stability and disciplined work. All in all, one commentator said, "It was not a bad little session as these things go. Perhaps the 50th anniversary commemoration will be more exciting."[11]

It is worth noting that Portugal still operates under a constitution which explicitly acknowledges the revolutionary character of what took place in 1974. The preamble declares the armed forces movement to have

acted on April 25, 1974 in response to the spirit of resistance exhibited by the Portuguese people and to have overthrown the "Fascist regime." The preamble declares that the armed forces acted to free Portugal from dictatorship, oppression, and colonialism. This, it maintains, represents a revolutionary transformation and the beginning of a historic reversal of Portugal's society. This revolution, the preamble continues, restores to the Portuguese people their fundamental rights and liberties. It then speaks of how the constituent assembly was convoked to codify these rights and liberties. It affirms that the goal of the constituent assembly was to open the path to a socialist society which would arrive at a more just, free and fraternal nationhood.[12]

The specific provisions that were drawn up by this constituent assembly and put into effect in April, 1976, were modified in 1982, 1989, 1992 and 1997. The basic structure of the constitution remains intact, however, and the institutions it ordains are more prosaic than the rhetoric of the preamble seems to promise. The chief of state, elected by universal adult suffrage for a 5-year term, names a prime minister who can command a majority in the legislature. Members of the council of ministers are appointed by the president on the nomination of the prime minister. The president is advised by a consultative council of state and is more than the figurehead found in some parliamentary systems. The unicameral assembly of the republic is made up of 230 members elected for 4-year terms by universal adult suffrage. The constitution also provides for a supreme court (the Supreme Tribunal of Justice). Its judges are appointed for life by an independent "Superior Council of the Magistracy." There is also a constitutional court set up to decide on the constitutionality of legislation. Portugal has accepted the jurisdiction of the International Court of Justice with certain reservations.[13]

The most recent elections to the assembly in October 1999 (with the next scheduled for October 2003) produced the following results:

Portuguese Socialist Party (PSP) 43.9 percent (113 seats)
Social Democratic Party (PSD) 32.3 percent (83 seats)
United Democratic Coalition (PCP/CDU) 9 percent (17 seats)
Popular Party (PP) 8.3 percent (15 seats)
The Left Block 2.4 percent (2 seats)[14]

The leading political personalities to emerge from these elections were Antonio Guterres—reconfirmed as prime minister—and Jose Manoel Durão Barroso succeeding Cavaco Silva as leader of the Social Democrats. The moderate Popular Party is led by Paulo Portas and the Communist Party in alliance with the United Democratic Coalition was guided through

the elections by Carlos Carvalhas. Francisco Louca achieved the forlorn distinction of leading the Left Bloc with its two assembly seats.[15]

For a country that came so late to the exercise of a democratic franchise and an open political process, Portugal has evolved a relatively uncomplicated system and a tendency to orderly elections. Even the convulsions of the 1970s, with strident appeals to marxism and impulsive demands from various sectors of society, were only minimally violent. While some may attribute this outcome to stagnation or resignation, there are those who persist in crediting the paternalistic hand of Professor Salazar. The Old Man, they say, believed that most of the country's problems could be solved if people would just sit down and keep quiet.

New Frontiers: The Opportunities of Democracy

In the realm of foreign policy, Portugal's most important relations are those with her nearest (indeed, only) neighbor—Spain. Bound together by history and geography, the two Iberian states have passed, despite centuries of rivalry and warfare, into a state of peaceful coexistence, disturbed by occasional stresses and strains.

Inevitably, the larger nation has tended to regard the smaller as an object either of aggression, or, in later years, patronizing condescension. The great Spanish philosopher, Miguel de Unamuno, for example, spoke of Portugal as the place where one goes to commit suicide. Even he, however, saw natural affinities and a need for mutual respect and solidarity. He recognized the need to overcome "the petulant pride of Spain and the petty suspicions of Portugal." His own travels and literary excursions moved him to demand that Portugal and Spain develop a mutual study and knowledge of their respective cultures. Portugal's current minister of the presidency, Guillerme D'Oliveira Martins, has recently echoed these sentiments, quoting not only the Spanish philosopher but his own ancestor, the author of a history of Iberian civilization, who wrote of the "need to mobilize the disposable energies" of both peoples. Appealing to the pragmatism of both nations, the minister holds that each will serve the cause of cooperation by understanding clearly her own particular interests without being hampered by either illusions or selfishness.[17]

This positive approach has been reflected in the diplomacy of the quarter century since the near-simultaneous advent of democracy in the Iberian lands. Spain's most prestigious instruments of this diplomacy, King Juan Carlos and Queen Sofía, have made 3 state visits to Portugal. The first came in 1978, following the establishment of constitutional regimes in both countries. The second occurred in 1989 after both had begun their active participation in the European Community. The third took place in

September 2000, symbolizing a common Iberian approach to the challenges of the new millennium. In marked contrast to the periodic consultations through which Salazar and Franco had shaped their common experience of pseudo-Fascism and international isolation, these royal visits emphasized a shared commitment to liberalism and Europeanism. Each element in the September 2000 tour was designed to highlight a different dimension of the new Iberian spirit. Portugal's President, Jorge Sampaio, escorted the visiting chief of state throughout most of his time in the country. The king discussed practical politics with Prime Minister Antonio Guterres and addressed the National Assembly on the joint concerns of the two nations. Juan Carlos presided over several "working breakfasts" with Portuguese and Spanish business leaders in Lisbon and Oporto to promote trade and joint ventures. He then journeyed north to the province of Braga where he spoke with prominent intellectuals and the rising generation of students in various academic settings. He and the queen concluded by formally opening an exhibition highlighting the historical and cultural connections between this region and his own Galicia. Ministerial discussions held on the sidelines of the royal circuit dealt with European Union issues affecting both countries and the agenda of the next Iberoamerican Conference in Panama. Plans were also made for negotiations at the head of government level early in the coming year.[18]

By the time Spain's prime minister, José María Aznar (accompanied by nearly a dozen cabinet officers) arrived in Lisbon in January 2001, a single topic had come to dominate the dialogue with his Portuguese counterpart. Spain had grown increasingly upset by the Basque nationalists' tactic of claiming political asylum in various parts of Europe when too closely pressed by Spanish police. An extradition agreement had recently been signed with Italy, and talks were proceeding with France, Belgium, and Germany toward a similar end. The host, Premier Guterres, showed no inclination to take part in this trend. He insisted that there was a constitutional impediment to the extradition of those who had been granted political asylum in Portugal. Despite Spain's insistence that such members of ETA as José Luis Telletxea Maia were common criminals with no right of sanctuary in Portugal, Antonio Guterres maintained the inviolability of the law, suggesting that only a general EU agreement could produce the response to crimes such as terrorism that was needed. The Spanish premier was less than happy with this derailing of his bilateral campaign and warned that countries needed to make certain concessions and modifications in the name of international cooperation. Commentators who enjoy attributing every public dispute to private antagonisms did not fail to note that Mr. Guterres had broken off an engagement to Mr. Aznar's sister-in-law a few

months earlier. Newspaper reports at the time had quoted an old Portuguese saying: "No good marriage comes from Spain." Whatever the impact of hurt feelings and harsh proverbs, the Portuguese prime minister subsequently found a bride closer to home. In April 2001, he married Catarina Vaz Pinto, formerly state secretary for culture in his own administration.[19]

Transcending the boundaries of Iberia, Portugal has linked herself with all of the major European and international organizations. A member of NATO since its foundation, she has contributed to a number of its operations, including the 1999 intervention in Kosovo, where four planes from her small air force took part in the crusade against Serbia. In April 2001, the government announced with obvious relief that none of the Portuguese troops involved in Balkan operations had suffered any effect from the depleted uranium exposure that had so agitated the European public. Admitted to the European Union during the 1980s and the holder of its rotating presidency in 1992, Portugal benefited greatly from financial subsidies and technical support provided by the more affluent members. By 2001, however, the bloom had worn off and EU's central commission was warning of grave consequences unless Lisbon put its economic affairs in order. Portugal entered the United Nations in 1955 and spent the next 20 years answering bitter criticism of her colonial policies. During the decades since the revolution, she has become an active and respected participant in a multitude of specialized organizations and activities on the world stage.

Like other former imperial powers, Portugal has retained a special relationship with the now-independent countries she once ruled. As has so often been the case in the post-colonial era, lingering bitterness has yielded to economic imperatives and cultural connections. Less than two decades after the bloody African wars had come to an end, Portugal was crafting a Commonwealth of Portuguese-speaking nations which included Angola, Mozambique, Guinea Bissau (former Portuguese Guinea), the Cape Verde Islands, and Sao Tome e Principe. Brazil and Portugal itself rounded out the membership list. Considering the underdevelopment of the ex-colonies, even modest financial aid was welcomed. Yet Portugal could not give on a lavish scale, in the manner of Britain and France. When the rising prosperity of Mozambique during the early 1990s was devastated by a series of natural disasters, for instance, Portugal could pledge less than $20 million in assistance. Even Spain, promoting its Iberoamerican initiatives, tended to usurp Portugal's place in Brazil. Nevertheless, the cultural nexus remained strong and continues to be cultivated through everything from literary prizes and educational missions to exchanges of individual hospitality between the former masters and subjects.[20]

Although overshadowed in the large-scale emancipation of the African territories in 1975, the fate of East Timor came back to haunt the Portuguese people in later years. This tiny remnant of the country's first outreach to the Spice Islands in the sixteenth century shared an uneasy boundary with a Dutch colony on its western flank until the Indonesians attained sovereignty in 1949. As soon as Lisbon declared its intention to withdraw and local nationalists proclaimed independence, Indonesian troops invaded East Timor and annexed it. A resistance movement continued down through the late 1990s, with the Jakarta government characterizing the fighters as communists and the United States choosing to accept the status quo because of Indonesia's value as a Cold War ally. The Catholic church, which retained the loyalty of most Timorese, was virtually the only institution to advocate on behalf of the island's people and to publicize their plight.

Changing circumstances focused the attention of the United Nations on East Timor in 1997–98. Two Timorese nationalist leaders (one a bishop) were given the Nobel Peace Prize for their work on behalf of social and political justice. The United States began exerting its influence in the same direction. Portugal belatedly took up the cause of its former colony and appointed herself the particular champion of a population she had chosen to abandon 20 years before. Jakarta at length succumbed to the storm of bad publicity and potential boycotts by offering a referendum in which East Timorese voters could chose between continuing the Indonesian connection or reclaiming their independence. When, in 1999, they chose the latter option, reactionary elements in the Indonesian army and their paramilitary protégés launched a campaign of reprisal that left thousands dead or dispossessed and much of East Timor's infrastructure in ruins. Only an intervention authorized by the UN and spearheaded by Australian troops saved the country from annihilation. During the period when the worst horrors were being inflicted on their former colonials, the people of Portugal followed events in the distant island with shocked sympathy. Statues and public buildings in Lisbon were draped in black to symbolize their grief. As the tide of destructioin receded in the East Indies, Portugal used its good offices and what economic aid it could muster to help in the task of recovery.

Yet, by sending a large number of language teachers to East Timor, Lisbon has stepped into the midst of a vociferous debate. Only about 10 percent of the country's population speak Portuguese. This minority corresponds very closely to the old elite and to the leaders of the independence struggle. Men like the Nobel Prize winner José Ramos Horta reject the most widely spoken indigenous language Tetun as unsophisticated and self-

isolatory, while dismissing Indonesian as the tongue imposed by an oppressive military regime against which they and their fallen comrades fought for so long. Younger Timorese, however, educated in Indonesian schools and universities, see no reason to be suddenly reduced to second-class citizens in the emerging new nation. Many of them share the sentiments of a young man who complained, "Europe is awfully far away. And take a look at Europe. Even there, almost nobody speaks Portuguese. Who are we going to talk to?" Another asserts that Portuguese is the language of the pre-1975 generation who want to control East Timor through a linguistic monopoly that will sideline those under thirty. The Indonesian military, not the Indonesian language, traumatized them, those critics insist. Indonesian will continue to be the most important language for carrying on the public affairs and commercial activities of the region. Moreover, there are those who insist that all Timorese should be trained in the global language of the new millennium: English. Visitors to Dili, the capital of East Timor, who hear the constant clamor of "Dollar America!" in the marketplace may well doubt whether this ex-colony will ever return to Portugal's cultural embrace.[21]

Far to the northeast of Timor, the most remote outpost of Portugal's empire would be the last to go. In 1557, a band of merchant adventurers sailed into a bay on the China coast and leased a plot of land from the local authorities. Thus was born the colony of Macao. It flourished as a foothold of commerce, culture, and Catholicism, then declined into somnolence. Four hundred years later a visitor could roam the nine square miles of the peninsula, with its picturesque but decaying palaces and churches, its gambling casinos and its incongruous garrison of black soldiers imported from Mozambique, and feel far removed from the bustling activity of Hong Kong, a mere thirty miles away across the broad mouth of the Pearl River. But change was in the air. The distant echo of colonial rebellion in Portuguese Africa was followed by violent riots in Macao itself. Communist China fanned the fire of anti-imperialist rage, and an insurrection by workers in the colony was put down only with difficulty. Perversely, however, by the time the Carnation Revolution led Portugal to offer the return of Macao to China in 1975, the Cultural Revolution had ebbed, and Beijing declined the opportunity for reunion. The Chinese regime preferred to leave the enclave in Portuguese hands for the time being, as an outlet for international contacts. It was another twenty years before serious negotiations were undertaken, leading to a plan for the retrocession of Macao on December 20, 1999.

As the countdown to the hand-over date began, the Portuguese authorities seemed torn between impulses of historical nostalgia and political

posturing. They undertook substantial steps to repair and polish up the public buildings and facilities of the colony, determined to transfer a handsome legacy of their stewardship to the new rulers. The airport was modernized, a new causeway linked the peninsula to the 2 small islands that lay off shore. Even bullfighting (in the nonlethal Portuguese form) was reintroduced. On the other hand, little control was imposed on the criminal element that flooded into Macao after the British yielded Hong Kong in mid-1997. The colonial police force was notoriously corrupt, and the Chinese gangsters of the "triads" bought immunity from interference as they took control of the gambling casinos and waged gun battles in the streets. Beijing talked about sending troops as early as 1998, but Lisbon, which had long since withdrawn its own garrison, refused to hear of this, even though tourism declined in the disorderly environment of the final months. As the clock of empire ticked away, the legislature that Portugal had belatedly created voted under Chinese guidance for a prominent Macao businessman as the chief executive of the new autonomous region, modeled on the arrangement with Hong Kong that was to preserve "two systems within one country." It could hardly be expected that, with only 3 percent of the territory's 430,000 inhabitants speaking Portuguese, much beyond the material remains would survive.

December 19,1999, saw a rather forlorn gathering at the cathedral, as clergy and congregants prayed for the survival of Catholicism and solemnly laid a copy of the accession agreement upon the high altar as a reminder of China's promise to Portugal to preserve religious freedom. Similar apprehensions were evident in the columns of the Portuguese-language newspaper *Punto Final,* whose name ominously signifies "full stop." In the afternoon, a flag-lowering ceremony, with parading police and playing of the anthem was held in the courtyard of the governor's palace. The folded banner was handed to General Vasco Rocha Vieira, who clasped it to his heart and walked "stone-faced" to his limousine. As he drove off, a crowd of civilians, who had applauded politely, surged through the gate to explore the official residence, only to be firmly excluded by the police.

In the main square, the Largo de Senado, decorated with Chinese lanterns and Christmas bells, local people and visitors wandered about taking photographs to commemorate the historic occasion. One Chinese said, in response to a reporter's question, that he would not miss the Portuguese: "They have been here long enough: their time is up." Yet some new Portuguese had arrived at the last minute, taking advantage of package tours from Lisbon. One woman said she had been fascinated since childhood by picture-book views of Macao. Now she said sadly, "I thought it would look grander."

During the evening the most distinguished personages gathered in a glass pavilion erected for the occasion on the waterfront. Beijing was somewhat annoyed that the guests included Sir Christopher Patten, the last governor of Hong Kong, who had been highly critical of Chinese anti-democratic practices, and José Alexandre Gusmão, a former leader of the Timorese resistance and no friend of the communists. Nevertheless, the president of China, Jiang Zemin, and the Portuguese president, Jorge Sampaio, exchanged personal pleasantries and solemn good wishes. At the stroke of midnight, the green light that had bathed the pavilion was replaced by a red illumination signaling the beginning of Chinese rule in Macao.[22]

Although December 20,1999, marked the formal end of the Portuguese empire, one more historical commemoration remained. It took place in 2000 as Brazil noted the 500th anniversary of that nation's discovery by the Portuguese navigator Pedro Alvares Cabral. A government delegation journeyed from Lisbon to meet with the Brazilian president and his ministers at the spot on the Atlantic coast where the Europeans had landed in 1500. Unfortunately for the solemnity and exchange of good wishes that had been planned, a series of demonstrations by indigenous people complaining that their ancestors had not needed to be "discovered" and that they had been badly treated over the centuries, disrupted the event. Overzealous police action brought on riotous disruption. Symbolically, the imperial experience of Portugal thus ended as it had begun, in a mixture of glory and pain.

Not far from the Torre de Belem, the monument to Portuguese exploration and discovery stands proudly in the plaza where it was erected during the last years of the Salazar regime. On a grand stone reproduction of a caravel's prow stand statues of Vasco da Gama, who opened the way to India, Bartolomeu Dias, who explored the coast of Africa, and other builders of empire, as well as Luis de Camoens, who chronicled their achievements. At the forefront stands Prince Henry the Navigator, organizer and director of Portugal's great age of maritime enterprise. An optimistic Portuguese looking out from atop the Torre de Belem may see in his mind's eye a new generation of adventurers and entrepreneurs setting forth into a world that their predecessors helped to make known and seeking new frontiers to explore.

A Bridge in Need of Repair: Resources

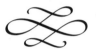

The mayor of Castelo da Paiva had been petitioning Lisbon for years. Petitions were succeeded by complaints and desperate appeals. The answer was always essentially the same: we have many demands on our time and limits on our budget, but rest assured that by this time next year you will have a new bridge. The old bridge over the Douro was crumbling under a load of traffic it was never intended to bear. On the night of March 3, 2001, a section of the roadway collapsed, plunging a bus and several cars into the flood-swollen river. Dozens of travelers were drowned. The next day a weeping mayor stood at the entrance to the bridge repeating, "I told them it was in need of repair."[1]

As José Saramago has said, Portugal is always behind the times. Her eighteenth century lasted well past the middle of the nineteenth, and she only discovered that she was no longer in the nineteenth when she was nearly at the end of the twentieth.[2] There is much in Portugal that is long overdue for repair. The bridge at Castelo da Paiva was by no means the only piece of her infrastructure that had gone too long untended. Moreover, most of her natural resources have been neglected or abused. The environment continues to suffer. So do her people. Education, health, and social welfare needs demand attention. Domestic crime, international drug trafficking, and population issues have added new stress to the life of a people traditionally burdened by poverty. Old values, including those sustained by custom, family, and religion have eroded. The history of the Portuguese economy is one of endless improvisation, with each generation making do by temporary expedience. In the most recent decades, the country has

experienced radical Marxism, agrarian decay, industrial incoherence, repeated convulsions of the labor force, and a dangerous dependency on foreign subsidies. As the *escudo* gives way to the euro, questions about essential repairs remain unanswered.

The Missing Lynx: The Environment

Portugal has been called an arbitrary, or even accidental, country. There is some historical truth to this, for there was no compelling reason why it split off from the rest of Iberia during the *Reconquista*, leaving the rest of the peninsula to spend another 300-odd years working out its political destiny. Portuguese nationalists insist that their language is quite distinct from that of their neighbors in Spanish Galicia and even appeal to the judgment of ancient Rome, which made a distinction between the Lusitanian territory and the rest of Hispania. Spanish nationalists dismissed these arguments as insignificant and periodically attempted to end by force of arms what they regard as an unjustified separation. Yet Portugal has survived within what are essentially its present political boundaries for so long a time that its physical geography seems to ratify the decisions of bygone soldiers and kings.

Although its two largest rivers, the Douro and the Tagus, both flow westward out of Spain, the estuaries where they empty into the Atlantic have become the site, respectively, of Oporto and Lisbon, Portugal's two greatest cities. A Portuguese would no more think of these rivers as being of Spanish origin than a German would consider the Rhine to be Swiss. Within a mainland area that measures only some 360 miles north to south, with an extreme width of 140 miles, Portugal encompasses a variety of distinctive regions: The Minho, Trás-os-Montes, The Douro, the Beiras (Alta, Baixa and Litoral) in the north, and Ribatejo, Estremadura, the Alentejo (Alto and Baixo), and the Algarve in the southern lowlands. Each of these traditional provinces maintains an identity reinforced by local customs, agricultural emphasis, and political memories that reinforce geographical characteristics and defy modern administrative realignments. The offshore islands of Madeira and the Azores were acquired at the end of the Middle Ages, but to many Continental Portuguese they seem to be a sort of colonial afterthought. They think of their country in terms of the cooler and rainier climate north of the Douro and the warmer environment south of the Tagus, as the terrain slopes down in the southeast toward the Mediterranean.

Within this small corner of Europe, mineral resources are scarce. Much was made of the country's deposits of tungsten, wolfram, tin, and gold during the late Salazar era, when the necessary power plants to exploit these

mines were developed. These resources have proved distinctly finite, however. Without a substantial basis of coal and iron, Portugal remains mineral poor.

Portugal's agricultural and marine resources are likewise rather sparse. In the northern region, farming is famously hard and unproductive, providing only modest crops of grains and potatoes and compelling many to leave the land for urban employment or foreign settlement. The Alentejo is more productive. Cultivation of olive trees has traditionally assured a significant source of revenue. Competition from Mediterranean lands has diminished the value of this resource, however, just as the once- vast take of sardines by Atlantic fishermen is no longer as significant as it was in earlier decades. The cork oak has long been a mainstay of the Portuguese economy, with vast areas of the countryside covered by the carefully managed plantations whose bark, stripped in precisely regulated nine-year cycles, provided the raw material for the manufacture of bottle stoppers and other products. This, too, has been a declining resource in recent years, with the increasing use of metal and plastic bottle caps and other synthetic substitutes for cork.

The port wine trade has proved a more durable activity. Building on earlier mercantile contacts and stimulated by the Methuen Treaty of 1703 with England, the production of the fortified wine known as port has become synonymous with the very character and identity of the country. Just as Oporto (or simply Porto to the locals) gave its name to the country in medieval days, so it gave its name to what long remained one of Europe's favorite beverages. The product of vineyards in the interior of the Alentejo was floated down the Douro on barges to the city at the river's mouth where it was mixed with brandy and stored in casks of native wood in the so-called "wine lodges" along the river bank. These red-brick warehouses, many of them bearing the names of the English merchant families that once ruled the trade, are still thronged with overseas visitors, who are treated to historical lectures and sample glasses. But even the wine trade is not what it used to be. The once-insatiable English demand for port has markedly diminished, and sales to France, other European countries, and the United States have never replaced the old Anglo-Portuguese commerce.[3]

Given the paucity of her natural resources, Portugal has had to fall back upon ingenuity, enterprise, and solicitation of foreign investment. During the 1980s and early 1990s, financial support from the European Union and, to a lesser extent, the United States, was crucial in rescuing the nation from its "poorhouse" status. Although some development of its modest manufacturing capacity took place, a very large proportion of the

newly available funds went into cultivating tourism. Portugal had a seacoast, possessed an abundance of picturesque castles, churches, and palaces, and (especially in Trás-os-Montes) boasted ancient walled villages set amidst grand mountain scenery.

The Portuguese government has targeted specific, as well as generic, attractions, ranging from the 1998 international exposition in Lisbon to the 2001 designation of Oporto as a cultural capital of Europe to the 2004 hosting of the World Cup. Roads have been built or upgraded, with an expenditure of $7.5 billion (even though guides still refer to the county's roads as merely "adequate" and note that it has the highest rate of automobile fatalities in Europe).[4] Beaches ranging from the warm sands of the Algarve all the way up to the cooler Atlantic shores of the north have been improved and made more accessible. National parks and nature reserves have been established. Historical sites have been renovated and new facilities, some exhibiting genuine architectural distinction, have been erected. Museums, both national and local as well as art galleries have been dusted off, and the talents of men and women skilled in the traditional crafts have been mobilized to offer distinctly Portuguese handiwork to foreign visitors.

Inevitably, the drive for a form of modernization that can preserve the distinctive character of Portugal and generate a productive tourist industry has created problems. Visitors have complained of roads poorly marked and directions vaguely indicated. Attempts to preserve the pristine character of the environment have sometimes failed, leaving a proliferation of poor-quality beachfront construction, or succeeded all too well, creating the kind of frozen zone in which no modern amenities can be created. While the 1998 gala at Lisbon, celebrating Portugal's oceanic heritage during the 500th anniversary of Vasco da Gama's voyage to India, was well planned and well executed, recent criticism has focused on the neglect of Lisbon's tenement dwellers. A candidate for mayor has produced a list of no less than 1,772 buildings that are in danger of collapse, providing a sharp contrast between the architectural delights of the exhibition zone and the neglected habitat of the urban poor. The situation has been described as a "gradual earthquake" potentially as devastating, in its own way, as the infamous Lisbon earthquake of the eighteenth century. The notorious collapse of the bridge at Castelo da Paiva, and another river crossing a few months earlier have been cited as examples of widespread neglect of maintenance on existing structures in favor of dramatic new public works projects.[5]

An important, if highly specialized, subject of concern has been the preservation of prehistoric remains. Gigantic footprints and fossils have long been noted by inhabitants of Portugal's Atlantic coastal regions, who attributed them to wondrous beings and divine doings. A medieval legend,

for example, says that the tracks at Cape Espichel, near Lisbon, were made by a giant mule that rescued the Virgin Mary from a shipwreck and carried her on its back up the steep cliff to safety. The event was commemorated by a chapel dedicated to "Our Lady of the Mule." Seven hundred years later, in 1976, scientists identified the footprints as those of a giant dinosaur of the late Jurassic Age. An International Dinosaur Conference held at Lisbon in 1998 heard a review of some unusual discoveries. Not only were there abundant bones and footprints but nests filled with eggs, some of which contained embryos, an unusually rare find. Portugal was declared by a leading American researcher to be a "showcase" for dinosaur remains. The sauropod trackway near Fatima, at 147 meters, is the longest ever discovered, and, at an estimated 175 million years, they are also "the oldest known wide-gauge sauropod footprints." Paleontologists agree that remains and tracks found in the Fatima area and near Lourinha must be preserved. Elaborate plans have been developed for combining site protection with road development and dam construction, but anxiety remains. Although Portugal has celebrated its Jurassic heritage on postage stamps, the survival of the old is in need of constant vigilance against the encroachments of the new.[6]

The ancient fauna of Portugal, may, however, fare better in the era of modernization than the country's current animal population. Like her other natural resources, wildlife is not abundant. The familiar western European species of smaller animals, including hares, foxes, and the like are to be found in the rural areas, often displaying subtle variations that mark them as peninsular. A few species that have migrated from North Africa such as genets and chameleons are also to be encountered in the Algarve. But large animals such as the Iberian wolf and lynx are facing extinction.

Recent estimates suggest that only about 200 of the 1,500 Iberian wolves in the peninsula are still to be found within the Portuguese frontier. They still lurk in their traditional northern haunts such as Serra da Estrela and in the Parque Natural de Montesinho, a protected area of Trás-os-Montes. Protected or not, the wolves still bear the onus derived from centuries of livestock killing and occasional attacks on humans. The tradition of village huntsmen banding together to resist local wolf packs has meant an ongoing loss of about twenty wolves a year, although most of the sheep and goat depredation is now attributable to wild dogs. An endangered species in Spain, the Iberian wolf may soon be a vanished breed in the mountains of Lusitania.[7]

If the wolf is, to a large extent, the victim of long-held passions and prejudices, the Iberian lynx in Portugal is far more clearly the victim of modernization and mismanagement. Concern over the survival of the

lynx began shortly after the Portuguese revolution, when a massive logging project in the south threatened some of its traditional breeding areas. Agitation by conservationists led to the creation of the Malcata Nature Reserve to provide a sanctuary and survival zone. The history of this enterprise over the next twenty years contains elements of outright farce as well as an underlying theme of tragicomedy. Although the Institute of Nature Conservation (ICN) was charged with the oversight of the reserve, it repeatedly failed to carry out essential tasks. Million of dollars in European Union funds earmarked to set up a lynx preservation center produced no results. An EU-financed impact survey to explore the implications of the Alqueva dam project for wildlife habitat received little or none of the data it needed. The *Natura 2000* plan for an integrated corridor of preservation areas received inadequate cooperation with regard to the Malcata Reserve as well as other possible areas of lynx population. In one of its best publicized and most embarrassing initiatives, the ICN flew in a wildcat specialist from the United States to help capture a lynx at Malcata. A prime female specimen was caught and equipped with a radio collar to track her pattern of movement and behavior. The transmission failed within three days because worn-out batteries had been used. In May 2001, the ICN gave its approval for an All-Terrain-Vehicle Rally to wind its way through the territory of the reserve. Eighty jeeps and motorbikes "thundered" in and around the reserve in an off-road rally that was widely advertised as following the "Lynx Route." The vehicles continued on into a separate area south of the reserve also believed to contain a lynx-breeding population. Conservationists were horrified, claiming that terrified females may have abandoned their recently-born cubs at a moment critical for renewal of the population. Several organizations demanded the resignation of the ICN's director, who defended himself by asserting that there was no legal basis for him to deny access to the vehicle enthusiasts. It was even suggested that the "Lynx Route" publicity might have had a positive effect in raising public awareness about the Malcata Reserve.[8]

By the most favorable calculation, the total lynx population of Portugal numbers fifty three. In some former breeding areas, no more than two or three animals are known to remain. A recent survey in one formerly populated area of Malcata found none at all. All- terrain vehicles are alive and well in Portugal, but the lynx may well have gone missing.

O Povo: Society

The most important of all a country's resources is human. Portugal, limited in her land resources, must place particular reliance on *o povo*—the people.

Foreign commentators emphasize the homogeneity of the Portuguese people, describing them as short to medium in stature, with black hair, brown eyes and sallow complexions. They speak of their hospitality, their individual dignity, and their industrious commitment to hard work and simple living. The Portuguese are just as fond of facile self-analysis as visitors are of sweeping generalizations. They like to think of themselves as more reserved and thoughtful than their fellow Latins in Spain and Italy. They acknowledge a prevailing air of calm, or even gloom, which their poets attribute to *saudade*. This word, most often translated into English as "yearning" or "nostalgia," embodies a melancholic longing for an idealized past, whether in one's own home place or in the Portugal of some vanished golden age. It also implies frustration and bitter disappointment with the present and, perhaps, some glimmer of hope for a better future. The concept of *saudade,* especially as cultivated by nineteenth century Portuguese writers, has become so deeply ingrained in the perceptions of foreigners and the self-conception of natives as to be virtually unquestionable. Like all ethnic labels—the logical Frenchman, the happy-go-lucky Irishman, the morose Swede—it risks becoming a misleading stereotype. *Saudade* has been used to explain everything from the flow of Portuguese people overseas to their determination to return to the homeland. It has been characterized as their underlying source of strength and as their fatal flaw.[9]

In fact, the decisive characteristic of the Portuguese people is their poverty. Living in a land whose meager material resources have been monopolized by a small elite, the masses have been obliged to subsist on marginal cultivation of the soil and the sea or periodic self-exile. From the early days of empire, first in Asia, then in America, to the late-nineteenth century exploitation of the African colonies, *o povo* have been the settlers—and the cannon fodder—who made possible the enrichment of their rulers. Whether as agricultural laborers on the estates of the aristocracy or factory toilers in the small-scale industries of the moneymen, the great majority of the population lived a hand-to-mouth existence from generation to generation. Periodically, they relieved the pressures of population by leaving for the colonies, other European countries, or the fabled opportunities of the New World. Under the Salazar regime, their very poverty provided a form of social control, which, supplemented by police supervision and religious resignation, maintained the stability of the new state.

The most shocking dimension of this institutionalized poverty was the illiteracy of the masses. To the sensibilities of late twentieth-century Europe, the inadequacies of Portugal's educational system seemed almost medieval when compared to the standards that had long since been set and achieved

elsewhere. For all his academic credentials and his desire to enhance the wealth and dignity of the world's last colonial power, the dictator seemed to prefer a populace that was ignorant to one that was restless. When the Carnation Revolution opened the way to a realistic reassessment of the country's needs, the truth could no longer be evaded.

More than 20 percent of the population was found to be illiterate, a figure far higher than that of any other country on the Continent. The bulk of these 2,000,000 Portuguese were elderly men and women, or, deplorably, middle-aged men who had been forced to choose between schooling and work, often seeking employment abroad when still mere children. The rate of functional illiteracy was much higher, reflecting the minuscule educational requirements of the Salazar regime. It was calculated that 75 percent of the working population in Portugal had little or no schooling. The total picture, based on analysis by the Organization for Economic Cooperation and Development, was that of the worst-educated country in Europe. Two decades of improvement (aided by EU funding) have at least laid the foundation for progress, making available a sequence of voluntary and compulsory schooling that enables most Portuguese to complete a secondary-level education. The persistent deficiencies in availability of school buildings and modern equipment have been met (although not eliminated), and the shortage of well-trained teachers has been alleviated. There are approximately eighteen university-level institutions in Portugal, although not all of them are up to the standard of Lisbon, Oporto, and the revered Coimbra. High-grade vocational training still lags behind what can be obtained virtually everywhere else in Europe. Worst of all, the need to earn a living still compels many families to send their children into the workplace without the diplomas or even the basic skills necessary to improve their employment prospects. Government regulations about compulsory school attendance and EU norms notwithstanding, the old cycle of poverty and educational deficiency is far from being broken.[10]

Similar problems have arisen in implementing a modern state-supported health system in post-Salazar Portugal. As recently as April 2001, the minister of health was forced to admit, in advance of a parliamentary inquiry, that the national health system was an embarrassment to her. In a subsequent interview with journalists, Prime Minister Antonio Guterres agreed with her assessment, arguing that it took a long time to set up adequate health programs and to make sure they are implemented properly. A few weeks later reports surfaced that as many as 10,000 head of cattle infected with "Mad Cow disease" might have been consumed in Portugal during the initial phase of discovery and identification between 1989 and

1995. Adequate records and follow-up investigation were both lacking. Later in May 2001, a group of leading neurologists reported that a dangerous new strain of Creutzfeld-Jacob Disease was likely to have penetrated into Portugal, where twenty-four cases of the original form of the disease had already been diagnosed. In the midst of this alarming news, the indictment of a former health minister for allowing the use of AIDS-infected blood to treat hemophiliacs, several of whom had already died as a result, seemed almost an incidental event. Equally, the announcement that Lisbon, with five hospital beds for every 1,000 residents, had the lowest ratio of treatment availability of any district in the country seemed to attract little concern.[11]

As with the deficiencies of the Salazar-era education system, the post-revolutionary governments have tried to address the shortcomings of the health and welfare services. Much remains to be done in both of these areas, whose long neglect had been counterbalanced to some extent by reliance on the church and the family. With the state still not capable of meeting its newly recognized obligations, the burden continued to rest upon these traditional institutions. Unfortunately, neither of them is as capable of playing its part as was formerly the case.

The Catholic church retains the nominal affiliation of 95 percent of the Portuguese people, but it no longer enjoys the entrenched position of authority assigned it by Salazar. Recent administrations have initiated several modifications of the Concordat that was negotiated with the Vatican in the 1940s. The moral and social influence of the clergy has diminished along with their numbers, and the availability of church-run facilities has declined along with revenues. Visitors to the country will still be impressed by the annual pilgrimages to Fatima, where the reported apparition of the Virgin Mary to 3 shepherd children in 1917 has ever since captured the attention of the Catholic world. They will also note the enthusiastic celebration of local saints' days and the apparently fervent attendance of numerous Mass-goers. Portugal is still, unquestionably, a Catholic country in ways that some others are not. But the freedom of religion guaranteed by the constitution stands for more than the mere tolerance of 2,000 Jews, 15,000 Moslems, and the Hindus and Eastern Orthodox who have lately settled in the country. It is even more than the fact that a score of Protestant denominations now proselytize vigorously or that Catholics can obtain civil divorces. It symbolizes the end of a special relationship between church and state that not only guaranteed the stature of the Church but committed it to repair many of the State's insufficiencies. Observers have noted the decline of attendance at religious services by the younger generation, many of whom seem to be seeking what neither Church nor State

is prepared to provide. Even the old missionary commitment seems to be lacking. Recently the archbishop of Newark, whose jurisdiction includes some 100,000 Portuguese -speaking residents of New Jersey, served by no more than ten priests with knowledge of that language, visited Lisbon seeking priests to enlist for service in America. There were no volunteers.[12]

Even more than in the case of the church, family traditions and values have been shaken by years of turmoil. The larger community, of which each particular family is a part, has suffered the disruption of population shifts. Rural areas have been abandoned by those seeking employment in the cities, in the "near- abroad," or in America. Hundreds of thousands of Portuguese settlers "came home" after the emancipation of the colonies in 1975, though many of them had lost their ties to the motherland and found difficulty in resettlement. Ironically, they would be followed a few years later by Africans fleeing the civil wars that swept the now-independent imperial territories. Some of these would remain in Portugal, where they would be joined by refugees from the Middle East and the former Soviet realm. Whether as permanent or transient residents, these newcomers created a sense of flux in a formerly static society. By early 2001 approximately 200,000 foreign nationals were legal residents of Portugal. When one recalls that the official population of the country is a mere 10,000,000 (many of whom are, in fact, not actually living at home), the proportion of newcomers is striking. Statistically, the largest single group of foreign residents come from the Cape Verde Islands (over 45,000), followed by Angolans (nearly 20,000), and expatriates from the former Portuguese Guinea (15,000). The total of foreign residents rose steadily during the last decade of the century, going from 110,000 in 1990 to 160,000 in 1995 with projections anticipating as many as a 250,000 by 2010. Although this pattern of population flow from economically deprived or politically disturbed areas has lately developed all over Europe, it is particularly stressful in Portugal, historically a country of emigrants rather than immigrants. While the Government speaks confidently of smooth assimilation, there are reports of racial tension in various parts of the country. There have been problems with gangs made up of young Cape Verdeans in Lisbon, where they have clashed with police as well as with young whites and rival gangs from other parts of Africa. As one commentator has put it: "It was always difficult to know where the Portuguese were. Now it is hard to know who they are."[13]

Even those who have no love for the Salazar regime are increasingly heard to lament the supposed stability of the "old days." They point out that Portugal was relatively crime-free in the Professor's time (and, indeed, Portugal was one of the first countries to abolish the death penalty as far

back as 1860). While cynics might respond that under Salazar there was nothing to steal and that political offenders suffered a fate worse than death, contemporary news media are full of sobering reports. Many of these reinforce the impression of external forces disrupting traditional Portuguese society. The Azores are hit by a crime wave resulting from the return of native sons who have been deported from the United States and Canada after serving time in prisons there. Of the thousand or so expellees, at least one third have been arrested for offenses committed since their return to the islands. An "Eastern European Mafia" has been discovered operating a nationwide network among refugees living in Portugal. Twenty-five individuals from Eastern Europe have been arrested for extortion, "protection rackets," and other criminal activities. The arrest of a major drug dealer operating in a suburb of Lisbon renews concern about the infiltration of North African and South American narcotics into the country. Newspapers supplement local alarms with news of Portuguese expatriates being systematically murdered in South Africa and stir up bitter comments by describing how a large detachment of Portuguese policemen has been assigned to duty in EU maintenance of order operations in the Balkans and other trouble spots abroad. Again from the Azores, investigative journalists have uncovered a traffic in the sale of newborn babies that has been going on for nearly 40 years. Thanks to the indifference of local authorities and gaps in birth registration procedure, mothers (and sometimes fathers) have been able to dispose of unwanted children in exchange for food, clothing, or money. Many of the purchasers were the families of United States military personnel stationed at the NATO base in Lajes on the island of Terceira. A local man was quoted as saying it was common practice to frighten disorderly children by saying that if they did not behave, they would be sold to the Americans. Almost simultaneously, readers are told that a reproductive services clinic in Lisbon is supplying childless couples with eggs almost entirely provided by Finnish and Russian women. Making light of these 2 stories, an essayist suggested that, at this rate, Americans would soon look like Portuguese and the Portuguese like Balts. More conservative citizens of the capital were surprised to learn that the Lisbon city government had made a grant of 10 million *escudos* (50,000 euros) in support of a lesbian and gay film festival to be held in September 2001. They were not particularly reassured to learn that additional funding had been pledged by British and German sources. A question was raised as to why the perennially underfinanced public works of the city were being neglected in favor of what many perceived as frivolous activities.[14]

Amidst these and other evidences of changing, or even collapsing, traditional patterns of life, the vital statistics published at the beginning of

the new millennium offered more than an impressionistic picture of Portuguese society.

Of the county's estimated 10 million population, 17 percent are under fifteen years old and 15 percent over sixty five. The older age group is growing proportionately and has doubled within the past three decades. The result is an inevitable increase in the demand for social services, which, along with broadened pension eligibility (legislated in the flush of socialist generosity) will confront the treasury with a horrendous burden. A major part of the prospective shortfall in social security funding will come from the fact that some 3 million Portuguese (nearly one third of the population) live abroad, whether on a long-term basis in the United States, Canada, Brazil, and South Africa or as annual workers in France and Germany. Although the latter periodically visit the old people at home and spend some of their earnings, the inflow of money from expatriates is clearly insufficient to sustain social programs. While conventional ways of life survive in such areas as the rural north, there is clearly a broad shift in patterns of behavior. The Portuguese are marrying later and less often and the average number of children per family is smaller than it used to be only 3 decades ago. The patriarchal structure of families (or its matriarchal variant when the father has gone to work abroad) has lost its power to control young people. Contraception is freely available to those over eighteen—and by no means inaccessible to those who are younger. Family planning services have been provided by the post-revolutionary government. Abortion has been a legal right since 1984 although under some restrictions as to availability. Despite the lamentation of church leaders, there is a steady increase in the divorce rate, paralleling the steady fall in the birth rate. Moreover, as births per thousand have gone steadily downward since 1980, the number of out-of-wedlock births has risen dramatically, further disrupting the ideal image of the solid and self-sustaining family.[15]

If the figures on birth are cause for concern, those of death can be perceived as grounds for desperation. Just as a third of the country's population is calculated to live abroad in order to sustain itself, another third lives at home in dire poverty. The rate of infant mortality caused by a combination of inadequate nutrition and insufficient medical services is currently 11.5 deaths per thousand. While Portugal has worked to improve this figure during the 1990s, it still places her at the low end of the EU's roster. The figures are also shockingly high for deaths during infancy and the first 5 years of life—shocking, but not surprising, considering the shabby and unsanitary conditions in which the masses are still obliged to live, often without plumbing or even a clean water supply. Plans for low- income hous-

ing have remained stalled for years, forcing at least 40 percent of the population to survive in illegally constructed and poorly maintained dwellings.[16]

Like her public works, Portugal's human resources are in need of maintenance and repair. Her leaders must not make the mistake, so common to those who tie their national income to the development of tourism, of catering to visitors and neglecting their own people.

Without Shield: The Economy

Among the various terms by which Portugal's currency has been known over the centuries, the *escudo* was the most durable. Taking its name from the coat of arms on the reverse of the coins used before the introduction of paper money, the *escudo*—shield—served a double purpose. Not only was it a medium of exchange but its very name evoked a sense of firm protection. It was the shield that provided security, no matter how fragile, to the people of Portugal. It evoked a proud past and some sort of continuity in a troubled present. Now the *escudo* has disappeared. Portugal has joined with most of the other members of the European Union to adopt the European monetary unit. The "euro" became a transactional currency in the last year of the twentieth century, and during the year 2002 it completely superseded the old Portuguese currency. Distinctively Portuguese coins and paper money have been supplanted by that of the European Union. The people of Portugal are without their shield.

Throughout her modern history, Portugal has survived by a series of fortunate accidents that provided economic booms ensuring wealth to the elite and at least a trickle-down benefit to the masses. The flow of imperial treasures in the sixteenth century, the mineral discoveries in Brazil during the eighteenth, the extraction of resources from Africa in the late nineteenth, set the precedent for Salazar's short-lived colonial schemes in the 1950s and 60s.

The revolution of 1974 ushered in a period of doctrinaire improvisation and predictable deterioration of the economy. The end of the colonial wars eased the tax burden but led to the loss of potential overseas riches. Nationalization of industry and collectivization of agriculture gratified the hearts of the workers and peasants but led to a flight of capital and managers that left both sectors of the economy in near-collapse. The late 1970s and early 80s saw violent strikes, seizure of farmland by rural workers, bitter quarrels between extreme and moderate marxists, and an outbreak of terrorist bombings by ultraleftists who believed that the pristine vision of a new order in Portugal was being betrayed by the forces of expediency and corruption. The Portuguese people were buffeted by strikes in transportation and manufacturing fomented by Communist-led trade

unions. They were frightened by the bombing and shooting incidents in major cities that seemed to be drawing Portugal into the kind of urban terrorism that had recently surfaced in many other European countries. When, in 1984, some eighty members of the so-called *Forças Populares de 25 Abril* were arrested (including Otelo Saraiva de Carvalho, a hero of the revolution), the reemergence of the efficient but ruthless secret police force that had halted the violence was regarded by many as a mixed blessing. Ordinary citizens were alarmed, too, by the death in a plane crash of Prime Minister Francisco de Sá Carneiro. They were startled, in another sense, by the choice of Portugal's first female premier, María de Lurdes Pintasilgo. Nothing seemed to be going right, or, at least, following recognizable paths. Ultimately, reprivatization of industry and the elimination of communal farms were seen by many as a necessary return to economic and social coherence.[17]

A domestic demand for stability coincided with an external requirement for nondoctrinaire fiscal policy and balanced budgets from the European Union. After Portugal had gotten its economic house in some sort of minimum order, it became eligible not only for EU membership, but for massive subsidies that could help in modernization and wealth generation.

Once admitted to the charmed circle in January 1986, Portugal "took off" at a growth rate that outstripped those of many other European countries, quickly reaching the level of 4.5 percent or 5 percent annually. A feverish mixture of development in some areas and "temporary" neglect in others resulted in a sense that foreign investors were combining with domestic profiteers and corrupt politicians to skim off the benefits of the new prosperity. There was undoubtedly improvement in tourist facilities, certain aspects of public services, and infrastructure expansion, but "modernizing" Portugal still suffered from wage disparities, employment fluctuations, and the kind of militant labor activism that could bring out a million and a half workers in a general strike in March 1988. Agriculture remained backward, without a clear vision of what should be done to sustain it or how alternative approaches to industrialization could be achieved. Portuguese factories remained uncompetitive bastions of discontent. Education, perhaps the most vital element in the whole concept of modernization, continued to lag, with students periodically demonstrating against increased fees. At the very moment, in 1992, when Portugal succeeded to the presidency of the European Union, she was faced with the removal of trade protection barriers that had offered her a transitional period of getting up to speed alongside the rest of Europe. It was clear, despite all of the hyperenthusiastic proclamations coming from Lisbon,

that she was far from attaining her goals or satisfying the expectations of her partners.[18]

While Portuguese workers continued to agitate against the removal of social security measures and labor laws that had been passed in the optimistic post-revolutionary period, big business had reestablished itself in Portugal during the late 1980s. Along with managers and civil servants who left the country during the period of tumult, such magnate families as Champalimaud, Espirito Santo, and Mello withdrew after nationalization laws had stripped them of their conglomerates. Fear of reprisal for their support of the former regime combined with a loss of capital and an expectation that worse times were yet to come. Expatriates, whether members of the elite or of the bourgeoisie, found new homes in France, Switzerland and, especially, Brazil. Their departure left a gap in training and experience that was hard to fill. It created more of a problem for post-revolutionary Portugal, according to some authorities, than the parallel influx of hundreds of thousands of refugees from the African colonies who had to be integrated into the motherland's economy. Since 1987, however, the process of reprivatization has permitted some of the great ones of the *Estado Novo* days to re-establish themselves. The magnate of magnates is Antonio Champalimaud, once again the richest man in Portugal. This patriarch of a family which once controlled a multitude of industrial and commercial operations was able to transfer his expertise (as well as a part of his fortune) to Brazil, where he became "cement king," controlling a network of construction and related companies. Although it took five years of negotiations before he returned home, the octogenarian businessman has now focused his activities on control of major banks and financial services. His achievements have been matched by leading members of the Espirito Santo and Mello families. Like Champalimaud, they have found it more expedient to focus their renewed participation in the Portuguese economy on the financial sector, without entirely ignoring old commercial ties. Critics of the great privatization process have censured the Portuguese government of the 1980s for having "a bad conscience" about expropriating the old business empires. This led them, it is charged, to manipulate the supposedly open competition to purchase the government-owned property so that the old magnate families would be judged the best bidders and given back their erstwhile possessions.[19]

To be sure, a few new capitalists have emerged from the economic reorganization process. Belmiro de Azevedo, now second-richest man in Portugal, rose from modest origins in Lisbon to become the head of *Sonae*, a conglomerate that includes chemicals and wood products as well as banking, real estate, and other interests. Other "new men" include

Jorge Jardim Gonçalves, founder of the *Banco Comercial Português* (BCP) and Artur Santos Silva of the *Banco Português de Investimentos*. There are even some successful businessmen who have emerged from the ranks of the ex-colonial returnees, people who had, in some cases, made and lost fortunes in Africa and then achieved new successes in Portugal. These "Africans" have often provoked resentment among their metropolitan cousins for their tendency to stick together, hiring and favoring only other members of the former Diaspora.[20]

Those whose patriotic or political interests impel them to put the best face on Portugal's situation at the start of the twenty-first century highlight such tales of affluence and achievement. They are often interwoven with news items reflecting the notion of Portugal as a major player (or at least a player) in international affairs. Thus, we have Portugal mimicking Spain's protests over imagined nuclear contamination as the notorious submarine *HMS Tireless* sails back to Britain through Portuguese waters. Portugal is reported to be conferring with Morocco and other countries in the region about Middle Eastern affairs. President Sampaio confers with U.S. Secretary of State Colin Powell about the future of East Timor. His government suggests that another ex-colony, Macao, should play a role as facilitator of Asian-European relations. Portugal dispenses millions of dollars (an amount she can ill afford) as largesse to her old dependency, São Tomé e Principe. She strikes a high moral tone in concluding that none of the Nazi gold that found its way into Lisbon during World War II was obtained from illegitimate sources.[21]

Most grandiose of all were the pronouncements delivered by former president Mário Soares in a June 17, 2001, interview with the Spanish daily *El País*. Now a socialist member of the European parliament, and as much an international statesman as a Portuguese representative, he took the opportunity to critique the first 100 days of George W. Bush's administration. He found it to be "disastrous," citing such items as the repudiation of the Kyoto accord on global warming, a missile defense plan, and the United States' ongoing unilateral confrontation with Iraq. He urged the strengthening of the European Commission so as to permit the EU to become a balancing counterweight to America's role in the world. In an almost patronizing tone, Soares urged a convergence of Portuguese and Spanish policy in view of their shared interests in Europe and the Western Hemisphere.[22]

The reality of Portugal's economic situation in the opening year of the new millennium contrasts strikingly with these pretensions. In April 2001 the European Commission released a devastating report, spelling out Portugal's economic weaknesses and its failure to take effective action to

remedy them. She was warned that such domestically unpopular and environmentally questionable projects as the Ota Airport and the Alqueva Dam must be reconsidered, as they represented an unreal image of Portugal's most urgent development needs. A "final warning" was issued that Lisbon must reverse its trend of failing to comply with the Single Currency Stability Pact. If Portugal allowed its budget to go into "overdraft," the commissioners in Brussels warned, it would face what amounted to direct EU supervision of the country's finances. To back up its warning, Brussels released a series of economic forecasts that showed Portugal to be suffering from "stuttering" economic growth with its budget deficit the second largest of the fifteen EU members. Her balance between imports and exports was the worst in the Union and her unemployment level was expected to increase from 4.25 percent in 2000 to 5.1 percent in 2002 (a loss of 50,000 jobs within 24 months). Furthermore, her budget deficit, the EU expects, will grow from 1.4 percent in 2000 to 1.5 percent in 2002, despite Lisbon's pledge, when committing to the euro, to reduce the deficit to 0.7 percent by 2002.[23]

At the same time, the Swiss-based International Institute for the Development of Management (IDM) issued a report ranking Portugal near the bottom of a list of forty-nine European countries in fields such as education, managerial training, transparency of policy development, and other standard indices of economic modernization. Even some of her most favorable statistics had declined since the IDM's last report: on her ability to compete economically with other countries, she had dropped from 29th in 2000 to 34th in 2001. In some, the IDM declared that Portugal is no longer to be ranked among the other Western European countries but has to be considered on a par with such former satellites as Poland and Hungary. Her "economic competitors" also include Estonia and Slovenia. All of these countries were seeking admission to the European Union and struggling to meet the economic threshold set by a body of which Portugal was already a member. Not surprisingly, Portugal responded (in association with Spain) early in May by threatening to block the eastward expansion of the European Union unless the EU guaranteed to continue aid to their less-developed current members until 2006. The European Commission's response came on June 27, 2001, when it published a report declaring that Portugal had wasted a "golden opportunity" during the years of positive growth to "strengthen the vital sectors" of her economy. She had failed to comply with her agreement under the Stability and Growth Pact to bring her fiscal affairs into order. She was in urgent need of balancing her budget, and at present there did not seem any likelihood of removing her deficit until at least 2004. No one needed to be remind-

ed that a member state of the European Union that failed to comply with the Stability and Growth Pact (or even seemed likely to fail) could be subjected to various nonmonetary penalties or, ultimately, experience complete cuts in funding.[24]

Lisbon appeared blithely unconcerned with these threatening prospects. During the same week in which the complaint that it had wasted the "golden years of prosperity" had come down from Brussels, an announcement from the Lisbon and Oporto stock exchange described its intention to join Euronext, a consortium that included the exchanges in Paris, Amsterdam, and Brussels. Euronext, which had been established in September, 2000, and had already become the second-largest stock exchange in Europe, had been in negotiation with the Portuguese since October. Its directors' plan to create the largest operation of its kind in Europe was evidently unaffected by a 17 percent decline in the value of the top twenty shares traded in Lisbon/Oporto during the first half of 2001. The Portuguese exchange, for its part, was anxious to escape from the relative isolation affecting all of the Continent's smaller exchanges and to remedy the loss of several billion euros that have been wiped off the exchange in recent months.[25]

In the meantime, the cabinet had been drawing up its scheme for budget retrenchment, which included no less than fifty points. Analysts, combing through this complex of cuts and trims, concluded that the citizens of Portugal would have to tighten their belts drastically. This was the only way, it seemed, to fill what was now acknowledged to be a 150 billion *escudo* (750 million euros) gap in the budget. Two major elements of this emergency reduction were a drastic slash of public spending and investment in projects, as well as a freeze on the hiring of government employees. The "dormant" economy would receive stimulation from export incentives in the form of tax cuts and an array of encouragements to reverse the flight from the stock market. Public health services were slated to be cut back after several years of generous subsidies appeared to have been wasted. The recent inept performance of health minister Manuela Arcanjo before a parliamentary inquiry had sealed her fate, and within a few days of the budget announcement, she handed in her resignation. A similar destiny was judged likely for Finance Minister Pina Moura. The minister had estimated annual revenues of 476 billion *escudos* (2.38 billion euros), but, in May it was evident that sales tax receipts, instead of doubling as predicted, would drop by 5 percent. Furthermore, projections of increased tax revenues on share-profits and off-road vehicles had failed to materialize. Not only had Pina Moura "failed miserably," as one editorial writer said, but, as a benefactor of the disgraced health minister, seemed likely to follow that

lady out the door once the budgetary process was completed.[26]

Putting the best possible face on all of this, Prime Minister António Guterres assured a sympathetic audience, as the stressful month of June drew to a close, that a "slight but significant inflationary trend justifies the need for salary moderation in 2002." He affirmed that the budgetary cuts announced a few days earlier were "irreversible" and "would be applied in their entirety." He added that he "viewed the current national financial difficulties with serenity and confidence."[27]

The premier's serenity and confidence were not necessarily shared by the nation at large. A survey conducted at the end of 2000 and released in May 2001 showed that the Portuguese people were among the most depressed citizens in the entire European Union, with only the Greeks having a gloomier view of present circumstances and future prospects. Forty percent of them considered their economic outlook "bleak" and only 17 percent looked for improvements. The "economic dejection average" was 24 percent for the EU as a whole. More generally, 31 percent of the Portuguese were dissatisfied with their lives and only 5 percent very happy with their condition. Despite the government's attempt to put a happy face on hard times, the Portuguese appear committed as ever to *saudade*.[28]

When the *escudo* vanished once and for all from the banks and shops of Portugal in 2002, a familiar shield was gone, literally and figuratively, from a vulnerable population. Beset by economic uncertainty and unable to share unreservedly in the official optimism, the populace felt more than a mere pang of nostalgia. Yet, as one sardonic humorist has suggested, there is at least the comforting thought that deficits will look smaller when they are printed in euros rather than *escudos*.

On June 20, 2001 the Portuguese Navy announced that it was ceasing its search operations at the site of the Entre-os-Rios Bridge collapse. When the deteriorated structure gave way on March 4, 59 people were killed. When a minisubmarine located a car containing three bodies, making the total 23 recovered, the Navy terminated its search. On this news, 5,000 of Castelo da Paiva's 17,000 residents endorsed a petition to the Assembly asking that the quest for remains be continued. They also asked that the river be closed between the bridge and the Crestuma Dam until all of the missing 36 bodies were located. In Lisbon, it was not expected that this petition would be granted, nor was there any word on when, if ever, the ruined bridge would be repaired. In the meantime, the ten-mile-long span across the Tagus, built as part of the celebration of the 1998 Expo, was reported operating at full capacity. Lisbon, according to the latest traffic statistics has the highest rate of automobile fatalities in the country.[29]

12

Embracing the Trees: Culture

Recalling his birthplace, the village of Azinhaga in the Ribatejo region, Nobel Prize winner José Saramago describes the day that his grandfather had to leave for a hospital in Lisbon. The old man walked among the olive and fig trees in his yard, tearfully embracing each in turn. He knew he would never see them again.[1] Portuguese culture often involves a similar clinging to the much-loved (or at least familiar) traditions and creations of the past. Knowing that whatever hope of cultural survival they have demands a resolute advance into new times and new practices, the Portuguese nevertheless preserve the experience of the past, dwelling upon what they remember as good and lamenting the perhaps fatal flaws that are all too recognizable.

Perpetually overshadowed by the literary output of its Iberian neighbor, and alternately stimulated by and imitative of other European cultures, Portugal entered the twentieth century with a literature that was known to relatively few beyond its borders and accessible only to a minority within its undereducated population. A worthy but inevitably self-absorbed few continued to write under the oppressive conditions of the Salazar era. Since the fall of the dictatorship, a new generation has hovered between contemplation of what has gone before and bold evocation of the newly possible.

Elsewhere in the arts, those who have emerged since the fall of the dictatorship seem more confident in their capacity to revere the best aspects of the old Portugal while pursuing innovation. Still, some artists and critics feel that their domestic audience is too conservative, more inclined to support museums than to patronize the avant-garde.

Popular culture, in many of its dimensions, remains a bastion of the old commitments and feelings. Yet few can resist the globalizing and vulgarizing influence of the contemporary mass media. To the extent that it has caught up with the rest of the world at the end of the twentieth century, Portugal is in danger of becoming merely another consumer of televised football, games and soap operas.

Novels from the Portuguese: Literature

Portuguese political sovereignty and linguistic distinctiveness were firmly established by the mid-thirteenth century, but both continued to be challenged by the proximity of Spain, especially as the predominance of Castile emerged. Indeed, many Portuguese writers of the late Middle Ages worked in both languages. During the Renaissance, Portugal's status as a colonial power and a massive accumulator of wealth strengthened her literary independence and encouraged a strong output of lyrical poetry. The most enduring name of this period is that of Luis Vaz de Camões (1524–1580), whose *Os Lusiadas* (The Lusiads) was published in 1572. This epic account of Vasco da Gama's voyage to India (1497–1498) is also a lyrical evocation of Portuguese bravery and endurance in the great age of exploration. Although not a success in his own day, Camões is now regarded as the greatest of Portuguese writers and a national icon whose subject matter as well as his literary achievement embodies a typically Portuguese nostalgia for the glories of the past.

Respectable but not necessarily remarkable writers tended to be eclipsed by their Spanish contemporaries during the seventeenth century and both countries fell into something of a literary decline during the eighteenth. A vigorous new force upon the Portuguese scene was introduced by João Baptista da Silva Leitão, Viscount d'Almeida-Garrett (1799–1854) who returned in 1832 from a period of political exile in England with a mastery of that country's language and literature, a particular attachment to the historical novels of Sir Walter Scott, a Romantic reverence for the Middle Ages, and a firmly held belief that "Nothing can be national if it is not popular."[2] Distinguished as a poet and playwright as well as a statesman, Almeida-Garrett was perhaps most influential with novels such as *Viagens na Minha Terra* (Travels in My Homeland), an allegory of political conflicts. His efforts in the cause of political and intellectual progress were strongly supported by his contemporary Alexandre Herculano (1810–77) whose history of medieval Portugal gave an unsparing view of the negative influences of the Catholic church and the consequent retardation of Portuguese culture. Fiercely attacked by conservatives as unpatriotic and irreligious, Herculano retreated into the less controversial field of fiction and became

one of Europe's most prolific and highly regarded historical novelists. José Maria Eça de Queiroz (1845–1900) introduced social realism into the Portuguese novel, beginning with *O Crime do Padre Amaro* (1876). A diplomat who served in Havana, Paris, and London, he brought a broad perspective and sophisticated analysis to his studies of Portuguese life and earned an international reputation that made him the best known Portuguese of his time. However, like the other members of the "Generation of 1870," his prime goal was to awaken his own countrymen to the shortcomings of their society. In such novels as *Os Maias* and *A Illustre Casa de Ramires,* he portrayed realistically the complexities and class tensions of a nation that could no longer afford to regale itself with historical imagery or ignore the massive changes sweeping across Europe.[3]

The era of political crisis that began with the overthrow of the monarchy in 1910 saw the coming of age of writers who had to contend with the winds of change that had now reached Portugal with a force that could no longer be ignored. Fernando Pessoa (1885–1935) experienced the trauma of the Great War and the political upheavals that led to the establishment of the Salazar regime. Although he wrote under four different names, it was under his own that he gained his highest recognition with the 1934 publication of *Mensagem*. Posthumously, he came to be recognized as Portugal's leading poet of modern times. His introduction of free verse into Portuguese literature guaranteed him an enduring respect that survived the cramped intellectual environment of the dictatorship. Most writers who displayed any energy or originality during the Salazar years found themselves banned, like Miguel Torga, whose novel *Contos de Montanha* contained too much truth to be tolerated, and Maria Velho da Costa, who shocked polite society by her version of the diary of a seventeenth- century nun. Its feminist outlook brought her and two female collaborators before a court committed to condemnation.[4]

Since the revolution, the new political and intellectual freedom that has allowed Portuguese intellectuals to breathe once again gave José Cardoso Pires license to explore the dark inner workings of the fallen tyranny in such novels as *Balada da Praia dos Cães* (Ballad of Dog's Beach) and permitted António Lobo Antunes to experiment with new literary forms and psychoanalytical insights.[5]

For all their distinction and originality, these and other contemporary writers have been put in the shade by the announcement in 1998 that José Saramago was the year's Nobel Laureate for Literature. The first Portuguese writer ever to achieve this honor, the veteran novelist became an instant celebrity whose well-established reputation was transformed

into the kind of transient stardom conferred by globalization and the electronic media.

Born in the provinces in 1922 and raised in Lisbon, his peasant background meant that he shared the scanty education of most members of his class. Largely self-initiated into the study and appreciation of literature, he worked over the years in metal shops and low-level civil service positions before becoming editor in a publishing house and then in a newspaper office. It was not until a period of unemployment in his fifties gave him the opportunity to experiment with fiction that he began to think of himself as a full-time writer, and he was sixty before he gained recognition with the novel *Baltasar and Blimunda*. Saramago found that freedom of expression had its boundaries even in the new era of freedom. His novel *The Gospel According to Jesus Christ*, published in 1992, was denounced as blasphemous, an opinion apparently shared by the right-centrist government of the day. An ardent communist and "tolerant anticlerical," the author departed in disgust for the Canary Islands, where he settled with his wife, the Spanish journalist Pilar del Río. Despite this self-imposed exile, all the more ironic for coming after the dictatorship was long gone, Saramago remains a champion of Portugal and Portuguese literature who appreciates the plaudits he has received and who continues to promote cultural cooperation between the two Iberian nations. Despite some ventures into other literary forms, Saramago is primarily a novelist. In all of his work, however, one finds a strong identification with his homeland. This is more obvious, of course, in *Journey to Portugal* (first published in Portuguese in 1990). In a rambling excursion across the length and breadth of the country, the author interweaves history and geography, social commentary and criticism of art, architecture, and local peculiarities. The book, dedicated to Almeida-Garrett, reveals Saramago to be one who is profoundly conscious of, and sympathetic to, his nation's collective experience while freely acknowledging its present flaws and prospective problems.[6]

In what is still probably his best-known and most highly regarded novel, *Baltasar and Blimunda*, Saramago takes us back to Portugal's eighteenth-century Golden Age where his protagonists are involved in everything from conflict with the Inquisition to time travel. Here again, Saramago appears as a student of Portugal's past and a sly commentator on its present. In addition to the controversial reading of the "Gospel" that precipitated his departure from Lisbon, Saramago has written, among other novels, *All the Names*, which focuses on an archivist obsessed with the multitudes of people whose records he oversees, and *Blindness*, a tale set in an unnamed country where a mysterious loss of eyesight among a growing number of the inhabitants leads to the breakdown of society and

the testing of human relations under the most desperate circumstances. Despite his employment of styles and techniques which have been variously compared to magic realism and science fiction, and despite his more recent use of anonymous characters in anonymous settings, Saramago has never ceased to embrace the trees that signify his Portuguese heritage and his Portuguese sensibility. He flatly rejects the idea put forth by some commentators that he is a historical novelist. He insists that, for him, it does not matter whether something takes place 2,000 years ago or today, because it is all part of an interwoven pattern of human experience in which people and events can be moved about to arrive at a clearer understanding of what has happened or will happen. To illustrate this point, he has cited his novel titled *History of the Siege of Lisbon,* in which a proofreader tries to change history by adding the word "not" to an account of the medieval battle that resulted in the birth of the Portuguese state. Yet, arbitrary as our representation of history may be, Saramago cannot sever himself from it, nor, apparently, does he wish to do so.[7]

Soon after the announcement of the Nobel Prize, the prodigal son paid a visit to Lisbon, to find the walls plastered with posters bearing his picture and proclaiming "Congratulations, José Saramago." He was bemused by people coming up to him, not merely to offer congratulations, but to say over and over again "Thank you, thank you." For all his cynicism about historical truth and political manipulation, he was quietly pleased as he reflected that the entire Portuguese nation seemed to be taking pride in the honor bestowed upon him. It was, he said, as if everyone in the country had grown an inch taller.[8]

Saramago undoubtedly appreciated the irony of being lionized in his native land, despite the fact that he had left it in anger nearly a decade earlier after being denounced by Catholic and conservative elements. At that time the island of Lanzarote had seemed to offer him a sanctuary, with its excellent quality of life, its natural beauty, and the tolerant attitude of its people. By the end of 2000, a new irony had overtaken him. On the one hand, he was being claimed as "one of ours" by the head of the Canarian regional government, which had already awarded him a gold medal in honor of his literary distinction. On the other hand, there had been an upsurge of anti-Spanish nationalism in the Canary Islands that manifested itself in a variety of ways, including offensive grafitti that called for the expulsion of the "Goths" (i.e., Iberian mainlanders). In a public statement, Saramago complained that the very characteristics that had drawn him to Lanzarote were now being ruined and denounced the militant spirit of separatism that had resurfaced in the Canaries after a long period of quiescence. "I, too, am a Goth," he declared, and he went on to suggest that he might

have to reconsider his place of residence. Was Saramago contemplating a return to his ancestral homeland? Spiritually, had he ever really left it?[9]

Perhaps the larger question for the future of Portuguese literature, however, is not whether Saramago and his fellow writers live at home or in some other nearby corner of the European Union. Rather, it may be whether their national language will find its fullest expression during the coming centuries in the work of those who are the children of the old empire. Already, Brazil has bred several generations of notable novelists, to say nothing of experimenters in other literary forms. The next Nobel Prize awarded to a writer in the Portuguese language may well go to a Brazilian, or, for that matter, to a native of Angola or Mozambique. Such a phenomenon has already affected the English and Spanish-speaking world. The environment and sensibilities of Nigerians and Indians, Mexicans and Chileans are clearly different from that of those who grew up in the European metropolis. Will a distinctively Portuguese national consciousness survive to set its writers apart from all others, or will they cease to cling to their ancestral trees and allow themselves to drift away on a cosmopolitan tide? Even if Portuguese writers continue to dominate literature written in the Portuguese language, how truly Portuguese will their subject matter and point of view continue to be?

Something Old, Something New: The Arts

Portuguese art and architecture of the late Middle Ages, heavily influenced by Flemish and Italian masters, gradually gave way to the work of native painters such as Nuno Gonçalves (1475–1541). The unique Manueline style of the sixteenth century, with its interweaving of maritime and religious motifs and its hint of Moorish influence reflected the wealth and grandeur of an expanding empire. The Baroque sculpture and carvings of the seventeenth century gave way to a more "international" approach during the eighteenth, especially in the construction and ornamentation of the royal residence at Mafra, with its imitation of Versailles. After the Lisbon earthquake of 1755, the Marqués de Pombal worked with the architect Eugenio dos Santos in a rebuilding of ruined areas in a simple, unadorned style that came to be known as "Pombaline." This stimulated a countrywide reaction against the ornamental excesses of the Baroque tradition. After an early nineteenth century hiatus due to military and political disruptions, Portuguese architecture became essentially eclectic, drawing upon everything from Moorish exoticism and English neo-classicism to contemporary French Second Empire apartment-house design. France also gave Portugal the services of Gustave Eiffel, who designed bridges to span the

Douro and the Minho, and whose disciples created railway stations and other public buildings sheathed in cast iron, steel, and glass. From Paris, too, came the Art Nouveau that found expression in many restaurants, shops and places of entertainment throughout the country. Painters such as Sousa Pinto, Silva Porto and the Marques de Oliveira, and the sculptor Antonio Soares dos Reis reflected another dimension of Portugal's artistic susceptibility to French currents.[10]

When, in 1906, the nineteen-year-old Amadeo de Souza Cardoso set out for Paris to pursue his architectural studies, he was unknowingly embarking on a path that would end with his proclamation as the founder of modernist Portuguese art. The son of a wealthy landowning family, Souza Cardoso (1887–1918) was amply supplied with funds, and seemed at first to be following the life of a self-indulgent dilettante, surrounding himself with Portuguese expatriate artists, including Francis Smith, Manoel Bentes, and Eduardo Viana. Gradually he underwent a series of evolutions, abandoning architecture for painting, the companionship of his countrymen for that of a cosmopolitan range of artists then working in Paris, and the naturalistic tradition of Portuguese painting for the new directions that were opening up before his increasingly sophisticated eyes. After experimenting with primitivism and approaches influenced by his new friend, Modigliani, he emerged as an expressionist painter in important exhibits between 1910 and 1914. At the "Armory Show" in the United States (1913), a total of eight works were exhibited alongside those of Picasso, Matisse, Bracque and Duchamp. His meteoric artistic career swept him on from figuration to cubism, to exhibits and sales in Germany, and a planned first showing in London, but the outbreak of the Great War and his marriage, compelled his return to Portugal. Here his international contacts and growing reputation were less appreciated. He threw himself into support of the nascent avant garde in his own country, not only among painters, but in the context of the Futurist literary movement. This was not the moment, however, when anything labeled "modernist" or "futurist" was likely to find easy acceptance. Souza Cardoso's organization of a show called *Abstractionism,* first in Lisbon, then in Oporto (1916), prompted denunciations for its "radicalism" and its "anticlericalism." He was attacked in print, verbally abused, and even physically assaulted by those who regarded him as a promoter of alien values. The poet Pessoa might hail him as "the most celebrated Portuguese vanguard painter," and the critic Almada called him "Portugal's first discovery in twentieth century Europe," but the country at large was not ready for him or his ideas. Following his death in the influenza epidemic of 1918, when barely thirty years old,

Amadeo de Souza Cardoso sank into relative obscurity among his compatriots. Despite the efforts of his widow and isolated members of the cultural community, he remained a marginal presence for some thirty-five years. It was not until the Salazar regime began seeking international status in the 1950s, that he began to receive due attention as an artist of the first rank. His work was assembled in museums, his name was attached to galleries and public buildings, and his status as a pioneer of modern art was proudly celebrated. The new Portuguese icon was honored by major exhibitions in Brussels (1991), Madrid (1998), Washington, Chicago, and the place where he had enjoyed his first international recognition, at the Armory Show, New York City (1999–2000). Entering the twenty-first century, Souza Cardoso appears to have, however belatedly, secured his place not merely as a Portuguese painter but a significant promoter of modernism in the Western World.[11]

In comparative terms, post-Revolutionary Portugal might appear a far more welcoming place for the artistic avant garde than it was in Souza Cardoso's day. Political democracy, global access, and unlimited freedom of expression would seem to offer ideal conditions for the flourishing of painters and sculptors. But all is not well. Perhaps it is in the nature of the artist to be a malcontent, yet the note of complaint persistently sounded by artists interviewed at the Madrid ARCO exhibition in 1998 indicates more than an isolated grouchiness. José Pedro Croft, for instance, pictures Portugal as provincial and confining, saying that he had to leave the country to gain attention. Now that he has gone into the wider world to "nourish himself" he has discovered that Portuguese art is a "zero" abroad. Moreover, there is no market at home. No one collects, neither individuals nor institutions. The same note of frustration over the lack of a receptive market for contemporary art in Portugal is sounded by Julião Sarmento. Although his paintings have been exhibited at the Venice Bienale, and many other shows in Europe, his fragmented figures, which have been described as a mixture of expressionism and cartooning, have found less favor with the public at home. The rather lordly air he assumes in his dismissal of ARCO as merely an "Iberian exhibition," suggests that he has little immediate hope of things changing in Portugal. The painter Leonel Maura is a bit more positive, saying that the art scene in Portugal has improved in the 1990s although it is still not "a great moment" for the arts there. Portugal, he says, is not a country with great artistic weight in the world. He has been doing his bit by championing human rights in his paintings that mingle references to horrors of war from Goya and Picasso with scenes of contemporary horror in Algeria. The sculptor Pedro Cabrita Reis, laments the fact that Portugal is a "peripheral country" not only in

its political and economic status, but in its cultural weight. Not only does it lack a substantial number of collectors, but the institutions of government, such as museums and galleries, are subject to changing political currents. At the moment, he believes that the directors of these institutions are sympathetic to contemporary art, but this could change with a shift in administration. Attitudes will determine expenditures. As a man who has exhibited successfully abroad and has some means at his disposal, he actually has built up a modest but representative collection of contemporary Portuguese art. This, he says, is not intended as an investment but rather an encouragement to younger artists who need three times as much support as their peers in other European countries.[12]

Despite the difficulties posed by lingering conservatism, exploitative gallery owners, and apathetic officials, Portugal can find hope for its artistic future in a roster of vigorous and innovative artists, including not only Sarmento, Croft, Moura, and Cabrita Reis but Pedro Proença, João Penalva, Pedro Calapez, Gerardo Burmester, Rui Chafes, and Albuquerque Mendes.

An encouraging sign of new opportunities to display and celebrate contemporary art was emerging at the end of the century in Oporto. A consortium of government, business, and private donors committed itself to the construction of a museum dedicated to "modern" art on the parklike grounds of the Serralves mansion (already used as a venue for display of more traditional works). The new, plain, and straightforward structure will comprise fourteen galleries of various sizes and shapes to accommodate the wide variety of contemporary artistic production. There will also be outdoor space for larger and more complex installations. The design and development of the project was confided to Álvaro Siza Vieira, generally regarded as the county's most eminent living architect, and winner of the 1992 Pritzker Prize (architecture's equivalent of a Nobel). Born in 1933, and already well known for his restoration of the fire-ravaged Chiado district in Lisbon, the building of the faculty of architecture in Oporto, and the Pavilion of Portugal at the International Exposition of 1998, he has won praise for his dedication to clarity and simplicity. These qualities have set him apart from the massive glass boxes and neo-Moorish extravaganzas that sprang up in the business districts of the capital and the tourist resorts of the Algarve under the oversight of some less austere architects during the influx of EU funding. The Serralves Museum of Contemporary Art will represent an opportunity for the best of foreign artists to interact on a visiting basis with the visions of Portuguese painters and sculptors, all within the sympathetic framework created by a Portuguese master designer. After a century, the original architectural enthusiasm of Souza Cardoso

will be joined with his later artistic experiments in a symbolic way to, at long last, take Portugal into the European mainstream.[13]

Drama, whether on stage or screen, has a long and respectable, if not internationally recognized, history. The Salazar regime imposed the heavy hand of censorship on films and plays throughout the decades from the 30s to the 70s. Post-revolutionary opportunities for free expression have encouraged a new generation of playwrights and the restoration of a number of old theaters in the major cities. The government has provided subsidies to add new buildings and to extend the range of theatrical activities into the provinces. Film directors of an earlier day who had won distinction within a more traditional framework, such as João Botelho and João Cesar Monteiro, have been joined by Manoel de Oliveira, whose cinema career includes some twenty films. He has been hailed in Britain's *Guardian* as "the most eccentric and the most inspired of cinema's world masters." Younger directors in the contemporary cinema scene include Pedro Costa and Teresa Villaverde, both of whom show a particular interest in the grim and stressful life of the Lisbon citydwellers.[14]

For all the efforts of its present-day artists, Portugal, at the beginning of the twenty-first century, must still rely heavily for her international prestige upon the achievements of the past. Her dependence upon touristic revenues has encouraged successive governments to provide an ample array of museums and restored buildings to display her artistic heritage and her historical treasures. Naturally, she highlights such distinctive offerings as Manueline churches and monasteries and the remarkable *azulejos* that have been a feature of her public and private ornamentation since the Middle Ages. These elaborately carved and painted tiles have been used in the decoration of churches, houses of grandees, and state offices in a profusion of styles and colors, although the blue tinted tiles are the most admired and widely known. Although discerning travelers were seeking out Portugal for her castles and monastic buildings, her out-of-the-way special collections and, of course, displays of *azulejos* as far back as the 1950s, such stimuli as the EU bonanza of the late 1980s and the International Exposition of 1998 have led to a particular preoccupation with presenting the finest examples of Portugal's high culture before an international audience. The designation of Oporto (along with Rotterdam) as European Cultural Capital for 2001 stimulated an even greater outburst of construction and renovation. Yet, amidst all of this relatively recent rearrangement of the country's best and brightest possessions, special recognition must be given to the Calouste Gulbenkian Foundation. For more than half a century, the benefactions of the late Armenian oil magnate have promoted a wide range of cultural activities and institutional developments in Portugal. In addition to its princi-

pal galleries in Lisbon, filled with masterpieces, the foundation has sponsored educational and musical, theatrical and artistic events in various parts of the country and abroad. It has been particularly helpful to an often cash-shy government in preserving the national patrimony from decline. It is surely among the most curious of the many ironies in Portuguese history that a man from the far-away lands of the East should choose to settle in the heart of a now-shrunken imperial power and help sustain its relics of past glory. In addition to the Gulbenkian Foundation, Portugal boasts many other collections of treasures, ranging from the National Museum of Antique Art (actually housing medieval and early modern exhibits) through the Maritime Museum (rated the best of its kind in Europe), which preserves the record of overseas exploration, to the Museum of Ethnology, which houses the artifacts of the African empire, to the Museum of Folk Art (its domestic counterpart)—dozens of venues offer a rich variety of materials. There are museums housed in former monasteries that contain sacred art or local crafts, whole villages like Óbidos, with its medieval walls and its royal castle transformed into a highly atmospheric hotel, that constitute living museums. There are galleries celebrating the work of particular painters and sculptors, such as Nuno Gonçalves and Soares dos Reis. In Oporto the fourteenth-century *Casa do Infante,* believed to be the birthplace of Prince Henry the Navigator, is being restored to its former grandeur, to serve both as an architectural landmark and a repository for the customs records that document the city's great age of international trade. The overseers of these and many other institutions, large and small, are, of course, primarily concerned with showing visitors what is beautiful, evocative, or merely picturesque. The directors of the Serralves Museum of Contemporary Art, are driven by an essentially missionary impulse. Refering to the museum's focus on post-1968 work by both Portuguese and related foreign artists, curator João Fernandes says "this is because Portugal stood alone for too long, run as one farm by our agrarian dictator, Salazar." "Now," he explains, "we must force our audiences to come completely into the contemporary world."[15]

Some years ago, the American novelist Mary McCarthy wrote, after a trip to Portugal, that the Portuguese were like a nation of superstitious brides who wanted to have something old, something new, something borrowed, something blue. The blue is still there in the *azulejos,* as is the borrowing, whether we think of the influences that have shaped the country's history or the financial expedience that sustained it in recent years. Whether the Portuguese will continue to maintain a healthy balance between the old and the new remains to be seen.

Fado and Beyond: Leisure and Pleasure

It has been said that under Salazar, Portuguese popular culture consisted of *Fado,* football, and Fatima. Whatever one may say about the validity of this statement, then or now, and whatever relative importance one attaches to the sport or the shrine, there is no doubt of *fado*'s place in popular culture. In many parts of the world, the only word that comes to mind when the name "Portugal" is mentioned, is *fado.* Even Portuguese who would like to be recognized for a variety of virtues and achievements would probably not be too resentful of the implied sterotype. *Fado,* after all, has been characterized as the "eternal soul" of their country. Expressing "fate" or "destiny," it conveys a mixture of sorrow, loss, and lingering hope which is an undeniable summation of the Portuguese experience. Trying to describe the character of a true *fado* song, one facile commentator said that the Portuguese are never so happy as when they are being collectively unhappy.

Opinions differ as to the origin of *fado,* some giving priority to the influence of medieval troubadours and peasant lamentations which were ultimately channeled into the academic setting of Coimbra. Others insist its birthplace was the working-class environment of the Alfama district in Lisbon, where it became an increasingly upscale musical genre as it emerged from the taverns and the crowded streets. Musicologists often prefer to distinguish between Coimbra-based and Lisbon-based *fado,* leaving enthusiasts to dispute the relative merits of the two styles. Traditionally, the *fado* singer would present a group of three songs, not necessarily closely related in lyrics, but all expressing feelings of sorrow, resignation, or nostalgia. Purists demand an accompaniment by the Portuguese *guitarra,* an instrument sometimes compared to a mandolin, although the more familiar Spanish guitar has become acceptable.

Whatever the evolution of the *fado* through the generations, its preeminent performer and exponent in the twentieth century was Amália Rodrigues (1920–1999). In a career spanning nearly sixty years, she developed and refined a combination of technique and persona that left audiences enraptured. Whether on radio in the 1940s, on television (beginning in the United States in 1952), in a dozen films, or in concerts everywhere from England to Japan, she established herself as the Queen of *Fado* and, by unspoken acclamation, as the de facto Queen of Portugal. Fittingly, she performed for the last time at the International Exposition in Lisbon in 1998 with visitors from around the globe in attendance. Following her death, marked by 3 days of national mourning, the assembly voted to place her remains in the National Pantheon in the company of kings and heroes.[16]

Bruno de Almeida, an expatriate filmmaker, had, naturally, known of Amália Rodrigues as a child in Lisbon. But it was at a Town Hall concert in New York City in 1990, that he experienced the emotional impact of her singing that turned him into a devoted disciple who conducted hours of interviews about her life and artistic feelings and made no less than four documentary films and television productions about her. He also orchestrated a worldwide search for virtually every surviving recording and image of her performances. A woman of great charm and dramatic presence who combined intense sincerity of emotion with such skillful devices as performing totally clad in black (in contrast with the more random attire of previous singers), she had no hesitation in making such pronouncements as "*fado* is a lament that is eternal" and "I don't sing *fado*, it sings me." If de Almeida has become a particularly dedicated keeper of the flame, there are clearly hundreds of thousands of others who are prepared to listen not only to her songs but to her spoken words as reflecting profound transcendence.[17]

When a performer of such power and presence dies, it often takes a considerable period of time for the void to be filled. In the case of Amália, as she was popularly known, newcomers, like Cristina Branco, had already begun to appear in the late 1990s. Their followings were somewhat diminished by the growth of rival approaches to *fado,* including the idea that it must be "modernized" or even integrated with other, non-Portuguese, styles of music. Whether *fado* can survive these divergent tendencies is not yet clear. There have been downturns in its popularity before, notably in the post-revolutionary days when it was denounced in certain circles as a kind of "official Portuguese music" sponsored by Salazar. Periodically, too, there have been disputes over the commercialization of *fado*. In "tourist traps," busloads of foreign visitors are brought to listen, totally unprepared, to inferior renditions of the standard repertoire. Guides and guidebooks insist that only they can steer you to the "authentic *fado*" clubs, while old-timers grumble that the weight of the bad is forcing aside what is left of the good.

While waiting to discover whether it is truly eternal, the time may be ripe to go beyond *fado*. Portugal is home to numerous musical traditions, including the *charamba* of Madeira and the Azores, the stick dances of Trás os Montes, the unaccompanied vocal choruses, featuring quite different songs for men and women performed in many of the villages of the Alentejo, and many other regional folk dance and singing legacies that have survived either by fortunate accident or dedicated preservation. The "new" Portuguese who have migrated from the former colonies in Africa now contribute their own cultural products to the national mixture, and singers like

Cesarea Evora from Mozambique have acquired an international reputation. Although, like virtually every other country in Europe, Portugal is now being innundated by everything from American "pop" to the latest craze from across the nearest frontier, there is still enough that is truly a product of the Portuguese people available to sustain life beyond *fado*.

The very vitality of popular music—particularly but not exclusively *fado*—was seemingly a drag on the development of classical music in the twentieth century. From the Renaissance to the end of the nineteenth century, the country responded to a variety of European influences and, periodically, to the residence in Portugal of notable foreign composers living at the royal court or accepting the patronage of local magnates and impresarios. It is undeniable that Portugal's respectable but unremarkable record in this genre has not been maintained in the twentieth century. There are concert halls and opera houses where the great works are performed, and the major "stars" put in an appearance. But only recently have Portuguese resources and encouragement by the Gulbenkian Foundation and other patrons begun to raise up a crop of home grown composers such as Filipe Pires, A. Vitorino de Almeida, and Jorge Peixinho. Until more is heard from these and others, popular traditions will continue to dominate the Portuguese musical scene.

Even *fado* does not have as long a history in Portuguese popular culture as bullfights, which, according to a Roman historian, were practiced in a crude form by the inhabitants of Lusitania some 2,000 years ago. Like its Spanish counterpart, the Portuguese sport/show is surrounded by many legends related to its origin and evolution. It is known, however, that it had become a school of valor and martial skills for noblemen by the thirteenth century. As such, it placed emphasis on horseback encounters with the bull unlike its Spanish equivalent. The most significant variation in the two national forms of bullfighting came in 1799, just as the *corrida* was entering its golden age across the frontier. In that year, the Count dos Arcos was killed in a particularly gory confrontation beneath the shocked gaze of the royal family. Henceforth, it was decreed, Portuguese bulls would have their horns capped in leather or metal balls and the bulls would not be fought to their death. While not as popular as the *corrida*, the Portuguese *tourada* still has a large following, particularly in the Ribatejo bull-breeding region, where the towns of Santarém and Vila Franca de Xira are the sites of the most dramatic and authentic fights. Every year, between Easter and All Saint's Day, some 300 clashes between man and bull take place in Portugal, making the *tourada* still one of the major manifestations of traditional popular culture. Each *tourada* starts with a parade of the participants in the three fights normally scheduled for the day. The actual combat

begins with a mounted *cavaleiro,* clad in the garb of an eighteenth-century nobleman, including a plumed tricorn hat, elaborately embroidered satin coat, and polished thigh-high boots. He wears a black bandana around his neck in commemoration of the ill-fated Count dos Arcos. What follows is an elaborate demonstration of horsemanship as the rider maneuvers around the bull, provoking him with thrusts and avoiding his charges. In a reversal of roles as compared with the Spanish bullfight, *toureiros* on foot act as auxiliaries to the horseman, distracting and confusing the bull with capes. Finally, when the thousand-pound animal has been sufficiently wearied, the most peculiar and perilous segment of the battle takes place, as a team of *forçados*—young men who are all volunteers seeking to demonstrate their reckless bravery—enter the ring, dressed like the others, in colorful archaic outfits. Their leader, strutting defiantly up to the bull, rushes forward and grabs him by the horns and attempts to bring down his head. Although the captain is usually tossed aside, his mates, who have followed him in a column, rush forward to pile on the creature and attempt to drag him down. After much struggle, the bull is finally overwhelmed and then persuaded to exit the scene of his defeat trailing after a troupe of cows amidst the clattering of their bells and the raucous cheers of the audience. Alas for the nonlethal image of the *tourada,* the bull is, in fact, humanely put to death off-stage.[18]

As in Spain, there are those in Portugal who protest that any abuse of animals is an abomination and demand the abolition of bullfighting. They seem to be heavily outnumbered, however, although many enthusiasts are conflicted by what they perceive as the tourist-pleasing anomalies that have crept into the *tourada* as staged in Lisbon and the Algarve, where Spanish-style *corridas* are sometimes intermixed with the purely Portuguese encounters. For these admirers of the country's most traditional game, posters proclaiming in English "The bull is not killed!" are an abomination.

Some journalists have suggested that humans may be killed in 2004, and not by bulls, but by English-speaking "lager louts." Thousands of soccer fans from all over Europe, including those with the tendency to violent hooliganism that some unsavory British subjects have displayed at other international matches, will be attending the football championship in that year. The Portuguese government, far from sharing such apprehensions, is looking forward to the upcoming series of games on its territory with a mixture of patriotic rapture and commercial anticipation. There is no doubt that soccer is the great passion of most Portuguese sports lovers. Other forms of recreation, ranging from hunting to tennis, boating to rock-climbing, scarcely register on the index of activities. In this dimension,

Portuguese popular culture, like that of Spain, reserves only an affection-ate nostalgia for the bull ring while seeming to give its heart and soul to the soccer field. As in the rest of Europe (and, indeed, as in much of the rest of the world outside the United States) the general population supports teams—professional and amateur—in every corner of the country, follows the ups and downs of the season avidly, and sustains not only intense cov-erage by radio and television but newspapers and magazines devoted entire-ly, or in large part, to soccer. *Benefica* and *Sporting,* both of Lisbon, have the greatest following, but *FC Porto* commands the total allegiance of the Second City and its environs. Portuguese teams have done well on inter-national soccer fields in the recent past, but hopes and fears will undoubt-edly reach an unprecedented level in 2004 when the best teams from abroad will invade the country to battle for supremacy. This will be the greatest sports event in Portuguese history. Quite aside from the compet-itive aspects, it has already become a major fiscal issue. Ten venues in eight cities are being either specifically created or massively refurbished with a combination of public and private contributions. Infrastructure and support-facility outlay have been colossal, precipitating outcries from all sides, including budget monitors and environmental watchdogs. The tourism authorities may salivate at the prospect of nearly half a million vis-itors pouring into the country, but some locals are horrified as they con-template superhighways gashing their way across pristine countryside and armies of holiday makers mauling the landscape.

In the meantime, Portugal has been embarrassed by a scandal that sur-faced in the spring of 2001, when it was discovered that false papers were being used by non-European athletes to get around restrictions on the num-ber of overseas players allowed on EU teams. Brazilians, in particular, were said to be involved in scams that certified Portuguese citizenship and, therefore, EU eligibility. Although many Brazilians are valid claimants to Portuguese citizenship through Portuguese-born parents or grandparents, many others have been furnished with stolen or altered passports. In other cases, blank passports have been stolen from Portuguese consulates and filled out to meet the needs of those prepared to buy them. In some instances, it is alleged, policemen or other officials have participated in these frauds. A growing market in bogus EU passports during the past decade has affected a number of countries, but the apparent vulnerability of Portugal to this type of crime has raised an uproar precisely at the moment when the 2004 championship can least afford to be tarnished by questions about players or other foreigners who are taking advantage of Portuguese laxity to abuse the country's hospitality.[19]

Television has transformed popular culture during the few decades that it has been widely available in Portugal. It has changed every man, woman, and child in the country into a sports fan and/or moviegoer. No longer is it necessary to travel to a soccer stadium or cinema. Coverage of games seems to be virtually nonstop, although films (usually subtitled foreign productions) actually take up almost as much airtime. Soap operas, either Portuguese or Brazilian, also have a huge following. News, music, and more "serious" subjects have been largely relegated to the radio. Although the poorest segment of the population had to wait the longest to take advantage of the modern miracle, few are now beyond its reach or unwilling to pay its cost. As with radio, television is available either from state-owned channels or private commercial outlets. Although the post-Salazar era, with its freedom of expression, gave birth to little that could be called morally questionable, the proliferation of "reality-based TV" throughout Europe during the year 2000 finally made its way to two privately-owned channels in Lisbon, and a so-called war of pornography between them sparked a national debate in early 2001. Sexually explicit scenes were broadcast at a time of day when they could be seen by children. This led to plans by the commission that oversees the medium to impose fines or formal censures. When conservatives in the Assembly complained about the weakness of such gestures, the supervising agency insisted that it lacked statutory power to take stronger action. Wrangling over issues of democracy, censorship, intellectual freedom, and other heady questions continued. How much longer, critics wondered, would Portuguese television turn out such productions as the 13-part series on the clandestine sanctuary given by the Portuguese villagers to Spanish political refugees during the Civil War, when the channel had to compete with a far more intense form of reality? In the midst of all this, Bill Gates, the Microsoft magnate, arrived in Lisbon to announce that Portugal had been chosen for the trial run of a new interactive television system that was to be introduced in Europe. Before long, lucky Portuguese, when they were feeling neither sexual nor historical, would be able to sit in front of their TV sets, playing games and ordering whatever products on the screen took their fancy.[20]

Unlike the electronic media, Portugal's periodicals are not a major source of scandal. Readers of newspapers and magazines find more to amuse them than to outrage them in the bizarre items that frequently turn up. Within the span of a few weeks in early 2001, both patriots and cynics could be gratified by a series of unrealistic images of Portugal as a major global player. There was an account of a meeting in the Azores between Portuguese and Spanish foreign ministers to discuss the implication of

Portugal's forthcoming chairmanship of the Organization for Security and Cooperation in Europe and Spain's presidency of the European Union scheduled for the first half of 2002. They also discussed a joint approach at the Iberoamerican Summit Meeting in Perú in November 2001. In addition, they reviewed their position on the proposed eastern expansion of the EU and reaffirmed their special concern about "ultra-peripheral zones of EU member states." The Azores, Madeira, and The Canary Islands have this status which gives them special EU economic support. The Portuguese foreign minister also made a flying trip to Armenia and Azerbaijan, where he conferred with the leaders of those two warring countries and promised to use Portugal's good offices as incoming chair of OSCE to resolve their territorial disputes. Meanwhile, President Sampaio was in Prague, urging a joint meeting of Czech and Portuguese business-men to develop mutually beneficial trade relations, despite all the concerns that had been raised in Lisbon over the potential difficulties that EU expansion might bring to Portugal.[21]

The Portuguese have an opportunity to gnaw on their grievances. They are told how their brethren living in Britain are exploited, over-worked, and underpaid by U.K. employers. They learn that plans to build another bridge over the Tagus and to extend the Oporto subway system have been postponed indefinitely because of the tight fisted policies of the EU. They also read that the European Union is responsible for damaging their environment by various unwise farming methods imposed upon Portuguese farmers. And, of course, the endless discussion over the intro-duction of the euro continued, with the rumor that the 200 and 500 euro notes would not be distributed in Portugal because such substantial sums do not play a part in the life of the ordinary Portuguese citizen. True, per-haps, but painful to the ego.[22]

The press is always eager to publish "scientific" items, such as the dis-covery of a "living fossil" by a Portuguese resident of South Africa. The pre-historic fish, the Coelacanth, was thought to be extinct, but now an heir to the Great Age of Discovery has tracked the beast to its lair. Closer to home, prehistoric engravings on rock walls lining the banks of the Guadiana River have stirred up more than antiquarian interest. Some say they are 5,000 years old, others 20,000, but they will disappear immediately if the Alqueva Dam project continues. Once again, this perpetually controversial and monstrously expensive dam is a source of debate. For those who are not moved by thoughts of prehistoric fish or carvings, there is the announcement by a Portuguese scientist that Einstein got it wrong. João Magueijo argues that the speed of light is not a constant and that the German-born genius's theory of relativity may, as a consequence, be flawed.

On a more practical level still, the press offers the Trigger, a three-wheeled minicar so compact and easily manufactured that it may revolutionize transportation. That this product of automotive ingenuity may enable more citizens to drive about at high speed, increasing the number of Portuguese auto fatalities, will clearly be the subject of yet another debate.[23]

Less entertaining than these anecdotes is the latest on the Portuguese drug scene. From the Azores, ever a fertile source of peculiar stories, comes the report of a massive quantity of cocaine, originally dumped overboard from an Italian ship to avoid a search by patrol boats. After floating ashore, it has now been turned into a major local commodity on at least one of the islands, enriching some and making others extremely sick. Far more serious is the detailed account of a massive influx of narcotics that has caused widespread addiction in mainland Portugal. Under the headline "Just Another Day in Paradise," a Lisbon paper cites evidence that Portugal has become the most drug-addicted country in Europe and adds that there is a massive increase in alcoholism. The spread of heroin use and the growth of treatment centers and clinics represent a disturbing new dimension of the country's popular culture, though one by no means unique to Portugal.[24]

It has been said that in order to be happy one must have good health and a poor memory. Unfair as it may be to generalize, the Portuguese suffer from poor health and an all-too-good memory. Long accustomed to poverty and unable to forget the constant cycle of grandeur and depair that constitutes their history, the mass of the people have every reason to remain gloomy. Yet popular culture, for all its negative elements, has served to sustain the national spirit through long stretches of adversity as well as transient periods of prosperity. As long as that popular culture continues to be essentially Portuguese, it should continue to sustain *O Povo*.

Anyone seeking to come to an overall conclusion about Portugal today is drawn inescapably to the concept of *saudade*. *Saudade* has been defined a thousand times, both by natives and foreigners. One of the most thoughtful definitions is that of art historians Helmut and Alice Wohl: "the longing for a retrieval of past greatness rendered irretrievable by fear of an unknown, nonexistent punishment, and by guilt over what one has not done."[25] Does the Portuguese ambivalence about modernization have its root in a fear of change? Is the collective guilt which the nation supposedly feels truly without foundation? Portugal may not want to submit to psychoanalysis, especially when conducted by non-Portuguese practitioners. Nevertheless, her well-wishers must advise her to live within her means. They are compelled to tell her to cease mourning past grandeur and accept the positive features of her present condition. They urge her to pay

close attention to her human and physical resources which constitute the only treasure that can sustain her in the future. They welcome her insights and experience but warn against foolish pride. When she honestly confronts her deep-seated problems, they assure her, she will feel both healthier and happier.

Conclusion

The young Spaniards and Portuguese of today have grown up in a society completely different from that known by their parents. For anyone born since 1975, political dictatorship, cultural censorship, and narrow restraints on personal conduct are merely tales told by the older generations. In both countries, the fall of a long-established authoritarian regime opened the way to democracy and a sometimes bewildering array of opportunities during the last quarter of the twentieth century. There were, of course, variations in their common experience. Spain's transition followed a relatively tranquil course, facilitated by Franco's decision to restore the monarchy and the patriotic good sense of the man he chose to be king. Aside from the brief threat of a military *coup* in 1981, Spain has followed an orderly constitutional path, and her principal political parties have recognized the virtue of moderation. Her greatest challenge remains the ancient problem of regionalism, now experienced in a particularly virulent form. Portugal escaped from dictatorship only by means of a bloodless revolution that had been provoked by a bloody colonial war. Unlike Spain, with her peaceful transition, Portugal had to endure the psychological trauma of finally abandoning her empire and the domestic tumult provoked by radical politics. Finally emerging into stable democracy, unlike her far-larger neighbor, she has had to depend heavily upon external subsidies and economic improvisations to achieve even a modest level of prosperity. What both countries have in common, aside from their geographical and historical heritage, is their demonstrated commitment to preserving a new sociopolitical order while safeguarding their distinctive cultural identities. Both Spain

and Portugal have emerged from isolation to become good Europeans and active members of the new global community. As such, they offer both example and inspiration to other nations striving to cope with the dizzying pace of change in the world of today.

Amidst the excitement and hyperbole surrounding the onset of a new century and a new millennium, Spain and Portugal both appeared confident as they took stock of what had happened to them in the last quarter of the old century. The Spanish media were full of retrospectives, with even Franco coming in for a touch of reassessment and the positive features of the monarchy being projected into a hypothetical reign of King Felipe VI. Cultural pride continued to flourish, as the country bade farewell to veterans like the writer Carmen Martin Gaite and those untimely lost like the sculptor Juan Muñoz and the opera conductor Luis Antonio Garcia Navarro, who restored the glory of Madrid's Teatro Real. Spain hailed the soaring achievements of architect Santiago Calatrava in the United States and linked the Golden Age with the future by creating a Velazquez Prize in the fine arts to match the Cervantes Prize in Literature. Familiar issues remained unresolved, with the natural environment threatened, unemployment never fully relieved, and immigration jeopardizing social stability. Portugal clung to the luster of its great imperial commemorations and looked forward to even bigger and better touristic achievements. Her government redoubled efforts to reduce the twin plagues of substance abuse and traffic deaths while assuring the European Union that it would get its financial house in order. Neither Madrid nor Lisbon could deny the negative implications of the slide toward recession in the United States during the summer of 2001 or the ripple effect that ran through Asia and Latin America and back into their own continent. Positive thinking and mutual support were the order of the day, for, after all, Iberians were used to tightening their belts. Then came September 11th.

Death and destruction in New York, Washington and a Pennsylvania field were met by a proclamation from the president of the United States declaring the "first war of the twenty-first century." Prime Minister Aznar immediately expressed solidarity with his American and NATO colleagues, but applied the worldwide anti-terrorism campaign specifically to Spain when he warned the Basque militants that they must now expect the most severe consequences of their actions. ETA responded by detonating a car bomb in front of a courthouse in Vitoria, an outpost of Spanish authority in their own territory that they had attacked a few years earlier. While Spain followed the European Union lead in tightening all forms of security, with special attention to her forty-seven airports, the strongest sign of the government's plans came in a statement by General Antonio Moreno Barbera,

chief of the defense staff, who warned that the armed forces were prepared to support the police in a vigorous program of anti-terrorist attacks. It was, some declared apprehensively, as if America's actions had given Spain a license for an all-out assault against ETA. Some even spoke of a new Spanish Civil War. In this atmosphere, a plea by Luis Rodriguez Zapatero, leader of the Socialists, to build a Spanish bridge between moderate Arab countries and the West went virtually unheeded. From Zapatero's socialist peers in Portugal came remarks that echoed his tone of conciliation. Prime Minister Guterres spoke about the need for Portugal and the other members of the European Union to create a zone of anti-terrorist security in Europe while exhibiting a firm and rational response to recent events. He went on to say that he was convinced that the United States would not undertake a massive military retaliation upon the refuge of the perceived authors of the atrocities against her citizens. Rather, he felt sure, there would be precise and surgical operations to punish the guilty parties. Yet, as soon as the air bombardment of Afghanistan began, Guterres summoned his cabinet and soon proclaimed Portugal's solidarity with America. His foreign minister, Jaime Gama, added that the air strikes in Afghanistan were "necessary to dismantle the world headquarters of terrorism." The airbase at Lajes in the Azores was specifically placed at the disposal of American forces engaged in the onslaught. Still, Guterres could not refrain from insisting that this must not be a "holy war" and that it should not be seen as an assault on Islamic civilization, while Gama promised that the European Union would mobilize resources to rebuild Afghanistan once the fighting was over.

Today, Spain and Portugal, having abandoned their isolation, find themselves drawn into a global conflict whose dimensions and duration can scarcely be comprehended. The larger country has responded to the challenge with its traditional vehemence, the smaller with a caution born of harsh experience.

Notes

Chapter 1

1. Victor Perez Diaz, *The Return of Civil Society: The Emergence of Democratic Spain* (Cambridge, MA: Harvard University Press, 1993), p. 10.

2. Paul Preston, *Franco. A Biography* (New York: HarperCollins, 1994), pp. 744, 749.

3. Perez Diaz, p. 75.

4. M. Fossi and J. Palafox, *España, 1808–1992* (Madrid: Alba, 1993), pp.393–5.

5. Vicente Cantarino, *Civilizacion y Cultura de España* (New York: Scribner, 1988), pp. 312–3.

6. Michael Newton and Peter Donaghy, *Institutions of Modern Spain* (Cambridge: Harvard University Press, 1998), pp. 97–9.

7. R.M. Goodwin, *The Spanish Army, 1956–1996* (London: Hyde, 1997) pp. 375–9.

8. John Hooper, *The New Spaniards* (New York: Penguin, 1990) pp.75–6.

Chapter 2

1. Gilberto Pérez–Matos. "Política contemporánea" in *España finisecular*, ed. Santiago Martínez Rojas (Madrid: Cánovas, 1997), p. 59.

2. Federico Sánchez Hidalgo, *Crisis del socialismo* (Madrid: Siglo XX, 1996), pp. 21–23.

3. *ABC*. December 10, 1996.

4. *ABC*, September 3, 1989.

5. Joaquín Benitez Arroyo, "Aznar," *ABC*, November 20, 1997.

6. Marlise Simons. "If Puppets Step Offscreen, They'll Get Torn Apart," *New York*

Times, May 10, 1997.

7. Al Goodman. "Squabbling, Spaniards Mark 20th Birthday of Their Constitution," *New York Times*, December 6, 1998.

8. *El País*, February 2, 1999.

9. Pérez Matos. p. 62.

10. Sánchez Hidalgo. p. 25.

11. Pérez Díaz. p. 196.

12. *El País*. January 12, 1999.

13. *New York Times*. March 10, 1999.

14. *New York Times*. April 30, 1999.

15. Alejandro Muñoz Alonso. "La Plurinacionalidad," *ABC*, August 3, 1998.

16. Ibid.

17. *New York Times*. April 8, 1999.

Chapter 3

1. John Lynch, *Bourbon Spain, 1700–1808* (Oxford: Blackwell, 1989), p. 72.

2. Paul Preston, *Franco* (New York: Basic Books, 1994), pp. 701,724.

3. John Hooper, *The New Spaniards* (New York: Penguin, 1990) pp. 89–90.

4. *Ibid.* p. 91–92.

5. *ABC*, May 26, 1983.

6. Hugh Thomas, *The Spanish Civil War* (New York: Harper, 1961), p. 203.

7. Stanley G. Payne, *Politics and the Military in Modern Spain* (Palo Alto: Stanford University Press, 1967), pp. 166–169.

8. *Ibid.*, pp. 277–291; 351–352.

9. Preston, pp. 547–549.

10. Spain. Ministerio de defensa español, *La Constitución y las Fuerzas Armadas* (Madrid: Government Printing Office, 1999), pp. 2–4.

11. *International Security Review* XII, 2 (October, 1985), pp. 39–43.

12. Spain. Ministerio de defensa español, *Spain and Peacemaking Operations* (Madrid: Government Printing Office, 1999), p.1.

13. *ABC*, June 6, 1999.

14. J. H. Elliott, *Imperial Spain* (New York: Meridian, 1962), pp. 110, 215–17.

15. Gerald Brenan, *The Spanish Labyrinth* (Cambridge: Cambridge University Press, 1990), pp. 159–164.

16. Thomas, p.538.

17. John A. Crow, Spain: *The Root and the Flower* (Berkeley: University of California Press, 1985), pp. 344, 353, 417.

18. *Ibid.*, p. 345.

19. Spain. Information Service, *Constitution of Spain* (Madrid: Government Printing Office, 1985), p. 2.

20. *ABC*, March 25, 1995.

21. Hooper, pp.140–143.

22. *New York Times*, May 5, 1997; October 8, 1997; *La Voz de Galicia,* July 26, 1998; *ABC*, August 2, 1998.

Chapter 4

1. William Brooke, *A Journey in Spain* (London: Dowell, 1770), p.139.

2. Raymond Carr, *Spain: A History* (New York: Oxford University Press, 2000), p. 431.

3. Paul Preston, *The Evolution and Decline of the Franco Regime* (New York, Barnes & Noble, 1976), p. 594.

4. *Ibid*, p. 740.

5. Victor Pérez Díaz, *The Return of Civil Society: The Emergence of Democratic Spain* (Cambridge: Harvard University Press, 1988) pp.80–94.

6. *ABC* , June 10, 1999.

7. *ABC*, November 28, 1999.

8. Crow, p. 408.

9. *ABC*, July 26, 1992; April 15, 1993.

10. *El Mundo*, January 19, 1996.

11. *El País,* August 15, 1999.

12. *El Mundo*, September 9, 1999.

13. Antonio Machado, *Poesías completas,* (Buenos Aires: Editorial Losada, 1958) p. 89.

14. Julián Marías, *Understanding Spain* (Ann Arbor, MI.: University of Michigan Press, 1999) P. 431.

15. *El País,* June 25, 1999.

16. Miguel Angel Barroso, "El Largo Adiós," *Ecología* (September, 1997), pp.53–59.

17. Marlise Simons, "Big Sludge Spill Poisons Land in Southern Spain," *New York Times,* May 2, 1998; "Year Old Spill Poisons Farms and Wild Life Food Chain," *Times,* May 24, 1999.

18. Jaime Campmany, "Los Galápagos," *ABC,* May 1, 1998.

19. John Hooper, *The New Spaniards* (New York: Fodor, 1988), pp. 259–265.

20. *Ibid.* 268–271.

Chapter 5

1. Stanley Payne, *Politics and the Military in Modern Spain* (Stanford University Press, 1967), p. 25.

2. John Crow, *Spain. The Root and the Flower* (Berkeley: University of California Press, 1985), p. 411.

3. John Hooper, *The New Spaniards* (New York: Penguin, 1990), p. 202.

4. *Ibid.*, p.202.

5. *Ibid.*, p.187.

6. *Ibid.*, p.204.

7. Marie Louise Graff, *Culture Shock: Spain* (Portland Oregon: Graphic, 1997), p. 133.

8. Crow, p. 406.

9. *New York Times,* January 17,2000.

10. Preston, p. 727.

11. Hugh Thomas, *The Spanish Civil War* (New York: Harpers, 1961), p. 425.

12. Hooper, pp.168–170.

13. Lidia Falcón, *La razón feminista* (Madrid: Vindicacion Feminista, 1983), pp.155–163.

14. *El País*, June 12, 1998.

15. Hooper, p. 168.

16. *Ibid.*, pp. 175, 178.

17. *Ibid.*, p. 178.

18. *Hola*, March 6, 1999.

19. *El País*, March 1, 2000.

20. Marlise Simons, "Resenting African Workers, Spaniards Attack," *New York Times,* February 12, 2000.

Chapter 6

1. Marie-Lise Gazarian Gautier, *Interviews with Spanish Writers* (Elmont Park, Il., Dalkey Archive Press, 1991), pp. x–xi. The authors are particularly grateful to Professor Gazarian Gautier for the fund of personal anecdotal and literary information contained in her fascinating record of her conversations with many of present-day Spain's leading writers.

2. *Ibid.*, p. 55.

3. *Ibid.*, p. xv.

4. *New York Times*, October 7, 1977.

5. *Ibid.*, May 6, 2000.

6. Gazarian Gautier, p.100.

7. *Ibid.*, pp. 260, 273.

8. *Ibid.*, pp. 112–113.

9. *Ibid.*, p.67.

10. *Ibid.*, pp. 31–39.

11. *Ibid.*, pp. 154,159.

12. *Ibid.*, pp177–180.

13. *Ibid.*, pp.182–192.

14. *Ibid.*, pp.165–172.

15. *Ibid.*, pp.288–301.

16. *Ibid.*, pp. 302–310.

17. Lidia Falcón, *Memorias políticas (1959–1999)* (Barcelona: Planeta, 1999), *passim.*

18. G.G. Brown, *A Literary History of Spain: The Twentieth Century* (New York: Barnes and Noble Books, 1974), pp. 152–153.

19. *Ibid.*, pp. 148–149.

20. *Ibid.*, p. 146.

21. *Ibid.*, p. 150.

22. Gazarian Gautier, p. 94.

23. *Ibid.*, p. 80.

24. Idem

25. *Ibid.*, p. 12.

26. *Ibid.*, p. 195.

27. *Ibid.*, p. 203.

28. *Ibid.*, pp. 228–232.

29. *Ibid.*, p. 239.; John Hooper, *The New Spaniards* (New York: Penguin, 1990), p. 347.

30. Gazarian Gautier, p. 244.

31. *Ibid.*, p. 225.

32. Marlise Simmons, "Don Quijote Rides Again," *New York Times,* April 26, 1997.

33. *ABC,* December 12, 1997.

34. James Markham, "Franco Dies Slowly," *New York Times,* August 17, 1980.

35. Idem

36. Gazarian Gautier, p. 225.

37. *El Mundo,* June 29, 1999; *ABC,* June 29, 1999.

38. Idem.

39. *New York Times*, July 8, 1999.

40. *ABC*, December 26, 1997, January 2, 1998.

41. *New York Times*, September 11, 1999; *ABC*, September 5, 1997.

42. *La Zarzuela* (New York: Amigos de la Zarzuela, 1995), p. 12.

43. *ABC*, December 12, 1997.

44. Mary Vincent and R.A Stradling, *Cultural Atlas of Spain and Portugal* (New York: Facts on File, 1994), pp. 141–142.

45. *ABC*, November 21, 1997.

46. Vincent and Stradling, *Cultural Atlas*, p. 174–175.

47. *ABC*, January 2, 1998.

48. *Ibid.*, November 28, 1997.

49. *New York Times*, May 17, 2000.

50. Raymond Carr, ed., *Spain, a History* (New York: Oxford University Press, 2000) p.9.

51. Preston, p.322.

52. *El País*, March 29, 2000.

53. Hooper, pp. 330–331, 346.

54. Semantha Conti, "The Treasures of Tita," *W* (October, 1997), 106–108.

55. Hooper, p. 327.

56. Stanley Meisler, "The Poetic Vision of Spanish Sculptor Eduardo Chilida," *Smithsonian* (July, 2000), 58–63.

57. *ABC*, December 5, 1997.

58. *The 20th Century Art Book* (London: Phaidon Press, 1999), p.328.

59. *ABC*, December 12, 1997.

60. *Ibid.*, February 6, 1998.

61. Edward Lucie-Smith, *Movements in Art Since 1945* (London: Thames and Hudson, 1995), p.74; *The 20th Century Art Book*, p.74.

62. The 20th Century Art Book, p.276.

63. *ABC*, December 12, 1997, December 19, 1997.

64. Al Goodman, "A Furor for Velazquez: His Art, but Also His Bones," *New York Times*, September 7, 1999.

Chapter 7

1. Marie Louise Graff, *Culture Shock! Spain* (Portland, OR: Graphic Arts Center, 1997), p. 176.

2. Suzanne Daley, "Spain Rudely Awakened to Workday World," *New York Times*,

December 26, 1999.

3. Culture Shock, p. 120.

4. *New York Times*, September 15, 1999.

5. Helen Partington, *Insight Guide to Spain* (London: Langenscheidt, 1999), pp. 101—103; Manuel Rios, "Tradición y Vanguardia," *ABC*, April 17, 1998.

6. *New York Times*, June 22, 1999.

7. Edward F. Stanton, *Handbook of Spanish Popular Culture* (Westport, CT: Greenwood Press, 1999), pp. 51–79; *Insight*, p. 110.

8. Raymond Carr, *A History of Spain* ((New York: Oxford University Press, 2000), p. 270; *Voz de Galicia*, December 27, 1999; Carlos Barrio, "La Gran Orgía," *Interviú* (12/27/00–1/2/00), pp. 11–17.

9. *Insight*, p. 71.

10. Stanton, pp. 81—98; John Hooper, *The New Spaniards* (New York: Penguin, 1990), pp. 357—367.

11. Stanton, pp. 119—125.

12. Letter to the editor from David García-Baamonde Gonzáles, *ABC*, June 29, 1997.

13. Constitution of Spain (Madrid: Government Information Service, 1999), Article 20.

14. Stanton, pp. 173—175; Hooper, pp. 305—320.

15. Ibid.

16. Hooper, pp. 294—295; Stanton, pp. 191—195.

Chapter 8

1. *Cambio 16*, August 16, 1999; *El Pais*, June 14, 1999.

2. *New York Times*, December 1, 1995; *El Pais*, June 14, 1999.

3. *ABC*, February 8, 1998.

4. *El Pais*, October 31, 2000.

5. *El Mundo*, September 18, 2000; *New York Times*, October 5, November 23, 2000.

6. *El Pais*, October 16, 2000; *New York Times*, July 7, 2000.

7. *ABC*, June 29, 2000.

8. *Ibid., June 10, 1999.*

9. John Hooper, *The New Spaniards* (New York: Penguin, 1990), pp. 117, 309.

10. *ABC*, February 8, 1998; *New York Times*, June 13, December 15, 2000.

11. *New York Times*, February 12, June 17, 1999.

12. BBC World News Service, July 17, 2000.

13. *El Mundo*, August 16, 1999; *El País*, August 16, 1999.

14. *El País*, September 19, December 18, 2000.

15. Ibid., October 18, October 31, 2000; *ABC*, June 29, 1999; *New York Times*, July 4, July 14, August 22, 2000.

16. *ABC*, February 8, 1998.

17. Anthony Faiola, "Spain Inc. Begins 'Reconquest' of Latin America," *International Herald Tribune*, February 15, 2000.

18. Ibid.

19. *El País*, November 15, 2000.

20. Ibid.

21. Ibid.

22. *New York Times*, October 3, November 3, 1999, September 2, 2000.

23. *ABC*, February 8, 1998; *El País*, October 31, 2000.

Chapter 9

1. Emma Daly, "Numbers for Magic in Spain: 01/01/01," *New York Times*, December 31, 2000.

2. Ibid.

3. Suzanne Daley, "Spain Turns Cool to the Chief Who Engineered Its Boom," *New York Times*, March 12, 2000.

4. *El País*, March 16, 2000.

5. *New York Times*, January 16, February 9, 2001; Emma Daly, "Fears of Mad Cow Disease Reach Bullfighting Rings," *New York Times*, February 11, 2001; *El País*, February 8, February 21, 2001.

6. *El País*, January 18, 1999; *New York Times*, June 13, July 22, August 8, 9, 30, 2000.

7. *ABC*, October 3, 1998; *El País*, February 26, 2001.

8. *New York Times*, January 13, 2001; BBC, *World News Report*, December 31, 2000, June 13, July 22, August 8, 9, 2000.

9. *El País, January 23, 2001.*

10. *El País*, December 18, 2000.

11. *El País*, March 9, October 25, November 1, 2000, January 3, 23, February 13, 2001.

12. El País, June 14, 1999, September 27, December 5, 2000, February 28, 2001.

13. *El País*, October 16, 18, 2000.

14. *El País*, November 20, December 13, 2000, January 11, 2001.

15. *El País*, November 15, 2000.

16. Frank Prial, "In Rioja, the Grape is Old, the Style All New," *New York Times*, August 16, 2000; *El País*, September 14, 2000, January 11, 2001.

17. *El País*, February 13, 2001.

18. *El País*, September 19, 2000.

19. *El País*, November 20, 2000.

20. *El País*, December 12, 2000.

21. Herbert Mitgang, "In Guernica, Determination to 'Forgive, but Never Forget,'" *New York Times*, July 24, 2000.

22. *New York Times*, January 27, 2001.

Chapter 10

1. Christine Garnier, *Salazar in Portugal* (New York: Farrar, Straus & Young, 1954), pp. 21—47; David Birmingham, *A Concise History of Portugal* (Cambridge: Cambridge University Press, 1993), pp. 156—168.

2. Birmingham, pp. 169—178.

3. *Time*, August 11, 1961, p.22.

4. *The Almanac of World Military Power* (Harrisburg: Stackpole, 1970), pp. 105, 226.

5. Ibid., pp. 228—238.

6. *Cultural Atlas of Spain and Portugal*, pp. 164—165.

7. T. Jepson, *Exploring Portugal* (New York: Fodor, 1998), p. 43.

8. Darwin Porter and Danforth Price, *Portugal* (New York: Macmillan, 1996), p. 24.

9. *The Almanac of World Military Power*, rev. ed., 1980, p. 155.

10. Jepson, p. 20.

11. *News Weekly* (Lisbon), April 28, 2001.

12. *Constituição da República Portuguesa* (Lisbon: Government Information Office, 2001), p.1.

13. *World Factbook 2000—Portugal* (Washington, DC: Central Intelligence Agency, 2000), p. 5.

14. Ibid., p. 6.

15. Ibid., p. 7.

16. Interview with Amalia Barroso, December 15, 2000.

17. Guilherme D'Oliveira Martins, "España y Portugal: un diálogo natural," *El País*, October 31, 2000.

18. *El Mundo*, September 11, 2000.

19. *El País*, January 30, January 31, 2001; *News Weekly*, April 14, 2001.

20. Ibid., April 21, 2001.

21. Seth Mydans, "A Tower of Babel for East Timorese as They Seek a Language," *New York Times*, April 23, 2000.

22. Mark Lander, "This Colony Can't Wait for the Chinese," *New York Times*, August 19, 1998; Mark Lander, "Portugal Lowers Its Flag, Handing Macao to China," Ibid., December 20, 1999; Daisann McLane, "Ghosts of Portugal in Macao, Now Part of China," Ibid., November 26, 2000.

Chapter 11

1. *BBC World News*, March 6, 2001.

2. José Saramago, *Journey to Portugal*, trans. by Amanda Hopkinson and Nick Caistor (New York: Harcourt, Inc., 2000), p. xii.

3. Mary Vincent and R. H. Stradling, *Cultural Atlas of Spain and Portugal* (New York: Facts on File, 1994), p. 214.

4. *Experience Europe*: Expedia.com. (2001 Expedia, Inc.), p. 3.

5. Mitchel Levitas, "Hilltop Castles Guard the Past," *New York Times*, June 14, 1998; Elizabeth Marcus, "Lower Alentejo at a Canter," *New York Times*, June 14, 1998; *News Weekly*, April 21, 2001.

6. Marvine Howe, "Portugal's Dinosaurs Get Their Due at Last," *New York Times*, August 8, 2000.

7. Julia Wilkinson and John King, *Portugal* (London: Lonely Planet, 2001), p. 31.

8. *News Weekly*, May 19, 2001.

9. Tim Jepson, *Exploring Portugal* (New York: Fodor, 1998), p. 10.

10. Julia Wilkinson and John King, *Portugal* (London: Lonely Planet, 2001), p. 37.

11. *News Weekly*, April 14, 21, 25, May 5, 19, 2001.

12. Ibid., April 28, 2001; Wilkinson and King, p. 55.

13. *News Weekly*, April 28, 2001.

14. Ibid., April 13, 14, May 26, 2001; *El País*, June 30, 1999.

15. Wilkinson and King, p.36.

16. Jepson, p. 18.

17. Wilkinson and King, p. 25.

18. *New York Times*, November 13, 1998.

19. Javier García, "El retorno de las grandes fortunas portuguesas," *El País*, December 7, 1997.

20. Ibid.; Richard A. Picerno, "Magnet-like, Democracy Draws, Repels Portuguese," *Hispania*, March, 1979.

21. *News Weekly*, May 12, 19, June 30, 2001; *New York Times*, August 5, 1999.

22. *El País*, June 17, 2001.

23. *News Weekly*, April 28, 2001.

24. Institute for the Development of Management, *Report on Portugal*, summarized in *News Weekly*, April 28, 2001.

25. Ibid., June 23, 2001.

26. Ibid., June 23, 2001.

27. Ibid., June 30, 2001.

28. Ibid., May 5, 2001.

29. Ibid., June 23, 2001.

Chapter 12

1. Alan Riding, "A Writer with an Ear for the Melody of Peasant Speech," *New York Times*, October 11, 1998.

2. Mary Vincent and R. A. Stradling, *Cultural Atlas of Spain and Portugal* (New York: Facts on File, 1994), p. 131.

3. Ibid., pp. 131, 141.

4. Julia Wilkinson and John King. *Portugal* (London: Lonely Planet, 2001), pp. 39, 40.

5. Miguel Ángel Villena, "José Cardoso Pires confía en que Lisboa se integre in la modernidad sin perder su alma," *El País*, December 2, 1997.

6. Alan Riding, "Nobel in Literature Goes to José Saramago," *New York Times*, October 9, 1998; José Saramago, *Journey to Portugal*, trans. by Amanda Hopkinson and Nick Caistor (New York: Harcourt, 2000), pp. xi, xii.

7. Riding, "Nobel in Literature...," "A Writer with an Ear..."

8. Ibid.

9. *El País*, September 21, 2000.

10. Wilkinson and King, p. 48; Tim Jepson, *Exploring Portugal* (New York: Fodor, 1998), p. 59.

11. Joana Cunha Leal, "Amadeo de Souza Cardoso: A Biography," in *At the Edge: A Portuguese Futurist, Amadeo de Souza Cardoso*, ed. by Laura Coyle (Lisbon: Gabinete das Relaçoes Internacionais, 1999), pp. 17–25.

12. Gema Pajares, "Portugal desde este lado," *ABC*, February 6, 1998; M. Fernández Cid, "Nombres para la península," *ABC*, February 6, 1998.

13. Marvine Howe, "Oporto: An Art Museum That Starts with the 60s," *New York Times*, March 3, 1999; Wilkinson and King, p. 49.

14. John Krich, "A Legendary City Updates Itself," *New York Times*, August 15, 1999.

15. Idem.; Vincent and Stradling, pp. 118–119; Jill Knight Weinberger, "Monuments to Love's Labors," *New York Times*, August 15, 1999; *News Weekly*, May 5, 2001; Jepson, p. 55.

16. *New York Times*, October 7, 1999.

17. John Pareles, "The Queen of *Fado*," *New York Times*, December 3, 2000; Wilkinson and King, p. 38.

18. Jepson, pp. 178–179; Wilkinson and King, p.54.

19. *News Weekly*, April 21, 2001.

20. *New York Times*, October 28, 1999; *News Weekly*, May 19, May 26, 2001.

21. *News Weekly*, July 14, 2001.

22. *News Weekly*, June 30, July 14, 2001.

23. *News Weekly*, May 5, 26, July 14, 2001.

24. *News Weekly*, June 30, July 14, 2001.

25. Quoted in Mitchel Levitas, "Hilltop Castles Guard the Past," *New York Times*, June 14, 1998.

Select Bibliography

Alpert, Michael. *A New International History of the Spanish Civil War* (New York: St Martin's, 1994).

Aronson, Theo. *Royal Vendetta; The Crown of Spain, 1829–1965* (Indianapolis: Bobbs-Merrill, 1966).

Bachoud, Andrée. *Franco* (Barcelona: Juventud, 1998).

Boxer, C.R. *The Portuguese Seaborne Empire* (New York: Knopf, 1960).

Brenan, Gerald. *The Spanish Labyrinth* (Cambridge: Cambridge University Press, 1965).

Brimingham, David. *A Concise History of Portugal* (Cambridge: Cambridge University Press, 1993).

Brown, G.G. *A Literary History of Spain: The Twentieth Century* (New York: Barnes and Noble, 1974).

Calleja, José María. *Contra la barbarie: Un alegato en favor de las víctimas de ETA* (Madrid: Tema de Hoy, 1997).

Cantarino, Vicente. *Civilización y cultura de España* (New York: Macmillan, 1988).

Carr, Raymond. *Spain 1808–1975* (Oxford: Clarendon Press, 1982).

———. *Spain, A History* (New York: Oxford University Press, 2000)

——— and Juan Pablo Fussi. *Spain, Dictatorship to Democracy* (London: Allen and Unwin, 1979).

Cassan, Patrick. *Le Pouvoir Français et la question Basque (1981–1993)* (Paris: L'Harmattan, 1997).

Clark, Robert P. *Negotiating with ETA: Obstacles to Peace in the Basque Country, 1975–1988* (Reno, NV: University of Nevada Press, 1990).

228 ❧ Select Bibliography

Cowlley, Olivia Lorrillard, ed. *Let's Go, Spain and Portugal* (New York: St. Martin's, 2000).

Coyle, Laura, ed. *At the Edge: A Portuguese Futurist: Amadeo de Souza Cardoso* (Lisbon: Gabinete das Relaçoes Internacionais, 1999).

Crow, John. *Spain: The Root and the Flower* (Berkeley: University of California Press, 1985).

Díaz-Plaja, Fernando, and William W. Cressey. *La España que sobrevive* (Washington, DC: Georgetown University Press, 1997).

Domínguez Ortiz, Antonio. *Las clases privilegiadas en la España del angiguo régimen* (Madrid: Istmo, 1973).

Duffy, James. *Portugal in Africa* (Baltimore: Penguin Books, 1963).

Elliott, J.H. *Imperial Spain* (New York: Meridian, 1962).

Falcón, Lidia. *La razón feminista* (Madrid: Vindicación Feminista, 1983).

———. *Memorias políticas (1959–1999)* (Barcelona: Planeta, 1999).

Fossi, M., and J. Palafox. *España, 1808–1992* (Madrid: Alba, 1993).

Gallagher, Tom. *Portugal, A Twentieth-Century Interpretation* (Manchester: Manchester University Press, 1983).

Garnier, Christine. *Salazar in Portugal* (New York: Farrar, Straus and Young, 1954).

Gazarian Gautier, Marie-Lise. *Interviews with Spanish Writers* (Elmont Park, IL: Dalkey Archive Press, 1991).

Goodwin, R.M. *The Spanish Army, 1956–1996* (London: Hyde, 1997).

Graff, Marie Louise. *Culture Shock! Spain* (Portland, OR: Graphic Arts Center, 1997).

Graham, Robert. *Spain: A Nation Comes of Age* (New York: St. Martin's, 1984).

Harrison, Joseph. *An Economic History of Modern Spain* (New York: Holmes and Meier, 1978).

Harvey, Robert. *Portugal: Birth of a Democracy* (New York: St. Martin's, 1978).

Hooper, John. *The New Spaniards* (New York: Penguin, 1990).

Hughes, Robert. *Barcelona* (New York: Vintage, 1993).

Jepson, Tim. *Exploring Portugal* (New York: Fodor, 1998).

Kay, Hugh. *Salazar and Modern Portugal* (London: Eyre and Spottiswoode, 1970).

Kurlansky, Mark. *The Basque History of the World* (New York: Walker, 1999).

Livermore, H.V. *A New History of Portugal* (Cambridge: Cambridge University Press, 1976).

Lynch, John. *Bourbon Spain, 1700–1808* (Oxford: Blackwell, 1993).

Marías, Julián. *Los Españoles* (Madrid: Revista de Occidente, 1971).

———. *Understanding Spain* (Ann Arbor, MI: University of Michigan Press, 1999).

Martin, Benjamin. *The Agony of Modernization: Labor and Industrialization in Spain* (Ithaca, NY: Cornell University Press, 1990).

Maxwell, K., ed. *The Press and the Rebirth of Iberian Democracy* (Westport, CT: Greenwood, 1983).

Morrison, R.J. *Portugal: Revolutionary Change in an Open Economy* (Boston: Auburn, 1981).

Newton, Michael, and Peter Donaghy. *Institutions of Modern Spain* (Cambridge: Harvard University Press, 1998).

Nowell, Charles E. *Portugal* (Englewood Cliffs, NJ: Prentice Hall, 1973).

Oliveira Marques, A.H. de. *History of Portugal* (New York: Columbia University Press, 1976).

Opello, Walter. *Portugal: From Monarchy to Pluralist Democracy* (Boulder, CO: Westview, 1991).

Partington, Helen, ed. *Insight Guide to Spain* (London: Langenscheidt, 1999).

Payne, Stanley. *Politics and the Military in Modern Spain* (Stanford, CA: Stanford University Press, 1967).

———. *A History of Spain and Portugal*, 2 vols. (Madison, WI: University of Wisconsin Press, 1973).

———. *Spanish Catholicism: A Historical Overview* (Madison, WI: University of Wisconsin Press, 1984).

Pérez Díaz, Víctor. *The Return of Civil Society: The Emergence of Democratic Spain* (Cambridge, MA: Harvard University Press, 1998).

Porter, Darwin, and Danforth Price. *Portugal* (New York: Macmillan, 1996).

Preston, Paul, ed. *The Evolution and Decline of the Franco Regime* (New York: Barnes and Noble, 1976).

———. *Franco* (New York: Basic Books, 1994).

Robinson, R.A.H. *Contemporary Portugal: A History* (London: Allen and Unwin, 1979).

Sanz Villanueva, Santos. *Historia de la literatura española. El siglo XX* (Barcelona: Ariel, 1984).

Saramago, José. *Journey to Portugal*, trans. by Amanda Hopkinson and Nick Caistor (New York: Harcourt, 2000).

Stanton, Edward. *Handbook of Spanish Popular Culture* (Westport, CT: Greenwood, 1999).

Thomas, Hugh. *The Spanish Civil War* (New York: Harper, 1961).

Vincent, Mary, and R.A. Stradling. *Cultural Atlas of Spain and Portugal* (New York: Facts on File, 1994).

Way, Ruth. *A Geography of Spain and Portugal* (London: Methuen, 1962).

Wiarda, Howard, J. *Corporation and Development in Portugal* (Amherst, MA: University of Massachusetts Press, 1977).

Wheeler, Douglas L. *Historical Dictionary of Portugal* (Metuchen, NJ: Scarecrow Press, 1993).

Index

Studies in Modern European History

The monographs in this series focus upon aspects of the political, social, economic, cultural, and religious history of Europe from the Renaissance to the present. Emphasis is placed on the states of Western Europe, especially Great Britain, France, Italy, and Germany. While some of the volumes treat internal developments, others deal with movements such as liberalism, socialism, and industrialization, which transcend a particular country.

The series editor is:

Frank J. Coppa
Director, Doctor of Arts Program
in Modern World History
Department of History
St. John's University
Jamaica, New York 11439

To order other books in this series, please contact our Customer Service Department:

(800) 770-LANG (within the U.S.)
(212) 647-7706 (outside the U.S.)
(212) 647-7707 FAX

or browse online by series at:
WWW.PETERLANGUSA.COM